THE RACIAL UNFAMILIAR

LITERATURE NOW

LITERATURE NOW

Matthew Hart, David James,
And Rebecca L. Walkowitz,
Series Editors

Literature Now offers a distinct vision of late-twentieth- and early-twenty-first-century literary culture. Addressing contemporary literature and the ways we understand its meaning, the series includes books that are comparative and transnational in scope as well as those that focus on national and regional literary cultures.

The Racial Unfamiliar

ILLEGIBILITY IN BLACK LITERATURE
AND CULTURE

John Brooks

Columbia University Press
New York

Columbia University Press
Publishers Since 1893
New York Chichester, West Sussex
cup.columbia.edu

Library of Congress Cataloging-in-Publication Data
Names: Brooks, John, 1989– author.
Title: The racial unfamiliar : illegibility in Black literature and culture / John Brooks.
Description: New York : Columbia University Press, 2022. | Series: Literature now |
Includes bibliographical references and index.
Identifiers: LCCN 2021057279 (print) | LCCN 2021057280 (ebook) | ISBN 9780231205023
(hardback) | ISBN 9780231205030 (trade paperback) | ISBN 9780231555807 (ebook)
Subjects: LCSH: American literature—African American authors—History and criticism. |
African American art—21st century. | African Americans—Race identity. | Race in literature. |
Race in art. | African Americans in literature. | African Americans in art. | African Americans—
Intellectual life—21st century. | LCGFT: Literary criticism.
Classification: LCC PS153.B53 B76 2022 (print) | LCC PS153.B53 (ebook) |
DDC 810.9/896073—dc23/eng/20211228
LC record available at https://lccn.loc.gov/2021057279
LC ebook record available at https://lccn.loc.gov/2021057280

Cover design: Milenda Nan Ok Lee
Cover art: Lorna Simpson, *Black and Ice* (2017) © Lorna Simpson.
Courtesy of the artist and Hauser & Wirth.

For Laura

CONTENTS

Part 3 History

ACKNOWLEDGMENTS

I could not have written this book without Shane Vogel's guidance and encouragement. When I began writing, I was trying to think through Percival Everett's allusions to bebop jazz, as well as the rich possibilities that bebop offers as a broader performance sensibility. Shane's insights proved to be invaluable. I am particularly indebted to him for introducing me to the analytical framework of performance studies, which came to inform every page of this book. He has been exceedingly generous with his advice and exceptionally patient with my work, and I am certain that his mentorship inspired the best parts of this project.

I also owe endless gratitude to Stephanie Li. She offered me many productive insights, including pivotal advice about my own subject position as a researcher and author. I appreciate her excitement about this work and her stewardship throughout my writing process, especially in terms of my engagement with Black feminist theory. Walton Muyumba and Paul Anderson were also vital to the completion of the project. They correctly told me not to write a book about jazz but, rather, to think about the possibilities that jazz promises and manifests. I am grateful for their brilliance, patience, and guidance.

While writing *The Racial Unfamiliar*, I was fortunate to receive generous support from many sources. I wish to thank Brian Gareau and Elizabeth Shlala, as well as the Morrissey College of Arts and Sciences at Boston

College, for providing valuable assistance and encouragement. A significant portion of this book was written while I was a postdoctoral fellow at the Fox Center for Humanistic Inquiry at Emory University. I am in debt to the program's administrators, including its directors, Walter S. Melion and Keith Anthony; its coordinators, Amy Ebril and Colette Barlow; and the other fellows who participated in weekly workshops and thinking sessions. These include Julie Miller, who has become a great friend, and Tonio Andrade, Elizabeth Carson Pastan, Beretta E. Smith-Shomade, Javier Villa-Flores, Erin C. Tarver, Ryan Carr, Donohon Abdugafurova, Ryan Kendall, and Michael Patrick Vaughn. My research was also assisted by the generosity of the Albert Wertheim fellowship at Indiana University, for which I have Theodore S. Widlanski and Martha Jacobs to thank. Their ongoing dedication to the intellectual community of Indiana University is inspiring. And years before I first set foot in Bloomington, the McNair Program at Central Michigan University provided me with significant support. Lynn Curry and Maureen Harke—as well as my fellow McNair scholars—have my gratitude.

Early portions of this book appeared in *PMLA* and *African American Review*. I am thankful to these journals for supporting this work. The editors' and reviewers' comments were extremely useful for refining my analyses. I was also fortunate to present parts of this research at various conferences, including meetings of the Modern Language Association, the Association for the Study of the Arts of the Present, the American Literature Association, and the Society for the Study of the Multi-Ethnic Literature of the United States. I am thankful to have had the opportunity to share my works in progress but more thankful for the feedback I received during these presentations. Many of my arguments benefited from audience questions and comments but also from the happenstance conversations that sometimes occur at conferences.

I am immensely grateful to Philip Leventhal, who has been willing to guide me through the various stages of the publication process. He is a first-rate editor. I am thankful for his patience and insights during the proposal process, through my revisions, and beyond. It has also been a pleasure to work with the editors for the Literature Now series. I thank Matthew Hart, David James, and Rebecca L. Walkowitz for their enthusiasm for this project since its early stages. And, of course, thank you to the entire production team at Columbia University Press, including Marielle Poss, Monique Briones, Ben Kolstad, and Lois Smith.

ACKNOWLEDGMENTS

Most of this book was written at Indiana University, but scholars and friends whom I met before arriving there also contributed to its foundation, although they did not know it. At the University of South Carolina, I owe special thanks to David Cowart, who retaught me how to write, as well as Susan Vanderborg, Holly Crocker, and Park Bucker. At Central Michigan University, I want to thank Mark Freed and Bill Wandless, who introduced me to the critical study of literature, as well as the cohort of students who were studying alongside me, in particular Dan Crowley and Cyrus Azizi.

Finally, I owe special thanks to my wife, Laura Partain. I could not have finished this book without all the work and love that she poured into it. She read the first drafts, the second drafts, on so on until the book was complete—and then she read everything again. When things were not coming together, she made the writing and revision process bearable. I am grateful for her encouragement, advice, and insights but mostly for her unending confidence in me. And, last, I am thankful for the pups, Digg, Lucy, and Dandelion.

THE RACIAL UNFAMILIAR

ENCOUNTERING ILLEGIBILITY

The Enactment of Critical Blackness

We must appeal to another way of thinking of things that is offered in the social aesthetics of black radicalism and its improvisatory protocols. Perhaps some critical inhabitation of the other, dancing civilization black radicalism is and calls, some consideration of how that other thinking animates the whole history of mourning, of goodbye, of farewell's relation to (antepolitical/antipolitical) mourning, is the disorder that is in order here.

—FRED MOTEN, *THE UNIVERSAL MACHINE*

ENCOUNTERING ILLEGIBILITY

An encounter can cultivate a sense of openness. This is not just because an encounter presents something new to us but because, when we accept its proposition, it reveals our sense of the world to be limited and contrived. As a chance meeting with something new, an encounter has a confounding effect, one that conditions a sudden epistemological break in which we confront what we think we know. The ensuing ambiguities and incongruities trouble our perception, haunt our assumptions, and upend our reasoning, creating the conditions in which new kinds of truth might become sensible—but only if, when we feel the rupture taking hold, we accommodate ourselves to the illegibility of not knowing. Then, an encounter opens up the possibility of meeting the world in new ways.

When promoting his 2017 film, *Get Out*, Jordan Peele explained that his directorial debut aimed to furnish an encounter with contemporary racial discourse, that it "originally started as a movie to combat the lie that America had become post-racial."[1] He clarified that he was targeting the "liberal elite," or educated whites who seemed blind to the ways that endemic assumptions about Black life preserve and reproduce racist ideas.[2] The film tells the story of Black photographer Chris Washington (Daniel Kaluuya), who travels to rural upstate New York to meet the family of his

white girlfriend, Rose Armitage (Allison Williams). After enduring a string of racist interactions, he is bound to a chair and shown a video that depicts how Rose's family transplants rich white peoples' brains into Black peoples' bodies. The procedure gives its white beneficiaries the physical advantages they associate with Blackness, the video explains, as well as a kind of parasitical immortality. Simultaneously, the consciousness that had belonged to the Black host descends into the "Sunken Place," an otherworldly, trance-like state in which the consciousnesses of the Black characters become trapped when wealthy whites possess their bodies.

Although Peele may have taken aim at the liberal elite, *Get Out* also furnished an encounter for promoters, critics, and filmgoers. Mixing horror conventions with comedic reversals and a science fiction conceit, the film fit into—yet also exceeded—many of the categories into which people tried to fit it. Most critics described it as a horror film about benevolent racism and white hegemony, but they also acknowledged its strong comedic elements, exemplified most clearly by Chris's friend, a TSA agent named Rod Williams (Lil Rey Howery). Peele disputed the horror classification when he told interviewers that the film was a "social thriller" in the tradition of *Rosemary's Baby* and *The Stepford Wives*, although he emphasized that it has "an overarching satirical commentary" that is "very funny."[3] Debates over the film's genre flared when Universal Studios submitted *Get Out* to the 2018 Golden Globes as a comedy, meaning the Hollywood Foreign Press Association considered it under the category "Best Musical or Comedy Motion Picture."[4] In its generic irresolution, *Get Out* began rupturing aesthetic categories, revealing the limits of genre's authority to impose a sense of order where there is none.

These public debates about the generic contours of horror and comedy veiled a separate discussion in which commentators categorized *Get Out* as a distinctly Black film. Several reviewers went so far as to imply it was a Black perspective on *Invasion of the Body Snatchers*, a Black version of *Dante's Peak*, or a Black remake of *The Skeleton Key*, and many critics prefixed the film when depicting it as an example of Black horror, Black comedy, or simply a Black movie.[5] Like Universal Studios, which had surmised that *Get Out* was a comedy because of Peele's background as a well-known comedian, these viewers assumed that the movie was categorically Black because of its Black director, its Black leading actor, or its representations of racial conflict. The invocation of Blackness as an aesthetic category raises

familiar questions about Black artistic production: What is Black art? Does it come from a Black artist? Is it meant for a Black audience? Should it reflect the experiences and concerns of all Black people?

This book argues that a cohort of twenty-first-century Black writers and visual artists have taken up abstractionist aesthetics to challenge audiences' assumptions about Blackness and Black artistry, rendering race illegible in the process. In this mode of abstraction, artists intentionally distance their depictions of Blackness from free-floating cultural ideas about Black identity, Black experience, and Black style. This expressive mode does not aim to counteract stereotypes about Black identity with "authentic" portrayals of the variety of individual Black experiences, however wide-ranging such representations may be. Instead, it agitates Blackness's cultural legibility by distorting and embellishing established ideas about it. Abstracting Blackness produces provocative misrepresentations and nonrepresentations of Black life, interventions that expose the incongruities that underlie socially conditioned ways of seeing, imagining, or knowing Blackness. Artists practicing such a radical, antiessentialist aesthetic are making art and living lives that are circumscribed by the thickest political realities, and they assert that liberation requires breaking the bounds of every epistemic enclosure that attempts to capture and fix the meaning of Blackness. What is at stake in this project of epistemic unmaking is not cultural correction; rather, it is the power of illegibility to refute the idea that any collective Black identity or experience exists to be represented in literature or art.

Much has been written on the topic of racial legibility and representation, including investigations into the social function of overtly "positive" and "negative" representations to pose questions about Blackness, Black culture, and U.S. society.[6] By turning to the opacity and uncertainty of illegibility, rather than legibility, as a factor in upending popularly held beliefs about race and difference, this book uncovers the generative role of misperception and conceptual disorientation in querying the cultural determinants that make racial Blackness intelligible. *The Racial Unfamiliar* thus tracks the myriad ways that established modes of cultural production—such as "African American literature" or "Black history"—reproduce familiar but confining models of Blackness while investigating what the poet Kevin Young (alluding to *Invisible Man*) has called the "blackness of blackness," or the radical aesthetic strategies through which Black artists enact "a machining, rejiggering, and at times rejection" of the status quo.[7]

This investigation riffs on the blues matrices of Huston A. Baker Jr. the signifying of Henry Louis Gates Jr. and the "drumvoices" of Eugene B. Redmond, but it also follows up on earlier studies of Black cultural production, such as Ralph Ellison's *Shadow and Act* and Zora Neale Hurston's "Characteristics of Negro Expression," to show how twenty-first-century artists strategically abstract constrictive conceptions of Blackness.

When Peele publicly rejected Universal Studios' classification of *Get Out* on Twitter, he abstracted Blackness and indicated that it exceeds categorical representation. He wrote, "'Get Out' is a documentary."[8] This blunt tweet feigns generic resolution but raises questions about the nature of categorization and the degree to which classification inadvertently conditions audiences' perception, in effect amplifying the encounter that the film's genre-bending style offers. By drawing attention to the limitations of categorization as a meaning-making process, Peele questioned the ways that reviewers made *Get Out* legible as horror, comedy, or an artifact of Blackness. Calling *Get Out* a documentary humorously renegotiates these categorical frameworks by asking filmgoers why they believe the film seems scary, funny, or Black. The tweet thus encourages audiences to adopt a critical reflective viewpoint precisely "because people know it's not true," in Peele's words.[9]

Kevin Young might liken this prompt to an aesthetic strategy that he variably calls "storying," "counterfeiting," or "slanting truth," metaphorical processes that describe how "black writers create their own authority in order to craft their own, alternative system of literary currency and value, so to speak, functioning both within and without the dominant, supposed gold-standard system of American culture."[10] As a disruption of the ideas that make race and Black aesthetic practices seem well defined and stable, Peele's tweet also makes possible an encounter that troubles the boundaries of Blackness's cultural legibility and pushes audiences to confront their complicity in reproducing racial discourse.

Peele's invocation of classification as a strategy for rejecting the idea of categorization, as well as the generative confusion that this performative gesture engendered, encapsulates the structuring principle of what this book calls *critical Blackness*. Critical Blackness denotes a mode of abstractionist expression that prompts audiences to question what they think they know about race. It is neither an epidermal quality nor a discourse on authenticity. Rather, by studying the methods of recent abstractionist

artists, I describe it as a sensibility that expands, synthesizes, and comments on ideas about race. As an aesthetic response to racialization and white hegemony, critical Blackness troubles discussions of authenticity by subverting popularly held ideas about Black identity, experience, and style. In that sense, critical Blackness confronts and disputes the ideologies that inform racial knowledge. It renders established narratives of race illegible and, in the process, exposes how the modern racial episteme constructs and perpetuates fictions about race. Such experimental and abstractionist strategies celebrate unfamiliarity and unknowability over essentialized notions of identity and experience.

Across six chapters, *The Racial Unfamiliar* shows how critical Blackness disrupts conventional visual-interpretive processes, defies the expectations that shape artistic genres and aesthetic traditions, and disputes cultural preconceptions about history and historical narration to provoke audiences to question how they think and see race.

THE ENACTMENT OF CRITICAL BLACKNESS

Toni Morrison, reflecting on her own novels in "Rootedness: The Ancestor as Foundation," alludes to the aesthetic sensibility that this book delineates. She indicates that Black literature should not be confused with ideas regarding Black skin, assumptions about Black subject matter, or some elusive notion of Black style. Instead, she characterizes Blackness as a fleeting quality of a critical mode of expression: "I don't regard Black literature as simply books written *by* Black people, or simply as literature written *about* Black people, or simply as literature that uses a certain mode of language in which you just sort of drop *g*'s. There is something very special and very identifiable about it and it is my struggle to *find* that elusive but identifiable style in the books. My joy is when I think that I have approached it; my misery is when I think I can't get there." Morrison specifies that distinctive elements of Black literature include an oral quality, the participation of both the reader and the chorus, and the presence of an ancestor. But more critically significant is her suggestion that Blackness is neither a product of an artist's skin color nor the result of a work's content; rather, it is an indefinable yet perceptible quality that select artworks express. When paired with her argument that Black writing "must be political," Morrison's characterization of Blackness unfolds as a performative quality that can

be encountered and felt in art that criticizes, analyzes, or comments on notions of race and processes of racialization.[11]

Margo Natalie Crawford explores some of the expressive objects and practices of this elusive sense of Blackness in *Black Post-Blackness*. In her work, she uses the term "black post-blackness" to describe the work of some contemporary artists who—like Morrison—turn away from established notions of Blackness yet still find value in complex engagements with its strategic abstractions.[12] Some of the strategic abstractions Crawford analyzes include explorations of Blackness as a process of fragmentation and reinvention or as a structure of feeling. While tracing these artistic sensibilities, she asks us to rethink Blackness as "the circular inseparability of the lived experience of blackness and the translation of that lived experience into the world-opening possibilities of art."[13] She argues that expressive works like Langston Hughes's *Ask Your Mama*, Amiri Baraka's "It's Nation Time," Sun Ra's *Space Is the Place*, and Kara Walker's *A Subtlety* translate and express critical Blackness—the "elusive but identifiable style" that Morrison discusses—when they contest and reshape extant ideas about Blackness. In a description that resonates with Morrison's reflection, Crawford indicates that black post-blackness is thus a performance of Blackness's unnaming (and renaming), a critical sensibility in which some artworks antagonize the very ideas that make Blackness appear defined.

The Racial Unfamiliar contributes to these conversations about the aesthetic dimensions of Blackness by examining a constellation of contemporary artworks that strategically abstract, deform, and misrepresent ideas about race to enliven the "beyond black art" sensibility that Crawford associates with twenty-first-century aesthetics. These artworks trouble the racial discourse that supplements processes of viewing and identifying and of reading and interpreting to create a sense of disparity between established racial knowledge and a budding, oppositional mode of thinking in which the incoherencies and contradictions of racial formation become sensible. The sociologists Michael Omi and Howard Winant have indicated that the rearticulation of racial ideology is a dual process of challenging dominant thought and constructing a new racial framework,[14] but I contend that some experimental and abstractionist artworks disrupt this dialectical process by creating a conceptual space in which nonessentialist perspectives on identity, authenticity, and collective subjectivity become intelligible.

Get Out enacts critical Blackness when it encourages viewers to appeal to—and then question—their own preconceptions about racial Blackness and its expressions. This happens when Chris talks to Walter (Marcus Henderson), the Armitages' Black groundskeeper, who has been colonized by Rose's grandfather's consciousness. The scene plays on the incongruity between Walter's Black body and the apparent non-Blackness of his speech patterns. For instance, when describing Rose, Walter says that she is "one of a kind, top of the line, a real doggone keeper," conjuring anachronistic "white" phrases that contrast from his physical appearance. Walter is not so much "talking white" as he is performing a non-Blackness that channels popularized ideas about Black identity and Black style. His racial gaffe plays on viewers' preexisting knowledge about racial signifiers, especially when they compare Walter to Chris, who opens the scene by saying, "What's up, man? They workin' you good out here, huh?"

Peele uses this same technique when Chris interacts with the Armitages' housekeeper, Georgina (Betty Gabriel), who has been inhabited by Rose's grandmother's consciousness, and with Logan King (LaKeith Stanfield), an ally of the Armitage family who occupies the body of Andre Hayworth. After Georgina approaches Chris to apologize for unplugging his phone, he explains that he "wasn't trying to snitch," but she does not seem to understand what he means. Chris tries again—"to rat you out"—before Georgina corrects him with "tattletale," a milder (i.e., non-Black) substitute for Chris's slang terms. Similarly, when Chris meets Logan, he goes in for a fist bump, but Logan clasps his fist as if it were a formal handshake. Through these portrayals of racial incongruity, *Get Out* activates its own hypnotic effect, assuring audiences that it is perfectly natural to invoke stereotypes when viewing, interpreting, and ordering bodies into a familiar schema of racial knowledge.

But *Get Out* quickly reverses this position to critique the racial discourse that legitimates stereotypical ideas about Blackness, a strategy that lures viewers into confronting their complicity with the racial unconscious of social normativity. Viewers who, like Chris, recognize Walter, Georgina, and Logan as inauthentically Black, must appeal to historically ingrained ideas about Black identity and Black experience and should thus see a sliver of themselves in the white characters who attend the film's garden party. In this scene, the Armitages' family and friends repeatedly invoke clichéd notions of Blackness to construct Chris as "authentically" Black. A character

named Gordon Greene (John Wilmot) references stereotypes about Black peoples' natural athleticism when he conflates Chris with Tiger Woods. Another guest, Lisa Deets (Ashley LeConte Campbell), invokes cultural assumptions about Black sexuality when she squeezes his muscles and asks Rose, with a knowing look, "So, is it true? Is it better?" Finally, Parker Dray (Rutherford Cravens) aestheticizes the Black body when he lectures Chris on racial hierarchization and style: "Fairer skin has been in favor for the past, what, couple of hundreds of years? But now the pendulum has swung back. Black is in fashion."

The garden scene parodies these white characters by ridiculing their racist views, but because they appeal to the same types of ideas on which audiences rely to deauthenticate Walter, Georgina, and Logan, the film also implicates its viewers. *Get Out* creates a dramatic scenario that encourages audiences to question the legitimacy of the racial ideologies with which they are familiar, enacting critical Blackness as a radical ontology that questions and polices the racist machinery through which Western epistemology has predetermined how race can be perceived, known, and imagined.[15]

By referring to Western philosophy, I am invoking a tradition of thought engrossed in questions about truth and reality, with epistemology particularly concerned with the production, validity, and scope of knowledge. *The Racial Unfamiliar* argues that a sense of critical Blackness haunts this philosophical tradition, which has roots in a Eurocentric rubric of civilization, one that makes colonialist discourse seem neutral and cultural hegemony appear natural. In short, Western ways of thinking and knowing have normalized and empowered white supremacy by constructing the idea of Blackness through discourses of culture (which posits nonwhiteness as primitive), civility (which posits nonwhiteness as savage), and rationality (which posits nonwhiteness as unreasonable/backward), to name just three examples. "In normative Western philosophy since the Age of Enlightenment, Reason and rationality are believed essential for achieving modern personhood, joining civil society, and participating in liberal politics," La Marr Jurelle Bruce explains. "However, Reason has been entangled, from those very Enlightenment roots, with misogynist, colonialist, ableist, antiblack, and other pernicious ideologies."[16] The modern racial episteme, then, names the strategic deployment of logic and reason that legitimates notions of racial difference and preeminence, the historically entrenched ideas that render Blackness intelligible only through stereotypical figurations.

Following Bruce's disarticulation of "Reason," my use of "Western thought" and "Western epistemology" throughout this book is meant to draw attention to the history of meaning making that has legitimated racial knowledge, as well as how critical Blackness disputes such knowledges to challenge Western philosophy's epistemological and ontological roots.

Stuart Hall described such a deconstructive process as a means of destabilizing the logic of racial meaning despite the modern racial episteme's imperializing claims to truth. If, as Hall had argued, "identity is within discourse, within representation," then abstractionist representations can disrupt meaning-making processes and occasion a theoretical and conceptual decentering of Blackness that renders popularized ideas about race culturally, historically, and politically unintelligible.[17] How *Get Out* activates this deconstructive process by exposing audiences' reliance on racial stereotypification helps to delineate the critical dynamics of radical Black expression. Hortense J. Spillers, who observes that language and grammar function as governing processes that substantiate racial thought by instilling certain manners of thinking, has argued that the language of critical Blackness serves "to break apart, to rupture violently the laws of American behavior that make [quantification, objectification, and systematic dehumanization and degendering] possible," as well as "to introduce a new *semantic* field/fold more appropriate to his/her own historic movement."[18] For Spillers, "black writers, whatever their location and by whatever projects and allegiances they are compelled, must retool the language(s) that they inherit" in order to adopt "a *critical* posture" or "a *process*, a *strategy*, of culture critique, rather than a condition of physiognomy."[19] Like the other artworks discussed in this book, *Get Out* assumes this critical posture when it urges audiences to question the assumptions and preconceptions that make Blackness comprehensible.

Paul Gilroy's description of Blackness as a metaphysical condition that creates and is created by the social surroundings of modern existence— and not some stable, fixed, knowable identity reducible to recognizable meaning—further clarifies the relation of critical Blackness to the West's modern racial episteme. In *The Black Atlantic*, Gilroy frames Blackness as a counterculture of modernity or a political sensibility that critiques the rigidity of modernity's discourse of authenticity and identity. This condition, which he attributes to the "syncretic complexity of black expressive culture,"[20] suggests that the state of racialized being takes its most

discernible shape in an attitude always at odds with the dominant racial paradigm, the collection of ideas that mechanisms of racial legitimation reinforce and perpetuate. Gilroy's attention to Blackness's relation to modernity resonates with Spillers's description of its position in regard to the intellectual tradition against which it places itself. Rather than endorsing Blackness as a supplement to already established, dominant intellectual practices and technologies, she characterizes it as the always-present Other against which tradition is formed: " 'blackness' had to be cast as [other traditions'] 'blindness' in the field of vision that enabled their 'insight' as a tool of speech performance." This is to say that critical Blackness is both in opposition to Western epistemology and necessarily part of its foundation or, as Spillers explains, that "black culture 'argues' with the west, and it is *in* and *of* it."[21] The relation Spillers theorizes is one marked by discordant hostility, as she indicates that the performance of Black expression is always radical and resistant.

The poet and scholar Fred Moten has further charted the fugitive contours of critical Blackness by arguing that it emerges in performance as "the irruption of the thing through the resistance of the object" or that it disrupts the structural apparatuses through which one navigates the world, especially the world of race and power.[22] He begins *In the Break* by suggesting that Blackness has a different basis than the image or word. Like Gilroy, who argues that Black music can sound the unspeakable terrors of slavery,[23] Moten organizes his theorization of Blackness and aesthetics around sound and its irreducibility to verbal meaning, an irreducibility that he argues constitutes a radical exterior aurality. The materiality of this Black performance—"the ongoing improvisation of a kind of lyricism of the surplus," of radical sensuality[24]—constitutes an ontological condition that, Moten emphasizes, is in need of a new analytic. To grasp the radical exterior aurality, this new analytic must be capable of recognizing the role of the ensemble (by which Moten suggests an improvisatory sensorium) as "a force that reveals the limits of a systemic mode of thought, namely, that thinking in the spirit of system that has heretofore been called metaphysics, that thinking of the whole that is continually interrupted by temporal and ontological differentiation."[25] Moten's project to disarticulate and redefine knowledge, fugitivity, and Blackness underlies this book's analysis, as his work captures how the tension between Blackness and Western epistemology is sounded.[26]

TOWARD A GENEALOGY OF CRITICAL BLACKNESS

The Racial Unfamiliar focuses on twenty-first-century literature and art, but artists and writers were enacting critical Blackness long before critics named the Black radical tradition and traced its genealogy. To gloss just a few examples, critical Blackness infuses performance art by Adrian Piper, paintings by Alvin Hollingsworth, drama by Amiri Baraka, and vocal performances by Nina Simone. It is critical Blackness that enlivens Ishmael Reed's "Jes Grew," a personification of jazz improvisation and polytheism that opens onto an experimental exercise of freedom in *Mumbo Jumbo*, as well as his appropriation—and parodying—of the genre of the slave narrative in *Flight to Canada*. Fran Ross's *Oreo* and George Schuyler's *Black No More* enact critical Blackness when they question racial identity formation and the relation of Black being to Black skin. Critical Blackness inspires Alain Locke's *The New Negro*, the blues poetry of Langston Hughes, and the genre-busting experimentation of Jean Toomer's *Cane*. Earlier still, critical Blackness motivates Frederick Douglass's rootworking in *Narrative of the Life of Frederick Douglass* and its follow-up, the more aesthetically ambitious *My Bondage and My Freedom*, as well as the inventive escape strategies described in *Narrative of the Life of Henry Box Brown* and William and Ellen Craft's *Running a Thousand Miles for Freedom*. It is also critical Blackness that animates William Wells Brown's scathing novel *Clotel* and Phillis Wheatley's strategic uses of evangelical Christianity to challenge the logic of racial subjugation. And in 1790, enslaved Ghanaians enacted critical Blackness during the Middle Passage when they responded to New World racialization by carving stars and half-moons into their hair with glass shards.[27]

This genealogy is not meant to suggest that critical Blackness has a stable chronology or a sequential form of development. Rather, it is meant to link together some of the literature, art, and creative acts that consciously advanced new perspectives on Black identity, culture, and sociality. The vitality that links twenty-first-century enactments of critical Blackness to enslaved Africans stolen to the Americas reminds us that the aesthetic periodization that organizes Black artistic production—such as the Harlem Renaissance and the Black Arts Movement—can also erase the questions, concerns, and expressive practices that connect them. As Paul C. Taylor argues in *Black Is Beautiful*, seemingly discrete Black art movements share

philosophical preoccupations. Accordingly, he describes the Blackness of Black aesthetics as an expression of the artist's orientation toward the mechanisms of social stratification that ascribe a sense of racial Blackness to bodies with Black skin. Taylor emphasizes that we must think of Black aesthetics as the practice of using "art, criticism, or analysis to explore the role that expressive objects and practices play in creating and maintaining black life-worlds."[28] In this rubric, Black aesthetics refers to a collection of philosophical arguments about the collection of expressions created by and primarily identified with people racialized as Black, with critical Blackness denoting the creative expressions that enter into this conversation by uprooting Blackness and exposing the instability of biological, national, or diasporic identity paradigms.

Like any aesthetic tradition, critical Blackness develops and matures in the context of history and politics. It adapts to account for the racial ideologies that produce and sustain perceptions of race in a given cultural moment. This is the feature of Black aesthetics that Zora Neale Hurston saw as "not a thing of the past" but something "still in the making," a kind of ongoing and interactive "exchange and re-exchange of ideas" through which Black culture workers endlessly navigate, challenge, and modify normative cultural logics.[29]

The Racial Unfamiliar focuses on literature and art since 2000 to show how critical Blackness has responded to ideas about Black identity from around the turn of the century. Among other cultural shifts, this period saw the maturation of "post-soul" and "post-Black" discourses. These late twentieth- and early twenty-first-century philosophical/artistic movements aimed to dispel historically ingrained representations of Black life by highlighting the variety of individual Black experiences. For instance, in 1986, Greg Tate began arguing that, for the post–Civil Rights generation, " 'black culture' signifies a multicultural tradition of expressive practices."[30] Trey Ellis refined Tate's ideas about multicultural Blackness when theorizing the "cultural mulatto" as an emergent identity paradigm for culturally hybrid second-generation middle-class Black Americans in 1989.[31] In 1992, Nelson George termed this period of redefinition the "post-soul" era, which he characterized as a period "when black America moved into a new phase of its history."[32] Bertram D. Ashe traces how these ideas developed into new models of Black belonging and Black expression, becoming "post-Black" for Thelma Golden in 2001 and "NewBlack" for Mark Anthony Neal in 2004.[33]

Subsequently, in his 2011 *Who's Afraid of Post-Blackness?*, Touré posited that Black authenticity is achieved by "breaking the rules of Blackness."[34]

Even as these projects have challenged historical stereotypes about Black life and expanded Blackness's representational possibilities, their emphasis on hybridity has sometimes reaffirmed the idea that Blackness could be realized—and therefore also recognized—according to some elastic and adaptive modes of behaviors or backgrounds. Part of the trouble with post-Blackness, clarifies K. Merinda Simmons, is that "our interest should lie not in what is unique or different about a particular identity group but in what kinds of interests or motivations we bring to the table in order to classify that group as particular or 'othered' in the first place."[35] This is the undertaking of the contemporary moment of critical Blackness.

Because it is invested in critiquing racial power structures, this undertaking can sometimes feel distinctly pedagogical, as if critical Black expression exists just to educate racist whites. However, as an aesthetic sensibility that takes the modern racial episteme apart without providing new ideas about how Blackness might be known, it is more accurate to describe it as an exercise in opening new boundless possibilities for what Blackness will be.[36] This is a process that uncovers the creativity, beauty, and joy that stirs the Black radical imagination. It is not just for any one audience. Critical Blackness acts as a lens through which white and Black audiences alike might bear witness to the deconstruction of racist ideologies, meaning that its abolitionist ethos creates the conditions in which living otherwise can be both imagined and achieved.

For Cedric J. Robinson, like those who built on his work (in particular, Robin D. G. Kelley, Erica Edwards, and Moten), the radicalism of these fugitive Black life-worlds gains its coherency as a "negation of Western civilization" that takes the shape of a "specifically African response to [the] oppression emergent from the immediate determinants of European development in the modern era and framed by orders of human exploitation woven into the interstices of European social life from the inception of Western civilization."[37] It is this sense of critical Blackness that *The Racial Unfamiliar* describes. Critical Blackness—as a "place where reason is troubled" or as "the disruption of already given normative, regulative notions of totality," to have Moten tell it[38]—is not geographical, not locked to a specific time or even to any one specific racial community.

AGAINST REPRESENTATION

With this genealogy of critical Blackness in mind, *The Racial Unfamiliar* asks how strategically confusing ideas about race can spark feelings of conceptual disorientation in a broad array of sources, including photography (chapter 1), installation art (chapter 2), the novel (chapter 3), satire (chapter 4), drama (chapter 5), and poetry (chapter 6). The artistic objects that I have gathered straddle different genres, but they were all created in the twenty-first century. To reconcile their generic differences, this book approaches each of these media as a distinctly performative act. Drawing on performance studies, my analyses begin from the premise that performative enactments are "forms of cultural staging" that take shape as a "conscious, heightened, reflexive, contained" event that "*does something* to make a material, physical, and situational difference."[39] Starting with this premise, which comes from the work of D. Soyini Madison, this book shows how a disparate constellation of artworks are bound together by a singular ethos of defamiliarization that incites questions about how processes of looking (chapter 1), interpreting (chapter 2), categorizing (chapter 3), laughing (chapter 4), historicizing (chapter 5), and remembering (chapter 6) create and perpetuate fictions about race.

This book's understanding of abstractionism and its critical effects is indebted to Phillip Brian Harper, whose *Abstractionist Aesthetics* outlines the role of Black artists in a tradition of experimental artistic practice. Harper describes abstractionist aesthetics as a representational mode whereby artworks vigorously assert their representational limitations. He explains that an abstractionist artwork "is one that *emphasizes* its own distance from reality by calling attention to its constructed or artificial character—even if it also enacts real-world reference—rather than striving to dissemble that constructedness in the service of a maximum verisimilitude so highly prized within the realist framework."[40] *Get Out* engages abstractionist aesthetics and calls attention to the artificiality of racial constructs when it parodies the stereotypes that make Blackness culturally legible (in terms of athleticism, sexuality, or fashion). The film rebukes these clichés but does not provide any so-called authentic paradigm of racial identity or experience, creating a nonrepresentation of race that draws attention to the limitations of knowledges that are legitimated by racial ideologies. In this way, *Get Out* hints at Blackness's representational

impossibility. By disrupting the relation of representation to real-world referent, such abstractionist strategies invite audiences to experience an alienation effect that raises questions about the social issues to which the artwork abstractly alludes.

Kathryn Hume's *Aggressive Fictions* delineates this alienation effect as described by Harper and induced by Peele. Hume explains that alienating artworks (which she calls "aggressive fictions") undercut their audience's sense of conceptual contentment, particularly the complacency that rests on unquestioned or established beliefs.[41] Unlike conventional fiction, which Hume argues reinforces cultural norms, transgressive projects agitate perceptions of cultural normativity. Whereas Hume's exploration of transgression focuses primarily on authors who celebrate content that disgusts or annoys readers, such as gore and profanity, this book characterizes transgression as an aesthetic strategy that artists use to confound audiences' sensibilities and challenge processes of experience and expectations to such a degree that their work generates feelings of conceptual unease or disorientation, here specifically in relation to ideas regarding race. The French philosopher Michel Serres clarifies the link between this alienation effect and the epistemological rupture that it produces when he describes "the sense . . . of the confusion of encounters."[42] The nonrepresentational sort of Blackness that *Get Out* stages is alienating because it is irreducible to familiar ideas about Blackness, because it renders race illegible by troubling the processes on which racial recognition and differentiation depend. In its apparent illegibility, Blackness signifies only the opposition to audiences' desire for naming, description, and representation. Such a radical abstraction of Blackness reclaims the self-sovereignty that Western reason—and its attempts to fix the meaning of Blackness—denies Black people. My intention in rethinking transgression is not to suggest that the graphic imagery of some contemporary visual-art projects is not transgressive but to contend that violating conceptual normativity by subverting audiences' expectations and defying generic conventions can activate a more compelling alienation effect than the violence of vulgar overstimulation on its own.

The artistic strategies that this book explores trouble patterns and processes of racialization by interrogating the tension between knowledge and experience, the friction (and general slipperiness) between the "known" and the unknowable, unidentifiable, and incoherent. By asking how contemporary literature and visual-art projects put this friction and

slipperiness on display to render race illegible, this book replaces familiar questions about Black art's creators, audiences, and subject matter with a different line of inquiry: through what strategies might contemporary artists confront endemic cultural assumptions about race? In what ways can the devices that make race feel familiar—such as stereotypes—be used to make race feel unfamiliar? What new perspectives might emerge out of such disorienting encounters?

CHAPTER OVERVIEW

The Racial Unfamiliar begins with an exploration of visual abstractionism and its effects on processes of recognition and identification. Gilroy has written that "the human sensorium has had to be educated to the appreciation of racial differences," and the first two chapters show how the senses might be reeducated—or undisciplined—to reject those lessons.[43] My analyses are in conversation with the work of Nicole Fleetwood, who uses the phrase "troubling affect" to describe how Blackness is always already overdetermined in the modern visual field.[44] Following Fleetwood, I consider how abstracting and confusing sensorial processes calls "upon the spectator to do certain work, to perform a function as arbiter or decoder, of visual signs that become aligned with blackness."[45] However, instead of suggesting that Black visual-art projects charge audiences with the task of interpreting and translating troubling visions, I ask how the disruption of sensorial processes—and the confusion such disturbance engenders—might prompt spectators to question their preconceptions about racial identity.

To show how the modern period's racial episteme trains viewing subjects to recognize the Black body in line with already established racial ideology, and to probe the strategies of illegibility through which these tropes of Blackness might be disrupted, chapter 1 turns to the hazy and out-of-focus images of Roy DeCarava's photography collection, *The Sound I Saw*.[46] Published in 2001, DeCarava's collection comprises 196 pictures of the 1960s Harlem jazz scene, all of which feature heavy shadows and blurred lines, hallmark qualities of what he called his "black aesthetic."[47] When we apply the photographer's conceptualization of this Black aesthetic to his work, we can glimpse how his craft resonates with the sort of Blackness theorized by Crawford, Spillers, Gilroy, Moten, Taylor, and Robinson—indeed, it pivots around the creation of a transgressive visuality effect that challenges racial

knowledge by making sensible "a world shaped by blackness," as DeCarava put it.[48] With DeCarava's Black aesthetic in mind, I bring together both aesthetic and psychophysiological approaches to vision to show how the photography of *The Sound I Saw* plays with visual and conceptual unease.

Chapter 1 also surveys art included in Thelma Golden's groundbreaking *Freestyle* exhibition, which ran at the Studio Museum in Harlem from April 28 to June 24, 2001, and which showcased a number of visual artists invested in abstracting Blackness from Black skin.[49] Three of these artists are Adler Guerrier, Laylah Ali, and Kira Lynn Harris, all of whose visual-racial projects transgress audience expectations about narrative to create a sense of conceptual unease that is analogous to DeCarava's Black aesthetic. My analyses of this exhibition show how racial recognition and identification are part of a visual procedure that is vulnerable to social conditioning, then ask how abstracting the appearance and perceptibility of the Black body might undiscipline sight and recover the conceptual freedom lost to visual habituation.

Chapter 2 further considers the effects of encountering illegibility by examining the role of the body in navigating sensory confusion. This chapter focuses on the conceptual disorder produced by Kara Walker's transgressive visual-art projects, in particular *The Katastwóf Karavan*, an art installation that she erected in Algiers Point in 2018.[50] The work consists of an eight-thousand-pound steel parade wagon that hauls a thirty-eight-note calliope, a steam-powered organ that produces sound by releasing compressed air through train whistles tuned to the chromatic scale. My approach to Walker's artistry shows that feelings of shock, disgust, and confusion need not be the end products of audiences' encounters with Walker's installations. Rather, the chapter contends that by returning to foundational theories of phenomenology and transgression, affective responses—like shock, disgust, and confusion—are better understood as experienced events that spark an embodied mode of critical inquiry in which unease and disorientation become generative. In this mode of inquiry, it is the reacting body, and not the rational mind, that confronts the contradictions of the nation's racial mythology, initiating a process through which audiences can reconsider what they think they know about race.

Part 2 of *The Racial Unfamiliar* is an intervention in genre studies. The etymology of the word *genre* deserves pause. Genre can be traced to the Latin *genus* (origin, type, group, race) and to the Latin cognate *gener*

(to generate), which suggests that genres are productive of social/cultural knowledge or that they create meaning about the things that they categorize. These two properties of genre intersect in the construction of racial groupings, which typify Blackness as a racial category but also generate knowledge about that category. Racial genres are a kind of political machinery that cages "Blackness" into predetermined and flat categories even as it perpetuates the very ideas that impose limits on racial identity types. Critical Blackness responds to this problem of genre by interrupting the action of generic Blackness to expose how categorizations appear stable but are necessarily dynamic. Racial genres are constructed but also beholden to the determinants of their making, meaning that they must adapt, expand, or rupture when their conventions are questioned or challenged. I contend that the study of genre is the study of Blackness and that the study of Blackness is the study of genre.

Chapter 3 considers Percival Everett's 2001 novel *Erasure*.[51] *Erasure* tells the story of Thelonious "Monk" Ellison, a Black author whose experimental literature is dismissed for being "not black enough." In frustration, Monk publishes a book that exacerbates every thinkable racial stereotype, but his book ironically becomes a bestseller as a "truthful" representation of Black experience in the United States. My analysis of generic experimentation places Everett's novel alongside the music of 1940s bebop performers to show how improvisatory pace-changing musical techniques structure and inspire this literary work. Like a bebop composition, *Erasure* includes many generic digressions—a résumé, an academic article, and a novella-within-the-novel—that destabilize the text's primary voice, Monk's first-person journal. I show how the novel's structural discontinuity produces a sensibility that is specific to the bebop idiom, a sense of "disharmonious harmony" that marks the irreconcilability of the narrator's dissonant identity performances.

Chapter 4 asks how the genre of satire might open new possibilities for confronting and abstracting historically rooted ideas about Black experience. For a model of critical Black humor, I turn to the work of novelist Paul Beatty, specifically his 2015 novel, *The Sellout*.[52] Beatty is distinctive not just because of the critical acclaim his work has received; he is also a prominent theorist of Black humor. In *Hokum*, an anthology of African American humor that he edited, Beatty theorizes Black humor as a transgressive comedic idiom that confronts the absurdities of racism in order to make perceptible the social discrepancies he believes most people leave

unacknowledged.[53] Beatty's articulation of Black humor is useful for examining the critical range of satire as a genre because he presents racism as an exemplar of absurdity and because the transgressive humor of *The Sellout* mines the ironies of postracial discourse.

The novel is about a Black man who enslaves one of his town's most famous residents and reinstitutes Jim Crow by resegregating several of the municipality's public services, including the local transit system and the city's public school system. By arguing that Black Americans were better off under these oppressive systems, Beatty's narrator raises provocative questions about the nature of social progress and equality, as well as the idea of "postracial" America. Although Beatty's novels have long been labeled satirical, the chapter shows how *The Sellout* turns satirical critique on itself to expose the literary mode's liberalist underpinnings. For Beatty, satirizing satire itself becomes a radical strategy for exposing the myriad ways that the long tradition of liberal thought continues to legitimate discrimination in the name of progress, how liberalism's boasts of racial equality obscure its investments in racial inequality.

The book's last section examines Blackness's entanglement with history. In her investigation into the ideological consequences of slavery and emancipation in the United States, historian Barbara J. Fields describes the role of history in constructing Blackness in the present. She notes that preconceptions and assumptions about racial identity seem to have roots in observed notions of color difference but that scientific theories of racial difference and the institutional segregation systems they bore, such as the practices that were ritually ingrained during the Jim Crow period, play a fundamental role in processes of racial identification. Fields concludes that racial knowledges are burdened to history, that Blackness often struggles to shed the racist meanings it inherits from the past: "It follows that the notion of race, in its popular manifestation, is an ideological construct and thus, above all, a historical product."[54] To consider how critical Blackness might rupture such historical processes, the final chapters pursue questions of historical representation and historical narration with attention to ideas about temporal subjugation and Blackness's imposed absence in the historical archive. Christina Sharpe's notion of living "in the wake of history" and Saidiya Hartman's "critical fabulation" inform these chapters as historiographical methods that discover and divine abstract ideas about Black historical presence where it seems to have been erased.[55]

Chapter 5 argues that Suzan-Lori Parks's *100 Plays for the First Hundred Days* distorts audiences' sense of time to invite theatergoers to "endure" the historical stagnancy that Western philosophers have attributed to African-descended people.[56] For this work, Parks wrote a new play about the daily news every day for 102 days, beginning on January 20, 2017, the day of Donald Trump's inauguration to the office of the president of the United States. In its systematic day-to-day organization and linear narration, her dramaturgy represents time as a function of reason, assuring her audience that historicizing a period of about one hundred days (a standard unit of measurement for evaluating newly inaugurated presidents) will register some measure of political change or incremental progress. But *100 Plays for the First Hundred Days* also distorts the steady flow of this day-to-day structure, sometimes slowing time's passing to a kind of dramaturgical stagnancy that suspends its audience in a state of timelessness. I argue that the cycle's temporal play—and the absurdist stagnancy it creates—can be read as a critique of Western epistemology's efforts to render Black history frozen. By challenging the notion that Black history is stagnant, the chapter shows how *100 Plays for the First Hundred Days* enacts a negation of the idea that Blackness signifies the antithesis of modernity and modern subjectivity.

The final chapter attunes itself to the Black voices that subtend the historical archive's absences of Africanity by examining the historical process through which museums facilitate society's selective remembering and strategic forgetting of the past. My analyses focus on the museum's role in preserving specific historical representations of Black femininity, and I argue that museal poetics might abstract these representations to open up the narrow historical narrative they perpetuate. In this chapter I turn to Robin Coste Lewis's 2015 collection of poetry, *The Voyage of the Sable Venus*.[57] To write this long poem, Lewis collected titles and descriptions of museum-housed visual artworks that depict the Black female body, especially those that reference prehistoric Venus figurines, which the poem presents as figurations of Africa and its diaspora. Lewis assembles these titles and descriptions into a poem that charts Venus's historical movement from 38,000 BCE to the present. But Lewis does not simply reproduce the titles and descriptions of the museum-housed artworks. Instead, I argue, she develops an aesthetic strategy that allows the titles and descriptions to act on the sense of history that they help to create. To outline how Lewis

permits Venus to be heard through the silences of the archive, the chapter shows how the poet mixes and remixes the language titling and describing Venus. Identifying this practice as an act of "heretical history" (as defined by philosopher Jacques Rancière), I describe Lewis's heretical aesthetic as a mode of Black feminist poetics to depict how *The Voyage of the Sable Venus* critiques the historical narrative that museums articulate.

These chapters are driven by the idea that critical Blackness furnishes disorienting encounters in which uncertainty generates provocative questions about Black identity and Black experience. Arguing that the experimental aesthetic of critical Blackness challenges audiences to question what they think they know about race, *The Racial Unfamiliar* contends that Black expressive practices are antiessentialist, an intervention that underscores the significance of abstraction and illegibility to the study of contemporary Black artistic production.

CONFUSING SENSE

In her review of *Get Out* for *Harper's Magazine*, the novelist Zadie Smith stated that Peele's debut feature is easy to celebrate because each of its self-contained, ironic, and politically charged scenes "contains its own commentary."[58] She emphasizes that the movie offers Black viewers vindication when it depicts white-on-Black violence, offers white filmgoers the illuminating feeling of feeling slightly othered when it illustrates how white people interact with Black people, and offers all audiences—Black and white—an opportunity to feel good about identifying and smirking at micro-aggressions, inadvertent racism, and white characters' shallow liberal posturing.

But the film also alienates viewers from the image they have generated of themselves. Peele needs audiences to participate in constructing characters' racial profiles and detect instances in which characters violate the conventions that make their racial figuration culturally legible. Doing so is not important just for the development of the film's brain-transplantation conceit. It is also important because it highlights viewers' entanglement in discourse that preserves and reproduces racial meaning, how the modern racial episteme aims to have always already validated in peoples' minds the meaning of Blackness. The critical Blackness that *Get Out* enacts aims to confuse viewers and activate a self-critical standpoint in which they can

confront the racial unconscious of Western thought and consider its long-reaching effects. This is how *Get Out* defamiliarizes established notions of Black identity and experience to render race illegible, how it subverts the ideas that underlie racist attitudes and beliefs by challenging its audience to recognize their confidence in everyday acts of stereotypification. Peele may have targeted the liberal elite, but his film's critical Blackness has all viewers in its sights.

Just as Peele incites filmgoers to be attentive to how they look, recognize, identify, and categorize, the artists of the coming chapters challenge their audiences' expectations and the comfort of conceptual familiarity to unsettle our complicity with popularized assumptions about racial difference and racial essentialism. Over six chapters, I highlight how the Black radical tradition infuses and inspires a broad array of twenty-first-century artworks, all of which prompt their audiences to rethink their racial preconceptions and recognize the effects of racial ideology in the contemporary moment. Charting the strategies through which artists like Peele facilitate such critical, deconstructive encounters—those that stage racial illegibility—is the central undertaking of *The Racial Unfamiliar*. The literature and art discussed in this book destabilize the legitimating devices of race and racialization in all their forms. They ask their audiences to reconsider how they recognize the recognizable, why they accept conventions as conventional, and how they have come to know what they think they know—about identity, about culture, and, most important, about race.

PART I

Vision

PICTURING BLACKNESS IN THE PHOTOGRAPHY OF ROY DECARAVA

And yet there is something in the figures that is very creative, that is very real and very black in the finest sense of the word. So there is this duality, this ambiguity in the photograph that I find very hard to live with. I always have to make a decision in a case like this—is it good or is it bad? I have to say that even though it jars some of my sensibilities and it reminds me of things I would rather not be reminded of, it is still a good picture. In fact, it is good just because of those things and in spite of those things. The picture works.

—ROY DeCARAVA ON HIS PHOTOGRAPH *DANCERS, NEW YORK*

FUNDAMENTAL PERCEPTION: THE DISCIPLINING OF SIGHT AND ABSTRACTIONIST VISION

Our preconceptions dictate how we can see. The photographer Roy DeCarava suggested as much during an interview with Ivor Miller, a cultural historian. In that interview, he asserted that his perspective as a Black American enabled him to see—and represent—the world in a more fundamental way than did white photographers. Echoing W. E. B. Du Bois's familiar concept of double consciousness, DeCarava characterized his perception by contrasting himself with the white photographer and documentary filmmaker Robert Frank, whose 1958 book, *The Americans*, earned critical acclaim for presenting an outsider's view of U.S. society: "Frank saw the U.S. as a white person. If I had gone through the same towns side by side with Frank I would have seen something entirely different than he did. He is incapable of seeing what I see. But I can see what he saw. Because I have this duality, I am like a person with two languages. Most black people are. . . . He reflected the surface quality of some aspects of American life, as opposed to a more fundamental perception."[1] In his assertion that he could see beneath the normative surface of American life, DeCarava suggests that his experiences with racism enables him to recognize how social arrangements obscure marginalization, often hiding it in plain sight. How one sees the world is subject to vision's vulnerability to cultural influence, he explains,

drawing attention to the role that coded notions of race play in the disciplining of visual processes.

DeCarava's ideas about race and perspective raise questions about the fluidity between the visible and the veiled but also about the sociocultural effect of a visual field that is either only partially perceptible or perceptible only to certain viewers. If, as the art historian Norman Bryson contends, the society in which we live conditions our sight, making objective or neutral observation impossible, then how can a viewing community undiscipline its viewing process?[2] Furthermore, if, as Judith Butler has argued, "the visual field is not neutral to the question of race; it is itself a racial formation, an episteme, hegemonic and forceful," then we might also ask, how can the same viewing community come to practice a way of seeing that breaks from the white supremacist ideologies that shape the racial imaginary?[3]

These questions are not meant to suggest that the senses are innately deceptive; rather they suggest that the long history of rational thought determines how one sees, and for that reason, the normative visual field recognizes and understands the object of sight through a prescriptive lens. Robyn Wiegman traces the basis of this "rationalized vision" to the epistemological basis of natural history, specifically the idea that an apparently neutral viewer could rely on the eye as an objective mechanism of observation with the authority to establish clear and unambiguous descriptions of qualities marking difference in terms of bodily identities. It is through the rationalization of vision, she clarifies, that viewers came to associate skin color with a hierarchy for categorizing human beings.[4] This notion of rationalized sight remains relevant into the twenty-first century because vision continues to produce and reiterate knowledge of racial difference. The visual body remains inherently textual—it is a sign that can (and must) be read—but, as DeCarava's comment regarding the difference between his and Frank's perspectives indicates, the act of looking can often result in seeing bodies only through a specific set of predetermined racial notions.

This chapter argues that critical Blackness in the visual arts aims to undiscipline sight and recover the conceptual freedom lost to the social conditioning of visual processes. My analyses focus on DeCarava's jazz photography. By bringing together both aesthetic and psychophysiological approaches to vision, including the concept of *jamais vu* and associative visual agnosia, I show how his available-light, handheld camerawork

exposes the naturalized whiteness of rationalized vision. This analysis is motivated by what DeCarava called his "black aesthetic," an artistic technique that he devised to challenge white cultural hegemony and share his fundamental, Black sight. To strengthen my assertion that visual-racial projects of critical Blackness aim to undiscipline sight, I also look to the work of three artists from Thelma Golden's *Freestyle* exhibition, which ran at the Studio Museum in Harlem from April 28 to June 24, 2001: Adler Guerrier, Laylah Ali, and Kira Lynn Harris. Their visual-racial projects disrupt visualization processes to create the conditions in which viewers become conscious of the process of seeing as a performative act—a topic I discuss in the concluding section to this chapter.

To supplement my analyses, I have reproduced images of visual-art projects by Guerrier, Ali, and Harris. These appear in the text alongside my argument. When I contacted the DeCarava Archives about reprinting his photography, however, the collection manager explained that DeCarava's pictures are not available for licensing per their agreement with exhibiting entities. Moreover, they noted that the photographer generally restricted the public viewing of his works to exhibitions and their related catalogues, believing this to be the only effective way to display them. DeCarava recognized that his photographs furnish a phenomenological encounter that cannot be reproduced adequately outside of the gallery space. His attention to the body's role in enacting his photography aligns with the argument that this chapter develops, in particular my assertion that his dark and blurry images aim to obscure more than they disclose, in effect confusing sight and creating a self-reflective viewing experience. In that spirit, choosing to withhold the images' visuality advances the theory of visual disruption that this chapter delineates, as it conditions a kind of sightlessness that amplifies the illegibility that *The Racial Unfamiliar* pursues. With this sense of visual disruption in mind, and in accordance with the artist's preferences, this chapter does not include reproductions of the DeCarava photographs that I discuss, although they can all be referenced and viewed in his 2001 print collection, *The Sound I Saw: Improvisation on a Jazz Theme*.[5]

Phillip Brian Harper's notion of abstractionism binds my analyses and informs this chapter's perspective on visual disruption. Beginning from the premise that realism is no longer the primary stake of Black cultural engagement, Harper asserts that in "disrupting the easy correspondence between itself and its evident referent, the abstractionist work invites us to

question the 'naturalness' not only of the aesthetic representation but also of the social facts to which it alludes, thereby opening them to active and potentially salutary revision."[6] Harper maintains that visual art cannot consistently create the conditions that make possible abstractionism's productive social critique without the addition of narrative elements to guide the viewer. But my analyses suggest that *The Sound I Saw* withholds narrative elements in order to harness the full potential of ambiguity, thus amplifying abstractionism's disorienting ethos. By abstracting the elements of conventional portraiture and defamiliarizing the visual field, I argue, the collection encourages audiences to ask how looking, recognizing, and identifying function to reproduce culturally entrenched preconceptions about racial difference, producing a novel mode of sight in which Blackness disassociates from the epidermal condition linked with the Black body and appears as a critical attitude that queries what we think we know about race.

The undisciplining of sight aims to expand the visual field by revising audiences' visual habits toward a way of seeing that does not mobilize color for the production of racial difference. In that spirit, projects like DeCarava's create viewing situations whereby seeing becomes a reflective act, whereby viewers become conscious of how social constructions determine what is sensible in the visual field but also expose the limitations of established connotations of the Black body as a functional category of identity ascribable to all Black people. Put another way, visual-racial works, such as *The Sound I Saw*, aspire to condition an unregulated mode of sight that pushes against the scopic regime of Western normativity by loosening Blackness from its hegemonic cage of associations.

PRESENTING THE INTANGIBLE: DECARAVA'S BLACK AESTHETIC

Publishers initially rejected the 196 images and free-verse poem that make up *The Sound I Saw*. They considered the collection, which DeCarava conceived in 1962, too expensive—and, as the photographer told the critic A. D. Coleman, "too pretentious"—for print.[7] Although the Studio Museum agreed to exhibit the photographs in 1982, twenty years after DeCarava drafted the dummy book that publishers rejected, it did not reach a national audience until 2001.[8] Despite being the first Black American to be awarded a John Simon Guggenheim Fellowship, which he received in 1952, and despite publishing *The Sweet Flypaper of Life* with poet Langston Hughes

in 1955, DeCarava and his photographs of the Harlem jazz scene fell victim to the structural violence and commercial constraints that snubbed a good deal of twentieth-century Black artworks, especially those invested in challenging the long-standing devices of racial legitimation that continue to dominate the political imaginary of the United States.

Born to a single mother in 1919, DeCarava enrolled in art classes at an early age, quickly dedicating himself to painting. Soon after graduating from high school in 1938 and starting work as a commercial artist in the poster division of the Works Progress Administration, he won a scholarship to the Cooper Union School of Art. Facing racial prejudice, he left Cooper Union after two years to join the Harlem Community Art Center, where he took classes in printmaking and design. In 1947, DeCarava left painting and serigraphy to pursue a career as a photographer. Three years later, he held his first solo show at the Museum of Modern Art in New York. Several images from that show were selected for inclusion in the traveling exhibition *The Family of Man*.[9] Soon after, in 1955, he opened A Photographer's Gallery with the goal of cultivating recognition for photography as an art form,[10] and in 1963, he founded the Kamoinge Workshop for Black photographers.[11] He returned to Cooper Union to teach from 1969 to 1972 and then joined Hunter College in 1975. DeCarava received a National Medal of Arts in 2006 and died in 2009.

It was during his tenure as the founder of the Kamoinge Workshop that DeCarava developed his Black aesthetic. Many of the photographs in *The Sound I Saw*, especially those reprinted from his 1969 exhibition, *Thru Black Eyes*, reflect this artistic sensibility, which he characterized in terms of his fundamental Black sight. As DeCarava explained it, Kamoinge was "an attempt to develop a conscious awareness of being black, in order to say things about ourselves as black people that only we could say."[12] In his interview with Miller, DeCarava contrasted this spiritually driven attitude toward artistic production with a white, European-American compulsion to participate in a formalist tradition, which he thought resulted in "dispassionate and objective" work. The Black aesthetic, in contrast, has "a different agenda than the dominant culture," he clarified, because its subtle spiritual expressionality seeks to communicate the conditions of existence under white surveillance in ways that subvert the ideologies that legitimate racial knowledges and inform racial subjugation.[13] Or, more poetically, DeCarava's understanding of the Black aesthetic revolved around

disrupting racial politics by "tak[ing] the tangible to present the intangible," using photography to share his more fundamental perception.[14]

DeCarava's 1956 photograph *Dancers, New York* typifies his Black aesthetic. The photograph, taken at a Fifth Avenue social club, depicts two young men performing a dance during an intermission between jazz bands. They contort their bodies in a stereotypical, vaudeville style resonant with the minstrelsy that produced the Jim Crow racial caricature; yet DeCarava's presentation of the men does not reduce them to stereotypes. Instead, by obscuring them under deep shadows and blurred lines, he disrupts audiences' visual-analytical processes, effectively disconnecting the material aspects of looking from vision. The two men appear only as opaque silhouettes, offering an encounter in which we must ask what we are seeing and what details we rely on when interpreting the image. By refusing to make visible the dancing men's material particularities, DeCarava provides an atmosphere of ambiguity in place of a dispassionate or objective view.

As DeCarava explains, "what happens is that the subject is reinterpreted through my printing. It is my particular view. The print is my attitude toward the object."[15] If, as he emphasizes, his Black aesthetic is motivated by a recognition of and belief in the obvious humanity of Black people, meaning that it aims to amplify an idea that is largely illegible in white supremacist cultures, then we might read the ambiguity of the image as a spiritual expression. In that vein, such photographs present Blackness not as a familiar and recognizable epidermal state reducible to any collective paradigm of Black identity or experience; rather, they convey an attitude that escapes language and straightforward representation. DeCarava describes his Black aesthetic in those terms when he frames it as a means through which Black artists might "transcend [their] corporeal nature and become something else, something bigger than [them]selves," a means of abandoning the body as the origin of racial thought in favor of an incorporeal deportment.[16] The tonal and focal balance of his printing process, which both abstracts the real and accentuates the enigmatic, produces a mode of engagement in which Blackness comments on its established cultural associations but also exceeds them.

DeCarava describes the photograph along those lines. In the epigraph to this chapter, he quickly glosses the image's context and composition to emphasize that it "works" because it contains something "very real and very black in the finest sense of the word." It is this sense of Blackness,

he emphasizes, that "jars some of [his] sensibilities."[17] Interestingly, DeCarava's characterization performs the ambiguity and duality that he describes. On the one hand, he draws our attention to the dancers' race and thus acknowledges the cultural connotations that make racial Blackness intelligible. However, at the same time, he also abstracts Blackness by presenting it as an aesthetic category. By imbuing the idea of Blackness with the same kind of duplexity he sees in the dancers, DeCarava indicates that a photograph's capacity to unsettle us—or to trouble our vision and complicate what we think we know about race—is a sign of his Black aesthetic's generative affect.

The notion of "post-black" artistry that inspired Golden's *Freestyle* exhibition helps to clarify the aims of DeCarava's Black aesthetic and the alluring ambiguity of *Dancers, New York*. Golden explained that the twenty-eight artists who participated in *Freestyle* were "adamant about not being labeled as 'black' artists, though their work was steeped, in fact deeply interested, in redefining complex notions of blackness."[18] She added that there were "no prevailing themes in the exhibition except perhaps an overwhelming sense of individuality." Yet, the exhibition's title functions as a mechanism that conceptually groups the works included in the show; as much as conventions of style provide structure to a sense of tradition and allow for distinct modes of cultural participation, they also unconsciously constrain artistic production determining the features that make up an artistic genre. Golden's "freestyle" exhibition celebrated artists thinking in excess of any device or concept that is conceivable as limiting, the host of techniques thought to be conventional to Black art being some of these potentially restrictive devices. Like DeCarava, these artists were invested in querying popular ideas about Blackness in order to facilitate a mode of representing it and encountering it from outside a racially saturated visual field of knowledge.

For artists practicing a Black aesthetic like DeCarava's, the image's resistance to interpretation draws attention to the limitations of the knowledge legitimated by the modern racial episteme. The unease the viewer may feel when unable to perceive and understand the event of *Dancers, New York* is typical of abstractionist works, which use illegibility to produce an alienation effect. In its disruptive nature, Harper explains, the abstractionist artwork intentionally draws attention to its own artificiality and constructedness even as it engages with and comments on real-world phenomena,

exchanging realism's verisimilitude for illegible and minimalist representa-
tions.[19] The disruption of vision gives abstractionist artwork a performative
dynamic that hinders meaning-making processes while highlighting the
epistemic violence that visual racialization inflicts on the subjugated.

Practitioners of such a conceptually challenging aesthetic contest the
legitimacy of racial knowledge by making visible that to which rational-
ized vision is blind—in DeCarava's case, how the question of "what is
seen" is actually a question of what the modern period's racial episteme
produces as visible. This is why DeCarava's Black aesthetic unfolds as a
"critique of the modern era," to borrow a phrase from Cedric J. Robinson,
and builds on the posture of "blackness-as-fugitivity," as Moten describes
the aesthetics of the Black radical tradition.[20] The alienation effect that
DeCarava's aesthetic produces allows for a cut that, Moten says, "opens the
possibility of an expansion, both the disruption of already given normative,
regulative notions of totality, and an expansion into a different—another—
understanding of totality, another universality."[21] This new understanding
of the world comes from nothing less than a reorganization of the sen-
sorium. Having defamiliarized Blackness by obscuring and making indis-
tinct the features associated with stereotypical (recognizable) Black life,
DeCarava's Black aesthetic asks viewers to question how they see as well
as to establish a new way of seeing in which Blackness becomes sensible as
the subversion of recognizability.[22] For DeCarava, Blackness is not just an
epidermal quality belonging to the Black body; more significantly, it is the
attitude that provokes a policing of rationalized visual processes, as well
as the conceptual unease and critical discourse that this attitude produces
when challenging the normativity of the modern period's scopic regime.

VISUAL NOISE: GEORGE MORROW AND ELVIN JONES

Images of tenor saxophonist Coleman Hawkins open and close *The Sound
I Saw*. The first picture shows the musician preparing to play, poised but
looking outward at something above the camera, beyond the frame of
the picture. The second, probably taken on the same roll of film, catches
Hawkins staring directly into the lens, the subtle smile that grips his face
suggestive of a shared awareness that has emerged between the viewer,
who has paged through the work, and the photographed subject. Between
these bookends, DeCarava features a number of jazz musicians—including

vibraphonist Milt Jackson and vocalist Gloria Lynne, and several shots of pianist Thelonious Monk—as well as many pictures that focus on ostensibly nonmusical scenes, such as *Dancers, New York* but also his well-known *Man Coming Up Subway Stairs, Ketchup Bottles, Table and Coat*, and *Hallway*.

Across the collection, DeCarava's disrupts viewers' attempts at sense-making by obscuring the material details of his subjects. A picture that is exemplary of this abstractionist photography is the profile shot of George Morrow, a bebop bassist who played in a quintet led by drummer Max Roach that included trumpeter Clifford Brown. The photograph shows Morrow's face in right profile, his left hand carefully fingering the strings of the upright bass, which fills the background of the left side of the image. The remarkable feature of Morrow's silhouette is not the musician himself but the approach DeCarava takes in capturing him: a deep shadow bathes Morrow such that his facial features are largely unrecognizable, visible only as a sort of ambiguous outline. Instead of focusing on the strictly visual elements around which photography—especially portraiture—conventionally revolves, DeCarava represents Morrow as a kind of void, a screen that obscures more than it discloses.[23]

This mode of visual presentation, which is a result of DeCarava's dark printing process, privileges the sonic undertones of the image over an easily identifiable facial shot. Resonant with the volume's title, *The Sound I Saw*, which signals a type of visual-auditory synesthesia,[24] the notes of the bass and its player's open mouth create a visible noise, which, as Jacques Attali defines it, is a figuration of power that takes shape as a type of disruption.

A noise is a resonance that interferes with the audition of a message in the process of emission. A resonance is a set of simultaneous, pure sounds of determined frequency and differing intensity. Noise, then, does not exist in itself, but only in relation to the system within which it is inscribed: emitter, transmitter, receiver. . . . Long before it was given this theoretical expression, noise had always been experienced as destruction, disorder, dirt, pollution, and aggression against the code-structuring messages. In all cultures, it is associated with the idea of the weapon, blasphemy, plague.[25]

If, as Attali puts it, "*noise is violence*: it disturbs," then to make noise in a work of art is to frustrate the conventions that allow one to interpret information, including the process of seeing and understanding the object

of sight.[26] In DeCarava's photograph, noise emanates from Morrow's shadow-laden presentation, and the image's disruption takes precedence over the recognition of the Black body, which remains perceptible but largely anonymous. DeCarava's figuration of Morrow generates a spirit of incongruity that interferes with viewers' reception of established racial knowledge—the ascription of categorical identity types, in particular— even as the interference itself (as a form of absence) may signal a type of meaning.

This sense of noise is not heard in the conventional sense but, rather, felt through a phenomenological process of enactive cognition, a kind of experience that DeCarava associated with the viewing of his photographs in the gallery space. Theories of phenomenal consciousness and experimental psychology help to explain the roots of enactive cognition as it relates to synesthetic experience. According to the psychologist J. Kevin O'Regan and the philosopher Alva Noë, the character of perceptual consciousness is constituted by sensorimotor activity,[27] which suggests that synesthetic experience is produced by exploring the visual field and, when encountering illegibility, reaching for other senses—and the associations they offer—to aid and inform the limits of sight. Put differently, synesthetic experience arises when we try to attune one sense and, in the process, subconsciously grasp at other phantom sensory stimuli to reconcile perceptual confusion. If, as this view of enactive cognition suggests, sensory experience (such as viewing) is a process in which body and mind co-originate through active exploration of the environment, then experiences of perceptual synesthesia are signs for the limits and breakdown of "rationalized vision."

In reading DeCarava's photography as an embodied and synesthetic event, I mean to invoke the philosophy of Henri-Louis Bergson, who considered the body a "center of action" in the production of knowledge, and Maurice Merleau-Ponty, who describes sensory experience as a primordial opening to consciousness itself and who thus argues for an active dimension of perception: "My body is the fabric into which all objects are woven, and it is, at least in relation to the perceived world, the general instrument of my 'comprehension.'"[28] DeCarava aligns his photography with these phenomenological theories when discussing the jarring effect of *Dancers, New York*. If the body acts as a prism through which the world is experienced, meaning that it and its sensations are constitutive of all that can be

known, then the immediate sensory confusion of synesthesia might be a more significant site for encountering the reach of the modern racial episteme than abstract rationalism alone.

Although the photograph of Morrow is not strictly about music, then, its production of noise generates a sensibility of musicality that resonates with formal jazz aesthetics. The jazz undertones of the picture take shape in the image's abstraction of the object of sight but also in the improvisatory feel of the natural-light style of DeCarava's camera work and printing process, which fragment the Black body. Morrow appears not as skin or flesh but, rather, as an ambiguous source on which the sonic qualities of the image are suspended. The visual-audio antiphony that emerges in the relation between Morrow and the musical elements of the picture overwhelms the particularities of the individual, whom the viewer can distinguish only as difference to the lighter background against which the image contrasts him. In effect, the bassist becomes an anonymous subject who is isolated but self-possessed in his act of creation, his musical performance, one that echoes the aesthetics of bebop and subsequent jazz movements, those that Keren Omry argues worked not to entertain an audience but to explore the greater possibilities of the unlimited self.[29]

DeCarava began printing his images with his characteristic palate of darker colors and more subtle tones after developing a friendship with the documentary photographer Homer Page in 1950.[30] He began his career interested in printing in a range of full contrast, which allowed for a color spectrum that included brilliant whites and dense blacks, but he gravitated toward a narrower range of deeper, gray tones because he felt they added complexity to the otherwise unexpressive areas of his images. Sara Blair describes this shift as a strategy for creating meditatively distant yet palpably intimate photographs: "Drawing on realism and expressionism, referentiality and abstraction, formalism and vernacular codes, DeCarava amalgamated and transformed [postwar cultural politics centered in Harlem], and in the process expanded the possibilities for the camera as an instrument of cultural response."[31] DeCarava knew that this mode of photography was far from monochromatic; in actuality, it is a method of studying the production of light in spaces that appear empty and dark at first glance. "The emphasis is really not on the black tones," he explains. "Most of my images that seem black are not black at all, they are very dark gray. I only use black when there is a black object, when it's solid, when it's a black wall. But space

is not black unless there is no light, and since there is always a little bit of light, such space is always dark gray."[32]

The power of this technique is evident in Morrow's silhouette. Although a wide-range palate would seem to imply more possibilities, the softer tones of DeCarava's narrow range give the bassist's portrait a considerable amount of intimacy and intricacy because they make clear the functionality of light in the creation—and abatement—of a vision. The deep grays draw the viewer's attention to otherwise overlooked elements of a photograph, leading to a deeper visual encounter that skirts the essentialism of black and white. Far from being inexpressive, this technique places emphasis on the less visible, spiritual elements of a scene or individual (in the case of Morrow).

The interpretive unease that Haitian-born, Miami-based artist Adler Guerrier creates in his photography helps to clarify the multisensory exploration motivated by *The Sound I Saw*. For instance, consider two of the photographs that Guerrier included in Golden's *Freestyle* exhibition. Like much of Guerrier's work, both of these photographs are untitled. The first is from a triptych he refers to as "Airport," and the second is from a series of twelve photographs comprising a project he calls "*flâneur* nyc/mia." Both images explore the relation of perspective to urban landscape and identity by hinting at the possibility of a story while denying the narrative elements necessary for the construction of anything resembling a visual plot or sense of place.

Initially, Guerrier's images seem straightforward. But the desolateness of each image's scene quickly changes audiences' initial feelings of familiarity to a sense of estrangement, as DeCarava's opaque photograph of Morrow does. The images focus on few, if any, people, one including only the left foot of a woman who appears to be falling but is actually reclining on an office chair and another the silhouette of an apparently faceless man who in reality is Guerrier, himself, walking the streets of Miami (figure 1.1 and 1.2).[33] Guerrier explains that in the gallery space, he likes to configure his photographs such that they unfold like a filmstrip, which suggests the passage of time and plot by simulating the experience of seeing the spaces as a traveler might. Yet, this mode of presentation ultimately feels more like snapshots taken and reproduced at random than a narrative progression, because the images are intentionally disconnected in their relation to one another. If a viewer feels that the images are united by a distinct timeline or even a singular traveler's viewpoint, it is only because of their proximity

FIGURE 1.1. Adler Guerrier, *Untitled* (Airport), 2000, photograph.

FIGURE 1.2. Adler Guerrier, *Untitled* (*Flâneur*), 1999, photograph.

in the gallery space, being grouped under a singular title (even the effect of their grouping under the name "untitled"), and the host of assumptions that an attendant may bring to his photography.

The remarkable aspect of "Airport" and "*flâneur* nyc/mia" is not only the creation of expectation regarding narrative but Guerrier's refusal to provide it. A consequence of his pictures' denial of conventional narrative elements is an added pressure on the viewer to speculate and imagine, to search for meaning where it is not apparent. By prompting the viewer to search for meaning, Guerrier turns the audience into the *flâneur*,[34] demanding that they assume a position in which the possibility of meaning-making is conditional on imagination and interpretation rather than preconceived knowledge of the specific urban landscape, the anonymous protagonist(s), and the protagonist's trip. Put another way, the features that the photographer suppresses, those that have a presence but not sufficient detail to be visible, prove inadequate when the viewer attempts to establish the connection between the object of vision and the free-floating racial knowledge on which rationalized sight relies when determining what counts as "legitimately" Black.

In this framework, the role of the viewing individual becomes to encounter critical situations (including the racial) rather than to see them through anesthetized sight of the modern period, and such a change in perception gives emphasis to the ambiguity of identity as surmised from the perspective of an outside observer. There may be a narrative at work in Guerrier's series of photographs, but it is the one that the audience devises through the rigors of interpretation as opposed to the one the artist supplies, given that the viewer is unable to develop an understanding of exactly what the actual story may be.

It is possibly because of the indecipherability of these urban spaces that critic Hunter Braithwaite suggests Guerrier's work speaks "to the relativity of a sense of place," but the space in question for visual-racial works like those of Guerrier and DeCarava is not merely geographical.[35] The images' illegibility guides viewers along not so much an intelligible path as a psychogeography. As the *flâneur*, the viewer is occupying not an airport, New York, or Miami (the locations the works' unofficial titles imply) but a space of contested vision. The challenge to construct the story that the photographs refuse changes the act of looking from one of passive receptivity to one of active struggle. Thus, Guerrier's and DeCarava's images condition

a situation of abstracted and heightened visuality in which the eye and its object do not make easy contact but grate against each other. In this way, the photographers' artistry creates a palpable phenomenological experience in which the act of looking produces in the looker a sense of the texture of the gaze, challenging our expectations of photography as a strictly visual form. Guerrier's refusal to provide context or detail functions like DeCarava's deep gray palate, which produces an opportunity to "break through a kind of literalness," as he told his wife, the scholar and critic Sherry Turner DeCarava, and to unfix his subject from its time and place by adding to its presentation a dimension of careful attention to tension and balance.[36]

DeCarava breaks through the literalness of conventional portraiture in the photograph printed on the page opposite that of Morrow, which depicts drummer Elvin Jones mid-performance, eyes closed in concentration and sweating heavily through his dark suit. The most startling detail of Jones's image is his perspiration, which Sherry Turner DeCarava compared to thorns.[37] Although Jones, unlike Morrow, faces the camera, much of his body (including the left side of his face) remains lost to one of the photographer's characteristic deep shadows, which contrasts the light reflecting in the sweat on the right side of his head. Peculiarly, this saturation of light on the right side of Jones's face makes his features no more recognizable than those on his left side. The glistening sweat may bring light into the image where it is most expected, on the individual himself, but less to illuminate his features than to interrupt his appearance by distorting and veiling the material details of his face.

Even though the space of the drummer's head is bathed in light, it is foreclosed in a type of mask, in this case one made from perspiration. Both sides of his face are covered; both the light and the shadow slow the viewer's visual process and help to draw attention to the power that the modern racial episteme has in disciplining that which is visible, because the viewer, in the act of slowing perception and becoming the *flaneur*, enters the psychogeography of the racial order and begins to detect the power of the visual cues on which rationalized sight depends. DeCarava's technique obscures the details that make Jones recognizable and asks the viewer to occupy the space of a minimalist viewer, one who looks from a space that precedes race as a way of knowing. Like the image of Morrow, in the defamiliarization of Jones's body, the image creates a visual sensibility of

noise that asks viewers to sketch a musical movement, one in which Sherry Turner DeCarava found "the beatitude of a man."[38]

So deep are the balanced grays of DeCarava's picture of Jones that the cymbal in the exposure's foreground is barely perceptible. The shadows that occlude it establish a realistic abstraction in the picture, an atmosphere of tonal nuance that demands careful interpretation in its refusal to represent clearly any recognizable features of its subject. Again, by veiling the material detail of Jones's body, this shot constitutes an instance in which the photographer, in DeCarava's words, "redefin[es] a situation, saying that this is more than what it is."[39] The image re-presents Blackness in a way that creates a contest within the visual field, a challenge regarding what is legitimately visible that keeps DeCarava's spiritually driven notion of Blackness partially sacred in order to hint at its representational impossibility. Rather than a static image of a clearly represented individual, we encounter an improvisation. The not-quite-blacks of the image—which DeCarava would insist are actually dark grays—allow viewers to see into the shadows but not to connect the photographical subject to a systemizing knowledge of race. Instead, the truth of the image becomes an abstract interpretation, dynamic and shifting as DeCarava forecloses meaning under a heavy darkness that spreads over Jones and his surroundings. Such opacity unites the scene in a dynamic interconnectivity that refuses to show the limits or edges of the drummer's body. This is to say that DeCarava figures Jones as the focus of a spectrum in which he exceeds the borders, and, as he emphasizes in the accompanying free-verse poetry, the musician comes to embody an aesthetic that brings "fresh winds / to times / of sameness."[40] Such fresh winds metaphorically lift the veil of rationalized sight by challenging the visual processes with which the viewer navigates the world of racial politics.

DÉJÀ VU / JAMAIS VU: THE PRODUCTION OF A NEW WAY OF SEEING

The embodied experience conditioned by DeCarava's photography highlights how regulatory knowledges of Blackness constitute an epistemic violence, how they make race the target of a visual pathology. Frantz Fanon records such a phenomenon in *Black Skin, White Masks* when a white child identifies and hails him by his color. "Look! A Negro!," the child announces to his mother.[41] As Fanon describes, the target of such racial

hailing comes to feel a history of race manifest phenomenologically as a condition of psychological pain by means of epidermalization: "the body schema, attacked in several places, collapsed, giving way to an epidermal racial schema."[42] Fanon's account of the epidermal racial schema is momentous because it denotes a relation between sensory apprehension and racial recognition/categorization. The child's visual process connects a percept of difference in skin color to a previously established system of racial knowledge in order to identify Fanon in a particular way, in this case a broadly conceived category of "Negro," which Fanon indicates carried with it the racial associations common to the political and popular imaginary of mid-twentieth-century France.

Whereas DeCarava's representations of Morrow and Jones allocate a considerable degree of improvisational illegibility to the field of sight, which creates a noise that slows the act of seeing and makes interpretation a challenge, the visual pathology that Fanon experiences constitutes a visual-racial *déjà vu*. It essentializes racial subjectivity by consigning it to a schema of racial knowledge, a process that flattens difference and figures Blackness as a condition of identity that is ascribable to any Black individual. This is to say that Black skin becomes the site at which sight experiences the sensation that it has "already seen" Blackness, a veiled vision in which the perceptive faculty constructs a partial perception that results in a false sense of familiarity.

It is because of this phenomenon that the "black body," Harvey Young argues, is not an actual physical body; rather, it is a constructed notion of the Black body that arises out of popular connotations that the racial episteme maps across or internalizes within Black people. He explains, "this second body, an abstracted and imagined figure, shadows or doubles the real one" and "is the target of a racializing projection."[43] As the gaze repeatedly deploys this popular notion of the Black body in racial situations, it replaces the flesh-and-blood body and Black subjectivity, allowing for the misidentification of individuals, which the popular connotation of a Black body eclipses. For this reason, Young explains that "black bodies, in the twenty-first century, continue to share in the experiences of their ancestors who were viewed as 'other,' unjustly incarcerated, and subjected to limitless violence."[44] Whether or not this violence arises in the literal incarceration or racial hostility, the modern episteme has always already (re)affirmed the association between Blackness and difference, which results in a connection

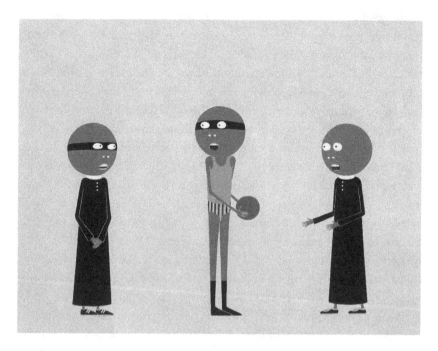

FIGURE 1.3. Laylah Ali, *Untitled* (Basketball), 2000, gouache on paper.

amounting to the same thing. The false sense of familiarity produced by the constructed Black body permits the viewer to overlook Blackness's spiritual and phantasmatic unknowability, because, perceived via *déjà vu*, Blackness can appear only in the terms that the modern period's racial episteme has produced as visible, only through the social identity categories that racial discourse has ascribed as legitimate ways for knowing Blackness.

Laylah Ali's visual art helps to clarify the violence typical of the *déjà vu* racial encounter as Fanon and Young understand it. Although they are all untitled, she refers to the eight graphic novel–type panels she included in Golden's *Freestyle* exhibit as "Greenheads." Each panel features a minimalist and cartoonish depiction of gray-headed, brown-skinned, gender-neutral bodies against a soft, monochromatic blue background. Often, Ali presents the figures in stereotypical manners, each of which aims to prompt a feeling of familiarity in the mind of the viewer. Examples include the presentation of the Black body as a basketball player, lynching victim, or convict (figure 1.3).

FIGURE 1.4. Laylah Ali, *Untitled* (Running), 2000, gouache on paper.

Importantly, even as Ali presents her figures in clichéd situations, her visual-racial project subverts the identity types that the racial episteme teaches as legitimate. Each Greenhead is quick to submit to textual sequencing as an identity type; however, Ali crafts each panel with a noticeable absence of written language or discernible narrative in the service of providing context. While the typical Greenhead panel usually depicts a dispute of some type, only the characters' gestures or expressions mediate the image's violent display (figure 1.4). This aesthetic strategy leaves the full nature of the interaction ambiguous and up to the individual viewer's interpretation.

When asked about the absence of language and narrative elements in the Greenhead pieces, Ali explains that their exclusion is a way of "prodding the viewer to participate" in the artwork's articulation, to "move from the image, off into [his or her] own reference system, and back onto the image again." She clarifies that this mode of participation involves creating and ascribing meaning to disordered situations: "I want the viewer to finally name these events, figures, and the goings-on. I want the viewer to decide what is happening, even if that is only for a moment where the assignment of meaning occurs, and then dissipates." In these encounters with radical ambiguity, the Greenheads mediate the process of signification between

vision and racial knowledge. By withholding didactic information (titles, captions, narrative elements) and "leav[ing] that interpretative space open, almost gapingly so," they push the viewer to create the image's meaning.[45] If audiences must retreat to their own reference system, however, then the image's interpretation depends on the racial associations that the viewer brings to the scene in question. This gap contains an open-ended ambiguity that, as Olukemi Ilesanmi explains, "our imaginations, with both shortcomings and unpredictable circuits, are essential in completing."[46] In its occasioning of the *déjà vu* experience, the nonnarrative strategy of Ali's work makes the viewer's racial preconceptions—political beliefs, cultural biases, and so on—painfully self-apparent.

Ali's panels, like DeCarava's printing process, aim to create an encounter opposite to the passive, anesthetized way of seeing that I associate with *déjà vu*. Similar to Guerrier's production of the *flâneur*, these works present a visual situation that conditions a nonessentializing mode of sight. This way of seeing resembles French philosopher Michel Serres's notion of vision as a process of "going to see" rather than subjecting the object of sight to an epistemological process of knowledge association and ascription. "Go visiting," Serres directs in *The Five Senses*, suggesting the adoption of a visual encounter free from previously established knowledge, and "suddenly, at the same time, you see both miniature and panorama," a bivalent mode of sight that is not reliant on the influence of history or discourse; instead, it allows for a free and undisciplined visual process while remaining conscious of the power of discursive and historical influence.[47]

Abstractionist imagery pushes viewers to "visit," or to reverse the normal sensemaking procedure of Western epistemology, that in which preconception (knowledge) is a prerequisite for the act of seeing. In the budding, prerationalized mode of sight, seeing leads to the creation of new and subjective senses of familiarity. Similar to Serres's urge to "learn the aesthetic error of submitting everything to a law," DeCarava and Ali ask the viewer to embrace illegibility and encounter the subject of a photograph outside of its hegemonic cage of racial associations (or, at least, to become aware of the power of such associations).[48] In the same way that Ali's allegories of racial relations ask viewers to confront a situation that they can know nothing about, to bear witness to a racial violence made sensible only through speculation, and to provide a story for a set of circumstances

that have no words, DeCarava's shadow-laden images of Morrow and Jones resist easy interpretation and thus constitute a prescription formulated to treat racial *déjà vu*.

The mode of visual encounter that Ali and DeCarava incite makes race visualization a process of *jamais vu*, a phenomenon that the experimental psychologist Alan S. Brown has characterized as the experiencing of well-known situations (or bodies) as unfamiliar even if they remain peculiarly recognizable in some inexpressible way.[49] As is evident in the noise of his images, this configuration allows DeCarava to present Blackness as precisely the fugitive deportment that resists the racial episteme's efforts toward naming, description, and representation. In this resistance, Blackness appears, disappears, and mutates as a confrontation between racist discourse and the noise that antagonizes it. Despite feeling eerily familiar—conceptually recognizable but experientially and cognitively unfamiliar—Morrow's and Jones's Blackness is "never seen" as an aspect of categorical identity. Nonetheless, in its unrecognizability and unknowability (its authentic figuration beyond biological, national, or diasporic identities) exists the possibility for Blackness to reclaim the self-sovereignty that rationalism tries to deny it.

Jamais vu is a novel mode of sensory engagement. Participating in the meaning-making of the image, the viewers must ask themselves not only what they see but whether or not they are comfortable with the host of associations on which they rely when interpreting the situation, whether or not they are comfortable with inferring a sense of identity or situational information from characters' outward appearance—Black skin, in particular—alone. As this ethical aspect of interpretation makes clear, the contexts and associations that viewers give to a Greenhead panel or DeCarava photograph depend entirely on how viewers look. Although the images seem to present Black bodies in familiar spaces, they are not representations of the old; instead, they constitute the creation of a context in which the viewer must read a situation with conscious awareness of the received knowledge that informs interpretation and meaning-making in the racial encounter.

Such critical encounters reveal that although DeCarava's dark shadows may initially appear to be the result of an imprecise formal technique, they actually make visible the more important quality of his images: his focus is not on Morrow or Jones, or any of the other jazz musicians or Harlem scenes included in *The Sound I Saw*. Rather, his focus is on the disruptive unease that comes with trying to make out the abstracted, detail-less

pictures through a rationalized—and therefore inadequate—visual process. Ali's Greenheads produce a similar embodied experience, explains Jareh Das, because "most of [her] works intentionally blur the lines between the recognizable and unrecognizable. Their distinct feature being the fact they allude to something familiar but which, upon reflection, is unfamiliar."[50] Darby English, too, writes that Ali's work is powerful because it appears "simple just as it slips from all but the most complex of interpretations."[51] Both artists transgress the comfort of visual familiarity in order to activate a transgressive, alienation effect.

By conditioning *jamais vu*, visual-racial projects like DeCarava's create a moment of irrational static that upsets rationalized vision and demands a new mode of seeing. The mode of sight that these artists push on the viewer disposes of the strictly physical—the mode of recognition responsible for the visual pathology of epidermalization that is endured when hailed racially—in favor of a relational encounter with a spiritual expression (or attitude of the artist) that is perceptible only in the interplay of the visual and auditory elements of the image. Blackness thus comes to be an always elusive harmonization of different modes of being in the world, each of which feels familiar yet unrecognizable as an essentializing category. The defining feature of such an aesthetic, as English writes about Ali, is the "maddening impenetrability of [the] work's narrative dimension," the lack of framework to assist the meaning-making processes when looking.[52] Visual-art projects in tune with DeCarava's Black aesthetic aspire not to represent Blackness in a way that might parallel a particular knowledge of it but to reveal the futility of efforts to ascribe Blackness as a category of identity.

TOWARD A VISUAL AGNOSIA:
JOHN COLTRANE AND BASS GUITAR

One of the most surprising—and, for some viewers, most frustrating—aspects of *The Sound I Saw* is the collection's absence of captions (and page numbers), a void that makes the identification of many musicians (nearly) impossible. Musicians featured in the collection are often recognizable only because of their popularity as American jazz celebrities. For instance, the photographs of Duke Ellington leading his band at the 1956 Newport Jazz Festival and the picture of vocalist Lena Horne embracing pianist Count

Basie capture well-known figures in a matter-of-fact manner. But DeCarava offers little (if any) additional clues to the identities of the people he photographs. As the art scholar Richard Ings discovered, this informational exclusion is part of DeCarava's larger project to defamiliarize (rather than document) Blackness: "When I approached the publishers in some despair at not being able to identify some of the jazz musicians depicted in the book, they wrote back to confirm that they had produced this book 'as an exact facsimile of the book Mr. DeCarava had mocked up himself,' that is, without any identifying captions."[53] Whereas Ings suggests that DeCarava wished to downplay the musicians' iconicity, the decision not to identify them also eliminates outside influence that might alter how viewers interacted with the photographed subjects.

Decontextualizing the photographs resonates with DeCarava's aim to produce a viewing experience that is uninfluenced by previously established racial knowledges or associations. This is why he refuses to caption not just the musical icons but also the ordinary individuals, groups, and spaces that he photographed while walking the streets of his community. The insistence on anonymity makes possible an insider/outsider dynamic that accommodates only those few people who are "in the know" while challenging other audiences, including those viewers who do not share DeCarava's fundamental perception—which is to say that *The Sound I Saw* may be particularly challenging for some white viewers.

The insistent nonclarity of DeCarava's artistry gives many of his images a sense of impenetrability, as we have seen in the portraits of Morrow and Jones. However, in several of his photographs, this illegibility overwhelms the picture so severely that the subjects become not only difficult to recognize but enigmatic in their apparent incomprehensibility. Such illegibility gives the image a performative dimension that not only resists being read but subverts entirely the viewer's interpretive processes. If the images of Morrow and Jones play with the connection between perception and the identity cues that the modern racial episteme validates as signs of the popularly conceived Black body, producing a kind of *jamais vu*, then these more intensely opaque photographs obstruct the visual process in the service of an improvisatory refusal of meaning-making. DeCarava does not simply hinder visual signification in some of these blurred works; he renders it absurdly illogical. Such a technique recalibrates our interaction with the visual field because anything identifiable as content appears only in the

abstract. As a result, the image conditions a doubling of sight (and a tearing of sight) that queries the normativity of Western ocular-centrism.

One of DeCarava's best-known pictures of the Harlem jazz scene, *Coltrane on Soprano*, captures the disruptive effect of this blurry incomprehensibility. In the photograph, the intensity with which saxophonist John Coltrane manipulates the keys of his instrument appears not as a clearly articulated focal point but as an indistinct and mysterious site of perceptual disorder. Although they occupy the center of the photograph, which conventionally signals an area of importance and focus, DeCarava represents neither the musician nor his saxophone with clarity. Instead, he recasts them as an unclear multiplicity that is the result of the image's reproduction and superimposition of the once-stable borders of the body. Coltrane's face, which is heavily contorted, helps to double the noisy intensity of this chaotic and disruptive blur, a feature that presents a sense of Blackness as a surplus, an excess of body knowledge that emerges in the gaps between the various parts of the always shifting harmonization of different confrontational modes of being. Effectively, Coltrane's expansion beyond the borders of the flesh-and-blood body highlights the noncorporeality of critical Blackness, the spiritual sense that underlies DeCarava's Black aesthetic.

As Nicole Fleetwood has explained, this sense of Blackness is always just beyond attempts to describe it precisely. "Blackness, in this sense, circulates. It is not rooted in a history, person, or thing, although it has many histories and many associations with people and things. Blackness fills in space between matter, between object and subject, between bodies, between looking and being looked upon. It fills in the void and is the void. Through its circulation, blackness attaches to bodies and narratives coded as such but it always exceeds these attachments."[54] It is in this defamiliarization of Blackness as a bodily feature that the viewer can best recognize DeCarava's bivalent vision, his fundamental perception, or the mode of seeing that he felt acknowledged the tangible and intangible simultaneously. The poetic sight he asks of his viewers requires that they approach the image with two visual modes, to see in and out of focus at once, as DeCarava insisted he could when he contrasted himself from Robert Frank.

Coltrane on Soprano abstracts the Black body by presenting its form in perceptible but nonsensical ways. As Sherry Turner DeCarava clarifies, the "figure assumes the nature of a sign as its tangible physical body diffuses into a mysterious aura of being. In its very ambiguity, the unfocused

figure serves as visible evidence for the existence of something implied in the photograph but not seen—the intimate nature of a human relationship."[55] Although DeCarava does not alter the photograph with any effects, Coltrane's body is illegible (despite his iconic familiarity) and seems to exist in multiple ways simultaneously. Because the vision does not align with typical body knowledges, the incongruous mode of seeing that DeCarava advances effects in the viewer a visual tip-of-the-tongue phenomenon in which Blackness feels unmoored from its hegemonic cage of (bodily) associations.

We might note that the primary effect of DeCarava's blurring of pictorial focus is an extreme case of *jamais vu*. This mode of seeing separates the object of sight from its conceptual referent to produce in the viewer the experience of associative visual agnosia. According to the cognitive neuroscientist Martha J. Farah, this condition is best characterized as an inability to connect a perceived object with previously stored knowledge of it.[56] Although people with visual agnosia are able to perceive the world normally and understand the objects they see, they are unable to name, describe, or identify anything in the visual field regardless of the object's familiarity or commonness. The apparent imprecision of the camerawork in DeCarava's photography fosters an atmosphere that similarly subverts interpretation and characterization. The performative dimension of the photograph asks the viewer to navigate the visual geography of the image without any perceptible details or other tools through which the subject can be made to appear identifiable. For this reason, audiences cannot connect the impression of the image with previously established knowledge of the musician's individuality (or supposed racial identity). DeCarava's ethos of defamiliarization not only prompts spectators to engage the image as Serres advises—through a mode of seeing that resembles the concept of a "visit" or a "go[ing] and see[ing]"—but further invites them to ask questions that resist rationality rather than ascribe essentialness, because, in contrast to apperceptive agnosia (an inability to construct a whole percept of visual information), associative agnosia leaves the viewer unable to recognize phenomena cognitively.

Kira Lynn Harris's installation art similarly ruptures vision and rationality to enact a dissociative disorder. In *96 Degrees in the Shade*, for instance, she transformed the corner of a factory into an experiment in perspective and perception. Harris conceived and installed her multimedia visual work

FIGURE 1.5. Kira Lynn Harris, *Void*, 2001, photograph.

during her participation in the group exhibition *White Hot* at Smack Mellon Studios, a gallery space that its founders, Andrea Reynosa and Kevin Vertrees, erected within an abandoned spice factory in Brooklyn in 1995. The exhibit focused on an obsolete brick staircase (to nowhere), which Harris covered with a sheet of silver Mylar (figure 1.5). The reflection of light off of the Mylar helped to create a feeling of boundlessness, while the mundane staircase (and the trail of loosely piled rock along the top of the installation) contrasted the shining light's futuristic magnificence in order to create a sense of divergence that played with perceptions of space.

FIGURE 1.6. Kira Lynn Harris, *Nocturne*, 2001, photograph.

The short series of photographs that survive the original installation amount to an experiment in capturing and representing the visual field through the creation of a phenomenological encounter that destabilizes the distinction between the real and the imaginative while dismissing the possibility of a universal or consistent visual experience. The first image from the series, *Void*, is a dark picture that documents the space the day prior to the installation. The second, *River*, captures the same space after its completion at midday during the exhibition. The third, *Nocturne* (figure 1.6), is a photograph of the stairs that Harris took at night following the installation's

conclusion. Grouped together, as they were in Golden's exhibit, they establish a visual sequence that documents Harris's transformation of the space, creating the conditions in which how the viewer approaches the act of looking becomes sensible.

Harris's photographs draw attention to the multiplexity of the visual field. In addition to capturing how the space changes over the course of the day, they also reveal how different viewer positions result in different viewings, as well as how the meaning of the object of vision is not static but changes depending on how the viewer approaches it. For example, because of their significant light and color differences, the viewer who encounters the indecipherable photograph *Void* alongside *Nocturne* is likely to notice that the physical space of each photograph is the same only by virtue of the subtle hint of stairs descending from the left side of the image toward the right.

Whereas *Void* initially seems to be a picture of nothingness, as the title implies, the light-flooded character of *Nocturne* informs how the viewer sees through the opacity of *Void* to make the staircase visible. *Nocturne*, in this sense, invents the visual capacity of *Void*. Nowhere in Harris's photographs can the viewer identify narrative elements that offer context or instruction regarding how to interpret the images. Instead, the pictures speak to one another by appearing as visual variations on the same scene. Out of the play between these images (the way they enlighten one another and condition interpretation based on their interactive relation) comes a sense of awareness to the act of looking that refigures the value and position of the audience.

The viewer comes to understand Harris's images not through preconceived knowledge regarding the installation site—that is, they do not resemble in any way a scene that accommodates preconceived notions of space. Rather, the images affect a visual agnosia because the scene has no available referent. Harris's dissociative effect decenters viewers' subject position within the visual field by challenging the unconscious assumption that their perception constitutes an experience that other viewers share universally, an experience that would accommodate any discourse of experience. The experience of visual agnosia is certainly unsettling to viewers, who rely on rationalized sight, but such a transgressive gesture is fundamental to Harris's work. As the art curator Nicole J. Caruth explains, Harris's practice is deeply interested in "playing with perceptions of space, especially 'upending' or subverting one's sense of orientation."[57]

How Harris's photography disrupts the commonplace draws our attention to the conventional practices of life and, according to Susette Min, opens "up an eerie possibility of transcendence through the sublime."[58] The transcendence in question—a kind of vision dissociated from normative ways of seeing—is an effect of Harris's figuration of Blackness as an encounter that resists the audience in its every manifestation, how the image expands individual viewers' perspectives such that they might acknowledge and live with difference.

Several of DeCarava's photographs share Harris's impulse to blur the lines through which recognition and identification occur. Consider his close-up photograph of an upright bass guitar, which appears in *The Sound I Saw* without a caption or title. Bathed in a deep shadow, the only visible qualities of the picture are the sharp curve of the left side of the upright bass's body, its two lowest-pitched strings, which run the length of the photograph, and a radiant glare from a light reflecting off of the instrument's semipolished face. Even to the viewer who reads the illegible image with patient care, it initially appears as illegible as Harris's staircase. The few visual clues that DeCarava provides are so distorted and out of focus that the thing pictured begins to appear as an abstract rethinking of itself. It asks viewers to question the nature of the object of sight—are we looking at an instrument, a body, steps, a play of light, or a spiritual apparition? As viewers come to recognize that their preconceptions are inadequate for making meaning out of the image, they may come to question the presumptions that guide conventional visual process and make the object of sight sensible.

These sorts of photographs upset the sensorium and recalibrate how we see, making vision a process of multisensory encounter as opposed to a mode of recognition and identification. Their subversion of interpretation enacts Susan Sontag's suggestion that photography "is the one art that has managed to carry out the grandiose, century-old threats of a Surrealist takeover of the modern sensibility," because their photographical presentations represent their subject in a way that disassociates visualization from rationality.[59] The images' indecipherability—caused by the break between the visual percept and its corresponding referent—creates the conditions for the formation of a space of nonreason. In this interruption of signification, critical Blackness's noncorporeal spiritual figuration as the very surplus that provokes a policing of the rationalized vision, an incommunicable

limit that is in excess of familiar meaning-making processes, becomes sensible. It is in the noise that disrupts Western epistemology's hegemonic ocular-centrism, what Jean-Luc Nancy might suggest is a manifestation of the limit of thought that can be sensed but never confined to a system of rationality, that DeCarava's critical Blackness is clearest.[60]

DeCarava's impulse to disrupt the pathway between vision and cognitive recognition urges the viewer not just to struggle with interpreting the subtleties of visual phenomena but to develop an awareness of the process of identification and realize the error of rationalized vision: meaning is not inherent in a percept. Instead, previously established knowledges cage the object of vision with deceptive associations. This is how the Black body is coded such that it becomes inaccessible in terms of an encounter or visit. Geoffrey Jacques's characterization of DeCarava's photography as "carefully executed compositions of light and accidental elements"[61] is relevant to such an analysis. The artist's work is spontaneous *and* planned, improvised but working within a specific imagistic logic that aims to establish situations of incomprehensibility, situations in which the viewer might feel out the borders of abstract rationalism. For it is precisely when we encounter the illegibility of DeCarava's photography that we can rethink how we see and what we look for. In the encounter, we can begin to (re)examine racial preconceptions, the sorts of violence they cause, and our complicity in their perpetuation.

DEMANDING PERSPECTIVES: VISUAL ABSTRACTIONISM, BLACKNESS, AND PERFORMANCE

When theorizing abstractionism, Harper remarks that visual-racial projects cannot consistently attain a critical abstractionist effect, because "the manner in which [they are] received is subject to too many uncontrollable factors, including predilections of the individual viewer."[62] However, the element of social critique that Harper associates with productively abstractionist work may have origins in the performative qualities of visual art rather than a given work's singular meaningful interpretation. In that spirit, the predilections of the individual viewer may be less important than the self-reflective mode of vision that visual abstractionism instigates.

Although the addition of narrative elements can complement an artist's message and may increase a viewer's chances of understanding an artwork's

intended purpose, it also inadvertently reduces the centrality of the visual elements of the artwork. Further, and more importantly, narrative elements also diminish the visual artwork's abstract quality by establishing a specific context through which the artist believes the viewer should understand the object of sight, effectively clarifying the correspondence between an artwork and its not-immediately-evident referent. Because a work of abstractionism must necessarily transgress audience expectations by disrupting realist representation, a degree of confusion and a destabilized sensibility are acceptable (and even expected). Harper's suggestion that too much conceptual unease may leave a visual-racial project unable to question the social conventions under critique appropriately is pertinent, but it is in the difficulty of interpretation and the act of questioning that abstractionism reaches its aesthetic effect most productively.

The Sound I Saw models such a nonnarrative, defamiliarizing aesthetic. Only a free-verse poem accompanies the images, and DeCarava indicated that it serves to complicate rather than explain the photographs, which places the burden of interpretation entirely on the viewer/reader. He said of his poem, "If you look at the images and you read the words, the words don't necessarily correspond to the picture—that's the beauty of it. If they did, you'd stop. This way, you go through it, and then go through it again and again, and each time it has a different rhythm."[63] The only available language of *The Sound I Saw* does not function as what Roland Barthes has called "the anchorage of meaning," an accompaniment to visual expression that "*directs* the reader through the signifieds of the image, causing him to avoid some and receive others."[64] Instead, it further dislodges meaning by foreclosing understandability and leaving the work's message one of dynamic, shifting, improvisational interconnectivity. The resistance of the (visual and poetic) text requires the audience to encounter the work anew in every reading—DeCarava's *jamais vu* is inescapable.

The possibility that a gap in visuality might bring about an active and potentially salutary revision of the social facts to which a given visual project alludes, as Harper indicates productively abstractionist projects should, is not a consequence of the viewer's successful interpretation of the artist's intended message. Instead, the alienation effect that abstractionism produces in the viewer creates the conditions from which productive social critique becomes possible. Importantly, DeCarava's Black aesthetic has an ethos of defamiliarization that aims not just to create a field of vision that

upsets the reproduction of racial knowledge but also to condition in the looker a new visual habitus. The images' resistance aims to make viewers hyperaware of the information they bring to the act of looking, creating a situation in which seeing becomes strangely sensible to itself. As viewers experience an abstract visual artwork without the aid of narrative elements—or anything else resembling Barthes's anchorage of meaning—they may begin consciously to occupy two positions simultaneously. In the first position, they have engaged the mission of the image and simply observe the object of sight. The second position is an outside mode of seeing in which viewers question the mechanisms involved in the act of looking. Essentially, in each of the visual-racial projects discussed in this chapter, audiences come to experience a doubling effect of both having a viewing experience and also watching themselves have it from a separate, conceptual vantage point. The visual artworks of DeCarava, Guerrier, Ali, and Harris allow for a visual experience, but the difficulty of their abstractionism also creates a visuality effect in which vision becomes conscious of itself as an act of meaning-making.

The Sound I Saw is a distinctive article of critical Blackness. If, as Walter Benjamin wrote, "experience is indeed a matter of tradition, in collective existence as well as private life," if "it is less the product of facts firmly anchored in memory than of a convergence in memory of accumulated and frequently unconscious data," then we can recognize its visual abstractions as attempts to create an unmediated experience, a mode of engagement that breaks from tradition and established scopic regimes.[65] For Guerrier, Ali, and Harris, like DeCarava, such a break depends not on artwork's capacity to share a particular message as a theme, or just to have an audience realize their specific intentions, but on the creation of confusion, misperceptions, and other disturbances that make viewers conscious of how they engage the objects of their sight.

DeCarava's ethos of defamiliarization supports Ariella Azoulay's argument that photography (or visual art in general) is no longer "a technology for the production of images operated by a singular subject." Rather, it is a multifaceted "event . . . made up of an infinite series of encounters" in excess of the strictly visual.[66] Azoulay's suggestion that the photograph constitutes an event helps us begin to understand the power of visual abstractionism in reconfiguring looking from passive engagement to a type of conceptually experiential occurrence that transpires within a discernible time frame,

making the event of the photograph a clear wellspring for critical thought and self-reflection. Although perceptibility of this critical Blackness may be as short-lived as the affect experienced in the act of looking, a sensibility of its fugitivity can produce notable effects in viewers' worldviews. The fleetingness of Blackness's perceptibility does not diminish its effect, DeCarava explained, because in the moment of an experience, "in between that one-fifteenth of a second, there is a thickness."[67] As the critical Blackness at work in *The Sound I Saw* advances dynamic subversion of historically informed visual processes, DeCarava's work generates this situation of active looking that fills the thickness inherent in the moment of the look and makes possible the conditions for productive social reflection on the part of the viewer.

In DeCarava's photography, such antagonism of normative thought forms the grounds of Black aesthetics. He explained that he wanted to transgress people's expectations and cause a sense of confusion, "to reach people inside, way down—to give them a quiver in their stomach."[68] Through his transgressive visuality effect, DeCarava made sensible the "concept of a world shaped by blackness" even as he resisted establishing a system of knowledge through which Blackness could appear recognizable as an identity type.[69] As he told the jazz bassist Ron Carter, his photographs resist such rational systems, whether they take shape in language or stereotypically driven conceptualizations of Blackness as an identity category: "To me, art is not about the conscious; it's about the part that we don't really—can't—put into words, which is so much more vast than our 'logic,' right?"[70]

The power of DeCarava's artistry is not to present a picture of "the black experience" or a collective "African American identity," but to antagonize the possibility of their representation by revealing Blackness to be a stance of opposition rather than an object of discourse.[71] Under such abstract and incongruous constructions, Blackness becomes visible not as an identity type but as a specter to Western epistemology, an always shifting, appearing, and disappearing antiknowledge that prompts policing of the limitations of rationality.

A MUSE FOR BLACKNESS

Kara Walker's "Outlaw Rebel" Vision

I have no interest in making work that doesn't elicit a feeling; not just a mood, a real visceral like, "oh you mean me?" . . . I actually think that kind of jittery feeling of uncertainty and, yeah, just a lack of clarity about who you are, how you define yourself, how you define yourself against the person who's next to you in the room watching the same thing with you is extremely vital.

—KARA WALKER

TOWARD AN OUTLAW REBEL VISION

A true encounter is always transgressive. This principle seems to be a keystone for Kara Walker, who is known for enveloping visual-art installations that affect disorienting and disillusioning experiences. One of her most celebrated—and criticized—silhouette tableaux, *The End of Uncle Tom and the Grand Allegorical Tableaux of Eva in Heaven*, is a prime example.[1] Composed of four vignettes that unfold on a curved wall at eye level, the installation takes its cue from a cyclorama, a 360-degree panoramic image set inside of a cylindrical platform designed to give viewers at the room's center an immersive experience (figure 2.1). When viewed from left to right, the scenes hint at an ambiguous narrative that plays on Harriet Beecher Stowe's 1852 antislavery novel, *Uncle Tom's Cabin; or, The Life Among the Lowly*.

At first glance, the silhouettes' plain exactness seems whimsical and welcoming, but the figures of *The End of Uncle Tom* depict a story far more graphic than the one Stowe tells. On closer inspection, we encounter racist caricatures in violent situations: three women, nude from the waist up, nurse one another; a wild-looking young boy leaves a trail of feces in his wake; an older enslaved man stands on his tiptoes with his hands clasped in the air, an umbilical cord with a newborn baby attached hangs from his

FIGURE 2.1. Kara Walker, *The End of Uncle Tom and the Grand Allegorical Tableau of Eva in Heaven*, 1995, cut paper and adhesive on wall.

buttocks. Beneath the guise of the silhouette's elegant and genteel surface, *The End of Uncle Tom* reenacts a carnivalized narrative of the rape, torture, and murder that chattel slavery ritualized in the American South.

Installations like this one occasion powerful experiences. Gwendolyn Dubois Shaw captures the phenomenological effect that Walker's artwork tends to produce when she describes *The End of Uncle Tom* as "a physical blow to the observer" that "rendered many viewers temporarily disoriented and speechless."[2] Rebecca Peabody similarly notes the sense of confusion that the tableau engenders when discussing the unclear connection of the silhouettes to Stowe's novel. "The title offers clues to the installation's meaning," she states, "yet frustrates attempts to discern that meaning by refusing to connect the images to the story in the most simple and imme-diately satisfying way."[3] For Shaw and Peabody, Walker's representations are bewildering and discomforting, but they also prompt a self-reflexive orientation, a feeling that compelled them to dwell on their conceptual tumult and search for its cause.

This chapter argues that Walker's critical Blackness aims to create disorienting sensory, perceptual, and embodied experiences that upend the discourse that makes race seem intelligible. I begin by rethinking

the role of the body in navigating Walker's visual-art projects. Some critics, artists, and viewers have censured Walker for her use of stereotypes and hypersexualized imagery, and others have even condemned her work as "shock for shock's sake."[4] I revise this worn-out interpretive model by showing how feelings of shock, disgust, and confusion are better understood as experienced events that spark an embodied mode of critical inquiry. By showing how Walker's installations furnish experiences that exceed vision, my analyses push against the ocularcentrism that I described in the previous chapter when examining Roy DeCarava's photography.

Much of my attention pivots around *The Katastwóf Karavan*, which Walker designed in collaboration with jazz pianist Jason Moran and steam instrument enthusiast Kenneth Griffard.[5] It consists of an eight-thousand-pound steel parade wagon that hauls a thirty-eight-note calliope, a steam-powered organ that produces sound by releasing compressed air through train whistles tuned to the chromatic scale. The calliope on *The Katastwóf Karavan* played three times during each day of the closing weekend of *Prospect.4: The Lotus in Spite of the Swamp*, a New Orleans art exhibition that ran from November 18, 2017, through February 25, 2018.[6] In her installation, Walker antagonizes popular historical narratives of race in New Orleans and, in the process, exposes how its tourist industry constructs and perpetuates narrow patterns through which Black identity and expression can be imagined. Scholars are usually quick to discuss Walker's installations, yet *The Katastwóf Karavan* seems to have been critically overlooked. Perhaps it was overshadowed by another of her site-specific artworks, *A Subtlety, or The Marvelous Sugar Baby*, which featured a seventy-five-foot-long sugar sculpture depicting a nude woman with embellished African features in the shape of a sphinx.[7] Walker's New Orleans parade wagon may seem understated relative to her New York confection, which was readily taken up by critics, but it produces a similarly confounding encounter, one that exhibits the enduring effects of the slave trade by interrogating sense in excess of the visual.

Throughout this chapter, I am concerned with Blackness as a category of representation, both in terms of its historically entrenched constructions and the possibility that a disorienting encounter might disarticulate them. This is a sensibility that evokes the work of bell hooks, who uses

the phrase "outlaw rebel vision" to describe a radical perspective in which racial-coding processes lose their symbolic integrity and the Black body can theoretically be seen outside the conventions that have historically determined its legibility:

For those of us who dare to desire differently, who seek to look away from the conventional ways of seeing blackness and ourselves, the issue of race and representation is not just a question of critiquing the *status quo*. It is also about transforming the image, creating alternatives, asking ourselves questions about what type of images subvert, pose critical alternatives, transform our worldviews and move us away from dualistic thinking about good and bad. Making a space for the transgressive image, the outlaw rebel vision, is essential to any effort to create a context for transformation. And even then little progress is made if we transform images without shifting paradigms, changing perspectives, ways of looking.[8]

Part of hooks's attention is on virulent racist imagery and how its reproduction oppresses all Black people, but she also calls for an alternative way of seeing that deconstructs the moralistic binary of positive/negative representation. In doing so, she critiques discourse that tries to offer conventional correctives to prevalent narratives of Blackness, including those that deploy "respectable" representations to counter demeaning ones. For hooks, the issue of race and representation is not a question of how the Black body should be represented. Representational transformation requires narratives and images that shift paradigms, she argues, representations so radical that they unfix Blackness from the clutches of conventional representation itself.

Walker's artistry reveals that the question of how race can be represented is always one of how race is already imagined. By teasing the limits of established ideas about race in New Orleans, I argue, she activates an outlaw rebel vision and creates the conditions in which imaginings about Blackness become conceptually unstable. This is to say that the disorienting experience created by *The Katastwóf Karavan* makes possible new perspectives about Blackness and its place in New Orleans's past; but also, close attention to how Walker transgresses audiences' expectations about city and its history allows us to re-view her earlier installations, including the silhouettes for which she has been most celebrated—and criticized.

WALKER'S TRANSGRESSIVE ETHOS: THE SIGHTLESS
ENCOUNTER AND THE REACTING BODY

Critical approaches to Walker's artistry tend to focus on "the very peculiar sort of viewing experience [her] work can generate," to borrow from Darby English, who argues that *The End of Uncle Tom* operates as a visual testimony that alters the image of slavery in the American imaginary.[9] Amber Jamilla Musser similarly emphasizes the power of looking at Walker's work, though she considers how *The End of Uncle Tom* encourages "interactive practices of viewing," arguing that "the viewer must insert him- or herself into the tableau to give it meaning."[10] Focusing on the comedic dimension of Walker's visual-art projects, which she calls "the imagery's mischievous agency," Glenda R. Carpio writes that archetypal—and clichéd—images of racial stereotypes elicit "laughter 'fit to kill,'" or that the artist's obscene silhouettes function as visual entryways to the brutality of chattel slavery and its remains.[11] David Wall consolidates these visual-focused approaches to Walker's art when he explains that "the ubiquitous visual tropes of Kara Walker's work—race, sex, the gothic, the grotesque, violence, violation, abjection, obscenity, desire, death, excrement, and slavery—collide and crash violently and constantly with the racial and sexual registers of American history and culture."[12] As English, Musser, Carpio, and Wall note, the aggressive visual register of Walker's artistry makes for strong—and often perplexing—impressions.

Though useful for contextualizing the unique visual language of her installations, critical perspectives that are confined to the effects of seeing Walker's artistry tend to overlook the larger experiential encounters created by her enveloping artworks, some of which intentionally impose a sense of sightlessness on viewers to comment on vision's limitations. One such work is Walker's audaciously titled *No mere words can Adequately reflect the Remorse this Negress feels at having been Cast into such a lowly state by her former Masters and so it is with a Humble heart that she brings about their physical Ruin and earthly Demise.*[13] This cyclorama wall installation depicts a raucous military parade in black silhouettes, but the tableau's center features five white swans, each of which has a black human head (figure 2.2).

Because the color white has total reflectivity, Walker's swans appear radiant even in the low-light conditions of the exhibition room. Alternatively, because the color black does not reflect light but absorbs it, the

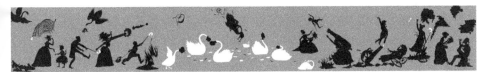

FIGURE 2.2. Kara Walker, *No mere words can Adequately Reflect the reflect the Remorse this Negress feels at having been Cast into such a lowly state by her former Masters and so it is with a Humble heart that she brings about their physical Ruin and earthly Demise*, 1999, cut paper and adhesive on wall.

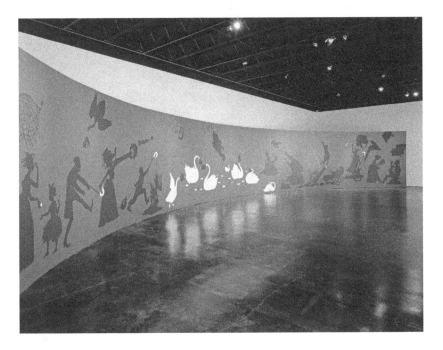

FIGURE 2.3. Kara Walker, gallery view of *No mere words can Adequately Reflect the reflect the Remorse this Negress feels at having been Cast into such a lowly state by her former Masters and so it is with a Humble heart that she brings about their physical Ruin and earthly Demise*, 1999, cut paper and adhesive on wall.

installation's other silhouettes are not as immediately differentiable from the tableau's dark gray background. In the art gallery, the swans' radiance is bright enough to momentarily delay audiences' eyes from properly dilating, meaning that viewers experience a brief photophobia, a feeling of light sensitivity during which the eyes must adjust and the visual field is only partially perceptible (figure 2.3).

Only after a period of partial sightlessness are audiences able to differentiate the black-and-gray color relation and see the tableau uninhibited, at which point it becomes apparent that a statement about sight and sightlessness, visibility and invisibility, is also embedded in the artwork's thematic register. At the far left, a woman appears to pluck out her eyes and to hand them to a young girl. To their immediate right, an older man goose-steps with his cane stretched out in front of him. He seems to be wearing glasses, and his open lips suggest a sense of confusion, as if he is blind and struggling to navigate the carnivalesque procession that stretches out before him—much like audiences are, as the tableau's subject matter reflects the visuality effect it induces. When asked about the genesis of *No mere words*, Walker similarly described the installation in terms of sight and sightlessness, explaining that she "wanted to make a piece that was about something that couldn't be stated or couldn't be seen," a remark that implies that sight is not necessarily a decisive tool for perceiving her work and its subject.[14]

In the title for her 2017 exhibition at New York's Sikkema Jenkins & Co., Walker acknowledges the confusion and discomfort that her artwork tends to induce. Separating potential attendees into viewer-type categories, she speculates about how scholars and art historians might respond to her show's paintings, considers the possible backlash from art students and parents of young viewers, and anticipates critics' indignation:

Sikkema Jenkins and Co. is *Compelled* to present The most Astounding and Important Painting Show of the fall Art Show viewing season!

Collectors of Fine Art will Flock to see the latest Kara Walker offerings, and what is she offering but the Finest Selection of *artworks* by an African-American Living Woman Artist this side of the Mississippi. Modest collectors will find her prices reasonable, those of a heartier disposition will recognize Bargains! Scholars will study and debate the *Historical Value* and *Intellectual Merits* of Miss Walker's Diversionary Tactics. Art historians will wonder whether the work represents a *Departure* or a *Continuum*. Students of Color will eye her work suspiciously and exercise their free right to Culturally Annihilate her on social media. Parents will cover the eyes of innocent children. School Teachers will reexamine their art history curricula. Prestigious Academic Societies will withdraw their support, former husbands and former lovers will recoil in abject terror. Critics will shake their heads in bemused silence. Gallery Directors will wring their hands at the sight of

throngs of the gallery-curious flooding the pavement outside. The Final President of the United States will visibly wince. Empires will fall, although which ones, only time will tell.[15]

In her long and unconventional title, Walker anticipates that collectors will eagerly purchase her work and academics will likely debate its value and question her artistic trajectory. More significantly, however, she indicates that many viewers will have an unsettling experience, and for this reason they will reject her paintings. These viewers will regard her work with suspicion, shudder in disgust and terror, or noticeably grimace. By predicting that the coarseness of her artistry will activate these responses and attitudes, Walker draws attention to how audiences tend to see and react to her installations.

But the show's title itself participates in an analogous sensibility of agitation. Adopting the performance styling of a carnival barker, Walker composes it to unfold like a sort of sideshow announcement. While she never actually describes the distasteful amusements that the exhibition promises to disclose, she plays on notions of novelty and grotesqueness in order to excite readers to attend the show and view her taboo artwork. The language of the title may predict resistance, but its irreverent tone presents a challenge to the exhibition's attendees, as if to say, "I dare you to look and, moreover, to remain composed as you do so." Walker's title threatens that if viewers are not mindful of their responses to the show's paintings, many of which are sure to feature the stereotypical figures and gratuitous sexual violence for which she is known, they risk performing one of the prophesized reactions and caricaturing themselves. It is not just her paintings that are to be on display and available for critique, Walker insinuates, but also the artwork's observers and their reactions.[16]

By anticipating and disarming the responses that she knows her artwork tends to arouse, Walker urges viewers to look beyond the racial stereotypes and graphic sexual imagery featured in her paintings and thus to participate in a more critical encounter with the artworks that are included in her shows. In such an encounter, confusion and disgust are not the end results of viewing, and viewing is not a singular mode of engagement. Walker posits that we can recognize that "racism is the real bread and butter of our American mythology," as she stresses in the artist statement that accompanied her exhibition's announcement, only by exploring the nature of our

body's reflexive reactions to its horrors.[17] Such a mode of phenomenological inquiry considers much more than the visual qualities of an installation. Moreover, by asking how perception, imagination, thought, emotion, desire, volition, and other sensations unfold experientially, it pursues questions about the structures of consciousness, including those that ask how objects of experience appear to us and the effects those perceptions have on us.

If we treat the title of Walker's 2017 solo painting show as a directive for encountering, grasping, and processing her artworks, then feelings of resistance or resentment are not the end products of engagement any more than the brief photophobia of *No Mere Words* is the end product of viewing. Walker urges us to also dwell in the phenomenological experience that prompts audiences to "eye her work suspiciously," "recoil in abject terror," "shake their heads in bemused silence," and "visibly wince" just from having looked. The tension between these predictable reactions and Walker's awareness of them suggests that the body is a site of negotiation in which transgressive representations mark the limits of audiences' conceptual contentment. Indeed, the range of reactions Walker anticipates pivot around various modes of rejection, revealing that transgression—and audiences' aversion to its discomposure—are at the heart of her experimental aesthetic.

Transgression is sometimes used to describe deliberately marginal and hostile artworks that are committed to rebelling against some culturally imposed limit.[18] However, the very act of transgressing—Walker suggests—is actually a negotiation in which those limits and their constituencies are queried and, necessarily, recomposed. Walker's notion of transgression resonates with Michel Foucault's, which describes transgression as a crossing-over experience in which one feels a sense of movement from an ordered, rational state to an unordered and irrational state, producing, for a transient moment, a feeling of being a destabilized subject. He writes, "the act which crosses the limit touches absence itself," and he describes this contact with absence as a moment of generative—and fleeting—possibility that marks the limits of what is known while simultaneously revealing a new set of limits.[19] Because the disorientation and discomfort of transgression are ephemeral, we must think of them as signs of an infraction that moves our limits as opposed to irrecoverably shattering them, adds the French writer and literary theorist Maurice Blanchot. "Transgression does not transgress the law; it carries it away with it."[20] This description of transgression lends

itself to phenomenologists' assertions that the subject is formed through acts of perception but also to Walker's interests in the generative effects of shock and discomfort. For Walker, knowledge is generated in encounters that problematize what is assumed to be known, and the body is the site where this experience unfolds and is processed.

These articulations of transgression and embodied inquiry become useful for rethinking how we see Walker's more disquieting visual-art projects. One such work is an untitled watercolor and gouache painting from 1998 that depicts a white flapper who appears to have a nude Black woman draped over her shoulders (figure 2.4). The painting bisects audiences' vision to query the act of interpretation itself, producing a destabilized viewing subject.

From a distance, spectators see the two female figures, as well as a series of surface-level binaries: the Black woman is nude, and the white woman is clothed; the Black woman crosses her arms in irritation, and the white woman poses opportunely with her hands on her hips; the Black woman's facial expression suggests frustration, and the white woman seems smug and self-satisfied. These binaries lure viewers into reading the image as a straightforward statement about how white America co-opts Black culture, an interpretation that the text in the upper-left quadrant of the image seems to reinforce. "Of course, the flapper was white Americas first real co-op of black, jazz culture," the text reads. "I see in her short, fringed gowns the tattered, loud fabric of her juke joint counter part-shimmying in non explicit whiteness (don't wiggle your bottom so like a Negro!) drinking her black night away in colored badness."[21]

Appearing in the space where viewers' eyes naturally look when reading a page, this block text seems to confirm that the white flapper has appropriated Black culture; however, the text in the upper-right quadrant of the image—where viewers might naturally look next—challenges this interpretation. This text is instructive: "Description for the visually illiterate and/ or impaired (this means you Howardina) This drawing water color is not quite finished—nor will it ever be—now that your name is on it, features a sassy white flapper wearing a pissed off looking black (African) type woman with pendulous breasts and arms crossed in front of them as if to say 'what you think I cain't wear a white woman like the feather boa constrictor she think I is?'"[22] This text block censures the painter and mixed-media artist Howardena Pindell, who the year prior had accused Walker of

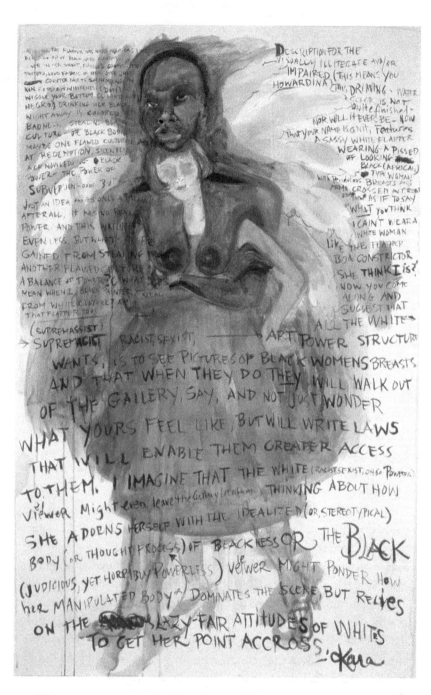

FIGURE 2.4. Kara Walker, *Untitled*, 1998, watercolor and gouache on paper.

stereotypification.[23] It then turns to the relation of the two women depicted in the painting. Instead of reproducing the interpretation offered in the upper-left quadrant, the text gives voice to the Black woman featured in the painting, whose speech upends such conventional readings. Suggesting that viewers have mistaken the painting's subjects, this Black voice indicates that she has adorned herself with the white flapper. This is not only a reversal of the power relation the painting seems to depict but an indictment against viewers, as it extends Pindell's visual illiteracy and/or impairment to the audience. By drawing attention to the vagaries of interpretation, the painting reveals the inadequacy of rational vision to extract stable meaning from a visual percept, shaking viewers' sense of conceptual stability in the process.

The painting's gestalt shift reveals the messiness of the relations among viewer, representation, and meaning, subverting visual interpretive processes to temporarily destabilize meaning-making. The illegibility of the text across the painting accentuates this messiness. Some of the text is large and legible, but much of it is too small to be easily read. Even readers who look closely will struggle with the writing that is smudged or scribbled out, as well as the writing that cannot be differentiated from the darker-skinned body over which it unfolds. Moreover, arrows connect and dissect different ideas, giving the paragraphs a disorganized, stream-of-consciousness feel that suggests the speaker is composing thoughts in a rushed and haphazard manner, further evidenced by the passages' minimalist punctuation and rampant misspellings (including "supremassist," "veiwer," and "relyes," but also the more pointed "Howardina" and "lazy-fair"). Even the placement of the text contributes to this disorientation effect, as it leaves viewers to wonder where the reading process should begin.

The interpretive norms that would assist in the analysis of Walker's untitled painting have become so indeterminate that the audience may struggle to find a stable visual object from which to launch or support an interpretation. In other words, whereas the visual component of the painting is striking, like *No mere Words* and *The End of Uncle Tom*, it also springs of contradictions and ambiguity. The painting's illegibility refuses to resolve into clear meaning; instead, for viewers, its meaning is created and recreated (and recreated, etc.) through attempts to decipher—and make rational—the abstruse and uncertain text surrounding the two women. The artwork pushes against the limits of rational perception by challenging

viewers' confidence in their ability to see and understand the artwork itself. From this perspective, we can begin to see that the work is not meant to be understood so much as it is meant to subvert viewing and disorient its audience. In this way, the painting rescinds the promise of visuality and produces, instead, a sense of sightlessness in which confusion reveals how racial discourse supplements processes of reading and interpretation.

The shock and discomfort caused by Walker's artistry are not ends in themselves; rather, these feelings are the grounds of a mode of embodied inquiry in which disorientation becomes generative.[24] The experience of feeling shocked or confused can be constructively disillusioning if, as Walker suggests, we perceive of bodily reaction—and not just mental reflection—as a productive means of transgressive sensing, of feeling the limits of racial knowledge and moving those limits. Reaction is a site of complex negotiations with the ideologies of the modern racial episteme, the often unquestioned set of ideas through which race is made to seem intelligible—which is to say that Walker's transgressive ethos is an important component of the critical Blackness that this book is outlining.

CONDITIONING TOURIST VISION: REDRAFTING "AUTHENTIC" NEW ORLEANS

In 2018, the year that Walker installed *The Katastwóf Karavan* in Algiers Point, New Orleans's tourist industry saw 18.5 million visitors spend over $9 billion. However, the narratives that these tourists consumed said little about the racist contours of "The Big Easy" and its entanglement with the transatlantic and domestic slave trades.[25] Over time, much of the city's history has transformed into a kind of "staged authenticity," a palatable and tourist-friendly narrative designed to sidestep the topic of slavery while leaving New Orleans's visitors feeling as though they have had a genuine encounter with the city and its culture. An ambulatory tour of New Orleans does not easily uncover "the stories and legends that haunt urban spaces like superfluous or additional inhabitants," as Michel de Certeau had argued that walking a city should, but rather a simulacrum of the past that softens and erases traces of racial subjugation.[26] For this reason, we might think of New Orleans as Joseph Roach describes it. He uses the phrase "genealogies of performance" to delineate the complex processes through which it has performed public enactments of selective remembering and

strategic forgetting, and of bringing forth substitutes and reinventing, in particular in terms of its myths of origins.[27]

Jean-Baptiste Le Moyne de Bienville, who served as governor of French Louisiana four separate times between 1701 and 1743, and who founded New Orleans in 1718, began holding the enslaved at Algiers Point after constructing a corral on its lower coast in 1719. At that time, New Orleans imported the enslaved from West Africa but also nearby Haiti and Belize; all arrived at Algiers Point, where enslavers unloaded and readied them for sale on the opposite shore in the French Quarter. After Congress abolished the transatlantic and international slave trade in 1808, New Orleans became the nexus of an emerging domestic slave trade, and Algiers Point continued receiving ships, though they now arrived from coastal cities in states like Maryland, Virginia, and South Carolina.[28] Ships kept coming through much of the Civil War, even after Union forces captured New Orleans in 1862, and did not stop until the Louisiana Constitution of 1864 officially abolished slavery. So many ships had arrived by then that in 1803, the year of the Louisiana Purchase, the enslaved comprised approximately 33 percent of New Orleans's urban population, whereas by 1860, 47 percent of the city's population was enslaved.[29]

The Katastwóf Karavan participates in, and is contingent on, the themes and emphases of its site in Algiers Point. As Walker recalls, she designed the installation to serve as a mobile monument to the institution of slavery, an idea she developed after an underwhelming encounter with a memorial plaque at that site.[30] Titled "Enslaved Africans," the two-sentence historic marker refers indirectly to slavery in a detached manner that buries any sort of historical accountability beneath several passive-voice constructions. In its entirety, it reads, "In the 1720s, at a spot of land now eroded by the river, stood the barracks where enslaved Africans from the Senegal-Gambia region, were held before being ferried across the river to the Slave Auctions. Early Algiers Point was also the home of the slaughterhouse and the powder magazine for New Orleans."[31] Allotting nearly as much space to a remembrance of the New Orleans slaughterhouse and powder magazine as it does to the role of Algiers Point in the slave trade, the plaque seems to do more to forget enslaved Africans than it does to memorialize them. In a performance handout at the site of her installation, Walker critiqued this monument for precisely this reason, calling it a "cheap bronze plaque constitut[ing] a paltry memorial to the Catastrophe called slavery

and Algiers Point's nearly forgotten but pivotal role in its perpetuation."[32] The river may have eroded the spot of land where Africans were enslaved, Walker reminds the Algiers Historical Society, but the monument to that site is washing away its significance.

Kevin Fox Gotham characterizes the development of New Orleans's tourist narrative as a similar process of racial erasure, writing that "during the latter half of the nineteenth century and continuing through the twentieth century, tourist advertisements and other promotional campaigns played up the rich ethnic and cultural diversity of New Orleans while completely ignoring the racial dynamics of the city."[33] If they contained any images of Black people, Gotham clarifies, advertisements and guidebooks usually represented Black bodies through stereotypical roles, such as domestic servants, wage laborers, or more historically engrained archetypes like the Mammy or the Sambo. Especially between the two world wars, Anthony J. Stanonis agrees, New Orleans cultivated a racial-historical mythology by recoding Black bodies according to a narrow set of marketable representations. In addition to the stereotypical caricatures that Gotham describes, Stanonis names "the elegance of Creoles, the skill of jazzmen, the seductiveness of courtesans, the joy of Mardi Gras maskers, the romance and exoticism of the French Quarter" as examples of emerging stereotypes about Black New Orleanians.[34]

The selective and strategic implantation of new racial caricatures and white-fantasized images into magazines, newspapers, and other advertising outlets helped to redraft the culture of New Orleans. According to Lynnell L. Thomas, over the course of the twentieth century, the city's various associations with voodoo, jazz, Creole culture, decadence, sexual permissiveness, and exoticism all concretized into a singular tourist narrative that exalts the city's European heritage at the expense of its African one, often sentimentalizing slavery in the process.[35] "In the rare instances when they addressed slavery at all," Thomas writes, "tour guides and tourism marketing literature focused almost exclusively on it during the colonial period, emphasizing a supposed unique and favored position of New Orleans slaves who were protected by the Code Noir, were given Sundays off to congregate in Congo Square, and were allowed to purchase their own freedom."[36] In such cases, various tourist outlets sustain distorted ideas about the city's past while simultaneously fortifying narrow representations of New Orleans's Black citizenry, history, and culture.

One such tourist attraction is the sternwheeler *Natchez*, billed as New Orleans's only genuine steamboat and celebrated as a classic expression of the city's spirit. Departing from the Toulouse Street Wharf in the French Quarter, the *Natchez* has been in service since 1975. Since that time, it has trafficked in sentimental visions of the Old South and, in doing so, has contributed to the tourist industry's ideological project to create a consumable representation of New Orleans and its antebellum past. Advertisements for the *Natchez* never mention slavery directly, choosing instead to activate tourists' nostalgia by playing on familiar narratives of Southern mythology and sentimentalizing the role of the steamboat within it. As the attraction's website emphasizes, the current ship is the ninth steamboat to bear the name *Natchez*, establishing its place in a genealogy that passengers are encouraged to trace back to the early 1800s: "It's a line that follows the course of river history, from the placid antebellum plantation era through the turbulence of the Civil War to the Gay Nineties, and, ultimately, the new millennium."[37] By likening the ship's history to the Mississippi River, this description aims to underscore connections between the *Natchez* and the connotations that the waterway carries, including ornate plantation mansions, Southern belles in decorated hoop-skirt-supported gowns, and other lineaments of Southern antebellum romanticism.

Details of the ship's actual background draw attention to the artifice of this construction. The first *Natchez* was built in New York City in 1823 and burned in New Orleans in 1835. Shipyards in Cincinnati constructed the next seven ships bearing the name *Natchez*; the second was eventually abandoned, the third sank due to rotting, and several others were burnt. After transporting Jefferson Davis during the Civil War, for instance, Confederate soldiers set the sixth *Natchez* aflame to keep it out of the hands of Union soldiers.[38] Significantly, the ship's designers did not model the ninth *Natchez* after any of its forerunners. Instead, it resembles the steamboats *Hudson* and *Virginia*, ships that were commissioned for service between Pittsburgh and Cincinnati. In the same way that the current *Natchez* is a departure from the history to which it lays claim, its individual parts speak to its construction as a simulation of genuineness. The ship's steam engines and steering system are recycled from the towboat *Clairton*, a West Virginian ship commissioned in 1925 to carry coal between mines along the Monongahela River, for example, and some of its most celebrated features are also taken from other sources. For instance, "her genuine copper and

steel steam whistle" was designed for the steamer *J. D. Ayres* (commissioned for service between Pittsburgh and Cairo, Illinois), though it now has on its top a copper acorn that at different times adorned the *Avalon* (for service on the Allegheny River) and the *Delta Queen* (for service between Sacramento and San Francisco).[39] Besides the name *Natchez*, the only feature that New Orleans's current steamboat shares with its predecessors is its racist ensign—like the other ships bearing that name, a cotton bale hangs between the steamboat's smokestacks.

Still, the *Natchez* tenders an experience that gleans an impression of authenticity from visitors' preconceptions about New Orleans, including those that Gotham, Stanonis, and Thomas trace through the development of its tourist narrative.[40] For passengers, jazz music and Creole culture are commodities that can be purchased for the price of a ticket, which suggests that the local economy continues to rely on an idea of Blackness to sustain its industry. The website for the *Natchez* implies that passengers can become part of the steamboat's storied past simply by joining the crew for one of the ship's two-hour-long jazz cruises, such as the Harbor Jazz Cruise, featuring live music by Duke Heitger's Steamboat Stompers Jazz Trio; the Dinner Jazz Cruise, which includes an "authentic creole dinner" and "live New Orleans swing style music" by a band called the Dukes of Dixieland; or, billed as "the most unique blend of 'real New Orleans,'" the Sunday Jazz Cruise, again featuring the Steamboat Stompers.[41]

But the crew of the *Natchez* does not think of jazz as the authentic New Orleans sound. They celebrate the steamboat's calliope. Daily—at 10:45 a.m. and 1:45 and 5:30 p.m.—Debbie Fagnano, the ship's calliopist, climbs to the top deck behind the pilothouse, opens a valve to send steam from the boilers to the instrument, and begins playing from a predetermined list of tourist-friendly songs. Audiences in Woldenberg Park wait for this moment, explains Doc Hawley, who started working on riverboats in 1957 and captained the *Natchez* from 1975 to 1995, because hearing the calliope is hearing "authentic" New Orleans. "When I started on the river there were at least twenty steamboats, and all of those boats had calliopes. It was really a prerequisite. It was really, really important to have a calliope," Hawley emphasizes, clarifying that "mainly the strictest boats would go up North, taking New Orleans bands with them, and they took the New Orleans sound up the river before radio was invented, before TV. . . . [New Orleanians'] daily existence was built around the smell of the beignets cooking and

the calliope playing."[42] Hawley suggests that the calliope's music embodies the spirit of New Orleans and that steamboats carry that spirit with them when they travel the Mississippi River, but he also captures the role that this music plays in creating affective communities within the city. His attention to the calliope's function at the center of New Orleans's "daily existence" implies that the instrument's unique tones create the conditions through which listeners of disparate backgrounds can feel connected under a singular sound, one that cannot be heard in other U.S. cities. For Hawley, the calliope acts as a social force that helps to constitute the very existence of New Orleans and its inhabitants.

But Moran's description of the *Natchez* calliope reveals a more complicated effect. He explains that beneath the music's cheery veneer lies a sinister sound. "I've never forgotten what that sound makes the body feel," he told Walker, "because it's unsettling even though it's trying to play the most settling music."[43] His responses about the calliope's visceral impact draw our attention to the double-voiced quality of the calliope, the way it always sings two contradictory songs. Its first voice cheers out a loud promise of innocent amusements, but the volume of this song drowns out a second voice that hails the Old South and its peculiar institution, ensnaring its listeners in the racist ideas in which it traffics. Moran's observation becomes clearer when we consider the instrument's songbook. Since its debut on July 4, 1855, the calliope has been used primarily as an entertainment instrument outside of carnival settings, where it would pipe familiar and predictable melodies that cue memories of childhood delights. Yet calliope favorites from the *Natchez* include songs that are sentimental expressions of Southern regional feelings, such as Daniel Decatur Emmett's "Dixie," Harry McCarthy's "The Bonnie Blue Flag," John Philip Sousa's "King Cotton," and Lewis F. Muir and L. Wolfe Gilbert's "Waiting for the Robert E. Lee." By sounding them daily, the *Natchez* perpetuates the themes they embody.

To be more specific, Christian McWhirter writes that the first verse and chorus of Emmett's "Dixie" were "especially resonant for Confederates who saw themselves as defending their homes and standing firm against northern aggression."[44] The lyrics evoke a sense of Southern nationalism not just through the affected language of "Dixie," a nickname for the South that gained popularity because of Emmett's song, but also from the stereotypical representation of enslaved Southerners that it helped to sustain. Written as a minstrel song, "Dixie" was originally performed in a comic

Black dialect intended to approximate racist ideas about the intelligence of enslaved Africans:

> I wish I was in de land ob cotton,
> Old times dar am not forgotten;
> Look away! look away! look away! Dixie Land.
> In Dixie's Land whar I was born in,
> Early on one frosty mornin',
> Look away! look away! look away! Dixie Land.
>
> Den I wish I was in Dixie,
> Hooray! Hooray!
> In Dixie's Land I'll take my stand,
> To lib and die in Dixie,
> Away, away, away down south in Dixie,
> Away, away, away down south in Dixie.[45]

The lyrics suggest that enslaved Africans were loyal to the system of slavery—even happy to be in bondage—by telling the story of a formerly enslaved man who proclaims he would gladly trade his freedom in the North to return to the Southern plantation of his birth. Reproducing the anti-abolitionist sentiment of the South, the speaker of "Dixie" even says he would loyally defend the Confederacy by taking up arms against the Union.

I dwell on New Orleans's tourist industry to show how selective remembering and strategic forgetting have tried to erase and recode the city's associations with racial Blackness. Like the magazines and advertisements that Gotham and Stanonis discuss, as well as the marketing literature that Thomas surveys, the calliope aboard the *Natchez* enacts a redrafting of race in New Orleans. By virtue of its embeddedness in the culture of the American South, the music of the calliope is distinctly representational, as it fortifies in the minds of its auditors narrow—and stereotypical—representations of Black identity and experience. As Moran describes, however, the calliope's polyvocality also sounds an artful critique of those representations. He notes that the songs of the *Natchez* calliope "have a code in them that always makes people feel a certain way, like a password for something else."[46]

If hearing the *Natchez* play "Dixie" is hearing New Orleans sing, as Hawley implies, then the mode of listening that the city has become habituated to requires a polysemous ear, one tuned to a frequency of Southern mythology and its propagandistic racial narrative but that also is able to hear its verso side of violence. Auditors of "authentic" New Orleans must listen according to a normative cultural consensus with white nationalist undertones, yet they might also hear the Black voices that the tourist trade tries to quiet or keep audible only by proxy, such as in the case of the minstrel troupes that originally performed Emmett's song. Moran notes that this radical voicing is difficult to discern, more easily sensed by its disorienting effects than by its straightforward messaging, because the calliope's Blackened voice is always under threat of the instrument's romantic vision of the antebellum South. And, of course, if tourists have not fine-tuned their ear to that vision, the whistles of the calliope will try to help them do so since, as the instrument that structures the social and cultural nature of New Orleans, the calliope on the *Natchez* revives the myth of the Old South three times every day.

SOMETHING IN THE AIR: THE VISCERAL ENCOUNTER AND SENSORY CONFUSION

Walker scheduled the calliope of *The Katastwóf Karavan* to erupt into song immediately after the *Natchez* performances, although it played from a different songbook, one curated to query the sonic mark that "Dixie" and its confederates have left on New Orleans. Installed at Algiers Point, *The Katastwóf Karavan* sat directly across the river from the *Natchez*. From this position, it played selections from an array of songs that Walker associates with Black liberation and celebration, ranging from gospel to reggae, jazz improvisations to chants and shouts. Her playlist also included popular twentieth-century songs, such as Aretha Franklin's "Respect," Jimmy Cliff's "Many Rivers to Cross," Jimi Hendrix's "Freedom," and Prince's "When Doves Cry." Finally, during the Friday and Saturday afternoon performances of *The Katastwóf Karavan*, Moran improvised on a keyboard that plugged into the calliope, adding another layer of experimentation to the art installation.

Walker's Black liberation songbook is a clear discursive challenge to the music of the *Natchez*; however, Moran's improvisatory performances

are also complex engagements with the romance perpetuated by the ship's renditions of "Dixie." Sitting behind the keyboard at Algiers Point, Moran composed real-time responses to the calliope of the *Natchez*. These improvisations were not, as one might assume, forms of spontaneous and free expression without regard for generic or stylistic conventions. Rather, Moran's performance can be understood as a technical activity through which he entered into conversation with the music across the water and the ideologies it inspirits. Danielle Goldman's description of improvisation as a practice that "demands an ongoing interaction with shifting tight places" reflects how Moran's inventive engagement with "Dixie" is a process of discovering new avenues of expression in—and therefore expanding—the narrow models of representation through which Black identity and experience are made culturally legible.[47]

Improvisation can be understood as a dual process of challenging the aesthetic conventions that limit artistic expression and thereby negotiating an ever-shifting landscape of expressive constraints. Many of the constraints that tested Moran were consequences of the calliope itself. Whereas a full-size piano has eighty-eight keys, the calliope restricted Moran to just thirty-eight. Walker's steam-powered instrument does not have an adjustable touchweight and does not respond differently to soft or hard key attack, nor does it have the foot-operated levers that are conventional on a piano, those that allow the player to soften, sustain, or damper the instrument's sound. Working within these constraints and making *The Katastwóf Karavan* sing is a struggle, one in which missteps, wrong notes, and irresolution are not musical errors but, rather, signs of a negotiation that threatens the legitimacy of the narratives that New Orleans's tourist trade has constructed.

Philosophers of music have shown that improvisational performances tend to yield a unique and participatory listening experience.[48] In his writings on musical cognition, Wayne Bowman has argued that, "when we hear a musical performance, we don't just 'think,' we don't even just 'hear,' we participate with our whole bodies. We enact it."[49] Bowman argues that whereas music is sometimes thought of as a static commodity (such as a recorded performance or notated score) that listeners perceive passively, listening is better understood as a mode of enactive cognition that takes place at the level of the body. By this rubric, listening is a process in which body and mind co-originate, meaning that corporeal, somatic, and visceral sensations compose one's musical experience and act as the bodily roots of

cognition. Such an understanding of listening as a dynamic individual and social activity suggests that it is not just Moran's musical production that is improvisatory, but also the psychosocial act of listening, an act in which auditors are engaged in personal and intentional embodied processes of discovery and interpretation.[50]

The erratic sound of *The Katastwóf Karavan* plays a significant role in producing this visceral listening experience. Timbre, often described as "tone" or "sound color," refers to the psychoacoustic category that differentiates one sound source from another; for example, the qualitative difference of the sound of a calliope and another instrument (like a grand piano) when they play the same pitch. Because the calliope's notes are sounded by air pressure passing through large whistles, and this pressure is determined by the temperature of steam, which is difficult to regulate, the whistling tones of the instrument bend sharp and flat as compression increases and decreases. As its player "lets off steam," the timbre of the calliope wavers in pitch, blurring the sonic line between musical sound and noisy incoherence. It produces a sense of discord that tends to sound off-key or out of tune, especially notes in the upper register. Played on Walker's calliope, even simple melodies and well-known songs sound unfamiliar, a performative dynamic that may prompt audiences to ask what they are hearing. The uncertainty of the sound and boundlessness of Moran's improvisational practice interrogate the relation between subjective sense perception and the knowledge that comes from it. Or, put differently, the calliope's compulsion to deny conventional pitch and melody can prompt auditors to become aware of the process and effects of listening.

Timbre is significantly undertheorized, but those taking a critical approach tend to discuss it in terms of heightened intensity and emotional expressivity, especially when it is considered alongside improvisatory practice.[51] Zachary Wallmark describes this heightened emotionality—and its affective qualities—as a sign of listeners' inner, embodied recognition of sound, or the knowledge of timbre that is held in the body. "Musical timbre is heard and appraised through the filter of this embodied knowledge," he writes, clarifying that "vocality is key to unlocking the way we experience the material nature of sound production."[52] For Wallmark and other scholars of music cognition, the transmission of emotion in music is closely tied to the similarities of musical sound to vocal expression, especially in the cases of instrumental sounds that mimic the nuances of human voices singing.

In a discussion about the calliope's unique sound, Walker picks up on the emotional register of Wallmark's vocality and describes the enactive cognitive experience of listening to *The Katastwóf Karavan*. She suggests that Moran's improvisations had an uncanny orality that made her feel something intensely moving that she was unable to describe. After Moran compared the calliope's timbre with human whistling, Walker paused, dragged her hands across her chest to signal a feeling that exceeds the limits of language, and replied, "there's something voice-like about those pipes. And you made it cry out, and th—, you know, and it's like, ah, you feel it going right across you."[53] Reading Walker's description of the calliope's voice-like timbre closely illustrates the immediate emotionality of the instrument's sound. The first "it" of Walker's statement refers to the calliope and its pipes, but the second "it" is about her embodied response, at which point she tries to appeal to a metaphor to capture the sensation that the sound produced, a level of abstraction that signals the limitations of objective language. Finally, the third "it" could refer to the noise of the calliope, the feeling it induced, or both. The ambiguity of what Walker felt "going right across" her reminds us that, as Bowman argues, listening is an active, embodied activity that often resists or exceeds the bounds of rationalism, here signaled by the inadequacy of language to represent how sound and sensation unfold experientially.

Auditors who, like Walker, sought to understand and decipher the uncertainty of such sounds may have tried to supplement their listening experience by looking at the silhouette cutouts that decorate *The Katastwóf Karavan*. However, the visual register of the installation similarly resists straightforward interpretation and thus amplifies the artwork's disorienting affect. Cut in black steel, the wagon's tableaux use a blank white background to set four scenes, one on each of the vehicle's outer walls, which, respectively, depict motifs culled from the sort of antebellum plantation imagery with which Walker has been experimenting since the mid-1990s. On the starboard side of the wagon (figure 2.5), three short male figures sit on one another's shoulders, the uppermost brandishing a whip, which he uses to lash a chain gang of four enslaved Africans, the last one carrying a baby. Instead of a forest reminiscent of the South, viewers encounter ferns and a palm tree beneath a crescent moon. The front of the wagon shows a female figure, possibly a runaway enslaved woman, struggling in the heavy brush of a sugarcane field.

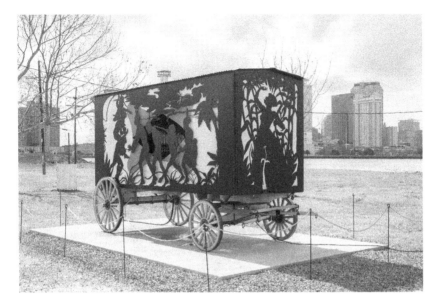

FIGURE 2.5. Kara Walker, starboard view of *The Katastwóf Karavan*, Algiers Point, 2018, installation.

On the port side, two figures carry a third individual (who might be dead) between trees heavy with Spanish moss (figure 2.6). Above them sits another figure, who seems suspended in the trees' vines and appears to pluck the heart from the chest of the body being carried. The rear of the wagon features an inverted cutout, one in which the negative space appears black and the body is colored white. This scene shows a female figure lying on the ground, arms and legs in the air, surrounded by frowning cotton bolls, which escape into the air like puffs of smoke rising from her body. Nestled into these tableaux are hollow spaces that give audiences a view of the calliope's mechanical inner workings, a blunt reminder of the industrial component of slave labor.

The four scenes of *The Katastwóf Karavan* seem to offer a concise visual restatement of New Orleans's entanglement with the transatlantic and domestic slave trade. But because they withhold the elements necessary for the construction of a cohesive and familiar narrative, they produce a visuality effect that leaves viewers unsure whether they should try to fill in the gaps or appreciate each cutout as an individual snapshot.

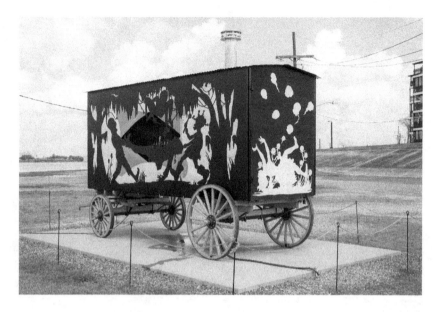

FIGURE 2.6. Kara Walker, port view of *The Katastwóf Karavan*, Algiers Point, 2018, installation.

The peculiar opacity of the silhouette form further exemplifies the confusion that this visuality effect induces. Whereas some might expect the form's high-contrast, black-and-white composition to lend itself to a sort of hypervisibility, the visible likenesses in which Walker's silhouettes traffic are made perceptible through the production of impervious visual voids, negative spaces that resist conventional modes of seeing. As curator Asma Naeem emphasizes, meaning accrues slowly as viewers struggle with the illegibility of the silhouettes, which enact a centrifugal dispersal of meaning, a unique visual property that stirs up a disorienting effect. "When first approaching Walker's wall-sized or room-sized murals, many viewers do not realize that they are entering into such fraught territory," Naeem explains, because "from afar, the silhouettes seem nostalgic, even cartoonlike and comical in their hyperattenuated gestures, but upon closer examination, the darkness of Walker's scatological, sexually perverse, and violent imagery comes into view. The rupture occurs in the aesthetic experience as details are deciphered and as disjointed narratives are pieced together."[54] In Naeem's view, Walker's silhouettes' apparent

simplicity and genteel restraint beguile audiences into looking closer, but those who do so tend to discover cryptic representations that do not yield to familiar historical interpretations. The resistance of the silhouette creates a rupturing experience that leaves viewers feeling as though they are trying to interpret shadows, opaque apparitions that are easy to see but difficult to recognize, read, or understand. And, as Moran's calliope performance developed, clouds of steam billowed from the interior of the wagon, obscuring the silhouetted scenes and further disrupting viewers' line of sight.

If the calliope performances of the *Natchez* make New Orleans's Black voices audible primarily through narrow constructions of minstrelsy and sentimental ideas like "the skill of jazzmen," then what are audiences to make of *The Katastwóf Karavan*, which refuses to sound simple or palatable ideas about the city and its history and which denies audiences the comforts of rational signposts that might assist their interpretive processes? Instead of recalibrating audiences' sensibilities by amending New Orleans's tourist narrative, Walker and Moran offer an indistinct and discordant whistling sound complemented by a handful of disconnected silhouette images, cultivating an encounter that does more to confuse than to explain. The foundation of the resulting aesthetic experience is not a comprehensible image or an intelligible sound but, rather, their subversions. We might recognize this performance as an amplification of the Black voice that Moran hears in the calliope's polyvocality. The very irreducibility of *The Katastwóf Karavan* momentarily scrambles audiences' sensibilities by pushing against the limits of their conceptual contentment, daring them to question what they think they know about slavery and its afterlives.

Because of the conceptual confusion it generates, *The Katastwóf Karavan* stands as a polemic against the tourist narrative of New Orleans and the aesthetic traditions through which it has constructed its sense of self, one that aims to prompt audiences to question the nature of the representations that the city asks them to see and hear. In this transgression, the installation incites a sense of movement from the comforts of an ordered, rational state toward an unfamiliar and irrational state, creating a feeling of being temporarily unmoored and adrift and rending discourses about race illegible in the process. By furnishing an encounter in which one confronts the impossibility of knowing, or an experience of being unable to rationalize one's various perceptions, Walker activates an outlaw rebel vision, a

novel perspective through which illegibility allows audiences to meet with Blackness as a critique of race's historically entrenched representations.

The sonic and visual elements of *The Katastwóf Karavan* do not aim to posit a representational corrective or a new image of Blackness; instead, by propagating confusion, they aspire to enact a critical sensibility that exposes how Black expression is always mediated by—and to a great extent expressed through—preconceptions and assumptions about Black identity and experience. For its audience, the installation highlights how the question of how Blackness can be seen or imagined is also a question of the extant cultural knowledges that predetermine its legibility. Disorientation and discomfort are not the end results of improvisatory, experimental, and abstract artworks, such analyses indicate, but signs of a deconstructive sensibility that aims to contest the conceptual validity of modernity's narratives, all the while reconfiguring the meaning of Blackness within them.

ENVISIONING CATASTROPHE: TRANSGRESSION AND THE MUSE OF CRITICAL BLACKNESS

The sonic and visual elements of *The Katastwóf Karavan* combine to create a confusing, multisensory experience that the installation's title complicates. The title of Walker's installation sounds phonetically familiar to the English speaker's ear but carries a meaning different from what English-only speakers might expect. Walker derived the title in part from the Haitian Creole word *katastwóf*, meaning "catastrophe," a word used by Haitian Kreyòl speakers to refer broadly to the institution of slavery and its role in bringing Africans to the Americas. As Walker has explained, this word confronts not just the economic practice of slavery and the slave trade but also the experiences (and enduring historical trauma) of the ship's hull, the auction block, and the field and thus carries meaning that has no English equivalent. "We here in the U S of A have never given a Name to the Event which has defined generations," she stated during the installation's unveiling. "We simply say 'Slavery' as if that were a legitimate job instead of what it was, a Catastrophe for millions."[55] The title of *The Katastwóf Karavan*, Walker suggests, has a code, certainly, but not one that is easily deciphered by the ears of the colonizer, whose language serves to mitigate hundreds of years of dehumanization—and its afterlife.

The visceral, multisensorial effects of *The Katastwóf Karavan* create the conditions through which audiences might "cross the limit to touch absence itself" and thus envision the irrationality of the catastrophe as Walker describes it. The French philosopher and aesthetician Mikel Dufrenne's *The Phenomenology of Aesthetic Experience* is instructive in explaining how catastrophe can be encountered. Dufrenne argues that aesthetic experiences arise when spectators perceive an artwork's various material substratum (sound timbre, color contrast, etc.) and then compose those constituent elements into an "aesthetic object," defined as an artwork's impression that is generated through acts of perception. Aesthetic experiences produce sensuous effects that necessarily exceed the artworks themselves, by this rubric, much like Walker describes shock, revulsion, and confusion as surplus effects of encountering her installations. The aesthetic object is not a sign for an existing idea in the world, then, but a vehicle for some more elusive sensuous impact that circumvents abstract rationalism as a way of knowing. As Dufrenne puts it, "the signifying object claims to justify the signification it bears and attempts to gain our conviction as to its truth or at least to present as convincingly as possible its testimony to this truth. The aesthetic object does not demonstrate [*demontre*], it shows [*montre*]. . . . Only that revelation which we shall call 'affective' is truly constitutive of the aesthetic experience. The aesthetic object does not speak to me *about* its subject. The subject itself speaks to me."[56] Almost as if he is in conversation with Walker's notion of transgression, Dufrenne presents the power—and truth—of aesthetic experience as a phenomenological process of enactive cognition, a process through which the perceiving subject accumulates sensory data and comes to envision an artwork's evocative and ephemeral aesthetic object.

Such an understanding of the aesthetic object is useful for grasping the transgressive movement that *The Katastwóf Karavan* effects. As Walker describes, the installation is a meditation on the machination of Black labor and the role of industrial progress—epitomized in the steam engine and cotton gin—in "usurping and grinding up" those workers' bodies. Significantly, such machination is not some distant historical phenomenon; rather, it is an enduring effect of racial capitalism. "The Machines have changed," Walker emphasizes in the performance handout she distributed in Algiers Point, "but that action stays the same."[57] She further suggests that the calliope might make audible the very voices that New Orleans has silenced:

"I wanted to create this paradoxical space where the kind of ingenuity of American manufacturing, the same genius that brought us chattel slavery, could then become the mechanics through which those voices that were suppressed could reemerge for all time."[58] As a reversal of industrial machination and the dehumanization it brought about, *The Katastwóf Karavan* sounds a critique of capitalism and the enslaved labor that it exploited.

But when we consider this critique alongside Walker's comments about the English language and the inability of rational thought to grasp the full horrors of slavery, it becomes clear that the "aesthetic object" of *The Katastwóf Karavan* is not enslavement as an economic practice, as many Americans have been conditioned to imagine it. Rather, it is the Haitian Kreyòl sense of catastrophe, which refers also to the trauma of the Middle Passage and slavery, as well as their continuing effects in the present. It is noteworthy that Walker must step outside the normative borders of U.S. language in order to reinsert into its history a sense of the violence that capitalism wrought, as the semantic ambiguity of *katastwóf* underlines how Western epistemology has rendered the catastrophe knowable only through the palatable, rational language of "slavery" as a type of economy. As a challenge to such rationalism, *The Katastwóf Karavan* pushes for a confrontation with the banality of slave labor in the American mythology and capitalism's grotesque violence, a transgressive act through which audiences can ephemerally envision America's historical preoccupation with enslaving and their own complicity with the nation's selective remembering and strategic forgetting, a sort of catastrophe in itself. In that spirit, Moran suggested that audiences are not just hearing the calliope's music. When the installation is activated, he insisted, "you are also touching the industrial with how slavery works."[59] Moran's reflection on the power of sense perception to spur new—and more critical—ways of conceptualizing the United States' entanglement with enslavement clarifies how *The Katastwóf Karavan* makes sensible the very horror that rationalism tries to obscure.

Initially, *The Katastwóf Karavan* may seem less antagonistic and poignant than silhouette-wall tableaux like *The End of Uncle Tom* or large-scale installations like *A Subtlety*. However, *The Katastwóf Karavan* does not sidestep or diminish the violence critiqued in those installations. Expanding the scope of audiences' engagement with the catastrophe, it instead foregrounds the existential violence that remains even when corporeal violence seems imperceptible, and in this way, it moves the historical

katastwóf back into the realm of transgression. Like Walker's outwardly violent visual-art projects, *The Katastwóf Karavan* insists that audiences feel the living presence of history, a more significant effect than the shock or disgust occasioned by a visual representation of the violated, mutilated body in and of itself. The transgression of *The Katastwóf Karavan* highlights the system of capitalism, its persistence, and the myth of its generative or prosocial effects. If to encounter *The Katastwóf Karavan* is to touch the "ingenuity of American manufacturing" as the "genius behind chattel slavery," as Walker states, then the disorienting aesthetic experience that the installation conditions is a chance to encounter and feel the contradictions of the nation's racial mythology.

Commenting on aesthetic experience's power to make sensible impressions that exceed or resist rationalism, Dufrenne describes the aesthetic object and its affective dimension by invoking the idea of a sort of second sight. "Such works attempt to render the invisible visible," he writes, clarifying that an artwork's aesthetic object "manifests an invisible that is much more real and present than the visible and that directs our vision of the visible."[60] Through such an envisioning process, one in which the invisibility of the catastrophe becomes peculiarly visible through the reacting body itself, *The Katastwóf Karavan* enlivens critical Blackness as an aesthetic response to racialization that troubles racial discourse by querying established ideas about Black identity and experience. According to Fred Moten, such a deconstructive sensibility effects another thinking of race by disrupting, critiquing, and reconfiguring what is thought to be known. "Blackness is always disruptive surprise moving in the rich nonfullness of every term it modifies," Moten begins. "Such mediation suspends neither the question of identity nor the question of essence. Rather, blackness, in its irreducible relation to the structuring forces of radicalism and the graphic, montagic configurations of tradition, and, perhaps most importantly, in its very manifestation as the inscriptional events of a set of performances, requires another thinking of identity and essence."[61]

Walker's transgressive ethos plays a fundamental role in activating the disorienting and deconstructive encounter that Moten describes. *The Katastwóf Karavan* is transgressive not because it shocks or disgusts audiences but because it aims to agitate their perceptions of normativity, including their normative participation in capitalist extortion of Black bodies. The installation's critical Blackness generates feelings of conceptual

unease and confusion by undercutting audiences' sense of consumptive contentment. By challenging viewers' complacency with unquestioned or established beliefs about America and its racial history, Walker dares them to reconsider what they think they know about race in and beyond New Orleans, the way that city and others have represented themselves, and the continuing effects of the catastrophe.

It is fitting that Walker sounds Blackness's radical critique on a calliope, an instrument that takes its name from the Greek goddess of music, song, and dance. In the Classical era, when the Muses were assigned specific artistic spheres, Calliope was thought to preside over eloquence and epic poetry, a genre through which ancient people and nations sought to understand themselves and their moral universe through extraordinary tales about epochs that preceded living memory. Moran charges the calliope of *The Katastwóf Karavan* with an analogous responsibility of aesthetically reconfiguring audiences' moral universe by fracturing historical representations (and living memory) of slavery. He explained that the installation creates "a moment where we bring something that would honor the millions of ancestors in a way that we aren't sure what we're about to touch."[62] Perhaps the ecstatic and metrical performance of Walker's calliope occasions a touch with absence itself, an ephemeral glance of critical Blackness's propensity toward rationalism's fissuring.

PART II
Genre

ANTIESSENTIALIST FORM

The Bebop Effect of Percival Everett's *Erasure*

This is what I want all of this to do, to be. I want it to sound like nonsense, have the rhythm of nonsense, the cadence of nonsense, the music, the harmony, the animato, the euphiousness, the melodiousness, the contrapuntalicity, lyrphorousness, the marcato, the fidicinality, the vigor, isotonicity, lyriformity, of nonsense.

—PERCIVAL EVERETT, *PERCIVAL EVERETT BY VIRGIL RUSSELL*

THE UNIQUE THELONIOUS MONK: GENRE AND
THE EXPERIMENTAL NOVEL

The only thing consistent about Percival Everett's body of work is its generic inconsistency. Everett published his first novel, *Suder*, in 1983. Following *Suder*, he wrote two other novels and a collection of short stories titled *The Weather and Women Treat Me Fair*, after which he published two novels that refashioned Greek myths, *Zulus* and *For Her Dark Skin*, both of which he released in 1990. He then changed directions by writing *The One That Got Away*, a children's book illustrated by Dirk Zimmer that tells the story of three cowboys who round up escaped number 1s. After publishing two Westerns, *God's Country* and *Watershed*, Everett released *Big Picture*, his second book of short stories. In addition to more novels, Everett added to his canon a novella titled *Grand Canyon, Inc.*, the introduction to an edition of *The Jefferson Bible*, and his first collection of poetry, *re: f (gesture)*, which features one of his original paintings on the front cover. As of 2021, when Everett published *The Trees*—a whodunit revenge fantasy composed of more than one hundred short chapters—his literary enterprise included twenty-plus novels, five books of poetry, four short story collections, a novella, and a children's book, as well as many nonfiction pieces.[1] Within this internally disparate literary trajectory, his 2001 novel *Erasure* can be read as his commentary on the limitations of genre and the idea of classification.

Erasure unfolds as a series of knotty and fragmented entries in the journal of Thelonious "Monk" Ellison, a middle-aged Black American recovering from a series of personal tragedies: he tries to care for his mother, who suffers from Alzheimer's disease; move past his father's suicide seven years before; bury his sister, who is shot and killed while working at the abortion clinic that she founded; and accept his brother's homosexuality.[2] Meanwhile, Monk grapples with a professional dilemma. As an unread and little-respected writer of experimental fiction, he struggles to reconcile his sense of artistic integrity with his desire to have a reading public celebrate him as a novelist. Editors and publishers tell Monk that he has received little commercial success because many readers feel his novels are "not black enough" (43); however, he refuses to publish fiction that reduces race to stereotype.

Much to Monk's vexation, the author Juanita Mae Jenkins's novel *We's Lives in Da Ghetto* is acclaimed as a realistic portrayal of Black experience for doing precisely this. To expose the danger of her work, which fortifies racial stereotypes in the minds of its readers, Monk writes a parody of *We's Lives in Da Ghetto*, which he titles *My Pafology* (quickly renamed *Fuck* to augment the work's obscenity) and publishes under the pseudonym Stagg R. Leigh. The second half of *Erasure* focuses on the unexpected success that Monk's parody receives.

Written as a catalog of racial stereotypes exaggerated to their most transparent and absurd degree, *Fuck* highlights the difference between Monk's life as an American of African descent and the stereotypical experiences that books like Jenkins's attribute to him. However, readers and critics alike endorse the novel as an authentic portrait of Black life. Ironically, with the overnight success of *Fuck*, Monk becomes the one who reaps profits and appears on television as an author of fiction featuring racial stereotypes. As his success grows, and as he disguises himself as Stagg with increasing frequency, he begins to lose his sense of autonomy. The psychological anguish caused by his disguise and the success of his novel—which ultimately wins a National Book Award—drives him toward a breakdown at the story's abrupt conclusion.

Taking the authority of genre as one of its primary concerns, *Erasure* defies form as a means of engaging with it. Within the novel's plot Everett embeds many narrative digressions and generic disruptions. The story consists of Monk's journal entries, but the journal contains an academic

paper titled "F/V: A Novel Excerpt," which deconstructs the opening line of Barthes's *S/Z* (14–17), as well as a short story titled "*Àpropos de bottes*," in which a Black character enters a game show—and defeats his white competitor—under the name Tom Wahzetepe (169–78). Most significantly, however, Everett includes *Fuck* in its sixty-eight-page entirety (63–178). Interspersed among these larger digressions are a number of smaller disruptive texts, including the protagonist's résumé, several biographical sketches, a number of interview excerpts, two fictional book reviews for *We's Lives in Da Ghetto* and *Fuck*, a collection of letters between his deceased father and a woman with whom he was having an affair, conversations between imaginary and historical persons, short story ideas, and musings on woodworking, fly-fishing, and literary theory.

These digressions produce jarring breaks in the relatively simple story that Monk is trying to tell, often in ways that frustrate the reader's expectations regarding narrative and trouble the novel's identification as belonging to genre.[3] As Seth Morton has argued, the book's disjointed narrative framework leaves *Erasure* neither conventional nor experimental; instead, the novel breaks apart the binary without providing an alternative concept through which the reader or critic can come to categorize it satisfactorily.[4] Morton's analysis of *Erasure* highlights the nonstatic nature of genres; how, as Ralph Cohen has argued, different conceptualizations of genre arise, evolve, and decline over time.[5] With such instability in mind, this chapter begins with the premise that genre is an open category that is always in the process of responding to the determinants of its making.

Noting that genres are subject to influence, this chapter shows how Everett prompts readers to question the limits of categorical thinking itself, a manner of thought that results in generalized classifications. Such questioning is necessary, Everett hints in his novel, because genres have political implications: they are a means of division and classification that reinforces hierarchy by positioning select components as more valuable than others. The stakes may appear relatively low for categorizations like experimental or conventional literature, but the thematic concerns of *Erasure* indicate that categorical thought extends to cultural groupings, such as notions of Black identity, style, and experience, which I characterize as a fabricated category of "imaginary Blackness." Because many of Everett's digressions address how misrecognitions and assumptions color cultural understandings of race-related issues, and because a number of his thought

experiments concern ways to engage these assumptions to challenge them and cultivate a mode of representation capable of capturing the complexity of contemporary Black subjectivity, I extend Morton's notion of generic play to a more expansive understanding of categorization, one that considers Everett's broader focus, the patterns of thought that generalize in order to classify and order human bodies.

I describe the manner in which Everett activates critical Blackness as the author's "bebop effect" because of the conversation I see developing between the performative aspects of *Erasure* and the musical sensibility of bebop jazz. My intention in this analysis is not to position music as a metaphor or method, nor am I overlooking the significant ontological differences between music and writing. Instead, my understanding of the emergent conversation between this period of jazz and *Erasure* focuses on the existence of a shared sensibility of musicality—a sensibility that is musical without being music—in spite of their outwardly different modes of cultural production. More specifically, I (and, I argue, Everett) find bebop to be a productive intertext because a number of the musicians who participated in its development in the 1940s were asking the same question that Monk asks when confronting racial stereotypification: how should an individual artist react when an art form (jazz or literature) undergoes mass commercialization, effectively limiting the expressive possibilities of its practitioners while reinforcing a series of reproducible tropes that signify more and more a debased and singular notion of Black identity and experience in the United States?

Everett's answer to this question involves the illegibility of generic play itself. Accordingly, my argument takes up Jacques Derrida's claim that genre designations provide an appearance of order yet are ultimately futile because individual components within any particular category are participating in multiple groups without fully belonging to any.[6] For Derrida, each constituent within a genre is composed of so many contradictory signifiers that archiving them within a single category is impossible, and the participation in competing categories—such as experimental *and* conventional—constitutes a paradox in which the participant undoes its own belonging.[7]

In the end, I argue that Everett's bebop sensibility is a device of critical Blackness because it furnishes an encounter with the nonsense of categorization in all its forms, but particularly in terms of the groupings through which the modern racial episteme composes the idea of Black identity and experience.

GENIUS OF MODERN MUSIC:
BEBOP AS A PERFORMANCE OF REVOLT

According to Jon Panish, bebop positioned itself as an oppositional move-ment committed to reinventing jazz as a genre of music in the mid-1940s, as many musicians felt it had grown increasingly static and standardized in the interwar period.[8] Scott DeVeaux similarly notes that musicians of this period—most notably Charlie Parker, Dizzy Gillespie, and Thelonious Monk—broke distinctly and dramatically with the styles of composition and performance that had dominated jazz music since its inception in the late nineteenth and early twentieth centuries.[9] The performative shift away from the swing conventions that had guided jazz through the 1930s has a number of possible causes, but a crucial factor was the dissatisfaction that many Black musicians felt as they came to recognize how commercial-izing and traditionalizing jazz inadvertently regulated it as a mode of art and relegated its expressive possibilities to restrictive conventions. These musicians felt the constraints that jazz sustained as it took shape as a genre and its listening culture came to associate with jazz particular forms, styles, and purposes.

Importantly, this hardening of jazz into a tradition had racial con-sequences. As Amiri Baraka puts it, "philosophically, swing sought to involve the black culture in a platonic social blandness that would erase it forever, replacing it with the socio-cultural compromise of the 'jazzed-up' popular song: a compromise whose most significant stance was finally catatonia and noncommunication."[10] Whereas the musical techniques that distinguish jazz evolved out of Black American musical folkways, the commercial pressure of the swing era often diminished the relevance of folk tropes like improvisation, call-and-response patterns, syncopa-tion, and vocalized timbre. DeVeaux argues that the flooding of the mar-ketplace with dance-oriented white jazz bands threatened to erase these expressive origins and, along with them, the employment opportunities that many Black musicians had found in jazz. Those who "traded on their musical culture for personal gain in the marketplace," he explains fur-ther, "inevitably found themselves boxed in and belittled by pervasive racial stereotypes."[11] Bebop was not a musical solution to a social prob-lem; rather, one way to understand the emergence of bebop is to build on Baraka's argument by framing it as a reaction to the racial implications of the commercialization of jazz.

The historical significance of bebop is evident when we consider how its performers challenged jazz's generic conventions, effectively expanding the public's notion of acceptable cultural and musical practice. Keren Omry, noting the subversive impulse that guided the bebop movement, argues that listeners can hear in the music of the mid-1940s a rejection of "social functionality in favour of a (modernist) concentration on the aesthetic value of the music."[12] Such a shift is instrumental in understanding bebop's place in the jazz tradition. Contrasting itself musically from the slower, more rigid, and less complex compositions of swing and the jazz of the pre–World War II era, bebop was not simply the logical conclusion of early-twentieth-century jazz style or even an evolution of it. Instead, its emphasis on experimental harmonies, polyrhythmic forms, and even outright dismissals of the governing logics of beat and key revolutionized jazz by drawing listeners' attention to the cultural expectations that constructed musical convention and limited aesthetic possibilities. Bebop musicians' experimentation turned such music on itself and subverted the expectations of those who were familiar with it, in effect making the music unrecognizable within the tradition from which it sprang.[13] For this reason, DeVeaux insists that bebop is recognizable as jazz today not because it satisfied the historical moment's criteria for the musical genre; rather, we consider bebop to be a form of jazz because the criteria for what constituted jazz evolved as an effect of bebop's ethos of musical subversion.[14] Although jazz performers are continuously reevaluating the conventions that shape their genre, bebop's experimental impulse is historically distinct.

The subversive effect of this genre-challenging sensibility was not lost on critics of the mid-twentieth century. Ross Russell, for example, characterized it as "the music of revolt" in the late 1940s by contrasting it with the swing standards that were circulating in the marketplace. He insisted that "the war against the horrible products of the tunesmiths . . . has been brought to a successful conclusion only by the beboppers, who take standard melodies at will, stand them on their heads, and create new compositions retaining only a harmonic relation with the original."[15] To clarify this claim, he stated that bebop subverted the increasingly static nature of jazz through the writing and performing of music that existed "within the framework of jazz, but with new tools, sounds, and concepts," making it a music that reasserted individuality in expression—especially expression of the creative artist—that was otherwise lost in the standardization of jazz as

an art form.[16] Through interpretations like Russell's, we can see how bebop arrived not simply as an evolution of preexisting musical expressions but, more accurately, as a reaction to an emergent discourse of authenticity that threatened to limit jazz performers. For critics like Ralph Ellison, whose essays unfold to reveal a complex and changing relation to jazz, the effect of this stylistic challenge to the standards that came to define jazz during the swing era amounted to nothing short of "a momentous modulation into a new key of musical sensibility; in brief, a revolution in culture."[17]

I take bebop to constitute a revolution in culture predominantly because of the way that it challenged the regulation of jazz tropes, including how its practitioners provided alternative perspectives on familiar musical patterns and compositions by recomposing well-known musical standards with more elastic metric structures or with an emphasis on improvisation, methods that resulted in unharnessed polyphony and discordant tonal configurations. Unlike previous jazz stylistics, which revolved around melodic improvisation and, in many cases, an orchestra of players, bebop musicians layered complicated harmonic structures to reconfigure musical space and time with a limited arrangement of instruments, a mode of musical production that unified an apparently disconnected sequence of improvisational solos in such a way as to create a sense of subject. This approach established a new logic for jazz as an intellectual achievement, a music of discontinuity and implication rather than a steadily swinging beat. Often recognized as an avant-garde movement for this very reason, explains Lorenzo Thomas, the bebop era was one of artistic rebellion characterized by "the evolution of a popular performance style toward a more sophisticated or 'serious' artform as a social and political statement."[18] The resultant music, a performance in dialogue with itself, resounds throughout *Erasure*, a book that self-consciously defies genre, as both it and bebop provide encounters in which audiences can consider the limitations of the categories into which culture places them, effectively making more porous the apparently impermeable notions of form, style, and purpose on which their reception may have depended.

Some scholars have theorized bebop—and jazz as a whole—as a collective and repeated philosophical expression of Black people out of which a careful critic could extract a master code for the race.[19] Taken too literally, such an approach can lead to the creation of essentialist models for Black experience or assumptions regarding race and identity. To avoid such a

pitfall, I alternatively recognize bebop's subversion of conventional modes of musical expression as a means of undermining emergent paradigms regarding the jazz tradition and the racial identities of its performers. In this interpretation, bebop deconstructs the notion of a unified or collective Black experience. This is not to say that it sheds its fundamental relation to Blackness; rather, that the communicated truth of a performative movement like bebop has less to do with the announcement of a distinct and essential racial experience than with Blackness's refiguration as a fugitive mode of thought and expression. Put another way, instead of recognizing bebop as a derivative of a racial community, I prefer to recognize it as an expression of a mode of being in relation to the racial episteme of the twentieth century, an aesthetic practice through which Blackness's illegibility marks an attitude that is critical of delimiting racial discourse.

This critical Black perspective on bebop is supported by Paul Gilroy. In his arguments against ethnic absolutism and racial essentialism, Gilroy frames Black music as a counterculture of modernity, or a political sensibility that critiques the rigidity of modernity's discourse of authenticity and identity. Black music, for Gilroy, disrupts these notions and models a way of understanding race and identity as neither fixed nor culturally constructed but "lived as a coherent (if not always stable) experiential sense of self." He offers specific praise for "the anti-assimilationist unintelligibility of bebop in the forties," which he characterizes as simultaneously American and Black, a pairing he presents as an ontological contradiction.[20] This characterization captures the paradox of bebop: at once Black and antiessentialist, bebop embodies the rich contradiction that Gilroy believes displaces notions of authenticity in favor of "self-fashioning and communal liberation."[21] Improvisation and experimentation are not just musical conventions, such analyses indicate, but strategies of a deconstructive sensibility that contests the conceptual validity of the categories that modernity produces and reifies, all the while abstracting Blackness.

STRAIGHT, NO CHASER: EVERETT'S BEBOP EFFECT

Erasure is not about jazz. Rather, bebop's effects, for Everett, are audiovisual signs for the activity of critical Blackness, an activity through which a practitioner works to produce a defamiliarizing sensibility that undermines the reader's complicity with racial discourse. Everett's enactment of

bebop techniques aims to dissolve the expectations that his reading pub-
lic might have regarding a work promising to participate in its particular
genre. The title page and dust jacket of Everett's work announce its category
of composition—*Erasure: A Novel*—yet the text works against category to
render this classification illegible.

One method by which bebop jazz troubled generic constraints of musi-
cal expression was intentionally disrupting its listeners' sense of steady
and uncomplicated musical time. As Paul Berliner explains in his land-
mark study *Thinking in Jazz*, "artists attain great freedom in their rhythmic
dance when they deliberately superimpose different tempos upon that of
the piece, rushing ahead or falling behind, applying different degrees of
pressure to the beat before resubmitting to its regulation."[22] At other times,
he continues, a group or soloist may abandon tempo altogether, a tech-
nique suggesting that the steady, unchanging beat is actually a constraint
of expression, an oppressive apparatus that determines too much about the
expressionistic potential of the music.

In *Erasure*, Everett similarly disrupts the tempo at which the reader
experiences the unfolding of text to provoke an analogous type of con-
templation regarding the constraints of narrative structure and, by exten-
sion, the limits that genre imposes as a means of categorical capture. For
example, when reflecting on the complexity that variances in spacing and
typography create in the progression of text, Everett confronts his reader
with a disruptive break in Monk's journalistic tone, a change of narrative
pace that produces a perceptual hiccup:

There may be space breaks between paragraphs of texts, between lines of text,
sentences or words of the text. That these spaces have some kind of
narrative significance or charge is not arguable, though the weight of such
import might be, and most times is, infinitesimal. What is more interesting is the
fact that narrative always travels in the same direction and so the

spaces, the negative or white spaces travel the same way. Never are
we dropped into a space and returned to the previous narrative position or into
nothingness[23]

Given that the strict metric frame of narrative does not allow for the neces-
sary level of freedom of expression, Everett here seeks autonomy through

a more elastic mode of improvisation. While this narrative device may appear to border the unrhythmic, it does not alter the progression of the story as a whole. Instead, it disrupts the reader's experience by stretching and compressing the speed at which the passage develops for a brief interval. The improvisatory unfolding of the text creates a sense of discontinuity and implication rather than a steadily swinging beat, and the resulting rhythmic structure marks its participation in a sensibility of bebop musicality. Recognition of this narrative strategy as a bebop effect—rather than a broader modernist or postmodernist technique—highlights how the novel's deconstructive sensibilities erode the culturally impermeable notions of racial identity, those reinforced as stereotypes by the hegemonic cultural apparatuses with which Monk struggles. Like the bebop musician, Everett syncopates the otherwise steady text to create a sense of tension before resubmitting to the rules that regulate the progression of the novel (our narrator's name is, after all, Thelonious).

Signaled by changes in typeface, point size, line length, and line spacing, the contrast between the novel's primary narrative voice—Monk's first-person journal—and the numerous interludes of *Erasure* similarly changes the rhythm at which the reader navigates the text. By shifting from journal narration to a professional mode of self-branding in the résumé that Monk shares while seeking temporary work at the American University in Washington, D.C., for example, Everett disrupts the steadiness of the text's longer, expressive sentences with short and fragmented statements (55). Like the break in which Everett disrupts his character's journalistic tone to reflect on the relation of text to spacing and narrative direction, such digressions put pressure on the sense of beat at work in the language of Monk's journal. Though chapter partitions and, within each chapter, section breaks divide *Erasure* in a way that is both conventional and familiar to the reader of novels, these interjections disrupt and slow the tempo of the story that Monk is trying to tell much more dramatically. Thus, the nonnarrative passages in *Erasure* are moments that produce in the reader a sense of time and space that is not conventional within the genre. The appearance of these traditionally nondiegetic modes of writing serves to frustrate the boundaries that delineate the limits of the genre of the novel by prompting the reader to question where narration ends and other modes of written communication begin, where Monk's story stops and something new starts.

In addition to these pace-changing techniques, Everett's bebop effect also produces a jarring sensibility that resonates with bebop's tendency

to change keys unpredictably and experiment with unconventional chord progressions. Unlike pieces of music that are structured around a conventional, twelve-bar blues progression, a format in which soloists are able to play within a predetermined key signature for the entirety of a performance, the bebop repertory includes arrangements that shift keys and break from straightforward progressions—at times unexpectedly, in accordance with an improvisatory impulse that often guided the music.[24] Applied musically or textually, this effect challenges the expectations that an audience may have in regard to a particular category of composition.

Everett creates a similar sensibility of irregular modulation in *Erasure* by alternating between narrative voices. Throughout the novel, the voice shifts rapidly from Monk to the less central characters, such as Van Go Jenkins and Tom Wahzetepe, the protagonist of *"Àpropos de bottes"* (On the Subject of Boots), whose title is derived from an archaic French phrase indicating an abrupt and arbitrary change of subject. In such instances of shifting and disjointed narrative progression, Everett unpredictably switches point of view and tone, as well as narrative and fictional worlds, in a way that resonates with DeVeaux's articulation of bebop's primary impulse: "The bopping is inseparable from the stopping—the artful disruption of the natural expectation of continuity."[25] Everett's literary application of this stopping-and-starting technique allows for different linguistic modes and voices to perform in proximity to one another, producing a sense of antiphony that at times results in a type of discord that is analogous to bebop's sensibility involving challenging the constraints of genre by developing unconventional musical practices.

Consider, for example, the effect that Everett creates in the contrast between Monk's controlled, erudite journal narration and Van's violent, profanity-laced monologues, which resemble improvised solos when read alongside their seemingly composed counterpart: "I wake up and I'm just soaked in sweat, been sweatin like a fuckin pig. I throw them sheets off me and pull on some jeans. I tighten up my belt and then yank my pants down on my ass. The tee shirt I'm wearing be funky as shit, but I don't give a fuck. The world be stinkin, so why not me? That's what I says. So, why not me? That's my motto. So, why not me?" (64). Van's punctuated and abrupt narrative voice, which repeats as it revolves around rhetorical questions and surface-level descriptions of the immediate physical environment, contributes to Everett's bebop effect by helping to establish a framework of harmonic modulation, the shifting from one key to another. The result of

such rapid changes in narrative voice is, again, the production of a notion of musicality.

The startling contrast between Van's narrative voice and Monk's produces a dissonant and cacophonous clash (a stopping and restarting) that compels a renegotiation of the way the reader receives the text. Alongside sections of text that Monk narrates, which seem painstakingly composed and controlled, Van's dialogue takes on a sensibility of improvisation that does not accommodate the same method of reading.[26] The uncomfortable feeling that readers experience when recalibrating their reading process at such moments of transgressive textual progressions is a product of Everett's bebop effect, an impulse to generate in *Erasure* a nearly audible sense of musical discontinuity and implication. This ethos of defamiliarization works to deconstruct the notion of a distinct or essential genre of novel.[27]

Everett's bebop effect manifests in the musicality of these genre-challenging disruptions, the troubling of the novel's otherwise steady narrative time and the abrupt and improvisatory changing of key. Like the bebop composition, *Erasure* in this way seems, to borrow DeVeaux's characterization of 1940s jazz, to be "deliberately confrontational—a refusal to give audiences what they expected and wanted."[28] The result is a disruption of generic expectation that is decidedly transgressive. Breaking from narrative expectation allows Everett to achieve a fleeting but unregulated mode of self-expression and artistic autonomy in written language, a freedom from standardized narration. For readers, this freedom produces a disorienting encounter that asks us to shed the conceptual exoskeleton that accommodates our reading process and protects us from the frustration of not understanding a work of art. Through this bebop effect, Everett does for the eye what 1940s jazz did for the ear: his ambitiously disruptive and lushly arranged text helps to create a playful mode of self-aware narration— a mode of writing in dialogue with itself—that pushes against the limits that genre imposes in favor of an amplified expressional sensibility.

MONK'S BLUES: ART AND IMAGINARY BLACKNESS

Like bebop musicians, many of whom felt the racial consequences of jazz's hardening into a tradition and succumbing to commercial constraints in the 1940s, Monk becomes increasingly discouraged as an unread author of experimental fiction whom publishers and editors reject for not writing

"the true, gritty real stories of black life" (2). After receiving this very critique from a book agent at a party, Monk explains that he is "living a *black* life, far blacker than [the agent] could ever know, that [he] had lived one, that [he] would be living one" (2), but this explanation has no effect. The agent's quick dismissal of any American author of African descent whose subject lacks racial stereotypes serves to illustrate the enormity of the abyss between Monk's lived experience and the experiences that others attribute to him based on the color of his skin.

It is into this abyss that Monk loses his self-sovereignty, his ability to explore identity as a process of self-making through social life or, as he is a writer, narrative experimentation and expression, others having come to recognize him only as part of a larger—and essentially static—racial group. As he discovers while perusing the shelves of a bookstore in search of his own publications, his identity is less a self-created sense of individuality than a one-dimensional projection on which others trade: "I decided to see if the store had any of my books. . . . I went to Literature and did not see me. I went to Contemporary Fiction and did not find me, but when I fell back a couple of steps I found a section called African American Studies and there, arranged alphabetically and neatly, read *undisturbed*, were four of my books including my *Persians* of which the only thing ostensibly African American was my jacket photograph. I became quickly irate, my pulse speeding up, my brow furrowing" (28). Part of Monk's frustration is in response to the bookstore's ineffective sales technique, as is evident in his explanation. "Someone interested in African American Studies would have little interest in my books and would be confused by their presence in the section"; "someone looking for an obscure reworking of a Greek tragedy would not consider looking in that section any more than the gardening section"; and "the result in either case, [would be] no sale" (28). The language with which he narrates his scrutiny of the bookstore shelves, however, resonates also with the psychological damage that Frantz Fanon experiences and documents in response to the process of racial-epidermal identification, as discussed in the first chapter.

Invoking Fanon, Monk describes his search for his books as an ontological process, one that likens his novels to a version of himself: "I . . . did not see me" and "I . . . did not find me" sharply contrast with the passive construction in which he depicts his discovery that the bookstore has confined his works to the single shelf of texts that it groups as African American

Studies in spite of their irrelevance to the conventions that potential read-
ers may associate with such a categorization. In the eyes of the publishing
industry, Monk is recognizable only by his Blackness, meaning his life and
experiences must resemble the prepackaged stereotypes that such a cat-
egory signifies in the popular imaginary. His experience in the bookstore
recalls the psychological torment experienced by the target of racial hailing
in *Black Skin, White Masks*; as Monk's pulse speeds up, as his brow furrows,
what we might call his artistic-bodily schema collapses and gives way, in
Fanon's words, to "an epidermal racial schema."[29]

Through his disorienting experimentation in *Erasure*, Everett responds
to the limited category of fiction to which Monk is confined and articulates
his understanding of the relation of genre to race. He indicates that the
ongoing scripts of lingering racial stereotypes contribute to the perpetua-
tion of an imaginary Blackness, a cultural notion that reinforces racist ide-
ology by validating an existing rhetoric of difference. Monk's initial source
of irritation is the success of fictional author Juanita Mae Jenkins's bestsell-
ing novel, *We's Lives in Da Ghetto*, a work that reduces Black experience to
caricatures of teenage pregnancy, drive-by shootings, and prostitution.[30]
In general, Monk worries that that publication validates these stereotypes
as authentic and that the consumption of such caricatures reinforces the
legitimacy of the very ideas they portray in the minds of readers. He ago-
nizes that the success Jenkins achieves bolsters the public's desire for litera-
ture that fortifies stereotypical racial knowledge while leaving little to no
conceptual space for other narratives of race to exist.

The irony that the novel is not a reflection of Jenkins's experiences
becomes increasingly obvious to Monk, who sees an interview between
the author and a fictional talk-show host who includes *We's Lives in Da
Ghetto* on the reading list for her book club.[31] During the interview, Jenkins
explains that the novel evolved out of "visit[ing] some relatives in Harlem
for a couple of days"; that she is originally from Akron, Ohio; and that
she studied writing at Oberlin College before moving to New York (53).
As the conversation turns to the profits from having sold three hundred
thousand copies, as well as the additional earnings she accrued for selling
the film rights, the underlying motivation for her having written the novel
becomes increasingly evident: publishers and readers alike are hungry for
literature that preserves imagined notions of authentic Blackness. By posi-
tioning his character as an aware subject, Everett traces Monk's reactions

to this cultural process, noting in particular how it reinforces a damaging racial discourse. In this way, Everett posits imaginary Blackness as a generic grouping that operates to classify and order human bodies in the same way that categories of composition distinguish artistic projects with notable shared features.

The existence of such a system of generic identities is apparent in Monk's experiences, how his Black skin—the convention on which categorical identification of Black bodies depends—communicates to those he meets a host of associations regarding his supposed identity. Everett makes Monk's awareness of this process of epidermalization evident in the way his narrator opens his journal with a self-characterization that serves to complicate his subjectivity beyond any simple association with any particular racial stereotype. "Though I am fairly athletic, I am no good at basketball," Monk introduces himself. "I listen to Mahler, Aretha Franklin, Charlie Parker and Ry Cooder on vinyl records and compact discs. I graduated *summa cum laude* from Harvard, hating every minute of it. I am good at math. I cannot dance. I did not grow up in any inner city or the rural south. My family owned a bungalow near Annapolis. My grandfather was a doctor. My father was a doctor. My brother and sister were doctors" (1–2). As Monk discovers, however, announcing his difference from stereotypes does not mean that others will see him differently. His experiences indicate that imaginary Blackness is so deeply rooted in the United States' racial consciousness that any individual deviation from stereotypical expectations incites a common response: "Some people in the society in which I live, described as being black, tell me I am not *black* enough. Some people whom the society calls white tell me the same thing" (2). In these lines, Monk draws attention to the way in which people are identified by a sense of race, yet he also hints at his discomfort with doing so.

According to Ingrid Monson, many artists who participated in the bebop movement were also hyperaware of the damaging racial representations circulating in the nation's racial imaginary, especially the way that the idea of Black entertainment often signaled images of minstrelsy in the popular imagination of the 1940s. And it is for this very reason, according to Guthrie P. Ramsey, that many musicians self-consciously developed a subversive and expectation-challenging style of performance.[32] Monson explains that "while validating the liberating, social, and sensual aspects of African American music, musicians tended to be wary of those who

would reduce them to the stereotype of the primitive Other."[33] Dizzy Gillespie, for instance, condemned Louis Armstrong for perpetuating a "plantation image" in his performances, specifically for appearing with a "handkerchief over his head, grinning in the face of white racism."[34] Krin Gabbard reports that in his autobiography, Miles Davis similarly criticized Armstrong when he placed a photograph of the trumpeter alongside one of Beulah, Buckwheat, and Rochester, under which he wrote, "some of the images of black people that I would fight against throughout my career. I loved Satchmo, but I couldn't stand all that grinning he did."[35] Charles Mingus was still referring to Armstrong as Uncle Tom well into the mid-1970s, years after the jazz icon had died.[36]

Gillespie, Miles, and Mingus feared that the public would latch onto Armstrong's "Tomming," much like Monk fears would happen with the readership of *We's Lives in Da Ghetto*. In both situations, the fear is that the audience will come to expect similar performances of all other Black Americans. As Gillespie writes, "I didn't want the white man to expect me to allow the same things Louis Armstrong did."[37] Gillespie's concern resonates with Monk, who knows how stereotypes reinforce categorical identity types and activate racial *déjà vu*, and who has himself felt the phenomenological manifestation of epidermalization that Fanon records.

In *Erasure*, such concerns are warranted. Monk discovers that Jenkins's readership finds no issue with her exploitation of racial stereotypes. For instance, a woman to whom he is close describes *We's Lives in Da Ghetto* as "lightweight" and "fun," a passive endorsement that sanctions the novel's content as legitimate and appropriate (188). "Have you ever known anybody who talks like they do in that book?" Monk asks her, critiquing Jenkins's unsophisticated and degrading use of Black vernacular English throughout the fictional novel, before stating very clearly, "I find that book an idiotic, exploitive piece of crap and I can't see how an intelligent person can take it seriously" (188). Without the careful and critical reflection that Monk expects of an intelligent reader—a type of dutiful and conscientious reading that he alone seems capable of practicing—Jenkins's book, his comment indicates, is nothing more than a catalog of racist stereotypes, each of which constructs and reinforces particular ideas regarding how Blackness can be perceived, known, and imagined.

Armstrong's performances were ideologically powerful (and therefore dangerous) because of his role as a foundational jazz musician, a role that

conferred on him considerable cultural influence. Everett allots a similar degree of cultural influence to Jenkins, as the critical reception that *We's Lives in Da Ghetto* receives is overwhelmingly positive, effectively validating the content of the novel as authentic for readers within the milieu of *Erasure*. In a fictional review of the novel, he reads, "Juanita Mae Jenkins has written a masterpiece of African American literature. One can actually hear the voices of her people as they make their way through the experience which is and can only be Black America" (39). The review concludes with an additional assertion of the legitimacy of racial otherness by again reducing the variety of lived experience to a small set of racial stereotypes. "The twists and turns of the novel are fascinating, but the real strength of the work is its haunting verisimilitude," the reviewer writes. "The ghetto is painted in all its exotic wonder. Predators prowl, innocents are eaten. But the novel is finally not dark, as we leave the story, with Sharonda trying to raise enough money to get her babies back from the state. Sharonda, finally, is the epitome of the black matriarchal symbol of strength" (39–40).

Between the endorsement of "masterpiece of African American literature" and the suggestion that *We's Lives in Da Ghetto* captures the essential experience that all Black Americans live, the critical reception of Jenkins's work both narrows the borders of the genre of African American literature and reinforces a paradigm of experience against which all future Black cultural production must thereafter measure itself.[38] The publishers and editors who reject literature because it is "not *black* enough," those who wish American authors of African descent would "write the true, gritty real stories of black life" (2), are not looking for insightful narratives regarding the real-life experiences of individual racialized Americans any more than jazz producers were looking for the self-possessed musical expressions of Black performers during the height of the swing era. More marketable are/were the predetermined "exotic" representations that play on existing, imagined notions of racial identity and experience—in short, the very ideas that constitute Jenkins's work and appeared in Armstrong's performances.

Monk's understanding of the reproduction of racial knowledge highlights how devices of racial legitimation make bodies meaningful by bestowing on them specific qualities, as well as how hegemonic cultural apparatuses reinforce one-dimensional ways of recognizing and knowing difference. Jenkins's success leaves Monk feeling like the aforementioned jazz musicians, as though the culture in which he lives has endorsed "a

display of watermelon-eating, banjo-playing darkie carvings and a pyramid of Mammy cookie jars" as a paradigmatic model through which it can recognize all Black Americans (29). Monk's awareness of such a categorization indicates that the validation of a collective racial experience serves only to reinforce the fantasy of a stable culture and that this fantasy preserves the hegemonic status of whiteness by diminishing the cultural viability of nonwhite groups.

Like a bebop musician, who, by questioning the idea of the song, also broadened the imagined notions of its performers' racial identities, Everett unsettles his readers' expectations of the "African American novel" to prompt critical inquiry into the legitimacy of racial representation that readers may expect from such a category. When an individual's identity is based solely on racial characteristics—as was Monk's by his experience in the bookstore—self-sovereignty is stolen and a voice is muted. Accordingly, the figuration of any racial identity as authentic and paradigmatic is inherently problematic because the reduction of an individual to a type is political machinery that generalizes (and erases) the historical and economic processes against which a racialized subject fights.[39]

In the same way that notions of genre can limit artistic expression, the racial associations against which Monk struggles serve to imprison racial minorities by locking them inside predetermined and category-driven racial identities. Everett's bebop effect thus not only confronts the stereotypical representations found in novels like Jenkins's but also assaults the idea of representation itself by producing a nonrepresentation of race.

MONK'S DREAM: *FUCK* AS UNHEEDED
PROPHECY AND IMPROVISATION

Monk's impromptu parody, *Fuck*, resembles the unheeded prophecy of Cassandra in the *Oresteia* of Aeschylus.[40] The drama of Aeschylus's *Agamemnon* peaks in Cassandra's role. Although she has few lines in the play, her character possesses a peculiar second sight. The deity Apollo had blessed her with the gift of prophecy; however, when she afterward refused his romantic advances, he placed a curse on her that ensured that nobody would ever believe her predictions. When she prophesizes the murders of King Agamemnon and herself, the other characters ignore her foresight, which results in the prophesized deaths.[41]

In clinical psychology, the Cassandra myth has become the foundation for the profile of an individual who endures a dysfunctional relation with the Apollo archetype. Melanie Klein has interpreted the Cassandra as a representation of human moral conscience who "predicts ill to come and warns that punishment will follow and grief arise."[42] Laurie Layton Schapira builds on Klein's analysis with her argument that the Cassandra's grief arises out of an inability to accommodate an individual's or a culture's pattern of thought "dedicated to, yet bound by, order, reason, truth and clarity" that "disavows itself of anything dark and irrational."[43] Because such an Apollonic consciousness informs the culture of Western nations like the United States, Schapira explains, the metaphorical application of the so-called Cassandra complex helps to clarify a condition in which an individual comes to see "a truth which others, especially authority figures, would not accept."[44]

Importantly, such archetypes need not be gender-specific, according to Jean Shinoda Bolen, who has further described the relation of Cassandra to Apollo as one defined by frustration over the privileging of thinking over feeling, objective assessment over subjective intuition, and surface-level rationalism over that which underlies appearances.[45]

Monk's relation to the modern period's racial episteme is akin to the relation of the Cassandra to the Apollo archetype. Having foreseen the dangerous association of art steeped in racial stereotype to the perpetuation of racist generalizations, he attempts to disrupt the cultural reproduction of imaginary Blackness by writing a novella titled *Fuck* (originally named *My Pafology*). Exacerbating every stereotype that he can think of, he intends this work to parody *We's Lives in Da Ghetto*. Specifically, he hopes that a presentation of "authentic" (read, "racist") markers of Blackness in their most absurd forms can undermine the conceptual footholds that such stereotypes have in the nation's racial consciousness. Monk expects his novella to function as a prophetic warning that highlights the metadiscourse that the publishing industry reproduces and the reading public consumes. In his mind, *Fuck* is a tool for disrupting the naturalized ideologies of white supremacy.

Like the prophecies of Aeschylus's Cassandra, Monk's warning falls on deaf ears. After publishing the work, he discovers that his audience is unable to recognize his parodic intent. What he intended to be subversive has instead become an overnight success even more acclaimed than *We's Lives*

in Da Ghetto. Referring to it as "the truest novel [he's] ever read," Wayne Waxen, an imagined reviewer of *Fuck*, argues that the novella's value is in its capacity to represent the criminal nature of Black people by providing an "honest" and objective "glimpse of hood existence," effectively fulfilling a race fantasy that popular culture teaches its readership to expect (260). In the end, *Fuck* even wins a National Book Award, ironically upstaging Jenkins's work and solidifying the novella's place as "the true story of what it is like to be black in America" (235).

His message ignored, Monk comes to endure Schapira's articulation of the Cassandra complex: he is one who "may blurt out what [he] sees, perhaps with the unconscious hope that others might be able to make some sense of it. But to them [his] words sound meaningless, disconnected and blown out of all proportion."[46] He is haunted by tragic foresight regarding the deterioration of the health of art in response to the public's desire for easily digestible representations of racial difference, as well as the consequences that such work has in the minds of its readers. Yet, even as an author, he seems to lack the agency to do anything about the future direction of American letters or their role in the fortification of imaginary Blackness.

Publishers and critics within the milieu of *Erasure* fail to recognize Monk's warning, but for the novel's reader, Monk's figuration as the Cassandra is a function of Everett's effort to defy genre and challenge the notion that categorical racial identities are viable. The Cassandra model of divination creates an encounter in which the audience comes to possess knowledge greater than that of the work's players. That is, in *Agamemnon*, Cassandra's prophecy, as well as its fulfillment and her necessary death, aims to prompt viewers of the play to consider the important ethical question around which Aeschylus's work revolves: is justice the will of the gods or the result of human vengeance? Further, it allows the Chorus (representative of the State) to ask how social chaos and disarray can revert to normality without reaffirming the tyrannous social structure that bred the violence of the play. For these messages to come through, audiences must not only hear Cassandra's prophecy, they must also know that it is true and foresee its tragic realization (and endure the discomfort of being unable to do anything about it). Everett adopts this structure—in a bebop idiom—by representing *Fuck* as a prophetic warning and then dramatizing its fulfillment. Like Aeschylus's audience, Everett's readers know that *Fuck* will be misunderstood and that Monk will endure a tragic ending.

Even though *Fuck* is not successful in the way that Monk intends it to be, the improvisatory sensibility that Everett's bebop effect produces within *Erasure* offers extra-diegetic commentary on the candor of the novella's epistemic violence. This extra-diegetic function undermines Monk's claim that it is "a failed conception, an unformed fetus, seed cast into the sand, a hand without fingers, a word with no vowels" (261). Alternatively, for the reader of *Erasure*, it forges a critical relation between the thematic concerns of *Erasure* and the novel's literary ancestry, raising ethical questions about discourse that enriches imaginary Blackness. Specifically, the Apollonic consciousness that gives form to the target of *Fuck* is the canon of African American literature itself. For the reader of *Erasure*, Everett artfully recomposes a number of qualities and tropes now presumed to be conventions of that literary tradition, signifying on Richard Wright's *Native Son* in particular.[47] The changes that Monk makes to Wright's novel in Everett's recomposition draw attention to the cultural function of such books when misread but also the consequences of traditionalization as a force that inevitably narrows expressive possibilities by authorizing some ideas as conventional while curtailing others as experimental.

As a component in Everett's bebop effect, we might see *Fuck* as a kind of improvisatory musical break, a solo section in *Erasure* as a sort of musical score. Characterizing *Fuck* as a mode of improvisation does not mean that the novella is free-form invention. As Berliner explains, improvisation does not exist apart from the tradition out of which it springs. Solos that may appear to be "disconnected demonstrations of technique" are usually in conversation with the work of other jazz musicians' personal and collected experiences, the best solos building on a theme to create tension and suspense before arriving at a sense of resolution.[48] Like a bebop soloist, Monk, responding to Jenkins's novel, is entering into conversation with a specific body of work, as is evident in the way *Fuck* signifies on the conventions that are traditional within the genre in which it participates.[49]

The improvisational objective of *Fuck* is to highlight the limitations of texts that are considered foundational narratives of Black experience. Such a process of recomposition, as Panish explains in his likening of Beat generation literature to jazz, is a technique through which an author works "to 'liberate,' or at least revitalize the structure of American fiction."[50] By signifying on the tradition of African American literature, Monk queries its categorical limitations, and in this way he expands it in a stimulating manner. Because jazz is a collective achievement rather than an individual one,

improvisation is a technical activity through which Everett can deliberately script a type of critical Blackness that functions as a bridge over which the reader is able to encounter and critique African American literature's cultural lineage. Specifically, it comments on the direction of American letters that validates and reproduces the stereotypes on which novels like Jenkins's depend. With this in mind, *Fuck* is, as Monk explains, offensive, racist, and highly ineffective as a mode of aesthetic resistance or as a warning within the milieu of *Erasure*, but it is also, as Everett's authorial voice indicates, not without subtext for the readers of *Erasure*. That subtext allows Everett to revitalize and recompose the discourse on which he signifies.

Fuck constitutes the reappropriation of African American literature from writers like Jenkins, as well as Monk, who assimilates the very social ideas that work to alienate all Black Americans for being unable to fit the mold that culturally accepted notions of imaginary Blackness demand. The improvisational sensibility of Everett's bebop effect challenges the law of genre and prompts the reader to question the cultural associations that give shape to a category like African American literature or racial identity. *Fuck* is more than just the failed warning of the Cassandra, as Monk may feel it is. Additionally, for the reader of *Erasure*, it becomes a prompt to question the relation between improvisational forces—convention and invention—and their role in the perpetuation of modes of thought that reinforce the racial associations that constitute the apparent identity category of Blackness.

THELONIOUS HIMSELVES: DISHARMONIOUS HARMONY AND NARRATIVE'S VERTICALITY

We cannot talk about *Erasure*'s competing identity performances without discussing the connection between Everett's narrator and both Thelonious Monk, the jazz pianist and composer with whom he shares his name, and Ralph Ellison's character, Rinehart, the Harlem preacher who straddles a number of divergent identities in *Invisible Man*. These allusions are clear from the opening of Monk's journal.[51] However, they are most powerful in his playacting of Stagg R. Leigh, the pseudonym under which he publishes and promotes *Fuck*.[52] Before appearing as Stagg on television, for example, Monk dresses in a way that resonates with both individuals. Everett writes, "Stagg Leigh leaves his hotel room, 1369, dressed casually in black shoes,

black trousers, black turtleneck sweater, black blazer, black beard, black fedora. Stagg Leigh is black from toe to top of head, from shoulder to shoulder, from now until both ends of time. He bops down the carpeted hallway to the elevator, down again, farther down, down" (245). Monk perfects his Stagg routine by completing his look, at which point he says, "Stagg Leigh had slipped away from me. . . . I closed my eyes and conjured him again. I reached into my pocket, pulled out my dark glasses and put them on" (247). This outfit likens Stagg to Ellison's Rinehart and Thelonious Monk because both are renowned for their distinctive fashion—most importantly, hats and dark glasses.[53]

For Rinehart, Thelonious Monk, and Stagg, a flair for offbeat style cultivates a sense of mystery and freedom, although the sartorially constructed personas of these characters revolve not around any specific outfit or accessory but, rather, the idea of disguising and inventing oneself by appearing distinct from others.[54] As Baraka explains, bebop style "pointed toward a way of thinking, an emotional and psychological resolution of some not so obscure social need or attitude. It was the beginning of the Negro's fluency with some of the canons of formal Western nonconformity."[55] The development of Stagg's radical dress parallels the revolutionary spirit of bebop jazz, as both encourage the separation of the individual from the generic categories through which the modern racial episteme had taught others to recognize him/her.

Dubbed the "high priest of bop" in the late 1940s, Monk is recognized today by critics as one of the founders of modern jazz. Listeners did not always appreciate his music during his lifetime, as is evident from early reviews. One in *Down Beat* magazine expressed impatience with the "farfetched type of composition and inventiveness which are displayed by the much publicized Monk for a very simple reason. Nothing happens," but he undoubtedly helped to demarcate bebop.[56] For instance, in 1962, André Hodeir looked beyond Monk's unorthodox technique to praise his contribution to reinventing traditional musical structures.[57] Likewise, Ran Blake's 1982 analysis of Monk's effect on the jazz tradition, in which he argues that the jazzman's "approach to the keyboard was a radical departure from what had gone before, and he unquestionably qualifies as one of the great jazz innovators," reframes the significance of his distinct musical style.[58] More recently, Robin D. G. Kelley's 2009 biography of the jazz icon celebrates in meticulous detail Monk's influence within the Black radical tradition.[59]

One of Monk's biggest contributions to bebop was his unique sense of jazz harmony, a musical process that has significant import for Everett's novel. Like a progression of musical notes, narrative is said to move along a horizontal axis, developing in time as the plot progresses. However, the identity-making experiments and dense allusions of *Erasure* give the novel a vertical orientation that allows Everett to expand the space in which his characters move by compounding and multiplying their personalities the way a bebop composer like Thelonious Monk can layer notes of a scale to build harmonic structures. Monk's identity confusion begins in the opening pages of the novel when he chooses to represent himself as more than just an author: "I will be something else, if not instead, than in addition, and that shall be a son, a brother, a fisherman, an art lover, a woodworker" (1). Everett establishes a sense of harmonization among the many voices of his narrator's journal by layering the pseudonymous Stagg on top of his narrator's identity performances, then complicating both characters with non-diegetic (and sometimes contradictory) biographical documents and ideas for experimental short stories, as well as allusions to historical personalities or characters not belonging to *Erasure*'s milieu. The narrative element of *Erasure* is still moving always forward, but the protagonist's polyphonic identity—the novel's vertical orientation—makes the story resemble less the threading of a singular strand than a tapestry of tensely woven yarns, each of which influences the reader's engagement and understanding of its character's identity (especially in terms of Monk's inclusion in any particular racial category). This emergent sense of harmonic arrangement contributes to Everett's bebop effect because it extends his work's thematic concern with genre to its performative element, establishing a parallel between the novel and a musical score.

The value of bebop as a tool for interpreting Everett's novel hinges on Thelonious Monk's unique and experimental approach to harmony, which, as his biographer, Thomas Fitterling, puts it, resulted often in "a peculiarly disharmonious harmony."[60] Because his signature sound is largely indebted to his reliance on the whole-tone or augmented scale, a scale in which each note is separated from the next by the interval of a whole step, Monk's music (whether composed or improvised) often has a wandering, indistinct quality in which no single tone stands out from the others.[61] As a scale with no semitones, the whole-tone scale produces a harmonic and melodic feel that differs from the modal music with which the Western ear is familiar,

in particular the patterns of notes that make up the Ionian, or major, scale and the Aeolian, or minor, scale. Whereas C major includes the pitches C, D, E, F, G, A, and B, the whole-tone scale in the same key unfolds as C, D, E, F#/Gb, G#/Ab, A#/Bb. The first three pitches of the whole-tone scale match the familiar major scale, but each note in the second half of the scale is in a tritonic relation to one of its predecessors (F#/Gb with C, G#/Ab with D, A#/Bb with E).[62] The extreme dissonance of these tritonic relations generates the disharmonious harmonies of Thelonious Monk.[63]

In *Erasure*, Monk's sense of disharmonious harmonic arrangement contributes to Everett's bebop effect because it further grounds his work's concern with the limits of categories and genre in the novel's formal structure. The disharmonious, bebop sensibility inherent in the polyphonic arrangement of identity types becomes clearer as Monk's investment in his performance grows and he begins to wonder whether Stagg is displacing his sense of self. Monk begins to worry about where his identity, like the individual yet indistinct notes of bebop's whole-tone scale, stops and his construction begins. He wonders whether he "might in fact become a Rinehart" (162). If we recognize Monk's musical-narrative function as the novel's root note, or tonal center, each of the competing identities emerges as the other half of a (dissonant) harmonic relation. The intervallic arrangement of these categorically figured identity types always places them in tension. Some figurations may feel sonorous, such as the connection of Monk's journalistic self-characterizations to the versions of himself that he presents in his résumé or author biographies. Alternatively, Monk's harmonic connection to Stagg, for instance, seems distinctly tritonic, since their categorically driven identity types exist in extreme dissonance.

The critical relation that Theodor Adorno sees between harmony and dissonance opens this discordant identity arrangement to analysis. In Adorno's theorization, harmony "presents what is not reconciled as reconciled," making dissonance "the truth about harmony."[64] For Adorno, discontinuity is a sign of the irreconcilability of the part and the whole, whereas harmony (or its appearance) is the imposition of order on disorder. Focusing interpretation on the dissonance created by the contrasting identity types of *Erasure*, rather than comparing the legitimacy of one identity category with that of another, clarifies how the disharmonious harmonic arrangements that Everett creates trouble the identity boundaries on which imaginary Blackness depends.

In addition to illustrating the disharmonious connections binding characters in *Erasure*, the slippage between Monk and his pseudonym reinforces the novel's relation to the jazz musician with whom its narrator shares his name—although never officially diagnosed, a number of scholars have suggested that the quirky behaviors of Thelonious Monk were the effect of untreated mental illness, possibly manic depression or schizophrenia.[65] Exactly how the musician's abnormal conduct manifested in his personal life is difficult to know, but it showed itself candidly in his concerts. For example, two of Monk's 1954 performances puzzled the British critic and record producer Raymond Horricks, who was reporting on the pianist's participation in an international jazz festival. Monk's first set was a catastrophe, Horricks had written, the musician's "fingers splayed stiffly, stabbing rather than touching the keys"; yet, two days later, when performing for a second concert, he reported that Monk appeared "an obviously changed man, calm and subdued . . . his spontaneous search for new harmonic structures successful, his rhythmic emphasis clear and direct."[66]

These concerts illustrate more than just how Monk was sometimes the infamously inaccessible jazz musician renowned for abstruse performances and at other times the composed artist of carefully arranged jazz experimentation. Additionally, the two-day interval between the concerts draws attention to the variations that performances inevitably accrue over time, effectively framing his representation as one that is increasingly at odds with itself. Like much of his music, these performances create a sense of disharmonious harmony, as any notion of stability and consistency is lost in the gap between the two conflicting concerts. Focusing interpretation on the event of the difference between these two nights rather than comparing one with the other makes this notion of a disharmonious harmonic identity more apparent. The critic's comments regarding the divergence between the shows—"thus the complete enigma that is Thelonious Monk," he wrote—is apt, but whereas Horricks read the difference between the two nights as "the curtain parting to reveal the other side of his nature, the Jekyll added to the Hyde existence," I read the notion of the disparity itself as a sign of the impossibility of constancy in identity.[67]

My intention in this analysis is not to position mental illness as a metaphor for fluid identity but to provide an intertext for Everett's character, who, at several points in *Erasure*, seems out of tune with himself and his alter ego.[68] During such moments, Everett amplifies the dissonance

between Monk and Stagg. Monk slips between the individual notes of the text's vertical orientation and thus finds himself "in the break," being neither himself nor one of the stereotypical roles he has created for himself.[69] For example, as the novel progresses, he begins to fear that his "charade might well turn out of hand and that [he] would slip into an actual condition of dual personalities" (238). Although this fear arrives perhaps too late, as he feels an increasingly dissociated sense of self, even representing his given name, nickname, and pseudonym as separate selves: "Thelonious and Monk and Stagg Leigh made the trip to New York together, on the same flight and, sadly, in the same seat" (237). He soon wonders, "had I by annihilating my own presence actually asserted the individuality of Stagg Leigh?" (248). Further, he asks, "what would happen if I tried holding my breath, if I had to come up for air? Would I have to kill Stagg to silence him? And what did it mean that I could put those questions to myself?" (248). As the multiple narratives that Monk writes for himself at the beginning of *Erasure* merge with those that he gives to Stagg near the novel's end—a dark-glasses-wearing parolee who "they say . . . killed a man with the leather awl of a Swiss army knife" (218)—the very concept of a *true or definitive self* becomes nonsensical.

Such a disharmonious harmony of narrative subjectivities comes to deconstruct the notion of identity in *Erasure*, as Everett makes evident in a series of passages in which Monk assesses his identity-making processes. Preparing to receive the National Book Award for *Fuck*, Monk, disguised as Stagg, begins to experience a dissociative break. While standing in front of his hotel bathroom mirror, he first remarks that he has two bodies, then likens compromising his writing to castrating himself (257–58). Monk's meditation on his multiple selves repeats during the award ceremony a few pages later: "Then there was a small boy, perhaps me as a boy, and he held up a mirror so that I could see my face and it was the face of Stagg Leigh" (264). Both mirrors give Monk the chance to enter into a daguerreologue, a literal and metaphoric reflection on his performance of another self—Stagg—but they also capture, reproduce, and ultimately extend Monk in a way that reveals both a conceptually visible manifestation of polyphonic identity and, more important, the gaps between each of the categorical bodies that Monk has crafted of and for himself.

As we see in the dissonance between Monk and his alter egos, which closely resembles Adorno's understanding of dissonance as the truth of

harmony, Everett's bebop effect insists that the irresolution of Monk's racial identity is the truth of categorical thought, that the apparent cultural harmony of imaginary Blackness is actually the imposition of delimiting boundaries that the individual always exceeds. For Everett, Blackness manifests itself in the restless and discordant irresolution of the racial body, but only as the very discontinuity that prompts his reader to question the legitimacy of any categorical identity type.

Monk's breakdown continues as he comes to believe that he has to silence Stagg—"I had to defeat myself to save my self, my own identity" (259), he tells himself—but he has trouble recognizing which distillation of his discordant polyphony constitutes his self and which part he seeks to destroy. A close reading of this line reveals a subtle separation of self as a concept: Monk feels he has to kill "myself" in order to save "my self," which his language figures as a possession or attribute separate from "myself," his sense of an innate and consistent personhood. Monk's self is thus an object he has already somehow lost. Such a critical formulation of identity indicates that Monk can—and perhaps must—do without "my self" or "my own identity," or perhaps that he has no self apart from the subjects he has constructed, a condition that helps to fortify his disharmonious harmonic identity as a sort of nonself, a category-escaping figuration akin to the fugitive attitude that Baraka associates with the bebop uniform and, further, the musical movement of 1940s jazz as a whole. This nonself also resonates with Everett's refusal to script race as anything other than illegibility personified.

Such questions regarding the starting and stopping of distinct identity performances are a product of Everett's bebop effect, in particular the pressure it puts on the limits that seem to demarcate distinct generic groupings. The strongest instance of generic mixing arrives just after the aforementioned mirror scene, at which point Everett collects his previously distinct characters in the same way that members of a jazz band regroup after a series of improvised solos in order to perform together: "Egads, I'm on television" (265), Monk's utterance at the close of *Erasure*, finds a sense of reconciliation with Tom Wahzetepe's televised, game-show success at the end of "*Àpropos de bottes*" (178) and Van Go Jenkins's final lines in *Fuck*, "look at me. I on TV" (131). Monk's harsh reintegration with the other character types in *Erasure* reasserts the novel's emphasis on disharmonious harmony while applying pressure to the margins that seem to mark the borders between each character. With the sudden increase of pressure, the

borders collapse, and the character types bleed into each other, signaling Monk's escape from categorical belonging.

Indeed, as soon as readers feel they can recognize Monk as any particular type, his enigmatic multiplicity manifests itself most strongly. This is how he undoes his own categorical belonging by exceeding the limits of categorical capture. Everett's bebop effect thus breaks the law of genre by disarticulating Monk's racial identity. If, as Derrida argues, "at the very moment that a genre or a literature is broached, at that very moment, degenerescence has begun, the end begins," then Everett's bebop effect prompts the reader to conceptually dismantle the generic categories with which the modern racial episteme orders and categorizes bodies like Monk's.[70]

Everett's bebop effect refuses to accommodate the reader who wants to force Monk into a generic racial category. Moreover, *Erasure* is the author's announcement that a cohesive, stable whole does not exist to be represented. In response to the popular notion that African American literature promises a paradigmatic representation of Black life, *Erasure* tells the story of Monk's disharmonious harmonic identity, an enigma of Everett's design whose activity is the unwriting or erasure of the possibility of its own representation. According to such a reading, Black subjectivity in the twenty-first century may be achieved not as W. E. B. Du Bois suggested in *The Souls of Black Folk* when he wrote that the free Black person "began to have a dim feeling that, to attain his place in the world, he must be himself, and not another."[71] Instead, Monk must be himself *and* another (and another, and another . . .), continuously resisting identification and representation; this leads, however, to madness. Because any attempt to fashion a stable and consistent Black identity results in a construction "as real as the unreal" (264), Everett argues, his reader may understand Blackness best as a shifting and multiplied (dis)harmonization of the self, always returning from being back to becoming, always finding its expression at the limits of the racial knowledge that Western epistemology has legitimated.

MISTERIOSO: THE NOVELTY OF THE NOVEL

Everett first published "F/V: A Novel Excerpt," the academic paper that Monk delivers to the *Nouveau Roman* Society toward the beginning of *Erasure*, as a slightly longer standalone article titled "F/V: Placing the Experimental Novel" in a 1999 issue of *Callaloo*. The version in *Erasure*

concludes with a deconstruction of the opening lines of Barthes's *S/Z*. In the *Callaloo* edition, Everett continues by providing advice for future novelists: "What the next generation of novelists ought to do is affirm the novel's existence as novel while taking on as *stuff* the critical theory which has pretended to uncover the novel's so-called tricks." This admonition, coupled with Everett's suggestion that "the *new* new novel will rely less on ego, less on an attempt to establish personal existence and mark, and more on the stuff of its own fictive reality," indicates that his larger concern is less about the posturing of individual authors than the capacity of literature's fictive reality and performative dimension to provoke a critical reaction in the minds of readers.[72]

For *Erasure*, such fictive reality takes shape in an ongoing refusal to accommodate the conventional devices on which a reader depends for meaning-making. Everett's focus on literary apparatuses like genre and canon formation highlights his assuredness that negotiations of power increasingly play out in cultural fields. The deconstructive sensibility of Everett's critical Blackness reflects this concern, questioning the categorical confines placed on *Erasure*, a work marketed as part of a tradition of African American literature despite its concern with its own classification as such. That is, Everett affirms the novel's existence as novel by destabilizing the law of genre and denying the expectations that categorical thought advances. The promotional praise on the back cover may place its author "alongside Wright and Ellison," inserting the book into the tradition it pushes against, but Everett's bebop effect shows how the novel's contents render illegible the racially marked features on which such groupings depend.[73]

If, as Monk remarks at several points in *Erasure*, meaning-making processes depend on accepting the rules and conventions governing a given critical situation, such defamiliarization as a performative gesture depends on strategic transgression of such governing rules. As he notes on separate occasions, this phenomenon is understandable through a simple linguistic analogy.

Anyone who speaks to members of his family knows that sharing a language does not mean you share the rules governing the use of the language. No matter what is said, something else is meant. . . . But since I didn't know the rules, which were forever changing, I could only know that she was trying to say something, not what that something was. (32)

I watched his lips and realized I understood nothing [my brother] was saying. His language was not mine. His language possessed an adverbial and interrogative geometry that I could not comprehend. I could see the shapes of his meaning, even hear that his words meant something, but I had no idea as to the substance of his meaning. (213)

The condition that Monk endures in these instances is one that the performative dimension of *Erasure* simulates for the reader. Precise meaning in Everett's novel may not always be clear, but this is in part because the author aims to confuse his readers' understanding of the tradition of Western epistemology rather than to accommodate rationality and the racist discourses it has produced, as *Fuck* (inadvertently) does for its fictional reader.

As a manifestation of fugitivity, Everett's bebop effect produces a communicative sensibility that verges on structural indecipherability at every opportunity. The jarring activity of critical Blackness created by Everett's bebop effect aims to prompt readers to filter and reassess their reliance on subconsciously accepted assumptions—especially those revolving around the relation between racialized individuals and the identity categories that the modern racial episteme assigns them—and to consider new, more critical approaches to understanding the construction and recognition of race in the political imaginary of the United States. As Monk explains while delivering "F/V: A Novel Excerpt" to the *Nouveau Roman* Society, "embedded here is already the conclusion that there is this universal story" (17). It is through the dissonance of Everett's bebop effect that *Erasure* practices critical Blackness and unwrites the conclusion that any universal Black story exists to be represented in literature.

BEYOND SATIRE

The Humor of Incongruity in Paul Beatty's *The Sellout*

I don't consider myself an activist by any stretch, I'm just a writer; I write about things that I think about, I write about things that I pretend to care about, or I try to figure out how much I care—and that's what the books are about. It's trying to weigh up what progress is, what being an activist is, what concern is—all those things.

—PAUL BEATTY

CONFRONTATIONS WITH ABSURDITY: THE GENERATIVE TRANSGRESSIONS OF BLACK HUMOR

The idea of racial equality obscures the fact of racial inequality. In a short essay for *Hokum*, an anthology of African American humor that he edited, the novelist Paul Beatty describes black humor as an expressive mode that unveils and critiques this absurd reality. For Beatty, the Blackness of Black humor is based not in race but in the nature of the encounter it permits by "confront[ing] life's black imponderables."[1] He explains that Black humor cultivates encounters with the unthinkable—the "public secrets" that our society is unwilling (or unable) to acknowledge because doing so threatens our unmaking[2]—and thus makes perceptible the social irrationalities that many people do not see or wish to avoid. Beatty emphasizes that "it's much easier to ignore absurdity than to deal with it" because "to acknowledge the absurdity of life implies responsibility." This description indicates that Black humor is transgressive and generative, uncomfortable even as it prompts self-reflection and critical inquiry, particularly when mapping the reach of the modern racial episteme and our complicity in its power. If, as Beatty puts it, "we don't stand for inequity and incongruence," if "all contradictions must be rectified," and if "all wrongs must be righted," then Black humor exposes one's role in inequity and incongruence, reveals that

contradictions are not being rectified, and shows how wrongs have not been righted—in a comic idiom.[3]

This sensibility of Black humor animates all of Beatty's novels, especially his fourth, *The Sellout*, which interrogates the conceptual legitimacy of social progress and equality.[4] Although the novel is set in Dickens, a fictional city on the outskirts of Los Angeles, it begins when the narrator, referred to only by his last name, "Me," and his girlfriend's affectionate nickname of "Bon Bon," is brought before the Supreme Court. The narrator is there to defend himself. He has enslaved one of his town's most famous residents—Hominy Jenkins, the last surviving Little Rascal—and reinstituted Jim Crow by resegregating a number of the municipality's public services, including the local transit system and the city's public school system (15). Both actions, readers learn, are attempts to put Dickens back on the map after it is silently unincorporated. Following the novel-spanning detour in which the narrator recounts the events that precede the court case, *The Sellout* ends by revisiting the courtroom in which it begins. Instead of reaching a verdict, as the reader might expect, the novel comes to an abrupt ending, during which the narrator mocks the idea of closure. He lets out a sigh of exhaustion and declares that he will never understand the cognitive dissonance between the United States' culture of white supremacy and discourse suggesting that the nation has "paid off its debts" (289).

The subject matter, thematic concerns, and aggressive comedic style of *The Sellout* prompted many to characterize it as a work of satire, although Beatty has disputed this categorization. His concerns about satire's conventions and aspirations, as well as his theorization of Black humor as a mode of critique, inspirit the questions of genre and unfamiliarity around which *The Racial Unfamiliar* revolves. Previous chapters have asked how established categories of cultural production map familiar but confining types of Blackness and how transgressive aesthetic strategies might challenge such processes and render race illegible in the process. Although I engaged with the problem of literary genre most directly in my discussion of *Erasure* and Percival Everett's bebop effect in chapter 3, the opacity of Roy DeCarava's out-of-focus photography discussed in chapter 1 and Kara Walker's sensory confusion explored in chapter 2 similarly defamiliarize the devices that make race seem intelligible. This chapter follows on these inquiries by asking how another kind of genre—satire—opens up possibilities for

further defamiliarizing Blackness and rendering race illegible, looking to *The Sellout* as a particularly illuminating example.

After a brief discussion about conventional satire's liberalist underpinnings and the thematic concerns of *The Sellout*, I turn to Glenda Carpio's theorization of African American humor as a rubric for reading Beatty's novel. Carpio is interested in the affective capacity of a distinctly Black humor, by which she means the rich tradition of humor through which Black artists have confronted the insidiousness of racism. Like Beatty, she argues that this mode of humor may generate laughter through the production of incongruities and that these incongruities magnify the irrationalities of racist thinking. The incongruities on which Carpio and Beatty focus indicate that humor is a significant strategy of racial illegibility, one that is in the service of the deconstructive impulses of critical Blackness. By facilitating transgressive encounters with ironic cultural discrepancies, writers like Beatty aim to prompt readers to develop new, self-reflective perspectives, especially in regard to the force of the modern racial episteme in reaffirming the racist ideas that we are told the United States has overcome. In that spirit, Carpio argues that Black humor marks "the multifaceted nature of [black and white] relations, both how much they have changed and how much they have stayed the same."[5] I argue that the conceptual incongruities that Beatty raises in *The Sellout* lay open the psychologies of Black and white characters to this effect, thus prompting inquiry into the myriad ways that racist ideologies have adapted and survived in the post–Civil Rights era.

Across my analyses, I am in dialogue with Ibram X. Kendi's *Stamped from the Beginning* and Richard Dyer's *White*. These studies help to delineate the representation of racial hierarchy that Beatty critiques in the resegregation and reintegration projects that occupy the central plot of *The Sellout*. In their analyses of racist ideas and whiteness, both Kendi and Dyer contend that a perception of racial hierarchy has been foundational to the formation of Western culture, so much so that many white people are not cognizant of how racial preconceptions continue to recreate the social conditions that civil rights legislation has sought to dismantle.[6] It is the imperceptibility of racial hierarchization that Beatty makes discernible in *The Sellout*, and it is the inequity and incongruence exposed in this endeavor that marks the transgressive quality of his critically Black humor.

A QUESTION OF RANGE: NORMATIVE SATIRE AND
THE PROJECT OF CIVILIZATION

Because of the aggressive comedic style of Beatty's writing, many review-
ers characterized *The Sellout* as a satire of the racial politics that followed
the Civil Rights movement in general and the nominally "postracial"
United States of the twenty-first century in particular. For example, in
two reviews published in the *New York Times*, the critic Alexandra Alter
and the poet Kevin Young each invoked a tradition of African American
satire when discussing Beatty's novel.[7] Reviews in *The Guardian* also
played on the idea that *The Sellout* is "a whirlwind of satire,"[8] as did arti-
cles published by PBS and NPR.[9] In the United Kingdom, the country
that awarded the novel the 2016 Man Booker Prize, Sameer Rahim of the
Daily Telegraph described Beatty's work as "an outrageous scattergun sat-
ire taking aim at racism and what racism has done to black Americans,"
before adding that "*The Sellout* aims to do for race relations what Joseph
Heller's *Catch-22* . . . did for the Second World War."[10] For many review-
ers, satire served as a touchstone that made the style and subject matter
of Beatty's novel accessible.

This critical reception was not new for Beatty, who had been labeled a
satirist before publishing *The Sellout*. For instance, Darryl Dickson-Carr
describes Beatty's first two novels, *The White Boy Shuffle* and *Tuff*, as exem-
plary models of the genre's future. He writes that Beatty's first novel in
particular "points in the direction African American satire is likely to fol-
low."[11] Several analyses included in *Post Soul-Satire*, a collection of essays
that editors Derek C. Maus and James J. Donahue frame as a follow-up to
Dickson-Carr's work, similarly pivot around Beatty's prominence as a sati-
rist. In this volume, Cameron Leader-Picone reads *The White Boy Shuffle*
as Beatty's satirization of the idea that the contemporary Black American
community is diminished by an absence of Black leadership. In the same
collection, Christian Schmidt interprets Beatty's third novel, *Slumberland*,
as a satire of clichéd tropes of Blackness.[12] Even more recently, in *Runaway
Genres*, Yogita Goyal reads *The Sellout* as a post-Black neo-slave satire that
falls "somewhere between critique and skepticism, euphoria and nihil-
ism."[13] Across these analyses, Beatty's acerbic humor is read as a sign of his
predisposition toward the satirical.

But Beatty has expressed uneasiness with this insistence on the satirical scope of his work. Speaking on *The Sellout* in particular, he indicated that his reception as a satirist might prevent people from discussing the more critical issues that his aggressive style raises. When discussing the novel with writer and journalist Amrita Tripathi, for example, Beatty emphasized that he is uncomfortable with the way the satirist label seems to limit the complexity of an idea to make it more digestible, the way that it can soften the discomforting feelings that his transgressive humor aims to provoke. He explained that satire is "an easy word to just hide behind and not have to really deal with or confront, whether, as a reader or a reviewer, one is implicated or not."[14] Beatty expressed a similar discomfort with satire in an interview with Chris Jackson of the *Paris Review*, during which he noted that *The Sellout* has comedic elements but that calling him a satirist hides his novels' more substantive attributes.[15]

To understand Beatty's uneasiness with being labeled a satirist, we need to examine the theoretical genealogy that informs popular assumptions and preconceptions about satire. Northrop Frye's seminal 1944 essay, "The Nature of Satire," is at the root of this genealogy. Frye describes satire's fundamental impulse as helping to determine the direction in which civilization unfolds by challenging undesirable social constructs and illicit political activities: "I should define satire, then, as poetry assuming a special function of analysis, that is, of breaking up the lumber of stereotypes, fossilized beliefs, superstitious terrors, crank theories, pedantic dogmatisms, oppressive fashions, and all other things that impede the free movement of society."[16] In Frye's formalist theory, satire's wit, mockery, and ridicule act as a social corrective that contributes to the ongoing development of civil society, which is to say that he characterizes satire as an instrument of modern liberal thought, an intellectual and moral tradition that aspires to individualist, egalitarian, universalist, and meliorative conceptions of equality, liberty, and justice.[17]

Frye's theory is significant because it remains a dominant paradigm for understanding the function of satirical critique in terms of the non-academic perspective about satire's purpose and aims. Although contemporary literary criticism has developed a more robust vocabulary for describing how African American satire deconstructs stereotypes and dogmatisms, general audiences of texts like *The Sellout* continue to assume that satire aims to expose and right social wrongs, despite the apparent limitations of such

a view.[18] The limitations of Frye's "normative" perspective are evident in the examples that he devises: "If a satirist presents a clergyman, for instance, as a fool or a hypocrite, he is primarily attacking neither the man nor his church. The former is too petty and the latter carries him outside the range of satire. He is attacking an evil man protected by the prestige of an institution. As such, he represents one of the stumbling-blocks in society which it is the satirist's business to clear out."[19] According to Frye, the object of a properly satirical attack is any deviation from a society's extant moral principles, the established and agreed-upon standards of behavior that inform the prevailing *forma mentis*. It follows that, for Frye, satire is a mode of critique that favors slow, incremental reform, not an expression of the kind of revolutionary consciousness associated with the deconstruction of institutional knowledge and systemic inequalities; those ideas are "outside the range of satire," in his view.

Like Frye, mainstream audiences assume that liberal institutions are the virtuous standard toward which satire seeks to reorient viewers. This reflexive faith in liberal ideals matters because, as Charles W. Mills has shown, a spirit of white supremacy tacitly (and explicitly) underwrites the long tradition of liberal thought. Mills posits that social and moral philosophers of the Enlightenment Age sought to regulate only relations between whites, giving rise to a "racial contract" that permits formal and informal oppression of nonwhites.[20] He notes that the liberal tradition preserves this racial contract, effectively denying Black people any agency to influence the social order. This is not just because the racial order of chattel slavery and the liberal tradition share a "twin birth," as Italian philosopher Domenico Losurdo puts it, but also because the historical development of liberalism unfolds as a dialectic of emancipation and disemancipation, a process in which the very idea that liberty has been expanded (for "all") clears the way for the dominant racial group to impose new restrictions on what freedom can mean for subordinate racial groups.[21] Put differently, the assumptive logic of liberal thought extols progress but retracts progressive concessions when it is politically advantageous to do so, in effect preserving and reproducing historically entrenched systems of domination and oppression.

The process by which an expansion of liberty begets new forms of racial subjugation is apparent in the historical transition from slavery to reconstruction, a transition during which the enslaved were formally emancipated, but which W. E. B. Du Bois and others associated with the rise of

sharecropping and debt servitude, chain gangs, the Ku Klux Klan, and Jim Crow.[22] And recent scholarship chronicles the many ways that similar systems of oppression developed as a response to the liberties secured by the Civil Rights movement. For instance, Michelle Alexander's *The New Jim Crow* shows how the criminal justice system mobilized the "war on drugs" as a tool for the mass incarceration of Black men beginning in the 1960s, and how a notion of colorblindness in the 1980s legitimized such discrimination by trivializing Black suffering.[23] Likewise, Richard Rothstein's *The Color of Law* examines discriminatory housing practices that emerged after the Fair Housing Act of 1968. He argues that local, state, and federal laws continue to reproduce the conditions of racial segregation in neighborhoods across the country.[24] Mehrsa Baradaran lays bare the policies that preserve the racial wealth gap in *The Color of Money*, and Carol Anderson explains how voting law continues to disenfranchise the Black electorate in *One Person, No Vote*.[25] Even more recently, Harriet Washington's *A Terrible Thing to Waste* shows how U.S. environmental policy leaves Black communities disproportionately vulnerable to atmospheric pollution, infectious disease, and industrial waste.[26]

Beatty's resistance to the label of satire may be rooted in liberalism's penchant for racial retrenchment. Popular opinion might accept that racial discrimination is on the decline, believing that "history . . . is like a book—that we can turn the page and move the fuck on" (115), as Beatty's narrator describes those who are oblivious to racial inequity in *The Sellout*. But oppression adapts to the exigencies of its moment, often in ways that counteract the apparent progress of incremental liberal reform. Indeed, the idea of fixing things and moving on, the narrator suggests, belies the white power and privilege that is part and parcel of the liberal *mentalité*. If *The Sellout* is invested in querying liberal progress—or in "weigh[ing] up what progress is," as Beatty describes his goal as an author—then it exceeds the range of Frye's satirist and the general public's preconceptions of satire's aims. It is more accurate to say that the humor of *The Sellout* aspires to ask what civilization means, or who progress serves, having realized that conventional satirical questions like "How might civil society be improved?" assume a hidden grammar that has already asked and answered a separate, more fundamental question: "What does it mean to be a part of civilization?"

The question of what it means to be a part of civilization is central to *The Sellout*, which draws attention to the absurd social arrangement

of racial hierarchization by deconstructing the notion of progress and social belonging. In a declaration that pokes fun at the idea of being a contributing member of civil society, for example, Beatty's narrator, in the middle of the Supreme Court trial during which the book opens, proudly asserts, "I was only too happy to serve my country" (5). Not to be taken literally, the familiar, patriotic maxim here exposes an absurd contradiction, as it follows the complaint that he has reintroduced slavery and segregation to Dickens. If we read the narrator's statement as an ironic announcement, we quickly see how his racist initiatives contradict the prejudice-free pretenses of the nation he purports to aid, meaning that he must actually be announcing his service to a separate, nonnormative civic body.

Alternatively, if we are to believe that systemic oppression of the racial other is in alignment with the social agenda of the United States, then the narrator's declaration produces a contradiction in which he can serve his country only via his own oppression, meaning that he cannot ever truly belong to the civic body of which he is claiming to be a part. The ambiguity of the narrator's declaration highlights his position outside the purview of civilization, the "civic estrangement" he endures despite possessing full legal citizenship.[27] As we might gather from the proverb that follows the narrator's assertion, "be it ancient Rome or modern-day America, you're either a citizen or slave" (6), a statement in which the narrator seems to imply that he is the latter, belongingness cannot be assumed in the civil society modeled in *The Sellout*.

The novel further allegorizes the perilousness of this social arrangement in the erasure of the city of Dickens. As the narrator explains, residents wake up one morning to discover that their street signs have been taken down and that their city has quietly vanished from the *Thomas Guide* atlas of Los Angeles. The cartographical erasure of Dickens is not unintentional. The narrator clarifies that it is the result of a reterritorialization and expansion of "white space" in an effort to diminish the disquiet caused by the presence of otherness.[28] As the narrator describes the novel's inciting incident, "the City of Dickens's disappearance was no accident. It was part of a blatant conspiracy by the surrounding, increasingly affluent, two-car-garage communities to keep their property values up and blood pressures down" (57). The process by which Dickens is unincorporated is analogous to the historical othering that Mills and Losurdo theorize, an indirect representation

through which *The Sellout* scrutinizes the liberal structures that legitimate discrimination in the name of progress.

By invoking the figure of the enslaved, and by suggesting that nonwhiteness is analogous to statelessness, these passages begin to deconstruct popular conceptions of civilization and belonging. Rather than target a specific act or policy that might be reformed to ameliorate the conditions that delimit Black life, the novel's humor highlights the racial contract that the long tradition of liberal thought preserves. The idea of liberal society may provoke notions of advancement in the popular imaginary, but the deconstructive humor of *The Sellout* suggests that its development does not result in the notion of equality touted by popular conceptions of social progress. Quite the opposite, in fact: the novel indicates that the telos of liberalism's civil society corresponds to the marginalization and, the narrator implies, elimination of nonwhite individuals and communities, whose inequality and suffering imperil the myth on which claims to progress are premised.[29]

Beatty's ontological disarticulation and generic deconstruction of Frye's theorization of satire is apparent in the novel's incommensurability with the assumptive logic of the discourse of civilization to which such literature is tied. Rather than contribute to civilization's movement, Beatty's ironic humor interrogates the narratives of equality and freedom on which the idea of racial progress has been constructed. This involves a mode of humor fundamentally different from the normative conception of satire.

CONCEPTUAL INCONGRUITY: EQUALITY AND HIERARCHY UNDER SOCIAL INVERSION

In *Laughing Fit to Kill*, Carpio reassesses the meanings of "black humor" and "dark satire" in an exploration of the strategies that Black comedians, writers, and artists have used to criticize the ideologies and practices that supported slavery and, as she explains, continue to uphold racist practices. Because her analyses seek to explain how humor can expose and dismantle racial ideologies, the rubric that she devises is appropriate for evaluating the transgressive spirit of Beatty's work. As Carpio notes, the sort of aggressive attacks for which writers like Beatty are known create generative chance encounters in which we might "confront the maddening illusions of race and the insidiousness of racism."[30] But as I explained in the previous section, the ways in which *The Sellout* produces these encounters needs

articulation beyond the liberal incrementalism that undergirds the normative view of satirical production.

Philosophers have developed various theories to explain laughter's causes and effects.[31] In her reevaluation of African American humor, Carpio turns to a philosophy of humor advanced by Arthur Schopenhauer, who based his understanding of laughter on the observations of Immanuel Kant. According to Schopenhauer, laughter is expressed when discrepancies between an abstract idea and the reality to which it corresponds are exposed.[32] Commonly referred to as the "incongruity theory of comedy," this idea postulates that humor arises in the process by which one becomes aware of inconsistencies between assumptions and experience. "Simply put," Carpio writes, "this theory suggests we laugh when our expectations are somehow disturbed."[33] The strategies through which a humorist might disturb an audience's expectations are numerous, but Carpio explains that each of the methods she examines in *Laughing Fit to Kill* can be recognized as a different manifestation of a singular mode of social and political critique that furnishes an encounter with the cultural ironies that many people prefer to avoid.

Where the humor of incongruity diverges from Frye's theorization of satire is in its relation to moral consensus and social normativity. Whereas Frye had described satire as a force that legitimizes certain patterns of behavior and thought as a means of entrenching a common ground on which incremental reform might be achieved, Carpio insists that the humor of incongruity is not productive of a social-moral corrective. Instead, the humorist of incongruity disturbs the expectation of unanimity by imagining amoral social inversions in which no sense of stable normativity adheres. Within these playful thought experiments, authors dramatize racist preconceptions in ways that unsettle expectations and assumptions and thus destabilize familiar racial knowledges. Such encounters do not fortify or preserve existing attitudes, because they do not require any degree of author-audience concurrence. In fact, the audience of such humor tends to end up disoriented rather than reassured, as humor of incongruity transgresses the comfort of conceptual familiarity to highlight unnoticed discrepancies between abstract, grandiose notions—like equality or progress—and the discordant social realities that their discursive deployment can hide. To challenge audiences to dispense with preconceptions about Black identity and experience, the humorist of incongruity conjures

racial grotesqueries as critical catalysts through which a text "momentarily reconfigures habits of mind and language," Carpio clarifies, the sign for which might be restrained, uneasy laughter.[34]

Carpio's incongruity model invokes the same language that Beatty uses when describing Black humor in *Hokum*, which implies that it may be not only an appropriate rubric for analyzing *The Sellout* but also a productive concept for thinking about racial illegibility more broadly. Beatty animates a spirit of incongruity by prompting his reader to confront the incommensurability between the suggestion that the problem of the color line has been solved and the reality that it has not. Over the course of the novel, he illustrates this incommensurability by staging scenarios that disturb familiar claims to racial equality, effectively facilitating encounters with the racial conflicts that rhetoric of racial progress obscures.

A powerful example is the narrator's reinstitution of segregationist practices throughout Dickens, including the city's public schools and the local bus line. The social inversions that Beatty devises in the narrator's endeavor to reinstitute the policies of Jim Crow help to expose the unstable relationship between the ideas that guided the Civil Rights movement and the discursive deployment of its images and messages in present-day discussions of racial progress. In this way, the resegregation plot amplifies incongruities between the idea of equality and how race continues to find expression in situations of social conflict, whether played out publicly or in private minds.

Importantly, the narrator's plan to resegregate his city rests on a peculiar detail. Dickens has already been erased from the map because of the threat that its all-nonwhite demographic poses to the property values of the nearby, more affluent, more white neighborhoods. In the narrator's words, Dickens is "post-white," a locality that stopped separating neighborhoods by race in the 1960s not because racism had disappeared but because no white people continued to live within its city limits (22). The narrator endeavors to resegregate a city that is populated entirely by the to-be segregated, meaning that his undertaking is actually the reconstruction of the specter of Jim Crow and not the separation of people by racial difference. As he comes to explain, it is not the enforcement of segregationist policies that begins to change Dickens but the way in which the idea of resegregation produces notions of racial difference and a perception of hierarchy in the minds of its residents. "It's the signs," one local tells the

narrator, clarifying that "people grouse at first, but the racism takes them back. Makes them humble. Makes them realize how far we've come and, more important, how far we have to go. On that bus, it's like the specter of segregation has brought Dickens together" (163). Because the city is uniformly nonwhite, all of the psychological effects that the narrator observes are internal to a sense of Blackness, one that *The Sellout* maps by enlivening cultural constructs of race and critiquing the effects that they instantiate.

When describing the resegregation of Dickens, the narrator signifies on racial reform efforts of the past. For instance, when resegregating the local school system, he alludes to the Civil Rights movement in general and the *Brown v. Board of Education* decision of 1954 in particular. At the request of assistant principal Charisma Molina, the narrator reintroduces segregation to Chaff Middle School by posting signs in the abandoned lot across the street, each of which announces the soon-to-begin construction of an all-white institution called The Wheaton Academy Charter Magnet School of the Arts, Science, Humanities, Business, Fashion, and Everything Else (192). Although the all-white school is never to be built, its façade simulates the reintroduction of the Jim Crow laws that once divided schools by race.

In a similar manner, the narrator invokes the Civil Rights movement and one of its most recognizable figures, Rosa Parks, when describing the re-segregation of Dickens's transit system.

That wintery day in the segregated state of Alabama, when Rosa Parks refused to give up her bus seat to a white man, she became known as a "Mother of the Modern-Day Civil Rights Movement." Decades later, on a seasonally indeterminate afternoon in a supposedly unsegregated section of Los Angeles, California, Hominy Jenkins couldn't wait to give up his seat to a white person. Grandfather of the post-racial civil rights movement known as "The Standstill," he sat in the front of the bus, on the edge of his aisle seat, giving each new rider the once-over. (127)

While the narrator's description calls forth the history of the Civil Rights movement by representing Hominy as an activist who is making a symbolic social stand, which makes the scenario legible within a longer history of racial activism, it references Parks in a way that creates a dual effect. On the one hand, caricaturing Hominy aside Parks illustrates the disparity between his character and her historical figuration. By nicknaming Hominy the "Grandfather of the post-racial civil rights movement" after

referring to Parks as the "Mother of the Modern-Day Civil Rights Move-ment," the narrator draws a comparative connection that serves to empha-size the extent of their difference. Humor arises in the disparity between Hominy and Parks, which amplifies the absurdity of the narrator's effort to resegregate Dickens.

At the same time, the passage's historical correlation treats Parks irrev-erently, which reveals how her image is deployed in discussions of racial progress. By violating Parks's sacrosanctity, Beatty calls into question how her figure has been memorialized in the popular imaginary as "the first lady of civil rights" and "the mother of the freedom movement."[35] Alluding to Parks in a scene that concerns an expansion of inequality trivializes her figuration as a harbinger of equality and thus puts pressure on discourse that mobilizes her image as evidence that racial discrimination has been meaningfully addressed. In accordance with Carpio's rubric, this passage's profane treatment of Parks conjures a grotesquery, which in turn raises questions about the habits of mind reinforced by discursive deployment of civil rights imagery and the popular narratives of equality to which they correspond. The novel raises similar incongruities when the narrator ques-tions the lasting effects of civil rights legislation, such as when he refers to Dickens as "supposedly unsegregated" while posting his sign on the bus and again when he emphasizes that "Chaff Middle School had already been segregated and re-segregated many times over" (167). Both remarks open the idea of equality and racial progress to inquiry and doubt by implying that a spirit of inequality may surmount the piecemeal legislation achieved during and after the Civil Rights era.

The Sellout pushes this incongruity further in its examination of the racial scheme activated by the narrator's signs. On the bus, his sign announces "priority seating for seniors, disabled, and whites" (128). Similarly, in a discussion regarding the admissions policy of the Wheaton Academy, Charisma invokes a notion of color difference. When asked if prospective students have to take a test to gain entrance, the vice principal explains that they must be white: "Your child can pass that test, they're in" (193). By privileging white-skinned individuals, these signs generate a sense of racial division that categorizes residents according to a Black-white binary. More-over, because this division offers privileges to one side of the racial divide, it also brings about a perception of racial hierarchy that is premised on an impression of whiteness's superiority.

This perception of racial division and hierarchy was familiar in the Jim Crow era, which *The Sellout* resurrects, but it has historical origins in the work of eighteenth-century human taxonomists, especially that of Johann Friedrich Blumenbach. As Nell Irvin Painter documents in *The History of White People*, Blumenbach's 1775 *On the Natural Variety of Mankind* gave rise to the category "Caucasian," a new grouping that reoriented the science of human taxonomy away from the geographical scheme that had previously made notions of difference legible according to regional background.[36] By associating a lighter complexion with beauty, Blumenbach devised a system of racialization that pointed to white skin as a sign of racial predominance.[37] Such an approach to the ordering of human bodies reinforced a sense of racial stratification that is repeated in the hierarchy that the narrator of *The Sellout* activates in Dickens, as both establish a binary means of classifying and ascribing value to human bodies.

Like the narrator, Blumenbach conceptualized racial difference according to a perception of epidermal variation alone. To this skin color taxonomy, however, his contemporary, Christoph Meiners, made a significant contribution. To justify Blumenbach's calculus of color, Meiners gave racial hierarchization a symbolic register. In his 1785 *Foundations of the History of Mankind*, Meiners characterized nonwhite people as "weak in body and spirit, bad, and lacking in virtue."[38] Whereas Blumenbach had ascribed value to epidermal fact, Meiners effectively constructed a symbolic whiteness. As Richard Dyer describes, the symbolic register of hierarchical thought survives into present-day conceptualizations of racial division and value, as the cultural construction of whiteness in the West continues to carry moral connotations with roots in ideas of "purity, spirituality, transcendence, cleanliness, virtue, simplicity, chastity."[39] Dyer's analyses reveal the staying power of Blumenbach's and Meiners's racial hierarchies; notions of color and their symbolic connotations endure as powerful ideologies through which perceptions of racial difference continue to be imagined and wielded politically.

Racial hierarchization has a noteworthy psychological effect on Dickens's residents, who similarly come to imagine a sense of symbolic whiteness and seem to ingest the idea that it is exceptional. Six weeks after erecting signs announcing the soon-to-come Wheaton Academy, Charisma sends word that "grades are up and behavioral problems are down" (208). The narrator also hears that resegregation has left bus passengers "treating

each other with respect," thus making the transit system "the safest place in the city" (163). In these comments, *The Sellout* uses coded language to invoke stereotypical constructions of race, those that Carpio might call racial grotesqueries. The characters' remarks about behavior, respect, and safety carry a subtext that plays on existing ideas about racial identity and difference. By indicating that behaviors are changing, that "there's no gang fighting" (163), these statements appeal to the familiar symbolic associations through which the modern racial episteme makes notions of Blackness legible and ideas about whiteness normative and, thus, imperceptible.[40] Significantly, these changes are represented as reactions to a perception of racial hierarchy, which indicates that residents of Dickens interpret the symbolic register of racial stratification as a chance to escape categorical capture.

By anatomizing this psychology of racial hierarchy, *The Sellout* shows how, as Dyer has argued, hierarchization can inspire an aspirational manner of thinking, how "the sense of a border that might be crossed and a hierarchy that might be climbed has produced a dynamic that has enthralled people who have had any chance of participating in it."[41] The narrator's observations indicate that the "domineering white presence" enlivened by resegregation has precisely this effect: "it brings out our need to impress, to behave, to tuck in our shirts, do our homework, show up on time, make our free throws, teach, and prove our self-worth in hopes that we won't be fired, arrested, or trucked away and shot" (208). Such aspirational thinking suggests that if an individual were able to replace purportedly Black cultural forms (represented as a kind of deficiency, lack, or absence) by performing some sense of white cultural forms (depicted as a normative sort of baseline civility), the subordination that accompanies the physical fraction of racial hierarchization, as well as the consequences threatened by such categorization, might somehow be escaped.

The Sellout does not stage these racial grotesqueries to suggest that Black people aspire to be or to act white or to reify cultural constructions of whiteness and Blackness. Instead, the novel exposes a significant irony: the aspirational manner of thinking engendered by a perception of hierarchy fortifies the notions of racial difference that it seeks to break down. Drawing on racial uplift ideology of the early twentieth century, Ibram X. Kendi refers to the assimilationist thinking exhibited in Dickens as "uplift suasion," a phrase he uses to describe the idea that "white people

could be persuaded away from their racist ideas if they saw Black people improving their behavior, uplifting themselves from their low station in American society."[42]

Ironically, however, uplift thinking reinforces the ideas that it seeks to escape. In their attempts to demonstrate their equality, as the narrator frames the changes he sees brought about by resegregation, residents of Dickens actually internalize and concede the inferiority of Blackness. By attempting to escape categorical capture, they indicate that "negative" Black behavior is responsible for racist ideas, which in turn implies that a sense of Blackness is in fact inferior. The narrator characterizes this process of internalization as the effect of an "on-call Caucasian panopticon," a description that highlights how notions of racial difference and a perception of hierarchy implant a sense of inferiority that incites the residents of Dickens to racialize and devalue themselves (209).

The narrator's reference to a panopticon invokes the theories of Michel Foucault and insinuates that this psychological overlay of racial inequality needs no outside enforcement and, accordingly, is unaffected by the Civil Rights–era victories that discourses of racial progress use to emphasize the conceptual legitimacy of equality. Observing how a notion of difference incites Dickens's residents to racialize themselves, the narrator concludes, "here in America, 'integration' can be a cover up" (167). In his reflection, he points to the way that impressions of racial difference alone have the power to reconstruct the cultural machinery of segregation.

During the narrator's grand jury indictment, a judge for the Central District of California comes to a similar conclusion, at which point he offers a concise summary of the deconstructionist sensibility produced by Beatty's humor of incongruity: "In attempting to restore his community through reintroducing precepts, namely segregation and slavery, that, given his cultural history, have come to define his community despite the supposed unconstitutionality and nonexistence of these concepts, [the narrator has] pointed out a fundamental flaw in how we as Americans claim we see equality" (266). As the judge explains, by reintroducing segregation and examining the psychological effects of the racial hierarchy that it activates, the narrator exposes how deep-seated the ideologies of the modern racial episteme truly are. By doing so, *The Sellout* seems to measure the degree to which society has advanced since the Civil Rights era but actually highlights how little it has changed. Instead of accepting the

incremental progress of racial reform or praising the victories of the Civil Rights movement, the novel contests the conceptual legitimacy of equality and asks readers to confront the many ways in which the present continues to recreate racist ideas that postracial discourse insists the United States has overcome.

RECONDITIONING RACIAL HIERARCHY: THE FALLACY OF WHITE VICTIMHOOD

Throughout *The Sellout*, making discernible the incongruities between postracial discourse and the realities of racial conflict takes center stage. In one example, the narrator listens while his girlfriend, Marpessa, analyzes a television advertisement for luxury automobiles. In her analysis, she first focuses on the commercial's surface-level representation of race and speculates about the advertiser's intended message:

The subtle message of the luxury car commercial is "We here at Mercedes-Benz, BMW, Lexus, Cadillac, or whatever the fuck, are an equal-opportunity opportunist. See this handsome African-American male model behind the wheel? We'd like you, o holy, highly sought after white male consumer between the ages of thirty and forty-five, sitting in your recliner, we'd like you to spend your money and join our happy, carefree, prejudice-free world. A world where black men drive sitting straight up in their seats and not sunk so low and to the side you can see only the tops of their gleaming ball-peen heads." (138)

As Marpessa notes, the luxury car commercial markets class in a way that intersects with perceptions of race and racial difference. The driver of the vehicle is Black, but Marpessa suggests that the advertiser communicates his wealth through the absence of signifiers of familiar cultural constructions of Blackness. By having him sit "not sunk so low to the side," she tells the narrator, the commercial presents a sort of non-Blackness as a sign of wealth. Marpessa's analysis underscores how notions of class are racialized, as well as the incongruity by which the outward appearance of a "prejudice-free world" can induce a blindness to the way that racialization and hierarchization are activated.

Looking further into the commercial's racial subtext, Marpessa then refines her interpretation. She claims that the advertiser activates this

perception of racial hierarchy to prompt its white viewers to buy the luxury vehicle and thereby reclaim the patrimony they may subconsciously believe to be promised by their whiteness. Marpessa explains, "but the subliminal message is 'Look, you lazy, fat, susceptible-to-marketing, poor excuse for a white man. You've indulged this thirty-second fantasy of a nigger dandy commuting from his Tudor castle in an aerodynamically designed piece of precision German engineering, so you'd better get your act together, bro, and stop letting these rack-and-pinion-steering, moon-roof, manu-facturer's-suggested-retail-price-paying monkeys show you up and steal your piece of the American dream' " (138). Focusing on the advertisement's subtext, Marpessa argues that a sense of racial superiority is implanted by the luxury car commercial. She suggests that the possibility of the non-white person's success is presented in such a way as to engender a crisis for the white viewer, who she insinuates is cultured to interpret the triumphs of a hierarchically lower community as threats to the racial order legitimated by the ideologies of the modern racial episteme.

As a thematic concern, the fragility of whiteness resounds throughout *The Sellout*. By ridiculing claims to white victimhood, for instance, the novel queries rhetorical constructions like "reverse racism" and dramatizes their absurdity. The incongruities that the novel uncovers highlight how, as Dyer has argued, whiteness is often "felt to be the human condition," mean-ing "it alone both defines normality and fully inhabits it."[43] Acknowledg-ing whiteness's cultural normativity and imperceptibility, Beatty makes it and its role in the perpetuation of hierarchization grotesquely discernible, as Marpessa does when she calls out the luxury car commercial's target audience. In her identification of the "lazy, fat, susceptible-to-marketing, poor excuse for a white man," Marpessa illustrates how, as Dyer argues, racial-hierarchical slippage is interpreted in societies like the United States: "a white person who is bad is failing to be 'white,' whereas a black person who is good is a surprise, and one who is bad merely fulfils expectations."[44] In identifying and portraying whiteness as a peculiar "victim," *The Sellout* facilitates an encounter with the illogic through which racist ideas recondi-tion the inequities that liberal thought insists have been mitigated by civil rights legislation.

The fallacy of white victimhood is clearest in the novel's presentation of school segregation and integration. The specter of the Wheaton Acad-emy activates a perception of racial hierarchy in the minds of Chaff Middle

School students, who respond to resegregation by engaging in a type of uplift suasion, which in turn causes scores on state proficiency exams to rise. The narrator explains that this adds up to a dramatic effect for the school, which is soon on track to become one of the highest ranked in the nation.[45] However, not everyone is happy about the school's new ranking. Parents of white schoolchildren in neighboring communities begin to ask what will become of their kids as the "chaff" rises to the top of a perceived racial hierarchy. Through this reaction, *The Sellout* begins to enliven a significant incongruity: in their efforts to outrun racism, not only have the nonwhite students internalized and conceded the inferiority of a sense of Blackness; additionally, uplift suasion prompts white onlookers to reaffirm the perception of racial hierarchy that the students of Chaff Middle School are attempting to escape.

According to Kendi, uplift suasion inevitably affirms the racist ideas it seeks to dismantle. For instance, he emphasizes that one recurring response to uplift suasion is to label those who seem to escape categorical capture "extraordinary Negroes," who are "not ordinarily inferior like the 'majority'" of their race but, instead, examples of Black people who have "supposedly defied the laws of nature or nurture that standardized Black decadence."[46] Kendi explains that these individuals are considered extraordinary only because they are measured against the stereotypical cultural constructions that their uplift suasion seeks to challenge, those that associate Blackness with innate inferiority.[47] For this reason, the acknowledgment that a small group of capable individuals might be exceptional is also a veiled assertion that the rest of the racial community remains hierarchically inferior. In other words, although this pattern of thinking acknowledges the possibility of the nonstereotypical individual, it does so in such a way as to reinforce the stereotypes that uphold a perception of racial hierarchy.

Parents of *The Sellout*'s white schoolchildren quickly recognize that the students of Chaff Middle School challenge a perception of racial hierarchy, but they do not come to think of these nonwhite students as extraordinary. Instead, they revive stereotypes that link whiteness to prosperity in a contorted conceptualization of the Civil Rights movement, effectively stating that race no longer has any bearing on opportunity while simultaneously insisting that equal circumstances should generate a disproportionate amount of white success. In his discussions of the relation of fear to the power of plutocracy and xenophobia, Cornel West proposed that this kind

of racial entrenchment is a by-product of a phenomenon he calls "nigger-ization."[48] According to West, the feelings of racial superiority implanted by a perception of racial hierarchy are far less stable than they may appear. He explains that white Americans who experience economic inadequacy or who feel frustrated about the stagnancy of their prosperity and fearful about the possibility of their impotency often turn to race-based explana-tions for their problems. In other words, the fear of inadequacy coupled with preexisting prejudice seeks a scapegoat, one easily found in the pro-duction of a hierarchically lower group against which whiteness might measure itself and reassert its value.

In *The Sellout*, this defense mechanism response is ignited by the *New-ish Republic* magazine, which publishes an article captioned "The New Jim Crow: Has Public Education Clipped the Wings of the White Child?" (251). In his interpretation of the article's caption, the narrator emphasizes that this question is actually a suggestion that reconditions a perception of hier-archy. The question implants the idea that the academic accomplishments of Chaff Middle School can be explained only by some notion of racial discrimination against white people, a suggestion that is intensified by the article's title. The phrase "The New Jim Crow" draws a historical parallel to the segregationist policies that the Civil Rights movement worked to repeal, effectively generating a false equivalency implying that white stu-dents may have a legitimate claim to discrimination. The narrator responds to the article's question with an emphatic "no," but it reaffirms the idea that equal opportunity should first and foremost generate white success and thus engenders a sense of racial superiority in the minds of white school-children's parents.

Driven by the sensationalism of the article and the impression of racial superiority that it activates, these parents begin pulling their children from their schools to enroll them in the steadily improving Chaff Middle School, all while claiming that their kids' academic shortcomings are a product of "reverse racism" (251).[49] *The Sellout* presents this claim in such a way as to facilitate an encounter with its built-in irony: the assertion of reverse racism mobilizes a sense of failure as evidence of an innate superiority. This essential contradiction amplifies the novel's spirit of incongruity, enabling the narrator to show how the notion of white victimhood fortifies a perception of racial hierarchy. In the parents' claim, which suggests that the white schoolchildren would have been outperforming the students of

Chaff Middle School had they been provided the same opportunities for success, is an implicit assertion that whiteness has a natural superiority over nonwhiteness. This notion of reverse racism does not seek to resolve racial conflict or dismantle devices of discrimination; ironically, it aspires to reaffirm the racist idea of Black inferiority to restore the perception of racial hierarchy troubled by nonwhite prosperity.

The narrator extends this incongruity by describing the attempted reintegration of Chaff Middle School as an inverted dramatization of the 1957 integration of Little Rock Central High School, again signifying on the Civil Rights movement in order to illustrate the dissimilarity between the protests of the past and the complaints of the narrative present. In his account of the event, the narrator emphasizes that the white students exit a school bus under the attention of reporters and television cameras: "Shoulders hunched and arms held up protectively in front of their faces, the Dickens Five, as the quintet would later come to be known, braced themselves for the pillory of rocks and bottles as they ran the gauntlet and into history" (252). However, the narrator explains, no violence erupts; instead, the nonwhite children are welcomed by the students of Chaff Middle School. "The city of Dickens didn't spit in their faces and hurl racial epithets; rather, it begged them for autographs, asked if they already had dates for junior prom" (253).

After Charisma reenacts Governor Orval Faubus's refusal of entry to the would-be students, and after it is suggested that they enroll in the soon-to-be-built Wheaton Academy if they are so eager to attend school in Dickens, the white students settle around the flagpole and begin a boisterous rendition of "We Shall Overcome." To heighten the effect of the disparity staged in the reintegration episode, the narrator ends the scene by recounting his father's history lesson about Little Rock High School. Describing what became known as the "Lost Year," the narrator's father had told his son, "if niggers wanted to learn, then no one was going to learn" (257). This remark draws attention to the extent of the discrimination faced during the Civil Rights movement, which saw white parents willing to sacrifice their children's education to keep nonwhite students from enrolling in the same school. Similar to when the narrator described Hominy alongside Rosa Parks, a feeling of incongruity arises in the disparity between the childlike image of the Dickens Five, who encounter mild resistance but are generally welcomed, and the severe racism faced by the Little Rock Nine.

These feelings of incongruity may feel vaguely satirical to mainstream audiences who are versed in a "normative" view of satire, but they do not provide an unambiguous social-moral corrective. Instead, the ironies of the scene disarticulate the conceptual legitimacy of white victimhood by exposing the triviality of white suffering and thus facilitate an encounter with absurdity—out of which the reader might develop a more critical understanding of how racist ideas persist in the nominally postracial era— without advising or prescribing any particular solution.

Significantly, the specter of the Wheaton Academy sits in the backdrop of this scene, which tempers interpretations that might focus on how the white students are blocked from entering Chaff Middle School. The narrator explains that the school represents the privileges that its all-white students are still able to enjoy, making it an apt metaphor for the advantages that racial hierarchization secures for whiteness. "With its pristine facilities, effective teachers, sprawling green campus, there was something undeniably attractive about Wheaton," the narrator emphasizes, cataloging the assets that remain unavailable to the nonwhite students of Chaff Middle School. Although the white students claim that the "no Anglos allowed" policy unfairly discriminates against their racial preponderance, the pre-eminence of the Wheaton Academy draws attention to the always already existing benefits available only to these white students. In the shadow of the Wheaton Academy, it becomes clear that the white students are protesting not because Chaff Middle School is superior but because its unavailability troubles the unconscious sense of racial belonging that whiteness enjoys in the United States. Such a disruption makes Chaff Middle School's unavailability feel like an instance of racial discrimination to *The Sellout*'s white characters even though it is not.

The way in which *The Sellout* dramatizes white victimhood gives rise to a representation of whiteness as fragile and inadequate, fearful of the possibility of its impotence. Through these attributes, the novel disrupts the cultural imperceptibility that characterizes a sense of whiteness as the norm against which other racial communities are identified and defined. As Dyer notes, whiteness is often unable to see its own particularity or to recognize the power that it has to construct and legitimate devices of racial-ization. By defamiliarizing the sense of normativity that makes it cultur-ally imperceptible, *The Sellout* vivifies whiteness and its racializing power for critique. That is, the representation of whiteness as ineffectual creates

the literary conditions that prompt readers "to question the habits of mind that we may fall into as we critique race," as Carpio describes the humor of incongruity.[50] In this case, specifically, the novel's spirit of incongruity conditions an encounter that exposes how whiteness itself is racialized, one that helps to destabilize the power of its universality.

UNMITIGATED BLACKNESS: FREEDOM IN FUGITIVITY

Beatty activates the spirit of incongruity that animates *The Sellout* most vividly in the plot of Hominy Jenkins's enslavement, which weaves through the resegregation and reintegration sections of the novel. Hominy's enslavement, and the sense of self-sovereignty he attains as the narrator's slave, deconstructs the conceptual legitimacy of freedom by disarticulating the dialectical relationship of the oppressor and the oppressed, enslaver and enslaved. By misrepresenting Black life to the point that representation itself comes to feel absurd, Hominy's performance of revolt ruptures the semiotic structure through which the modern racial episteme renders Blackness legible only through narrow, one-dimensional identity types.

Hominy first approaches the narrator to discuss the possibility of enslavement after a failed suicide attempt. To thank the narrator for saving his life, Hominy offers his forced servitude, explaining that such an arrangement appeals to him because he "want[s] to feel relevant," further emphasizing that slavery is in his nature: "I'm a slave, that's who I am. It's the role I was born to play" (77). In this request, Hominy represents the enslaved as a category to which he belongs seemingly by virtue of the color of his skin and characterizes enslavement as a kind of acting gig through which he hopes to regain the sense of purpose he had as one of the stars of *The Little Rascals*. The appeal seems straightforward, but Hominy has an irrational perception of what it means to be enslaved. For example, he complicates the master-slave dialectic by choosing enslavement even though choice cannot ever be made available to the enslaved. Furthermore, he disturbs the meaning of enslavement by wielding power over his enslaver. He demands to be whipped and crawls into his beating, despite the narrator's discomfort with their peculiar arrangement (79, 84). Beginning with these requests and demands, *The Sellout* stages an inversion of subjugation in which the enslaved holds a sort of authority over the enslaver.

Although the power reversal in Hominy's incongruous enslavement seems to come from these requests and demands—and, certainly, there is significant irony in his offer of forced servitude and desire for torture—the more significant inversion involves a politics of refusal. Practicing a non-compliance that resonates with Herman Melville's scrivener, Bartleby, and his repeated idiom, "I would prefer not to," Hominy challenges popular conceptualizations of freedom by mocking the notion of his powerlessness.[51] The first instance of such a refusal arises when the narrator attempts to free his unsought slave by drafting manumission papers. "To Whom It May Concern," the contract states, "with this deed I hereby emancipate, manumit, set free, permanently discharge, and dismiss my slave Hominy Jenkins, who's been in my service for the past three weeks. Said Hominy is of medium build, complexion, and intelligence. To all who read this, Hominy Jenkins is now a free man of color. Witness my hand on this day, October 17th, the year of 1838" (82). Written in the familiar language of emancipation documents, this certificate serves to announce Hominy's freedom from the burdens of enslavement.

As the narrator discovers, however, Hominy has a very different idea of what freedom might mean. "The ruse didn't work. Hominy simply pulled down his pants, shit on my geraniums, and wiped his ass with his freedom, then handed it back to me" (82). Following this humorous but perplexing response, in which he defecates and uses the document as toilet paper, Hominy turns to the narrator and declares, "true freedom is having the right to be a slave. . . . I know taint nobody forcin' me, but dis here one slave you ain't never gwine be rid of. Freedom can kiss my postbellum black ass" (82–83). By staging a scenario familiar to narratives of slavery and emancipation, *The Sellout* sets up a historical repetition with a predictable outcome. However, Hominy's response raises a new perspective regarding the desirability and conceptual validity of freedom itself by upsetting the scene's anticipated resolution and generating a sensibility of incongruity.

In these requests and refusals, *The Sellout* deconstructs the master-slave dialect with which we are familiar, at times inverting the directional relationship of power in such a way as to suggest that it is not Hominy's freedom that is in question or compromised but the narrator's. Although one reading of this power inversion suggests that Hominy has found freedom in enslavement, it seems more accurate to suggest that his self-sovereignty emanates from the performance of revolt that he enacts. Hominy's freedom

comes not from his ability to exercise a sense of choice, as freedom might be conceived in the popular imagination, but in the particular choices that he makes, which upset the normative social order. That is, Hominy's agency to determine his fate is largely insignificant; his decision to deliberately unsettle the narrator's complacency with the very concept of freedom, however, is nothing short of an insurrection against the ideas and codes through which power and subjugation are made intelligible. It is in such insurrections—the performance of revolt—that Hominy discovers a mode of freedom in excess of that which is inherent to the epistemic binary of freedom and enslavement.

Through Hominy's performance of revolt, Beatty abstracts Blackness and moves us into the territory of the nonrepresentational, a literary world in which Blackness's illegibility disputes and dismisses the ideas that the modern racial episteme ascribes to it while simultaneously resisting redefinition, thus escaping categorical capture. Importantly, Beatty is not prescribing a new paradigm by which Blackness might be known—instead, we find that the semiotic structures that make racial identification and recognition seem sensible come to break down under the weight of *The Sellout*'s conceptual inversions. In place of realism's straightforward sign structures, Beatty's humor of incongruity offers us the excessive, the gratuitous, and the irrational, none of which resolves into the kinds of meaning that the dominant culture considers to be intelligible or legitimate.

Beatty's meditation on Blackness and its relation to freedom does not end with Hominy's decision to quit slavery; at that point he tells the narrator, "we'll talk reparations in the morning" (283). On several other occasions, *The Sellout* juxtaposes these terms, such as when the narrator suggests that "being 'black' is the closest a person can get to true freedom" (241). The relation of these ideas is apparent in the Supreme Court hearing with which the novel concludes. Justice Elena Kagan begins the hearing with a question: "*Me v. the United States of America* demands a more fundamental examination of what we mean by 'separate,' by 'equal,' by 'black.' So let's get down to the nitty-gritty—what do we mean by 'black'?" (274). With Hominy's performance of revolt in mind, Justice Kagan's question appears as an opportunity to gain a more sophisticated understanding of Hominy's fugitivity.

The Sellout parodies the possibility of answering the justice's question by ridiculing paradigms for Black identity, focusing on the five-stage theory of

Black consciousness that William E. Cross, Jr., put forward in "The Negro-to-Black Conversion Experience."[52] Then a graduate student in psychology at Princeton University, Cross published this article in the July 1971 issue of *Black World* magazine.[53] His theory traces the process by which he believed a Black American might have embraced different actualizations of Blackness in the years immediately following the Civil Rights movement. He wrote it in response to the psychologist Joseph White's call for research and development of a "Black psychology."[54] Cross describes the actualization of Black consciousness as "psychological liberation under the conditions of oppression," an understanding of which he thought would help to ready other Black Americans for revolutionary thoughts and activities.[55] Beatty's references to "The Negro-to-Black Conversion Experience" seem to affirm his interest in Cross's assertion that "Blackness is a state of mind and, as such, is explained by dynamic rather than static paradigms."[56] However, *The Sellout* does not endorse Cross's classification system. Instead, it signifies on pop psychology profiles to call forth the idea of paradigmatic identity—the possibility that Blackness could be known—so it can then refute the authority that Western epistemology claims through its grammar of naming and categorization.

The Sellout ironically draws on Cross's theory by introducing the "theory of Quintessential Blackness," which the narrator attributes to his father, the social scientist and psychologist F. K. Me. Whereas Cross's rubric has five phases of Blackness's development, F. K. Me's has three, to which the narrator later adds a fourth stage. The narrator's attorney, Hampton Fiske, delivers the Supreme Court monologue that describes the essential attributes of the theory's first three developmental phases. Entering each paradigm of Blackness as empirical evidence during the trial, he begins by naming the stage, then describes its primary characteristics and concerns, each of which corresponds to Cross's theorization to varying degrees. To conclude his description of each stage, Fiske lists celebrities, political figures, and historical persons with whom we might associate such behaviors and attitudes. After Fiske details F. K. Me's three-part theory of Quintessential Blackness, the narrator exits the courtroom and hypothesizes the fourth phase himself. Termed "Unmitigated Blackness," this extra phase is a mode of conscious antagonism that resonates with Hominy's performance of revolt. It values process over fixity, illegibility over identification, and ambiguity over definition, effectively disarticulating the entire paradigm of Quintessential

Blackness and, by association, the developmental telos of pop psychology. The deconstructive ethos of this inversion suggests that Blackness can be known only by its unknowability, a nonrepresentation that mocks Justice Kagan's question.

Cross begins his five-stage theorization of Black development with a phase he called "Pre-encounter," a period during which a Black individual's worldview is dominated by Western determinants, and, accordingly, much of the world seems either non-Black or anti-Black. As he explains, members of this stage tend to ascribe to a value system that privileges a sense of whiteness: "Under the dictates of the assimilation-integration paradigm the development of an 'American' identity involves affirmation of 'White-Anglo-Saxon-Protestant' characteristics, and the negation, dilution, or even denial of non-WASP behavior."[57] Poking fun at Cross's theorization, *The Sellout* introduces a similar psychological profile, "The Neophyte Negro," which F. K. Me had used to describe an anterior stage of racial consciousness. The novel mocks Cross's suggestion that this stage engenders behavior that "*degrades* Blackness," for example, by explaining that "the Neophyte Negro is afraid of his own blackness . . . [which] feels inescapable, infinite, and less than" (275). Fiske explains that this category is to be taken as a legitimate identity paradigm, that it is occupied by Black people who "value mainstream acceptance over self-respect and morality," including Michael Jordan, Colin Powell, Condoleezza Rice, Morgan Freeman, Justice Clarence Thomas, and Cuba Gooding, Jr. (275).

The next stage of F. K. Me's theorization of Black development critiques the second and third categories of Cross's rubric. Cross termed these stages "Encounter" and "Immersion-Emersion." In the encounter stage, according to this hypothesis, one has an experience that inspires "a different interpretation of the Black condition."[58] Having had their perceptions of Black inferiority violently disrupted, he explains, individuals in this category feel guilt for having degraded their Blackness and angry for having been programmed to do so by the white world. The following stage, immersion-emersion, is a reaction to these feelings of guilt and rage. As the title implies, Cross characterized this phase as an absorption in new qualitative experiences, which help to further disrupt previously held orientations: "The experience is an immersion into Blackness and a liberation from whiteness."[59] At this juncture, Cross argues, a sense of Black pride emerges, which brings with it desires to dramatize,

concretize, and prove one's Blackness by engaging in activities of resistance and revolution.

The Sellout introduces F. K. Me's Stage II Blackness, called "Capital *B* Black," to mock the sense of Black liberation that Cross associates with the encounter and immersion-emersion phrases. Some of F. K. Me's theorization seems to share a one-to-one association with Cross's theory, such as his assertion that in this stage, "Blackness becomes an essential component in one's experiential and conceptual framework" (276). However, this ingenuous treatment of Cross's conversion paradigm is undercut by F. K. Me's insistence that individuals in this phase experience "waves of pro-Black euphoria and ideas of Black supremacy" (276). With these changes, F. K. Me puts pressure on the defining feature of Cross's "Immersion-Encounter." As he had done in the previous stage, Fisk again provides a list of associable figures, the incongruous diversity of which further disrupts the coherency of "quintessential" Blackness: Jesse Jackson, Sojourner Truth, Moms Mabley, and Kim Kardashian.

The Sellout does not provide much information regarding the third component of F. K. Me's theory, because the narrator exits the courtroom as Fiske begins to discuss it. Called "Race Transcendentalism," the reader learns only that F. K. Me characterized Black actualization as "a collective consciousness that fights oppression and seeks serenity" and that he associated the final phase of his three-stage arc with Rosa Parks, Harriet Tubman, Sitting Bull, César Chávez, and professional baseball outfielder Ichiro Suzuki (276–77).[60] The narrator's reaction to Stage III Blackness— "Fuck it, I'm out. I'm ghost," he says (276)—puts into words the dismissive tone through which *The Sellout* represents "Race Transcendentalism." F. K. Me's identity paradigm is romantic and idealized to the point that it is meaningless, a point the novel drives home with the final phrase of Fiske's Supreme Court monologue: "Stage III black folks are the woman on your left, the man on your right. They are people who believe in beauty for beauty's sake" (277). On hearing this poetic but empty description, the narrator makes his exit.

Feeling as though his father's three-stage theory were insufficient for answering Justice Kagan's inciting question—"what do we mean by 'black'?"—the narrator then proposes a fourth conceptualization of Blackness, one that mocks the identity paradigms offered by Cross and F. K. Me. The narrator calls this stage "Unmitigated Blackness." The parodic list

of figures associated with this psychological profile is long, and the narrator's description of its primary attributes is nebulous.[61] After musing that he is not precisely sure what unmitigated Blackness is, the narrator provides an inventory of the facets by which it might be perceived even as its illegibility continues to thwart attempts at defining it:

> On the surface, Unmitigated Blackness is a seeming unwillingness to succeed. . . . It's our beautiful hands and our fucked-up feet. Unmitigated Blackness is simply not giving a fuck. . . . Unmitigated Blackness is essays passing for fiction. It's the realization that there are no absolutes, except when there are. It's the acceptance of contradiction not being a sin and a crime but a human frailty like split ends and libertarianism. Unmitigated Blackness is coming to the realization that as fucked up and meaningless as it all is, sometimes it's the nihilism that makes life worth living. (277)

The attitudes and cases by which this passage suggests we might encounter unmitigated Blackness are elusive and unstable, but they bring to mind Hominy's requests for enslavement and his rejection of the narrator's idea of freedom. Hominy's offer of forced servitude and refusal of manumission certainly seem to correspond to an unwillingness to succeed—or a faith in an unconventional rubric of success, one compatible with a general demeanor of "not giving a fuck." More significantly, however, Hominy's unpredictable and confounding orientation toward the very notions of freedom and enslavement amounts to an insurrection against the comfort of conceptual familiarity, one that delights in appearances that are not reality, the cloaking and trickery of disguise and deception, and the nuanced perspectives that accept the necessity of inconsistency, ambiguity, and paradox. Taking shape as the apotheosis of antagonism, Hominy's unmitigated Blackness exceeds the paradigms of development hypothesized in F. K. Me's theory of Quintessential Blackness and Cross's Nigrescence, and, by extension, any positivist or psychologized definition of Blackness.

In his recalibration of Blackness, Fred Moten has described this sense of fugitivity as a disposition that refuses to acknowledge tenets of power and that, further, is predisposed to antagonize such structures to upset their part in the preservation of social order. Specifically, Moten writes that this sense of Blackness, "that desire to be free, manifest as flight, as escape, as a fugitivity that may well prove to veer away even from freedom as its telos, is indexed to anoriginal [sic] lawlessness."[62] If Hominy's performance

of revolt is an insurrection against the racial knowledge through which power, privilege, and independence are made intelligible, then his unmitigated Blackness is also an enactment of anoriginal lawlessness. Indeed, he first abnegates his freedom and then reclaims it in such a way as to deconstruct its conceptual legitimacy, affecting a paradox in which he achieves a sense of self-sovereignty by veering away from it. Moten represents this sensibility of fugitivity as an attitude that is critical of power itself, one that aspires to escape power by disarticulating it. He writes, "the predisposition to break the law is immediately disrupted by an incapacity for law, an inability both to intend the law and intend its transgression and the one who is defined by this double inability is, in a double sense, an outlaw."[63] As a figuration of outlaw, Hominy razes the idea of freedom and exposes the limitations inherent to the idea of being free, and thus he produces a disorienting sensibility in which freedom feels inhibiting. In this way, his fugitivity (a sign of critical Blackness) aims to challenge readers' complicity with tenets of power and thus to prompt a deconstructive encounter with the impossibility of racial knowledge's production.

DECONSTRUCTIVE ANTIPHRASIS:
THE BLACKNESS OF BEATTY'S HUMOR

Hominy's unmitigated Blackness captures the spirit of Black humor that Beatty describes in *Hokum*. There is noteworthy tension between the meliorative ambitions of satirical literature, as imagined by mainstream audiences, and the transgressive humor of *The Sellout*. Neither a call for moral recalibration nor a request for any particular political change, Beatty's humor has a deconstructive sensibility that acerbically disrupts the social complacency that might cause some to overlook the incongruities of liberalism's rhetoric of racial progress. If, as Beatty indicated in *Hokum*, Black humor facilitates confrontations with life's absurdities and in this way aspires to prompt critical inquiry by exposing the incongruities that its audience may wish to ignore, then we might associate the performative dimension of *The Sellout* with the sense of fugitivity that Hominy embodies, meaning a predisposition toward anoriginal lawlessness and unmitigated Blackness.

This sensibility is evident in the narrator's abstruse description of unmitigated Blackness, which pretends to offer a paradigm in which Blackness can be known but which instead performs the antagonism that the narrator

is attempting to pinpoint and delineate. Where readers expect a catalog of attitudes and behaviors, the narrator lists a series of abstract metaphors and in this way creates a depiction that is as ambiguous and illegible as its subject. The passage does not describe unmitigated Blackness; rather, at the level of the sentence and in the work of the word, it enacts it by troubling the reader's attempts at meaning-making. Such a predisposition toward conceptual fragmentation is not limited to this passage but permeates Beatty's novel. Like unmitigated Blackness, *The Sellout* opens concepts to critical scrutiny and reevaluation, but it offers no resolution to the contradictions and incongruity that it uncovers. It animates grotesqueries, makes paradoxes palpable, and creates (mis)perceptions that trouble the legibility of racial knowledges, which is to say that it disturbs expectations in order to disrupt the familiarity of its subject matter, or that it activates critical Blackness and performs its revolt.

Although *The Sellout* may feel conventionally satirical, this spirit of disruption comes to rupture the conventions that nonacademic readers tend to associate with satire. Instead of paving the way for incremental reform, the ironies of *The Sellout* deconstruct the conceptual legitimacy of the ideas that they target. To say that the novel is not conventionally satirical is not to say that its humor is not generative—to return to Beatty's description of Black humor, *The Sellout* exposes inequity and incongruence, reveals that contradictions are not being rectified, and shows how wrongs have not been righted. However, instead of prescribing a social-moral corrective, either implicitly or explicitly, the novel's humor engages in a deconstructive antiphrasis, a strategy in which irony facilitates confrontations with the simultaneous necessity and impossibility of discussing the status of race in a straightforward and meaningful manner. In phenomenological terms, this technique produces a troubling affect that furnishes generative chance encounters with the disorienting illogic of racial discourse. The critical intervention of the novel is to expose the racist foundations that underlie the rhetoric of racial progress, even as the conventionally humorous phrases and references included in the work make such an intervention feel palatable. For these reasons, *The Sellout* is a narrative of unmitigated Blackness, a literary manifestation of a parodic insurgency against the racial episteme of the modern period, one that mines the ironies of the social fabric of the United States. Under a veneer of nihilism, nonchalance, and exhaustion, Beatty's critical Blackness provokes the reader to see just how absurd discourses of equality, freedom, and civilization truly are.

PART III

History

Chapter Five

THE POLITICS OF INERTIA

Temporal Distortion in Suzan-Lori Parks's
100 Plays for the First Hundred Days

I walk around with my head full of lay-person ideas about the universe. Here's one of them: "Time has a circular shape." Could Time be tricky like the world once was—looking flat from our place on it—and through looking at things beyond the world we found it round? Somehow I think Time could be like this too. Not that I'm planning to write a science book—the goofy idea just helps me NOT to take established shapes for granted.

—SUZAN-LORI PARKS

IT'S ABOUT TIME: EXPERIMENTAL HISTORY AND TEMPORAL DISTORTIONS

Suzan-Lori Parks began 2017 with a writing marathon. Starting on January 20, the day of Donald Trump's inauguration to the office of president of the United States, she wrote a new play every day for 102 days. She published these raw and experimental plays the following year as a collection titled *100 Plays for the First Hundred Days*.[1] The cycle merges diarist and dramatist, each play commenting on the sociopolitical news of its corresponding day, often in a tone that reflects Parks's distress over the right-wing populism that Trump's administration espoused. A short way into the collection, in a play titled *Venus and Serena* (Day 18: February 6), Parks recounts the events that she had dramatized up to that date, providing readers with a convenient overview of the volume's thematic content and structure.

Day 1: Inauguration.
Day 2: He goes to the CIA and talks about how his crowd size was just as big or bigger than Obama's—even though all sources say that the 45th's crowds were teeny. He's lying out his ass to the fucking CIA.
Day 3: That was the day when Kellyanne called lies "alternative facts."

Day 4: Was the day that he said he was gonna investigate the voter fraud.
(Although nobody 'cept him thinks there was any. And several of his key people are
 registered to vote in more than one state.)
Day 5: He gave the Dakota Pipeline the thumbs-up so that's happening again. Jeez.
 (24–25)

By sequencing daily news events into a coherent storyline, Parks furnishes
a kind of experimental historical narrative that documents the beginning
of Trump's presidency. In its systematic day-to-day organization and linear
narration, her dramaturgy represents time as a function of reason, as if to
assure her audience that historicizing a period of about a hundred days
will register some measure of sociopolitical change and deliver some kind
of narrative arc.

But *100 Plays for the First Hundred Days* also distorts the steady flow of
this chronological structure in multiple and contradictory ways. On the
one hand, Parks's short plays and minimalist style blend days, and eventu-
ally weeks, into a kind of blur, accelerating the flow of time such that the
units through which we measure its passing seem to lose their symbolic
integrity. At the same time, however, the cycle tends to disregard plot—the
literary structure that signals progress—altogether, a trait that decelerates
dramatic action and destabilizes the steady rhythm of the volume's calen-
dric structure. By forestalling its storyline, *100 Plays for the First Hundred
Days* seems to slow to a kind of dramaturgical stagnancy that suspends its
audience in a state of timelessness.

This chapter approaches *100 Plays for the First Hundred Days* as a work
about time and of time to show how Parks's unique theatrical temporalities
critique Western philosophy's governance of time. As we will see, time is
not neutral when it comes to race; it is a hegemonic formation with sig-
nificant power in shaping how Blackness can be perceived, known, and
imagined. The modern racial episteme has exercised this power by curat-
ing a historical narrative that depicts Black history as frozen and Black life
as inert, representations that cast Blackness as the antithesis of Western
modernity and modern subjectivity.

I argue that Parks's temporal experimentation upends this temporal
regime. Across my analyses, I focus on the relation of the two conflicting
temporalities in *100 Plays for the First Hundred Days*—the tension between
its clock time and lived time—as well as audiences' experience of being

caught between them. By furnishing an encounter with the ahistoricity and stagnancy that racial ideologies try to attribute to people of African descent, I argue, Parks raises questions about the familiar historical narrative of Western development and supremacy. This analysis theorizes Blackness's "inertia" not as the historical-discursive idleness that white supremacist historiography tries to impose on Blackness but, rather, as the resilient and momentous force that disputes racial discourse insisting on Blackness's paralysis.

AGAINST THE CLOCK: WESTERN HISTORIOGRAPHY AND THE REGIME OF TIME

By framing *100 Plays for the First Hundred Days* as a kind of chronosophical inquiry, I mean to associate Parks's dramaturgy with the "temporal turn" in contemporary critical theory. This intellectual shift pursues questions about the dynamic force of time in creating the modern world. Scholars seeking to define and periodize this critical trend often describe it as a twenty-first-century reaction to accelerating technological change, global capitalism, and post-neoliberal extractive imperialism.[2] Interrogating the role of time in these processes is a way to resist the unnatural time that underwrites Western modernity but also the division of mind/body, subject/object, and thinking/feeling that is central to much of Western philosophy. Time is not just the way we live; it is in the way that we think and know according to that philosophical tradition.

As Daylanne K. English has shown, Black theorists and artists anticipated the temporal turn.[3] For example, scholars like Hortense Spillers and Karla F. C. Holloway were interrogating time as a category in the study of race and aesthetics in the 1980s and 1990s. As early as 1987, Spillers was describing history as a governing device that creates and perpetuates discursive constructions of race and gender through time: "In order for me to speak a truer word concerning myself, I must strip down through layers of attenuated meanings, made an excess in time, over time, assigned by a particular historical order, and there await whatever marvels of my own inventiveness."[4] Sharing Spillers's concern about time's role in derogating Black lives, Holloway had theorized colored people's time as a unique temporal schema in 1999: "The ghostly persistence of our history of dying and its absolute association with the color and character of our national

experience assure us that something about African America is a time, 'out of joint'—a 'CP TIME' that finds our daily lives are a complicated matter of color and death."[5] Years before Bruno Latour posited that the past is enfolded into the present and that the present thus carries along with it the marks of the past, Black writers were asking how the boomerang of history could be grasped through terms like "ritualization" or "pornotroping," as well as how it might be counteracted with folk histories or concepts like rememory.[6]

The temporal subjugation that Spillers and Holloway critique has roots in chattel slavery and racial capitalism. Whereas writings on modern time discipline and its historical evolution tend to associate the development of clock consciousness with the Industrial Revolution, Mark M. Smith explains that antebellum slavery economies had already quantified and commodified time both to maximize profits and establish and fortify racial hierarchies.[7] He argues that the Old South harnessed mechanical time as an instrument of social control, meaning that the rationality of the clock—as much as the threat of violence—played a significant role in subjugating enslaved Africans. "Slaveholders reckoned that, used properly, clock time could inspire discipline and obedience in a slave workforce that was always trying to upset plantation order and jeopardize planters' profits through individual and collective acts of resistance." Smith adds, "Simultaneously tyrannical, modern, and profit-oriented, the nineteenth-century clock and its attendant ability to rationalize and order the behavior of human beings became the planters' weapon of choice in their ongoing battle with their chattel." As Smith explains, enslavers had absolute control over modern time sensibilities and used them to widen the gap between the free and the subjugated. The widening gap speaks to the ways in which jurisdiction over time bestows power, how unequal access to time kept enslaved Africans in, but not of, modernity. Smith matter-of-factly summarizes this arrangement when he states that "masters, in short, owned time, clocks, and watches; slaves did not."[8] Without access to those mechanical timekeeping devices, he emphasizes, the enslaved lacked the means to develop an understanding of and resistance to the authority of the clock.

The disjuncture that Smith describes is part of a long and ongoing colonial project of temporal subjugation. By stealing time from the enslaved, the Old South literalized the complex temporal politics through which

Western philosophy has historically used modern time consciousness to try to regulate and govern people of African descent. Attending to this long-lasting project of temporal subjugation means examining how racially inequitable temporalities operate at the root of those philosophical traditions. For instance, the common Western idea of linear time presupposes a "progress narrative" that asserts whiteness's supremacy by insisting on Blackness's historical latency. This logic is evident in Georg Wilhelm Friedrich Hegel's assertion that Africa was without history, David Hume's comparison of a parrot and a multilingual African, and Kant's claims about African populations being "lazy" because of their hot climate.[9]

Glossing examples like these, Michael Hanchard argues that white supremacist conceptions of racial difference have always presupposed inequalities of temporality and that these inequalities associate Blackness with nonsynchronicity and incapability of development. Hanchard thus uses the concept of "racial time" to describe "the inequalities of temporality that result from power relations between racially dominant and subordinate groups." He traces racial time from the plantation to the present to show how white hegemony reproduces racially distinct temporal modalities, and he describes "waiting" as the fundamental conceptual facet that white culture levies against Black people when constantly deferring their self-sovereignty:

To be black in the United States meant that one had to wait for nearly everything. Legalized segregation, the maintenance of separate and largely unequal institutions, meant that blacks, as a consequence of prejudicial treatment, received health care, education, police protection, transportation, and a host of other services only *after* those same services were provided for whites. . . . Thus, for blacks, waiting has encompassed the sense of human vitality that is harnessed because of racial time, the imposition of a time-structure that varies according to race.[10]

By denying Black people the autonomy to construct individual and collective temporalities apart from the those produced by the dominant white culture, Hanchard emphasizes, this hegemonic arrangement continues to reproduce the temporal inequalities that Smith associates with the plantation. In that sense, waiting describes how colonial nations have both represented and restricted Africa and its diaspora to render them knowable first and foremost as perpetually not yet modern.

IN HER OWN TIME: PARKS'S ONGOING TEMPORAL PLAY

Questions about history, time, and their hegemonic force inspire and shape Parks's dramaturgy and have since the premier of one of her first plays, the 1987 work, *Betting on the Dust Commander*. In this one-act play, two speakers recount the events of their 110-year-long marriage over three scenes. Parks's unique theatrical temporality disrupts the flow of this story by creating a time loop in which the dialogue and action of scene two starts over halfway through the scene, repeating that scene's opening lines. Scene two opens with a conversation about Mare's eyelashes:

LUCIUS: Keep doing that to em they're gonna be stuck.

MARE: Theys gold on thuh undersides! Huh! Who woulda thought!?

LUCIUS: Theyre gonna get stuck and you wont be able to show your face nowheres. Aint nobody out there wants to see them uh old biddy with yellow wrong-side-stuck-that-way-forever-eyes.

MARE: Ssonly you, Luki—youre the only one I see, youre the only one for me.[11]

During the scene, the couple then discusses the Bermuda shorts that Lucius wore when he went to Churchill Downs, the newspaper clipping in which he appeared after a horse named Dust Commander won the race, and the plastic flowers they had at their wedding due to his allergies. Unexpectedly, the dialogue then returns to the beginning of the scene, repeating its opening lines and restaging the same conversation:

LUCIUS: No, Mare. Uh uhnn. Mm going. AAAAW! Stop that, Mare—You keep doing that theyre gonna get stuck.

MARE: Theys gold on thuh undersides! Huh! Who woulda thought!?

LUCIUS: Theyre gonna get stuck and you wont be able to show your face nowheres. Aint nobody out there wants to see them uh old biddy with yellow wrong-side-stuck-that-way-forever-eyes.

MARE: Ssonly you, Luki—youre the only one I see, youre the only one for me.[12]

Audiences who expect the third scene to escape this echo chamber find that it repeats the dialogue from the play's first scene. This return to scene one creates a circular time signature in which an overarching repetitive structure contains multiple instances of spiraling repetition. Under the weight

of this temporal confusion, made more difficult to follow by the players' unique speaking patterns and the continual interruption of sniffing and sneezing, the performance begins to feel like the racetrack that Mare (repeatedly) describes: "Running every day at 3:10. Every day 3:10 same horses and same track same ellipse ssame."[13] The play's repetition within repetition pushes circularity toward unintelligibility, challenging audiences to follow a story that sheds its beginning, middle, and end.

Parks continued experimenting with repetition and its disorienting effects in subsequent plays, such as her 1990 work, *The Death of the Last Black Man in the Whole Entire World*. One of its figures is unnamed but identified as Black Man With Watermelon. The play describes the multiple deaths he has endured over the course of history, including by fire, electric chair, lynching, falling, and suffocation when buried alive. Another player, identified as Queen-Then-Pharaoh Hatshepsut, mixes these many deaths into an incoherent timeline when she states, "Yesterday tuhday next summer tuhmorrow just uh moment uhgoh in 1317 dieded thuh last black man in thuh whole entire world."[14] She refigures the event of Black Man's passing until it is unclear what it even means to ask when the titular death occurred.

Noting the irrationality of this temporal logic, La Marr Jurelle Bruce characterizes the play as a dramatization of "schizophrenic time," emphasizing that players' lines perform the breakdown of space-time that each figure is trying to describe.[15] Consider, for example, how Black Man scrambles time when describing his many returns from death and arrivals at home:

Yep. Yep. Once we being here. Uh huhn. Huh. There is uh Now and there is uh Then. Ssall there is. (I bein in uh Now: uh Now bein in uh Then: I bein, in Now in Then, in I will be. I was be too but that's uh Then that's past. That me that was-be is uh me-has-been. Thuh Then that was-be is uh me-has-been. . . . Them thens stays fixed. Fixed Thens. Thuh Thems stays fixed too. Thuh Thems that come and take me and thuh Thems that greet me and then them Thems that send me back here. Home. Stays fixed, them do.)[16]

As she did in *Betting on the Dust Commander*, in *The Death of the Last Black Man in the Whole Entire World* Parks turns conventional senses of the past, present, and future into a disorderly moment in which all things are at once the "ssame" or "fixed" yet different.

When asked about her unique theatrical temporalities, Parks explained that she aims to confound audiences' time consciousness and that doing so raises questions about historical narratives that try to erase African and African American cultures' history and deny their contemporaneity. In a 1994 essay called "Possession," for example, she discusses her efforts to salvage Black history by reimagining and reconfiguring whitewashed historical timelines. "A play is a blueprint of an event: a way of creating and rewriting history through the medium of literature," Parks writes. "Since history is a recorded or remembered event, theatre, for me, is the perfect place to 'make' history—that is, because so much of African-American history has been unrecorded, dismembered, washed out, one of my tasks as a playwright is to—through literature and the special strange relationship between theatre and real-life—locate the ancestral burial ground, dig for bones, find bones, hear the bones sing, write it down."[17]

Parks describes her plays as a historical redress for the violence of Black history's systemic erasure; she characterizes drama as a radical tool for harnessing the temporal autonomy that white hegemony denies Black people. In an interview with dramaturg Shelby Jiggetts, she clarified that contesting and creating history is a process of confusing the historical timeline authorized by white supremacist historiography. To disrupt conventional perceptions of the past and query established historical narratives of white progress, she explained, she often displaces familiar patterns of chronological narration with spiraling repetition inspired by formal jazz aesthetics, a strategy that disorients audiences' time sensibilities and abstracts the idea of history's pastness: "History is not 'was,' history is 'is.' It is present, so if you believe that history is in the present, you can also believe that the present is in the past. It's mostly directional."[18] When we consider Parks's assertion that "history and the historical are mutable" alongside her remark that "history is time that won't quit," we can begin to see that history and time are inextricable for the playwright, that a violation of one's sacrosanctity serves to uncover the racist predilections of the other.[19]

Parks's treatment of time and history in her 1994 work, *The America Play*, exemplifies these aims. She parodies the "Great Hole of History" to describe Black Americans' absence or lack of significance in the established narrative of U.S. history. Parks literalizes the Great Hole of History by producing a replica of it on stage, furnishing an encounter with the absence of Africanity in the history that audiences think they know. The protagonist,

a Black Lincoln impersonator named The Foundling Father, dug the replica hole after visiting the real hole on his honeymoon and watching known historical figures—the "Greats"—parade in it.[20] The Foundling Father desires historical greatness, but his replica hole, much like the act of impersonation itself, can only alienate him from the real thing. His wife, Lucy, hints at his exclusion and the sense of alienation it produces: "You could look intuh that Hole and see your entire life pass before you. Not your own life but someones life from history, you know, [someone who'd done somethin of note, got theirselves known somehow, uh President or] somebody who killed somebody important, uh face on uh postal stamp, you know, someone from History. *Like* you, but *not* you. You know: *Known*."[21] The Black Lincoln impersonator is doomed to remain unknown; he is a spectator of history, and his participation is limited to being repeatedly murdered by white customers who pay a penny to reenact Lincoln's assassination (but also to ritualize the symbolic murder of a Black man).

Beginning on November 13, 2002, Parks further developed her interests in temporal experimentation by setting out to write a new play every day for an entire year. Although this project started as a private and inward-looking writing activity after her 2001 play, *Topdog/Underdog*, won the Pulitzer Prize, she published the year-long cycle in 2006 as a collection titled *356 Days/365 Plays*.[22] John H. Muse describes the year-long cycle as a marathon of very short plays—which he calls a "microthon"—that interrogates the minimal and maximal limits of drama, arguing that *365 Days/365 Plays* is both "a private compositional journey exploring dramatic form, and a public experiment testing theatrical possibility."[23] Across that cycle, Parks's brief, self-conscious plays explore race alongside topics of Hinduism, Indian mythology, and the act of meditation, often in ways that invoke the relation of time to the infinite, the limits of traditionalist storytelling structures, and the nature of endings.

Parks's ongoing experiments with time are rich sites of critical Blackness because they query Blackness's place in historical production and established narratives of modernity. Indeed, Parks has described her theatrical temporalities as a means of "rewriting the Time Line" and of "creating history where it is and always was but has not yet been divined."[24] These concerns infuse *100 Plays for the First Hundred Days*. As a continuation of the thinking and formal experimentation that have informed Parks's dramaturgy throughout her career, the temporal distortions of this cycle appeal

to a kind of dyschronometria—a condition of distorted time perception in which an individual is unable to accurately estimate the rate of time's passing, with acute cases feeling unmoored from time in ways that affect memory and other cognitive processes—to impose a kind of "racial time" on audiences.[25]

LIKE CLOCKWORK: PERIODIC WRITING
AS TIME MANAGEMENT

Before we can examine how Parks activates dyschronometria, we need to map the temporal structure of *100 Plays for the First Hundred Days*. The cycle emulates the disciplinary procedures of modern historians, who rely on dates, documentary evidence, and storylines to create a web of chronology.[26] Parks incorporates these elements into *100 Plays for the First Hundred Days* to give her cycle an air of historical authority but also to create the conditions in which chronological manipulation—time's slowing and stagnation—can subvert familiar historical narratives that exalt whiteness by exempting or suppressing the presence of Blackness.

Because it is difficult to apprehend the nuances of time through the senses and intuition alone, scientists (like Isaac Newton and Albert Einstein) and philosophers (from Plato and Aristotle to Descartes and Kant) have often deferred to regular cyclical processes—such as the natural rotation of the earth and lunar phases, or the artificial rhythms of clocks and calendars—to represent the nature of its passing. Philosopher Bradley Dowden explains that "clock time" names what these processes count, or that the word "time" refers to some elusive thing beyond the clock.[27] The clock may only measure the cycle of some regular periodic process and not time itself, yet such time-measuring devices authorize a uniform time scale that quantifies, regulates, and controls public life. Clock time, as the foundation of modern time consciousness, thus describes a culture's rationalization of time as an objective property of the physical universe, or time as a uniformly unfolding continuum in which events occur in a linear succession from the past through the present and into the future.

Isaac Newton played a significant role in rationalizing time. As Michelle M. Wright explains, Newton insisted that time gave the universe scaffolding and structure, a theory that presupposed a linear progress narrative.[28] Ideas about racial identity and hierarchization were well suited to this

cause-and-effect narrative of linear progress because its chronology sug-
gests that cultural advancement can be charted on a historical continuum
with a definitive beginning and arc of development but also that historians
could use information about a group's past to predict its future.[29] Wright
argues that "by imagining time as a *natural* force that moves development
forward, Newton provided Enlightenment philosophers with a stunningly
simple yet compelling understanding of time through which they could
interpellate Europe as the vanguard of civilization."[30] This historical dis-
course asserted whiteness's supremacy by positing that African-descended
people lacked an arc of historical development or by describing Black peo-
ple as stuck in a state of slaveness, which is to say that historical models of
Western development—and their insistence that Blackness represents the
antithesis of modernity—are products of modern time consciousness.

100 Plays for the First Hundred Days appeals to the familiar logic of clock
time. A glance at the volume's table of contents confirms that each play
marks the passing of a single day and that each play aims to contextual-
ize and comment on the events of that day. Some of the titles correspond
to headlines about the president's tweets and public announcements, such
as *Honered to Serve* (Day 4: January 23) and *Enemy of the People* (Day 30:
February 18), whereas others refer to political scandals that became news
stories, as in the case of *Golden Showers* (Day 23: February 11) or *Rick Carries
the Football* (Day 27: February 15). However, the majority of the titles name
specific historical events that garnered national attention, even if they seem
only indirectly related to the president's thoughts or actions: *Standing Rock
Is Burning in the Snow* (Day 34: February 22); *Muhammad Ali, Jr. Gets
Detained at the Fort Lauderdale, Florida, Airport* (Day 37: February 24); *A
Man Taking His Kids to School Is Arrested by ICE* (Day 43: March 3); and
Yes, the 45th Is Being Investigated by the FBI (Day 60: March 21). When *100
Plays for the First Hundred Days* is read in its entirety, its calendric structure
stabilizes the chaos of the fast-paced, twenty-four-hour news cycle, giving
a familiar and cyclical chronological pattern to the plays.

Although the table of contents resembles a conventional calendar, it is
more accurately described as an ephemeris. This is a type of event calen-
dar that measures the passing of time by documenting daily change. Most
often associated with astronomy and celestial navigation, a traditional sci-
entific ephemeris documents the position and trajectory of astronomical
objects over a set period. In the twenty-first century, electronic computers

create highly precise ephemerides, but these modern-day celestial diaries are part of a lineage that dates to around 1000 BCE, when Babylonian astronomers inscribed the first event calendars on Sumerian clay tablets in early Mesopotamia. As historian and mathematician Asger Hartvig Aaboe emphasized, Babylonian ephemerides are the elemental achievement in producing a refined mathematical recording of astronomical phenomena, making them the foundation on which rational conceptions of time rest. "All subsequent varieties of scientific astronomy, in the Hellenistic world, in India, in Islam, and in the West—if not indeed all subsequent endeavour in the exact sciences—depended upon Babylonian astronomy in decisive and fundamental ways."[31] Their ephemerides describe time as a function of planetary movement, meaning that they define time as an effect of the material universe, the basis for the first Scientific Revolution. But this approach to time measurement is not a thing of the past. Today's ephemerides preserve the empirical logic that informed Babylonians' predictive planetary systems by recognizing the "ephemeris second" as the benchmark for calculating and measuring the passage of time.[32] As such, ephemerides exemplify philosophical pursuits to quantifiably measure, rationalize, and surmount the mysteries of time.

The etymology of the Modern Latin term *ephemeris* clarifies its significance to Parks's cycle. It derives from the Ancient Greek *ephēmerís* (ἐφημερίς), meaning "diary," "journal," or "calendar," a derivative of *ephḗmeros* (ἐφήμερος), "daily."[33] Together, the Greek terms describe daily diary writing as a devotional practice. To construct an ephemeris, astronomers record the movements of celestial bodies at regular intervals of date and time. Parks's approach to writing *100 Plays for the First Hundred Days* emulates this timekeeping methodology. In the preface, she explains that she developed a daily writing exercise to achieve thematic consistency across the cycle: "I woke up every day and I read the news and I wrote a play" (xv). "It was a hard time," she clarified when speaking with the editor and journalist Diep Tran, "and I had to do it on the day, and it had to be about the news."[34] To ensure that she never strayed far from the news reportage that inspired each day's play, Parks approached the cycle as an exercise in "being present," an endurance act of ritualistically documenting current events as they unfolded and "directly comment[ing] on things that [were] going on in our world landscape."[35] By observing and recording the events that constituted the sociopolitical present between January 20 and May 1, 2017, Parks produced her own ephemeris timeline.

Parks's dramaturgical ephemeris observes and historicizes a period of about a hundred days and thus adopts the "first hundred day" standard, a unit of political measurement through which newly inaugurated presidents' administrations are evaluated.[36] By harnessing the authority of this standard as a structural element in *100 Plays for the First Hundred Days*, Parks appeals to the linear progress narrative that informs modern time consciousness and modern historiography. For the playwright, the steady and uniform temporal rhythm of the calendar establishes an orderly dramatic framework within which individual plays can register and comment on current events. But the rationality of clock time—which moves uniformly and linearly forward—also assures readers that each daily entry will give shape to the arc of historical development that the cycle's hundred-day timeline aims to chronicle. The cycle's structure thus approaches time as a force that moves development forward, with its ephemeral data purporting to mark some notion of progress from one day to the next.[37]

Emulating the timekeeping methodology of an astronomer and the documentary impulses of a historian, Parks writes each play to reflect the news of its corresponding day. For instance, a few days after the inauguration, Parks composes an entry that speaks to the amount of television news and talk shows that Trump was known to have consumed, as well as the feelings of unease this information engendered nationwide. *Watching TV* (Day 5: January 24) comments on Trump's television-viewing habits by staging his reaction to various news outlets, all of which report that his "inauguration crowds were smaller than those of the 44th President."[38] On hearing these reports, Trump begins insisting that his crowds were actually the largest to ever attend a presidential inauguration:

THE 45TH: Go tell them. Tell them that they were bigger than the 44th's and bigger than anyone else's ever.

SPOKESPERSON: *(Yelling)* They were the biggest. Ever.

THE 45TH: Shout it from the highest mountain or something.

SPOKESPERSON: You got it.

THE 45TH: "When I gave my speech, I looked out . . . and saw like a million people."*

SPOKESPERSON: You said that when you spoke with the CIA.

THE 45TH: Do you think they bought it?

SPOKESPERSON: They're the CIA.

THE 45TH: I don't care if they don't believe me. The people believe me. What are you standing there for? Go tell him.

 Spokesperson goes.

SOMEONE ELSE: What's he doing?

ANOTHER ONE: Watching TV. Like. A lot of it.**

THE 45TH: "Because I'm like a smart guy."*

*Actual 45th President's words.

**Actual 45th President's activities. (10–11)

By staging a conversation between the 45th, a presidential spokesperson, and some anonymous bystanders, *Watching TV* dramatizes the disinformation that the Trump administration began spreading after the 2017 inauguration. However, the play does more than just reproduce in dramatic form the news reports that inspired it. In its dramatic style, it also animates a spirit of incongruity that registers the astonishment that Trump's claims provoked and thus documents the social effects of his words, compiling ephemeral data and contributing to an experimental historical narrative.

Audiences get a sense of this astonishment not only through the reactions of Someone Else and Another One but also in the asterisks that appear in the script. Acting as parenthetical notes denoting documentary evidence, the asterisks anticipate resistance and assure the audience of the accuracy of the play's reportage, reinforcing the historical record-keeping impulse of *100 Plays for the First Hundred Days* by reminding viewers that the play reports the president's actual words and describes his actual activities. To give her dramatic retelling more authority, Parks adds quotation marks to Trump's statement, the only quoted material that appears in this play (although many plays in the cycle rely on this gesture).

Similar archivists' marks appear throughout *100 Plays for the First Hundred Days*, giving the cycle an air of scientific rigor and historical integrity. This impression of precise record-keeping is evident even as Parks's dramaturgy becomes increasingly minimalistic and abstract. Consider, for example, a short play titled *Because* (Day 65: March 25):

JACK: But, Mr. President, your—Alternative Facts—

THE 45TH: "I must be doing a great job because—I'm the president and you're not."*

JILL: Did he really just say that?

JACK: Yup.

*He really said that. (63)

Muse has called such short theatrical works "microdramas," which, he argues, self-consciously compress theatrical conventions to draw audiences' attention to normative expectations about time.[39] In this microdrama of just four lines, Parks condenses Trump's wide-ranging interview with *Time* magazine, in which he defended controversial statements on wiretapping, voter fraud, and an array of other political matters by insisting that the bare fact of his elected position validated the contents of his unsubstantiated claims. Perhaps as a reaction to Trump's bombastic statements during the interview, Parks distills his remarks to a single sentence, eliminating superfluous dialogue to spotlight the twisted logic of his statement. The brevity of *Because* draws audiences' attention away from the content of Trump's claim and toward the artfulness of its presentation, where small details tell us how to interpret the scene. The play's date, bystanders named Jill and Jack, quotation marks, and the playwright's supplementary footnote insist that *Because* can be read as a dramatic account of an absurd scenario with a specific historical referent. Like *Watching TV*, this play registers Parks's interpretation of the news of a particular day—in this case, March 25—even as the cycle situates this date within a larger hundred-day timeline.

If clock time is a pursuit to rationalize the enigma of time by breaking it into measurable and countable units, and if those units make up a historical arc that presupposes development and progress, then *100 Plays for the First Hundred Days* is more than just a personal journal by which Parks worked through feelings of anger and grief as a new administration entered the White House. Moreover, the cycle is a striking repository of social logic, one that appears to chart the forward march of time in an attempt to discover within that temporal continuum some evidence of sociopolitical change. This is not to say that *100 Plays for the First Hundred Days* sanctions the linear progress narrative through which the white cultural hegemony measures its historical development and asserts its supremacy; rather, it is to say that Parks uses the ephemeral form of measurement to set—and then upend—our temporal expectations.

THE TIME IS OUT OF JOINT: THEORIZING PARKS'S PERFORMANCE OF SLOWNESS

Parks's temporal experimentation critiques rationalized perspectives on time by showing that mathematical logic cannot account for the subjective experience of passing through time. This critique has a long history.

Edmund Husserl, for example, argued that countable units of time do not adequately explain how consciousness experiences a temporal object, an observation from which he concluded that time-consciousness is "the most difficult of all phenomenological problems."[40] Phenomenologists following Husserl, like his contemporary Henri Bergson, similarly argued that time cannot be broken down into discrete and uniform units. We may be told that there are sixty minutes to an hour or seven days to a week, he argues, but these metaphorical measurements have meaning only relative to one another. More significantly, units like minutes, hours, and weeks do not satisfactorily capture the dynamic experience of being in time, the experience in which the quality of a given minute, hour, or week feels shorter or longer depending on one's circumstances. Bergson thus criticizes clock time's unyielding rationalism for turning temporal experience into a sequence of nondescript mathematical moments, for superimposing abstract and intangible meaning on time. He argues that temporality is better understood as an ever-renewing present. Bergsonian time, which he had called "duration," thus refers to the enduring and unremitting flow of interpenetrating moments, all of which are qualitatively rich but unquantifiable.[41]

Bergson's sense of what is variously termed "lived," "subjective," or "phenomenological" time informs ongoing conversations that aim to describe and define the temporal nature of theatrical performance. Matthew Wagner reiterates Bergson's argument that duration is the essence of time when he discusses "theatrical time" and its capacity to trouble the authority of the clock by stretching and compressing audiences' time perception: "The theatre has a habit of abolishing clocks. Perhaps, more accurately, it dismantles and refigures them, making, in a god-like fashion, time in its own image, . . . suggest[ing] that the clock is not equivalent to time."[42]

David Ian Rabey, agreeing that temporal dissonance is the constitutive element of theatrical time, similarly notes that the theater produces a sense of time that seems "out of proportion to its technical duration in clock time."[43] For Wagner and Rabey—and, I argue, for Parks—theater advances its own time schemes in which the symbolic measurements of clocks and calendars have no authority.

In *100 Plays for the First Hundred Days*, Parks continues her longstanding preoccupation with temporal experimentation by activating a phenomenological experience in which time seems to slow to a halt. The ephemeral structure of Parks's cycle promises a conventional historical

narrative with an ordered and rational dramatic sequence arranged into clearly demarcated units of time. But within these domains, the individual plays produce a sort of listless and inactive temporality in which time seems to crawl along, confounding the symbolic integrity of days, weeks, and months for measuring its passing. Consider the cycle's opening play. *Is It Over Yet?* (Day 1: January 20) seems to call for an ending at the moment it sets out to begin, immediately querying the play's temporal logic. More significantly, to stave off action and resolution, and to slow audiences' sense of theatrical time, Parks infuses the play with punctuated and repetitive dialogue that quickly gives way to stagnation:

SOMEONE: Is it over yet?

SOMEONE ELSE: Nope.

SOMEONE: Are we "great again" yet?

SOMEONE ELSE: Nope.

SOMEONE: I want to cry.

SOMEONE ELSE: Let's cry together.
 They cry together. Ugly tears.

SOMEONE ELSE: Better? Even a little?

SOMEONE: Nope. I'm angry. Very.

SOMEONE ELSE: Me too.
 They yell and scream and gnash their teeth.
 Very real.

SOMEONE ELSE: Better?

SOMEONE: Not Really. *(Rest)*

SOMEONE: Is it over yet?

SOMEONE ELSE: It's Inauguration Day. 5 A.M. They're—they're just getting started.

SOMEONE

SOMEONE ELSE

SOMEONE ELSE: Just a question: Are you gonna keep your eyes shut for the next
 4 years?

SOMEONE: I'm planning on it. (4–5)

This scene not only reiterates the play's titular question—"is it over yet?"—but also creates an illusion in which theatrical time seems to slow. Action gives way to stagnation when Someone asks twice if things have improved or if catharsis has made the situation more bearable ("Better?") and when

Someone Else insists several times that nothing is different and that nothing has changed ("Nope."). As if channeling the Absurdist Theatre of Samuel Becket and Harold Pinter, Parks arranges the scene's dull and deliberate dialogue to wane into complete inaction and silence, illustrating the inadequacy of language to rationalize the players' feelings of distress, those that cannot be helped by crying, yelling, screaming, or gnashing one's teeth.

The inaction and silence become literal toward the end of the passage when we encounter one of Parks's trademarks, a *(Rest)*, which the playwright describes as a cue to "take a little time, a pause, a breather" (xvii). Over the next several lines, the inaction of this pause thickens as the players stop conversing altogether, denoted by repetition of speakers' names without dialogue. Parks refers to this unconventional theatrical element as "a spell," which she describes as "an elongated and heightened *(Rest)*" in which "figures experience their pure true simple state" (xvii).[44] Like the play's punctuated and repetitive dialogue, these moments, in which the players ruminate on their distress without making a sound, bring the scene to a crawl, asking audiences to endure a sense of stagnation that is likely to raise a familiar question: Is it over yet?

Parks explains these manipulations of dramatic action and how they slow theatrical time in her 1995 essay, "Elements of Style," which describes "Rep & Rev" as an experimental dramatic technique.[45] Shorthand for "repetition and revision," Rep & Rev "work[s] to create a dramatic text that departs from the traditional linear narrative style," resisting conventional narrative structures in which all elements lead the audience toward a single climactic moment. This technique breaks from the logic of cause and effect that governs historical narration and traditional drama, sometimes called "Aristotelian drama" because of the philosopher's emphasis on the catharsis that rhythmic beginnings, middles, and ends create.[46] Rep & Rev disregards these narratives' structural elements—most notably endings—by deferring their resolution and in doing so disrupts the symbolic integrity of beginnings and middles. Instead of locating suspense and resolution in conventional forms of rising action and climax, Parks's repetitive and circular style promotes the uncomfortable feelings affected by refusing catharsis. The playwright hints at the unease that Rep & Rev tends to generate when she acknowledges that "we all want to get to the CLIMAX."[47] However, as *Is It Over Yet?* makes apparent, her emphasis on inaction and silence tends to defer climax indefinitely. By rejecting linearity and slowing action to a sort

of absurdist stagnancy, such plays temporarily suspend audiences' perceptions of the flow of time.

Rep & Rev preserves the inaction of *Is It Over Yet?* throughout *100 Plays for the First Hundred Days*. Titles near the end of the cycle include *What Will You Do When It's Over?* (Day 94: April 23), *It's Almost Over* (Day 97: April 26), and *Now What?* (Day 101: April 30). Audiences who expect the cycle to observe a conventional dramatic structure or chart a familiar linear progress narrative with a beginning, middle, and end instead encounter days upon days of the same inaction that infuses *Is It Over Yet?* Consider, for instance, the dialogue of *What Will You Do When It's Over?*, in which speakers named Jack and Jill repeat (with revision) the same kinds of questions that appear in the cycle's opening:

JACK: What will you do when it's over?
JILL: Will you look back and think of all the things you could've fixed?
JACK: Or will you just
 Keep on keeping on
 With your eyes shut. (83)

What Will You Do When It's Over? recycles the questions and content of the cycle's first installment, *Is It Over Yet?*, suggesting that little has changed in the intervening period. Both plays feature two speakers fixated on ideas of closure and resolution, and both plays pivot around issues of self-anesthetization, asking if an eyes-shut approach might make the sociopolitical present more tolerable. As questions of endings and sightlessness repeat toward the conclusion of *100 Plays for the First Hundred Days*, the temporal distance that separates April 23rd from January 20th begins to feel immaterial, as if the two dates are part of the same static moment even though ninety-four days have apparently passed. If "time is a measure of change," as Aristotle contended, then Parks's changeless repetition invokes Bergson's philosophy of duration to slow the flow of time to an enduring stasis.[48]

Lutz Koepnick's investigation into the aesthetic qualities of slowness is useful for understanding Parks's experiments with decelerating theatrical time. Koepnick describes the impression of time's slowing as an opportunity for developing a nonnormative temporal consciousness that is suitable for approaching and interpreting the present as a meaningful dimension of time. At the heart of *On Slowness* is an attempt to refocus our attention

on the complexity of the ever-changing now, one he resolves by describing "going slowly" as being at once timely and untimely, at present a part of the flow of time and consciously apart from its authority. This dualistic awareness of time's passing, Koepnick argues, is achieved in slowness "as a particular mode of reflecting on movement and temporal passage that transcends how modern Western societies have largely come to prioritize time as a realm of dynamic change over space as a domain of stasis."[49] This description of modern time consciousness suggests that slowness can actively rework normative, rational perceptions of temporality in order to warrant radical, experiential modes of temporal experience. In other words, the feeling of time's slowing creates the conditions in which we can attune ourselves to the nature of the now, distancing ourselves from the rationalism of the clock and discovering a mode of presentness in the process.

Parks's deceleration of theatrical time makes use of slowness's unique affective qualities. By repeating the same kinds of scenes with the same sort of dialogue seemingly ad infinitum, and by infusing her dramatic text with rhetorical questions and silences, Parks enacts a performance of slowness that suspends audiences in a state of perpetual waiting, a state that is qualitatively rich but unquantifiable. Because it tests the limits of audiences' attention and patience, Rep & Rev—and the waiting it imposes—can be understood as much more than an idiosyncratic feature of Parks's dramatic style. Moreover, as an endurance test in which impatience and restlessness are signs of the weight of the present, the imposition of waiting furnishes an encounter in which one discovers, momentarily, the disquieting feeling of being at the burden of Western standard time.[50]

With Hanchard in mind, we might recognize how waiting describes the strategic deployment of time as a means of postponing civil rights efforts but also how being made to wait draws attention to the temporal disjuncture that racial power relations produce. Then, the irresolution of Rep & Rev supplants narrative conventions not just to create an atmosphere in which audiences yearn for a dramatic climax that Parks defers. By creating a dramatic illusion in which time slows to a crawl and audiences are forced to wait, and by activating a sense of anticipation that goes unresolved, Parks's dramaturgy destabilizes the nature of the present, as well as its relationship to the past and future, and thus manifests an experiential time modality that fundamentally unsettles normative perceptions of clock time and its linear progress narrative. By imposing timelessness on

its audience, *100 Plays for the First Hundred Days* draws attention to the temporal inequities that are obscured by rational conceptions of time, as well as white requests that Black people wait for their civil rights.

The final installments of *100 Plays for the First Hundred Days* clarify how Parks's performance of slowness distorts the pace of time authorized by the clock and the calendar and how the weight of Rep & Rev builds up to its unique dramatic effect. On day 97, in a play titled *It's Almost Over*, Jack and Jill's dialogue again creates the impression that the unceasing flow of time has had little effect on the politics of the present, prompting another speaker to wonder if one hundred days is truly a measure of anything at all:

JILL: It's almost over.
JACK: Thank Goodness.
SOMEONE: What's almost over?
JILL: The first 100 days.
SOMEONE: And then come the *second* 100 days.
JACK: Shit.
JILL: THIS IS BAD, PEOPLE! THIS IS REALLY BAD! (85–86)

In this scene, Jack and Jill seem to be observing the steady flow of rational clock time, which assures them that a period of one hundred days will produce a narrative of linear progress, softening the chaos, confusion, and distress with which the cycle began. However, Someone's question shocks them into an experiential mode of time consciousness in which the stagnancy of the present as a timeless temporal modality can be felt acutely. "What's almost over?," Someone asks, hinting at the arbitrariness of clock time's hundred-day scale before explaining that the present actually has no ending, that it actually forestalls one: "And then come the *second* 100 days." For Jack and Jill, this stretching of time is alarming, as it indicates that there is just one enduring moment, one that has lasted for one hundred days and that will last for a hundred more, meaning that change and progress have no stable beginning, middle, or end through which they could be reasonably measured. Jill's sudden realization—that "THIS IS BAD"—can be read as a reaction to being made to wait endlessly, as well as a sign of her perception of presentness, an emergent temporal consciousness in which time begins to shed its relationship to rational thought.

The cycle's penultimate play, on day 101, when *100 Plays for the First Hundred Days* exceeds its timeline, separates time from rational thought entirely. Titled *Now What?*, this play has no dialogue or players. It is composed of a single stage direction that reads, "the action of this play is everything that happens from here through eternity" (88). As the climactic moment in the cycle, this direction springs of contradiction. By evoking the infinite of "everything" and "eternity," *Now What?* exceeds the systems of comprehension through which action and time can be counted and measured. Parks's gesture toward infinity overwhelms the ephemeral structure of the cycle to render time irrational—indeed, what is the value of days and weeks when measuring the eternal? Paradoxically, the scope of the play reduces the scene of everything to a scene of nothing, in which action and time, as they would be recorded and measured by an ephemeris, slow to an absolute stop and no longer have meaning.

The dramatic slowness of *100 Plays for the First Hundred Days* suggests that we cannot apprehend time, as Bergson believed, through pure thought, however imaginative our thinking might be. According to Parks, time and the temporal inequalities that white hegemony produces are not just some concepts from which we can separate ourselves, although we can phenomenologically feel their force and weight when our temporal perception becomes distorted. Parks has described her use of Rep & Rev to these ends, noting that in her dramaturgy, "the 'climax' could be the accumulated weight of the repetition—a residue that, like city dust, stays with us."[51] By depicting the experience of Rep & Rev and dramatic slowness as a kind of accumulation that audiences bear, Parks invites us to "endure" a simulation of the waiting that Hanchard argues white cultural hegemony imposes on subordinate racial groups, exposing the cultural machinery through which white supremacist thinking continues to reproduce temporal inequalities between white and Black people.

TIME FIXES ALL THINGS: THE INERTIAS OF BLACKNESS

The temporal schemes that give *100 Plays for the First Hundred Days* its shape and aesthetic character have significant import for the study of racial discourse and critical Blackness. For example, by making palpable the tension between rationalized time and lived time, two unassimilable temporal domains, Parks's experimentation activates an experience of

dyschronometria. To neuropsychologists, dyschronometria describes lost-time syndrome, a disengaging condition in which the length of time's passing feels distorted to the point that it can no longer be accurately estimated or measured, which in turn throws off one's emotions, memories, and cognitive processes.[52]

Frantz Fanon addresses dyschronometria and its effects when he explains how his knowledge of time's passing feels out of sync with the historical racial paralysis that white hegemony imposes on him. Specifically, in *Black Skin, White Masks*, Fanon is interested in how phenomenology fails to consider fully how historically ingrained ideas about Blackness affect embodied subjectivity for the racially oppressed. He recognizes that Western epistemology has constructed the idea of Blackness out of stereotypes and preserved those stereotypes through time, leaving the white world to assume it has "already seen" Blackness (*déjà vu*). He describes the "historical-racial schema" as the sedimentation of this virulent racial discourse. "Beneath the body schema I had created a historical-racial schema," he writes. "The data I used were provided not by 'remnants of feelings and notions of the tactile, vestibular, kinesthetic, or visual nature' but by the Other, the white man, who had woven me out of a thousand details, anecdotes, and stories."[53]

The historical-racial schema is significant because it indicates that historical anti-Blackness predetermines Blackness's legibility and representational possibilities. In Fanon's view, racist ideas do not fade away over time, nor do they wane in the face of antiracist rhetoric. Rather, knowledge about Blackness endures unchanging through time and thus continuously reproduces the temporal inequities of the past. For this reason, when detailing how he is "overdetermined from the outside," Fanon describes racialized being-in-time in terms of restricted mobility, arguing that the modern racial episteme renders his Blackness inert: "I arrive slowly in the world; sudden emergences are no longer my habit. I crawl along. The white gaze, the only valid one, is already dissecting me. I am *fixed*."[54]

Fixity operates as one of the fundamental historical determinants of discursive constructions of race. It is also at the heart of disciplinary debates in Black studies, which ask whether fixity—as paralysis, social death, or slaveness—is at the root of Black ontology. For example, Saidiya Hartman offers "the afterlife of slavery" to describe how the present continuously resurrects the conditions of chattel slavery. She writes that "black lives are still

imperiled and devalued by a racial calculus and a political arithmetic that were entrenched centuries ago," describing enslavement's continuing effects as "skewed life chances, limited access to health and education, premature death, incarceration, and impoverishment."[55]

Christina Sharpe similarly characterizes the "wake" of history as "the past not yet past," clarifying that "living in the wake" means inhabiting a dis/continuous historical timeline in which there is no "after" of racial discourse. "Living in the wake means living the history and present of terror, from slavery to the present, as the ground of our everyday Black existence," Sharpe explains, "living the historically and geographically dis/continuous but always present and endlessly reinvigorated brutality in, and on, our bodies while even as that terror is visited on our bodies the realities of that terror are erased."[56] Hartman and Sharpe are grappling with the feeling of dyschronometria and the problem that fixity presented to Fanon, who recognized that without a measure of change, racial discourse and its effects on Black life have no coherent beginning, middle, or end, just an enduring now.

Hinting at a sense of critical Blackness, Sharpe describes "one aspect of Black being in the wake as consciousness," as opposed to death, when she argues that "to be *in* the wake is to occupy and to be occupied by the continuous and changing present of slavery's as yet unresolved unfolding." As a radical orientation toward being, such an articulation of critical Blackness is aware of—and working against—abject ontological negation and white hegemony's insistence that Blackness signifies the antithesis of modernity. Sharpe is thus interested in Black expressive practices that "do not seek to explain or resolve the question of [Black] exclusion in terms of assimilation, inclusion, or civil or human rights, but rather depict aesthetically the impossibility of such resolutions by representing the paradoxes of blackness within and after the legacies of slavery's denial of Black humanity."[57] In her description of living in the wake, Sharpe points to a Black ontology that critiques the modern racial episteme and its white supremacist historiography, an ontology in which a kind of existence in relation to modernity is borne from the experience of inhabiting—and resisting—the force of history itself.

100 Plays for the First Hundred Days models a response to the question of fixity when it queries the nature of Blackness in time and activates dyschronometria for its audience. Parks is certainly aware of the role that historical knowledge continues to play in constructing Blackness in the present.

However, as with her impulse to violate modernity's temporal logic, her desire to dispute history's authority in sensemaking suggests that, in her view, European philosophy's insistence on Blackness's ahistoricity and anti-modernity may disclose the resistive and resilient consciousness of critical Blackness. That is, Parks stages the historical that fixity Fanon describes when he says, "without a black past, without a black future, it was impossible for me to live my blackness," but also that her representation of Fanon's inertia subverts the white pathology that tries to depict African-descended people as historically frozen.[58]

For example, consider a play called *Happy Black History Month* (Day 13: February 1), a dramatic retelling of the news events of February 1, 2017, when Trump hosted his African American History Month Listening Session. During that event, Trump referred to Frederick Douglass in the present tense. Parks uses this temporal dissonance to activate a dual time consciousness in which rational time begins to feel out of sync with the temporal experience that the play occasions, dissociating clock time from lived time:

THE 45TH: Happy Black History Month. I've scheduled a whole month of events starting with a Listening Breakfast where I'm surrounded by my Negroes and they smile at me while I say things like: "Frederick Douglass is a great guy. He says and does great things."*

Y: He's using the present tense to talk about Frederick Douglass.

X: Are we still having Black History Month?

Y: Not for long. Enjoy it while we can.

HOUSE NEGRO: Mr. 45th, gang leaders in Chicago want to sit down with you 'cause they know you're for real, not like the last president.

X: Some black folks will only say what white folks want them to say. Post-Traumatic Slave Disorder.

Y: I wanna cry me a river.

X: I wanna slap me somebody.

　*Not an actual quote but close (19)

In her dramatic retelling of Trump's Listening Breakfast, Parks enacts several time distortions that confuse that event's temporal coherency. The most overt temporal rift comes in the play's opening lines, in which the 45th speaks of Frederick Douglass in the present tense.[59]

Trump's off-time remark begins to trouble the historical setting of *Happy Black History Month* by collapsing the chronological distance between the twenty-first-century present and the nineteenth-century past, detemporalizing Douglass as a historical figure.

Parks further embellishes Trump's chronological gaffe by bringing other historical-racial ideas into the present. These include defunct racial figurations that fix Blackness according to stereotypes of the Jim Crow era and the antebellum period. For instance, in his opening remarks, the 45th noticeably refers to the meeting's Black attendees as "my Negroes," regressing to the same language of racial identification that had captured Fanon.[60] By prefacing the word with "my," Trump implies a kind of ownership that further evokes images of the antebellum South's slaveholding past.

Parks completes this temporal confusion by renaming one of the meeting's attendees, Darrell Scott, pastor of the New Spirit Revival Center in Cleveland, Ohio. In her dramatization, she refers to Scott as "House Negro," the term for enslaved Africans who lived and worked in slave owners' homes. This term is often invoked to demean Black persons who are accused of rejecting their cultural identity because it describes enslaved Africans who were loyal to their white enslavers. The repetition of "Negro" across the play carries with it the cultural baggage of categorical identity, reducing the possibilities of Black self-sovereignty and Black humanity to predetermined clichés of Black identity, most notably slaveness.

The play's antebellum references fracture the timeline of *100 Plays for the First Hundred Days* and activate dyschronometria. The past begins to feel eerily present even as the now feels unnervingly historical. Parks's ephemeris confirms that the dramatic scenario has a stable historical referent, as it responds to the news of February 1, 2017, the thirteenth day of Trump's presidency. At the same time, however, the play's language and action diverge form this specific date by conjuring racial figures belonging to eras of segregation and slaveholding. In effect, Parks confuses the historical distance that separates the present from the past and thus distorts audiences' sense of time.

Enduring the dissociated timeline of *Happy Black History Month* involves confronting this chronological contradiction and recognizing that one's knowledge of time and immediate experience of time are two different things. This temporal dissonance places audiences in a moment of

historical rupture—a dyschronometria—in which a discomforting pres-
entness can be encountered. Some audiences may find themselves "in the
break" as they encounter the cultural machinery that purports to celebrate
Black history while simultaneously asserting that Black history is frozen
and that Blackness thus signifies the antithesis of modern subjectivity.

Such temporal rifts are opportunities for rich confrontations with the
limits of history. Sharpe draws on Dionne Brand's poetry, specifically her
notion of "sitting in the room with history," to describe inhabiting the wake
as a mode of consciousness, a way "of entering and leaving the archives
of slavery," of foreclosing "a kind of blackened knowledge, an unscientific
method, that comes from observing that where one stands is relative to the
door of no return and that moment of historical and ongoing rupture."[61]
The temporal dysperception that Parks activates places audiences in one
such moment of historical and ongoing rupture and permits them to dis-
cover within it a critical Blackness—or a Blackened knowledge—that resists
the authority of a historical narrative shaped by the ideologies of the mod-
ern racial episteme. This critical Blackness disrupts the racial unconscious
of white supremacist historiography by confusing its historical process. To
be in the wake of *Happy Black History Month* is to occupy this temporal
contradiction, to "sit with" the paradoxes that structure what we think we
know about Blackness.

In *Happy Black History Month*, two players referred to only as X and
Y repeat and revise Fanon's statement—"it was impossible for me to live
my blackness"—when they begin to question the conceptual validity
of Black History Month. X's question, "are we still having Black History
Month?" not only asks what it means to celebrate Black history amid the
Trump administration's veiled (and often unveiled) white nationalism but
also what meaning, purpose, or value Black History Month can possibly
serve if the modern racial episteme aspires to temporally fix Blackness's
historical dimension. From this perspective, X's question signals an exis-
tential crisis of Black identity-making, as Black History Month can have no
conceptual value if historically entrenched racial discourse tries to render
Blackness inert.

But alongside X's identity-making crisis, Parks's critical Blackness makes
sensible an inertia of a different order. She indicates that the question of
Blackness's social death can be asked only because of Black resilience.

By this suggestion, Black creative expression argues with the racial discourse that insists on Blackness's historical latency, in effect expanding Black consciousness and enacting Black lifeworlds. Newton's first law of motion provides a critical foothold for understanding this property of inertia as a mode of critical Blackness: "The *Vis Insita*, or innate force of matter, is a power of resisting, by which every body, as much as in it lies, endeavours to preserve in its present state, whether it be of rest, or of moving uniformly forward in a right line."[62] The inertia of Blackness, in this sense, does not simply describe fixity, paralysis, social death, or slaveness but, rather, the resistive consciousness that endeavors to defend and sustain Black life in the face of negation. In *Happy Black History Month*, for example, the possibility that Black History Month no longer has meaning is questionable only because Blackness persists to ask about the nature of its celebration; in the act of raising this question, X gains an antagonistic agency that argues with the Blackness-as-slaveness subjectivity that racial discourse insists on. Attention to the momentum of inertia reveals that the modern racial episteme's efforts to reduce Blackness to the antithesis of modernity and modern subjectivity ironically stir resistive consciousness, or that the radical ontological postures of critical Blackness respond to the racial discourse that tries to render Blackness inert.

This analysis picks up on Sharpe's assertion that living in the wake of history means embodying a Black ontology in which the struggle against social death engenders a kind of Black consciousness or Black life. In her words, the terror of a dis/continuous historical timeline comes to inspire "the ground of [Black peoples'] everyday Black existence," but it does so by constituting modes of being that upend and exceed historically entrenched discourse: "To be in the wake is also to recognize the ways that we are constituted through and by continued vulnerability to overwhelming force though not *only* known to ourselves and to each other *by* that force."[63] Sharpe's argument that a dis/continuous historical timeline is both the ground of Black peoples' existence and also the force of their resistance suggests that critical Blackness's forms and practices respond to racial discourses that assert Blackness's ahistoricity. To speak of Blackness's historical inertia is thus to speak of its critical velocity, its resilience as a dynamic force that prompts the policing of the limits of Western epistemology by querying the racial knowledge that it propagates.

Parks signals this resilience in *Happy Black History Month* by referring to two of her players only as X and Y. Debra Walker King has argued that such initialing upends a history of stereotyping, negation, and exclusion by "giv[ing] voice to the historical loss and absence that are the progeny of racial subordination and slavery."[64] As she explains, initials like X and Y are cryptic markers of resistance that reject naming and labeling as an act of ascribing identity to those who do not choose it. Glossing over Hortense Spillers, who called the X a "slash mark against the first offense," King shows how initialing voids all claims to historical ownership to neutralize the effects of commodification and diminished humanity.[65] By adopting no name when Trump calls Black people "my Negroes," Parks's players have stepped outside historical legibility in favor of historical ambiguity. Audiences cannot intuit X and Y as types because their radical figuration discloses only that they are not knowable according to any historically overdetermined category of Black identity. In their rejection of fixity, the players gain a kind of illegibility that rebuffs naming's role in the grammar of ownership and dehumanization. X and Y thus reveal that namelessness and illegibility need not be a sign of social death because they can also signal a radical orientation that refutes white hegemony and its authority over historical sensemaking.

100 Plays for the First Hundred Days is interested in mapping the logic of the temporal modalities through which white supremacy tries to render Black history frozen and Black life inert. But it does so to uncover the resistive orientations of critical Blackness as an aesthetic response to racialization, assuring audiences that critical Blackness resists, disrupts, and ruptures the power of racial hegemony. The cycle's temporal confusions do not associate Blackness's displacement from history with the antimodern. Rather, they show that the imperializing authority of white supremacist historiography is vulnerable to being rendered powerless. For Parks, strategically embracing ahistoricity—and willingly choosing a kind of illegibility—can productively challenge and upend the discursive constructions that seek to fix Blackness. The cycle's dyschronometria confuses perceptions of time to illustrate the enduring effects of historically sedimented figurations of Blackness but also to prompt audiences to sit with the timelessness that racial discourse imposes on racially subordinate groups, occasioning an encounter in which figurations like "the Negro" surrender their conceptual coherency.

THERE IS A TIME FOR EVERYTHING:
CRITICAL BLACKNESS ANTICIPATES LIBERATION

Although *100 Plays for the First Hundred Days* purports to historicize the events that transpired as the Trump administration transitioned into power at the beginning of 2017, Parks never gives the stage to the former president, who appears as an embodiment of white hegemony. Instead, she quiets Trump's voice as the cycle unfolds, so much so that he eventually begins to interject, disrupting dramatic action to remind the playwright that he is not receiving the attention that he feels he deserves.

In the second half of the cycle, beginning in a play titled *Former Russian Member of Parliament, Denis Voronenkov, Was Shot Dead in Broad Daylight* (Day 63: March 23), he says, "I thought your plays were going to be about me? This doesn't have anything to do with me" (62). A week later, in *A Play for Michael Sharp on My Mother's 80th Birthday* (Day 69: March 29), he again tells the playwright, "you should be writing plays about me" (67). Soon he begins suggesting play topics that might represent him in a better light, as we see in *Judge Sheila Abdus-Salaam Is Found Dead in the Hudson River* (Day 83: April 12), in which he asks Parks to narrate his rebuke of White House chief strategist Steve Bannon. By the cycle's conclusion, he has stopped appearing altogether, suggesting that the cycle does not chart the linear progress of Western powers as much as it diminishes their supposed authority over historical narration.

The critical Blackness of *100 Plays for the First Hundred Days* points to an aesthetic life of Blackness that anticipates Blackness's temporal liberation. This is particularly evident in the cycle's final play, titled *Mayday* (Day 102: May 1), which draws on a sense of illegibility to posit Blackness as a fugitive orientation of "righteous behavior." Until this play, Parks had abstracted audiences' perception of time's passing, stretching and compressing the days of the calendar until the plays' phenomenological slowness seems to decelerate into complete stagnancy. As the one-hundred-second play, *Mayday* exceeds the ephemeral timetable Parks had set out to observe and record. The title of the cycle's final entry is a distress signal, which communicates this overextension and the breakdown of time's rational dimension, but also the liberation that comes from regaining control of one's time. Stepping outside the ephemeral structure, Parks begins *Mayday* with a practical question: "It's day 102," a player named Jack asks, "and

what should we do?" Another figure, Jill, responds, "we should do our bit" because "doing our bit makes a spark of light" (88). The remaining dialogue develops an argument about the endurance of inspirational acts, suggesting that a "spark of light" preserves and perpetuates resistive consciousness:

JACK: And *that's* what is remembered. *That's* what people see in dark times when they look back. They see sparks of light that help them continue.

JILL: Sparks of light can give folks an example of righteous behavior.

JACK: Bravery in times of despair.

JILL: Justice in times of injustice.

JACK: Kindness in a time of cruelty.

JILL: Little sparks of light. That's what stars are.

JACK: That's what you make when you do your bit. You make a little spark of light.

JILL: And the star you make, it'll guide future travelers. So, hey, shine on. (88–89)

Mayday evokes light and its role in celestial navigation to represent courage, righteousness, and compassion as beacons through which future generations might locate their subject positions in the sociopolitical landscape of the United States. In doing so, it characterizes "a spark of light" as a resilient response to racial discourse, one that anticipates a past that can be remembered and future persons to remember it, gesturing toward a new historical timeline inhabited by those who oppose the hegemony that Trump represents.

If despair, injustice, and cruelty are the injustices to which *100 Plays for the First Hundred Days* responds, then we might recognize bravery, justice, and kindness as the attitudinal effects that the cycle aims to inspire. But these sparks of light can also be read as the effects of a kind of a Blackened knowledge or the foundations of a Black social life. Parks's allusion to a star that guides travelers contributes to this reading, as celestial wayfinding had guided enslaved Africans as they escaped bondage, the North Star and the Big Dipper—sometimes called the Drinking Gourd—serving as beacons of freedom. In her suggestion that new stars might prompt others to confront and question the ideologies of the modern racial episteme, Parks characterizes resistive behavior as a means of navigating the racial discourse that seeks to negate Black being.

The conclusion of *100 Plays for the First Hundred Days* calls to mind Fred Moten's exploration of the politics of fugitivity as the groundwork of Black

optimism, which he argues "demands a para-ontological disruption of the supposed connection between explanation and resistance." Moten suggests that a naive reading of the Fanonian encounter described in the previous section gives the "case" of Blackness a proper hearing, one that registers the optimism of Blackness's figuration despite the horror of its making. Moten does not mean to suggest that the terror of slavery ceases after emancipation, nor does his sense of optimism necessarily mean a hopefulness or confidence about the future of ongoing political struggles. Rather, he interrogates the nature of Blackness as social death by describing how categories of control, regulation, and hierarchization are revealed when we attend to the attitudes, behaviors, and ideas that a white culture calls "black." Moten asks, "how can we fathom a social life that tends toward death, that enacts a kind of being-toward-death, and which, because of such tendency and enactment, maintains a terrible beautiful vitality?"[66] His description of optimism as an unintelligibility that makes an ephemeral sort of Black resilience possible suggests that the answer is to attend to the vibrancy of Blackness's radical potential to upend the normative.

The case of Blackness thus raises questions about the aesthetic nature of Blackness and its deconstructive affect, the very issues that inspire Parks's dramaturgy. To be more specific, in an experimental 2005 essay called "New Black Math," Parks charts the delimiting effects of an aesthetic Blackness by responding to the question, "What is a black play?" Her reply is far-ranging and, in many ways, includes paradoxical answers. She begins by noting that a Black play is angry, fierce, double-voiced, and full of style.[67] As her response unfolds, however, her characterizations become more abstract, and many of them resonate with the optimistic orientation that *100 Plays for the First Hundred Days* aims to inspire. She writes that a Black play "keeps you up at night," that it "dreams the impossible dream," and that it "fights the power." At long last, Park depicts aesthetic Blackness by its relation to normativity, whiteness's temporal regime, and the sense of historical fixity through which the modern racial episteme aims to produce and preserve Blackness's culturally legibility. She writes that a Black play "takes shape just outside the reaches of your white understanding, no matter what your color, baby," that it "KNOWS what time it is," that it "knows all about the black hole and the great hole of history and aint afraid of going there," and that it "is not ignorant of history, but neither is the play history's slave."[68] The essay ends by affirming critical Blackness's radical orientation

against the holding power of racial discourse. "A black play employs the black not just as a subject, but as a platform, eye and telescope through which it intercourses with the cosmos," because it "recognizes the importance of the evidence of things unseen," Parks writes, before reaching an abstract conclusion: "a black play can take you there."[69]

Parks's "New Black Math" enlivens Blackness not simply as a product of racial discourse or a model of subjugation but as the timeless force that "embraces the infinite" to question the presumed authority of white supremacist historiography and the order of racial hierarchization that it aims to instantiate. Under the weight of her multiple and paradoxical responses, it becomes clear that Blackness's dynamic inertia escapes representation, as well as the paralysis of language, because it takes shape only as the ceaseless fugitivity that ruptures ideas about Blackness's historical fixity and challenges rationalized time consciousness. Moten associates such an animative deconstructive sensibility with Black optimism because it expresses what Blackness is—a vehicle for querying the racial order of the West—as opposed to what it cannot be. Instead of fixity, social death, or slaveness, in Parks's dramaturgy, inertia describes an antagonistic sublimity that reacts to—and upends—the very discourse that insists on Blackness's impossibility, the kind of radical orientation that breaks every epistemic enclosure through which we have been conditioned to think that we can know Blackness.

For Parks, upending the cultural determinants of despair, injustice, and cruelty is a process of querying a historical timeline shaped by white supremacist ideas and thus, as she represents it in *Mayday*, sparking a bit of light. These are the terms with which she describes *100 Plays for the First Hundred Days*. In the preface to the cycle, she says the plays are "full of hope and rage and humor and despair and joy and astonishment and pride and disbelief," and that dramatizing the full range of those emotions was the most effective way to voice her opposition to the right-wing populism that Trump and his administration espoused. She represents the plays as part of an exercise in developing and conditioning the resistive consciousness described in the previous section: "the best way, during those first 100 days of our new era, as our new president was elected on the promise that he will make us all great again, well, bearing witness and writing these plays was the best way I knew how to stay woke" (xv). Staying woke, as it appears here, involves some record-keeping and some dramatization, a blurring

of historicist and aesthetic critique, all in the service of producing a little spark of light. It is "righteous behavior" that inspires other righteous behavior, the inertia of critical Blackness as a momentous force that defends and sustains Black life.

100 Plays for the First Hundred Days does more than just show how Western history tries to predetermine and reduce Blackness from the outside, as Fanon emphasized when he wrote, "I did not create a meaning for myself," for "the meaning was already there, waiting."[70] In revealing that historically sedimented meaning is still there, waiting, in the twenty-first century, Parks exposes time as the dynamic force behind the historical-racial schema. By abstracting Blackness as a coherent paradigm of identity, the cycle also insists that Blackness is not reducible to slaveness or other paradigms of antimodern subjectivity. Rather, it gains momentum from the modern racial episteme's assertion of ahistoricity, disputing racial discourse to disclose, as Fanon also wrote, that "the black experience is ambiguous, for there is not *one* Negro—there are *many* black [individuals]."[71]

Although the ideologies of the modern racial episteme may contend that Blackness signifies the antithesis of Western modernity and modern subjectivity, Parks's dramaturgy troubles the linear progress narrative of white supremacist historiography by depicting Blackness's role in fissuring the ideologies that aim to fix Blackness. Parks's critical Blackness becomes sensible when it escapes or exceeds the historical-racist force that disavows it, when—as she had written—it sparks some bit of light that helps others continue.

HERETICAL POETICS IN ROBIN COSTE LEWIS'S *THE VOYAGE OF THE SABLE VENUS*

Not enough is said about the indoctrination of perception. Of course, you had to run because the duration of black performance was always very limited in the media. If you took your time, you'd miss it. It is difficult to explain the psychological damage of what it feels like never to see yourself reflected back in your world in any way, ever, even physically, except as caricature—and even then, so rarely. That's a skewed experience of perception that is hard to explain.

—ROBIN COSTE LEWIS

A DEPARTURE: THE JANUS FACE OF ART

Robin Coste Lewis's poetry makes museum art easy to visualize but difficult to see. For example, midway through the seventy-nine-page title poem of her debut poetry collection, *The Voyage of the Sable Venus*, readers encounter this series of ekphrastic couplets:

Nude Black Woman
in an Oyster Shell

Drawn by Dolphins
through the Water

and Accompanied by Cupids,
Neptune, and Others.[1]

The art object to which Lewis alludes—but does not reproduce visually—is William Grainger's 1794 engraving of Thomas Stothard's allegorical painting, *Voyage of the Sable Venus from Angola to the West Indies*. This painting illustrates Isaac Teale's 1765 poem, "The Sable Venus; An Ode," in the

second volume of the third edition of Bryan Edwards's 1801 book, *The History, Civil and Commercial, of the British Colonies in the West Indies*. A prime example of iconography as pornography, Stothard's *Voyage of the Sable Venus from Angola to the West Indies* reinvents the Venus of Sandro Botticelli in a way that glorifies the Middle Passage, an effect he achieves by replacing anything recognizable as slavery with the romanticized charm of Black femininity.

Stothard centers the classically embellished image on a Black female, who sits atop a velvet chair in a scallop shell pulled by two dolphins. Surrounding her are eleven white male figures. These include Neptune on her right, who wields the Union Jack rather than a trident, and Cupid, who Stothard pictures above the Sable Venus, drawing his bow in Neptune's direction; a Triton on her left blows a horn. Around the shell are eight cherubs, two below helping to pull the second dolphin, and six above, two of whom fan her with ostrich plumes while another holds a peacock feather. The Sable Venus, who wears nothing but a thin decorated girdle and some jewelry (a collar of pearls, bracelets, and anklets), eyes the dolphins' reins with a look of determination. Her grip on the reins seems to suggest that her journey is one for which she has volunteered, although the contemporary viewer knows that choice was never available to the enslaved.[2]

In an interview with the novelist Matthew Sharpe, Lewis explained that what struck her about this representation of Venus was the way it is "beautiful and horrible simultaneously."[3] She similarly told the journalist and author Angela Chen that it is "really compelling if you can wipe from your mind that it's a pro-slavery image."[4] These observations of the work's duality highlight the intersection of aesthetics with politics that gives a Janus face to museum-housed artworks: *The Voyage of the Sable Venus from Angola to the West Indies* is beautiful and horrible, a celebration and a delusion that reproduces Venus's grace even as it romanticizes the slave trade. Lewis has stated that Stothard's representation of Venus was the inspiration for her poem by the same name, "The Voyage of the Sable Venus," which she describes as "a narrative poem comprised solely and entirely of the titles, catalog entries, or exhibit descriptions of Western art objects in which a Black female figure is present, dating from 38,000 BCE to the present" (35). Venus is one of many figures who appears in Lewis's debut collection, which won the 2015 National Book Award for Poetry.

This chapter shows how Lewis's poem challenges historically entrenched figurations of beauty and femininity, such as those generated and perpetuated by *Voyage of the Sable Venus from Angola to the West Indies*, by mixing and remixing the language that historians and curators have used to title and describe artworks that stage the Black female body in Western art history. I argue that Lewis does not simply reproduce the visual-art objects to which she alludes but, rather, develops an aesthetic strategy that allows the titles and descriptions to act on the sense of history that they help to create. By making visible the invisibility of Blackness in the Western art-historical canon, "The Voyage of the Sable Venus" aims to provoke a response to the racial discourse that supplements the history that we think we know, the mythological narrative of Western supremacy.

In *Archives of the Black Atlantic*, Wendy W. Walters shows that many writers have turned to poetry to wrest new and radical meaning from historical representations of the Middle Passage, as well as the narratives such representations fortify.[5] She explains that works like Robert Hayden's "Middle Passage," for instance, raise vital questions about historical representation and identity, not to mention their relation to current regimes of racial knowledge. In conversation with Walters, Carl Plasa has observed that poets writing in Hayden's wake have given special attention to the visual dimensions of the transatlantic slave trade's archive. According to Plasa, poems in which ekphrasis meets the Middle Passage are confrontations with "a white visual culture [that] represents the black subject, whether enslaved or free, according to particular assumptions."[6] David Dabydeen's *Turner*, M. NourbeSe Philip's *Zong!*, and Claudia Rankine's *Citizen* are a few well-known examples of ekphrastic returns to the troubled waters of the Middle Passage.[7] As Plasa might argue, these sorts of texts act as powerful conduits of historical memory and, thus, as vehicles for addressing the historical catastrophe of the transatlantic slave trade, because they dispute and revise the material remnants of the archive and trouble historical consciousness.[8]

This characterization resonates with Lewis's aesthetic of recuration, which challenges the very notion of historical study by intercepting and rewriting the ekphrastic language that artists, artisans, historians, and curators have used to title and describe museum-housed artworks. In her radical adjustments of this language, Lewis reveals the power of the museum's words in predetermining how Blackness can be seen, imagined, and known.

To show how "The Voyage of the Sable Venus" queries the authority of the archive and its role in historical meaning-making, I put Lewis's poem in conversation with the French historian and political theorist Jacques Rancière. Building on Rancière's notion of heretical history, this chapter shows how Lewis mixes and samples the titles and descriptions of well-known visual works that stage the Black female body for Western consumption, and then argues that her poetry recurates such practices to expose racist patriarchal systems and provide a new, critical perspective on the potentialities of the histories that have gone unrecorded and untold. My intention in reading "The Voyage of the Sable Venus" alongside Rancière's notion of heretical history is not to suggest that Lewis's poetry comes to act as historical revisionism, or that she offers her readers any data that they could record and share as a conventional history. Indeed, according to another of this chapter's interlocutors, Saidiya Hartman, the unarchived stories of Africa and its young enslaved women are irrecoverably lost.[9] As an alternative to reviving a historical narrative in any traditional sense, and with Hartman's critique of the archive's limits in mind, I argue that the critical Blackness of "The Voyage of the Sable Venus" marks the limits of history and historical recovery by tracing the radical ambiguity of the figure of Venus through the Western art-historical canon. In other words, this chapter does not suggest that "The Voyage of the Sable Venus" recounts and records the facts and details of the lives and events that manifest our sense of the past; rather, it comments on the historian's relation to history and its telling and, in doing so, celebrates the illegibility of the past as an opportunity to challenge history's rationalist aspirations.

HISTORY HIDES IN THE TONGUE: THE POLITICS OF HISTORY WRITING

In an interview with Leah Mirakhor, Lewis noted that she often feels written out of history, that she regularly feels she is "asked . . . to deny the colonial history of [the United States]" because it does not align with the propagandistic story of American exceptionalism.[10] She emphasized that this narrative has little to no interest in recounting the colonization of Indigenous peoples' lands or the horrors that enslaved Africans endured, so it erases those kinds of catastrophes, historicizing them only as a kind of unspeakable absence. In Lewis's view, mainstream conceptions of the U.S.

past remain whitewashed even as individual historians, such as Vincent Brown or Robin D. G. Kelley, continue to uncover and share the Black stories that survive these erasures. For this reason, she is consciously suspicious of "history" as a tool of white hegemony:

I also refuse to accept 1492 as the inception of black history. I refuse that at every step of the way. I think it's a brilliant sleight of hand to ask African Americans to think of ourselves this way, with a history that is only a few centuries old, and before that we were nothing, a blank. I refuse to agree to this fantasy, because that means we began in slavery, which is to say, as no one, and we all know that that is not true. To think we started from slavery means that we are doomed; it lets everyone off the hook from reconstructing a more nuanced, less propagandistic history.[11]

Lewis's suspicions are in line with the intellectual framework of the Black radical tradition, which has shown that English-language history acts as a colonial governing device that creates and perpetuates discursive constructions of race and gender. These critiques remind us that the manner in which the story of the past is told functions as political machinery that magnifies or minimizes certain events and communities (as well as the injustices that they have faced and, in many cases, continue to face). If Lewis refuses to accept historical narratives that exclude or erase Black life, then we might ask how "The Voyage of the Sable Venus" challenges the racial politics of historical production, by which I mean the ways that the past has been conceptualized, discussed, and narrated in terms of Africa and its descendants.

In *The Names of History*, Rancière proposes a radical historical method for acknowledging the people and groups who die unheard, unseen, and unnoticed by history, even as their repressed presence haunts both the historical record and our present understanding of it.[12] Like Lewis, he seeks a historiography that is politically and aesthetically self-conscious, one that divines new ways of knowing the past by studying history's silences. Such an approach to historical production is distinctly egalitarian, as it aims to recover a sense of the anonymous people and communities that tend to be overlooked, effectively reversing Walter Benjamin's thesis that the story of the victors always overshadows the tales of the vanquished, abject, or downcast.[13]

Rancière argues that by focusing on long-lasting historical continuities, many historians have effectively silenced the dissenting voices that might make radical exclamations in the course of history.[14] He characterizes such

dissenting exclamations as heresy. As "the excess of speech" in history, heresy broadly refers to the radical potential of the unorthodox thoughts, writings, and actions that he believes historians have overlooked, whether they have done so accidentally or purposely due to disciplinary constraints. Since the narrative of history with which we are familiar renders this dissent anonymous and unidentifiable, Rancière figures heresy not as "a particular object of the history of mentalities" but, rather, as the irreducible dissidence between the past's disorderliness and the conventional historiographical methods that rationalize it to make it seem intelligible.[15] According to Rancière's unconventional historiography, the thoughts, writings, and actions that haunt the legitimacy of the conventional, grand narrative of the West, such as those that Lewis's work animates, are distinctly heretical. These voices are neither revisionist nor part of a conventional mode of historical recovery, however, because they attempt to read existing historiography against its erasures. That is, they offer no alternative narrative through which the past might be made rational but, rather, call into question the possibility of its narration.

Fundamentally, Rancière urges the historian to study the illegibility of the content in, beneath, or behind the events that manifest the existence of the past.[16] As he explains, the words, names, images, and objects that form the foundations on which the narrative of history seems to rest are actually the effects of the individuals, phenomena, and structures that they inevitably obscure. For example, while William Grainger and Thomas Stothard, Isaac Teale, and Bryan Edwards are figures who we can locate in the historical record, their careers and artworks—such as *Voyage of the Sable Venus from Angola to the West Indies*, "The Sable Venus; An Ode," and *The History, Civil and Commercial, of the British Colonies in the West Indies*— each signifies far more than any factual recounting of their lives ever could. Hayden White has clarified that Rancière would urge the heretical historian to consider how "lying beneath or behind or within [their careers] are the lives, thoughts, deeds, and *words* of the nameless millions of people who made that career possible, participated in it, were ruined or destroyed in the course of and because of it, and left their *anonymous* mark, their *unidentifiable* trace on the world of that time."[17] The political potential of the unknown figures that help to determine the order of history also threaten to disrupt it, in other words, and it is the task of the heretical historian to make their voices audible even if they remain irrecoverable in a conventional sense.

By interrogating the relationship of the Western art-historical canon to the language with which the museum titles and describes its objects, "The Voyage of the Sable Venus" shares the impulse of a heretical history. Lewis's heretical poetics, like Rancière's, is unconcerned with a study of history understood as "the past," in which certain events have occurred. Alternatively, she examines how the language that historians and curators have given to museum-housed artworks have affected (and continue to affect) the ways we think about Venus and the Black female body, as well as the voices that they muffled, voices we might still be able to hear. Her project is heretical because it challenges the grounds of historical sensemaking, because she is interested in "how easily we agree to the definitions of history" and the poetics through which that agreement might be fractured.[18] In this fashion, "The Voyage of the Sable Venus" develops as a meditation on the historian's relation to history and its telling. As Rancière might say, Lewis's work unfolds as an assault on "the procedures of meaning by which a historicity is defined," because it asks historical science to confront its own constraints and limitations.[19]

"The Voyage of the Sable Venus" thus joins the host of projects that Darby English has described as interrogations of "the social relations reflected in, or implied by, standard museum protocols, approaching philosophies and methodologies of collecting—concretized in presentational schemes deciding what and how objects are arrayed, revealed, and encountered—as readable models of social thought."[20] The archive that emerges over the course of Lewis's poem constructs a conceptual museum in the mind of her reader, effectively helping audiences to encounter the illogic through which the grand narrative of Western history has privileged certain accounts of the past—its events, people, and structures—while misnaming, obscuring, and ignoring others. Central to Lewis's heretical poetics, the title of her work suggests, is an analysis of the ways that the language of the museum reveals or conceals the figure of Venus, how it validates certain ways of thinking about Black femininity while discouraging others.

WRITING HERESY: THE LIMITS OF
THE ARCHIVE AND THE FIGURE OF VENUS

Characterizing Lewis's poetics as heretical historiography raises a complicated question: how should we approach the vacuousness of a history

that has papered over Africa and its diaspora? As Hartman has shown, our relation to the historical archive surrounding slavery is tenuous. Following *Lose Your Mother*, a book that attempts to describe the afterlife of slavery, Hartman published "Venus in Two Acts," an essay that reflects on the challenges raised in that project. In "Venus in Two Acts," Hartman illustrates an obstacle faced by those who wish to recover and share the unarchived stories of Africa. Her focus shifts to a young woman who appeared in the archive only by a passing mention to her enslaved name:

One cannot ask, "Who is Venus?" because it would be impossible to answer such a question. There are hundreds of thousands of other girls who share her circumstances and these circumstances have generated few stories. And the stories that exist are not about them, but rather about the violence, excess, mendacity, and reason that seized hold of their lives, transformed them into commodities and corpses, and identified them with names tossed-off as insults and crass jokes. The archive is, in this case, a death sentence, a tomb, a display of the violated body, an inventory of property, a medical treatise on gonorrhea, a few lines about a whore's life, an asterisk in the grand narrative of history.[21]

In her attempt to salvage the lost narrative of Venus, an enslaved woman who died aboard the *Recovery* and about whom history has afforded only a few words,[22] Hartman arrived at a dilemma. Retrieving her stories seems to require pushing beyond the boundaries of the historical record, which results in a romance exceeding even the fictions of history, Hartman explains. Yet, the alternative approach of recounting demographic projections and the perverse arithmetic of the slave trade amounts to hollow quantifications that seem to serve the very rationalism that had been used to justify the woman's enslavement. Unable to recoup anything beyond an imaginative recreation, "a vision of . . . the bodies of two girls settling on the floor of the Atlantic,"[23] Hartman mourns that she has reached the archive's limits in terms of rescuing Venus from obscurity.

Rather than using Hartman's "critical fabulation," a writing methodology that fills in the gaps of the archive to generate speculative histories, Lewis develops an intricate compositional practice that extrapolates hints of meaning from the traces of Blackness that survive history's whitewashing. To this effect, "The Voyage of the Sable Venus" does not aspire to create a historical counternarrative or to make sense of the vacuousness

of the archive. Instead, it celebrates the radical potential of the unknown and unknowable as a means of interrogating the rationalist impulses of historical study and historical recovery. It transgressively defamiliarizes history as a figure of rationalism by recurating the language and art objects that seem to legitimize the colonialist fiction with which we are familiar, that which narrates Western development and supremacy while erasing any sign of Africa and its diaspora, including the role of enslaved labor in creating the wealth and power that nations like the United States hold in the present.[24]

"The Voyage of the Sable Venus" is composed of eight sections, which Lewis calls "catalogs" to signify on the sort of historical periodization commonly used to organize the art-historical canon and museum space. Following two brief preludes, titled "The Ship's Inventory" and "Blessing the Boat," which call to mind the Middle Passage, a dominant theme throughout Lewis's collection, readers enter the poem's dramaturgical museum by way of a catalog named "Ancient Greece & Ancient Rome." After a second catalog, titled "Ancient Egypt," Lewis guides readers toward the present in catalogs called "The Womb of Christianity" and "Medieval Colonial." The four remaining catalogs are "Emancipation & Independence," "Modern, Civil, Right," "Modern Post," and "The Present/Our Town."

To guide her approach to troubling and recurating the archive, Lewis devised a set of formal rules, which she outlines in the preface to her work: "No title could be broken or changed in any way. While grammar is completely modified—I erased all periods, commas, semicolons—each title was left as published, and was not syntactically annotated, edited, or fragmented" (35). In other words, Lewis accumulated titles, descriptions, and catalog entries, then removed all their formatting devices. Next, she reassembled the titles and descriptions but selectively added capitalization and punctuation to alter their original meanings. Although, as she explains, no title was syntactically annotated, edited, or fragmented, her process did include adding space to break the individual titles over multiple lines of poetry. Consider, for instance, how the following passage, from her "Ancient Egypt" catalog, weaves together and splinters apart the titles and descriptions of numerous museum pieces:

A Cleopatra holding a—?
Cornucopia Attendants moving

from left to right linen,
from mummy-wrapping Aphro

Dite rising from the bath. I Sis Aphro
Dite clasping a garment

rolled about her hips:
The Place of Silence (56)

Even though Lewis calls "The Voyage of the Sable Venus" a narrative poem of history, it displays few narrative hallmarks and resembles neither a typical account of the past nor a conventional mode of historical revisionism. Instead, Lewis is interested in the phenomenological impressions that an encounter with historical language can activate. "American readers tend to look away from the horrors of our history," she explains, "so if I write it lyrically, and use interesting words in intricate ways, perhaps the reader will stay longer with me on the page, long enough to feel the history."[25] This mode of lyrical seduction allows for subtle experimentation with grammar and enjambment, sometimes to provoke a sensibility of fragmentation and delay the line's resolution and other times to create a sense of continuity between the individual titles, descriptions, and catalog entries with which Lewis worked. More than just a historiographic challenge, then, Lewis's formal rules set the limits within which experimentation and improvisation become aesthetic strategies for restoring history's illegibility.

In the foregoing passage, for example, Lewis troubles our preconceived notions of history's inhabitants by adding space to the names Isis and Aphrodite. Isis becomes both "I," the first-person singular nominative case personal pronoun that seems to name both Lewis and her reader simultaneously, and "Sis," which suggests a familial relation that collapses the temporal distance between the present and the ancient time of the Egyptian goddess. Similarly, Lewis breaks apart the name Aphrodite—the Greek goddess of love, beauty, pleasure, and procreation whose Roman equivalent is Venus—to create a sense of Africanity in the homophonic association of "Aphro" to afro. We might note, further, how the long dash and question mark in the first line draw attention to the ambiguities and disorder that the archive attempts to make rational, as well as how Lewis's

experimentation culminates in a confusion of the senses, the synesthetic final line of this selection suggesting that silence might be locatable in space rather than sound.

Although Lewis alters the language of the museum, her grammatical changes do not result in an invented or romantic historical narrative, against which Hartman explicitly warns. In part, this is because "The Voyage of the Sable Venus" participates in a tradition of found poetry, a tradition in which poets construct their work out of words, phrases, and passages of preexisting sources, making only minor changes to spacing and punctuation—rather than adding linguistic content—to impart new meaning to a source text.[26] Lewis neither reproduces directly nor rewrites completely any of the language belonging to her archive. Instead, she finds historical implication in the reserve of meaning made visible by exhibiting and (re)arranging the preexisting language of the museum, including that which has obscured or erased Blackness from the Western art-historical canon.

Whereas Hartman had concluded that Venus might be recoverable only in terms of a speculative critical fabulation, Lewis contends that she may also survive in the very language that appears to erase her, and that she might thus be permitted to speak under the right aesthetic conditions. In *Lose Your Mother*, Hartman describes such a mode of survival as a false promise, writing that she had been "unsure if it is possible to salvage an existence from a handful of words" and glossing Michel Foucault in her conclusion that "[Venus] 'never will have any existence outside the precarious domicile of words' that allowed her to be murdered."[27] However, unlike in Hartman's essay, the Venus of Lewis's poetry is not any Black female in particular, whose story of capture and enslavement might be recorded and shared conventionally.[28] As an alternative to the "history of an unrecoverable past" that Hartman describes in "Venus in Two Acts,"[29] or even of reading the archive as a record of what histories can be written or spoken, Lewis evokes Venus as a heretical figuration. She is an illegible, figural embodiment of the heresy that questions and polices the absence of Africa and its descendants from the history that we think we know.

The presence of Venus as a figuration of heresy is especially apparent in a passage from the poem's "Modern Post" catalog:

Silence.

Poise. Prayer:

> *Tinted Venus*
> *African Venus*
> *Dolni Vestonice*
> *Magdalenian Venus*
> *Ram Mal'ta Venus*
> *Venus from Laugerie-Basse*
> *Venus of Hohle Fels*
> *Venus of Monruz*
> *Venus of Willendorf*
> *Venus of Berekhat*
> *Venus of Lespugue*
> *Venus of Hradok*
> *Venus of Tan-Tan*

(THIRTEEN WAYS OF LOOKING AT A BLACK GIRL) (108)

By collecting and listing the titles of these sculptures and figurines, Lewis draws attention to Venus's broad presence in the Western art-historical canon, one that goes back at least to the Upper Paleolithic era, as the *Venus of Hohle Fels* is believed to be between 35,000 and 40,000 years old.[30] While celebrating Venus's archival omnipresence, "The Voyage of the Sable Venus" also condemns the museum. The parenthetical suggestion that these thirteen figurines amount to "Thirteen ways of looking at a black girl" references Wallace Stevens's "Thirteen Ways of Looking at a Blackbird."[31] Lewis positions this title to indict the archive for having created the stereotypical body of Venus, that which is associated with voluptuous breasts and incised vaginal openings. In her recuration, Lewis draws together these imaginative works about Black femininity and thus animates the idea of Venus without reproducing these physical markers, recuperating her illegibility. By suggesting that these works are versions of the same figuration, Lewis's poetics set a tone from which new historical imaginings might become possible. Though such a historiography may feel distinctly antihistorical, Rancière reminds readers that "the question of the poetic form according to which history can be written is . . . strictly tied to that

of the mode of historicity according to which its objects are thinkable."[32] It is the incoherency and illegibility of Venus's figuration that makes Lewis's discursive critique possible.

Hartman had decided against writing about Venus out of "fear what [she] might invent," believing that "it would have been a romance,"[33] but Lewis's formal rules demarcate a historical framework in which improvisation—allowing herself to modify grammar and play with enjambment at will—creates the conditions in which Venus's possibilities (rather than her irrecoverably lost historical actualities) might become discernible in an abstract way. We need not only mourn the emptiness of the archive as a sign of history's impossibility; we can also, Lewis's heretical poetics suggests, read the scars of historical erasure as openings for generative exclamations in history. This is not to say that Lewis prompts Venus to speak through her pained embodiment, as Hartman cautions against, but that Lewis asks readers to consider that the language of the museum might have preserved a notion of Venus. As an alternative to the quantifications of ship inventories or fragments of discourse in medical treatises, which Hartman characterizes as records of Venus's violated body, heretical poetics contemplates the possibility of Venus's persisting in the excess of the dismembered language that artists, artisans, historians, and curators have attributed to her.

Despite the historiographical difference between Lewis's and Hartman's works, we might read "The Voyage of the Sable Venus" as a complement to "Venus in Two Acts," as Lewis's success in recuperating a sensibility of Venus comes to depend on the very restraint for which Hartman advocates. Lewis heeds Hartman's warning, never asking, "Who is Venus?" Recognizing that such a question cannot be asked, or that it has no answer, the Venus of Lewis's work is always illegible and nonprescriptive, always at work to escape categorical capture. Indeed, the function of her radical figuration is to exist as an enigma, one that poses questions about the very possibility of historical sensemaking by rejecting its rationalist aspirations. For this reason, it is in the subtlety of Lewis's alterations and the artfulness of her presentation—in her poetry's capacity as an assemblage of preexisting scraps to communicate some meaning in excess of the individual titles, descriptions, and catalog entries themselves—that heresy comes to enact the critical Blackness that queries the history with which we are familiar.

THE WORDS THAT NARRATE THE ABSENT BODY:
MODIFYING THE MUSEUM

Across the eight catalogs that make up "The Voyage of the Sable Venus," Lewis comments on the relation of the museum as an institution to the grand narrative of the West and its telling. By adjusting the titles and descriptions of museum-housed art objects, she causes the language of the museum to reveal its racist patriarchal foundation, challenging audiences' perceptions of history similar to how Suzan-Lori Parks did so by distorting perceptions of time. Like Parks, Lewis conditions an encounter that asks readers to question the incongruities between the propagandistic knowledges about Blackness's role in history and the other possible pasts that her heretical poetics make sensible.

Lewis opens the first catalog of "The Voyage of the Sable Venus" by rewriting the description of a museum piece, "statuette of a woman reduced to the shape of a flat paddle." By adding enjambment and capitalization to the phrase, Lewis produces a dramatic shift in the relation of the words to one another. The art object in question becomes "Statuette of a Woman Reduced / to the Shape of a Flat Paddle" (43). In her heretical adjustment, Lewis shifts the adjective ("reduced") so that it functions not as a description of the statuette but, instead, serves to describe the female figure at its center. It is no longer the ornament that the language identifies as reduced; rather, it is the Black woman who is displayed in the exhibit as an object. Whereas positioning the adjective to modify the art object allows the source text's language to afford the feminine body of the statuette little to no recognition, Lewis offers the feminine figure a part of speech and testifies to the role that Black women's bodies have played in the production of such ornaments.

By breaking the museum's descriptive title into two separate lines, furthermore, the poetics of "The Voyage of the Sable Venus" isolates the seemingly erased Black femininity and puts it on exhibition: "Statuette of a Woman Reduced." Such a linguistic modification exploits the ambiguity of the archive to prompt a pause and reconsideration of the relation of history's language to the representation of the past it offers; moreover, it reads Venus's apparent absence in such a way as to conjure her presence. Of course, as Hartman states, the figure in whose image the statuette has been carved is irrecoverably lost as a historical referent. Yet, because Lewis's

poetics focus on the historiographical procedures and linguistic patterns that have systematically erased Venus from the archive, her critical Black femininity seems to retain a haunting presence in the sensibility of heretical critique that "The Voyage of the Sable Venus" is at work to produce. Lewis's heretical critique comments simultaneously on the archival absence and figural presence of Blackness in the museum. That is, in addition to drawing attention to the history of systematic erasure that Hartman assures readers Venus has sustained, Lewis's recuration also positions the language of the museum to make illegibly visible Black femininity's invisibility within the Western art-historical canon.

How Lewis situates the language of the museum to confront its own historicity is also evident in the way she highlights the description's passive construction in the phrase "a woman reduced." By doing so, Lewis insinuates that the commonsense historical narrative with which we are familiar is not concerned with identifying those who have reduced and erased Venus, that it aims to absolve them of responsibility for the violence of historical erasure. "The Voyage of the Sable Venus" thus shows how the words of museums themselves have played a role in reducing Venus to the point that her place in the historical record is no longer salvageable. Altering the relation of the source text's language to the art object that it titles or describes, Lewis draws the racist patriarchal ambitions of cultural hegemony out of the seemingly objective words of the museum. Under Lewis's poetics, the language reveals its epistemological function, how it substantiates certain ways of thinking about Black bodies and Black femininity while obscuring others. At variance with itself, having made visible the very Blackness that it had previously worked to render invisible, the language of the museum here shifts into heresy, speaking against itself in particular and the failures of its historiography in general. As this analysis shows, heretical critique finds expression not in the titles and descriptions that historians and curators ascribe to art objects featuring Black women's bodies but, as Rancière writes, in the way that Lewis's presentation narrates the "power that causes them to be written, that is expressed in them."[34] The exposure of the museum's racist patriarchal politics is distinctly heretical because it calls into question the legitimacy of the historical narrative with which many Americans are familiar, and in this way it upholds Lewis's suspicions of history's imperializing claims to truth.

In the beginning of her second catalog, Lewis creates a similar disso-
nance between historical science and the discursive outcomes of its dis-
ciplinary practices. In this case, her focus is on the body politics of an
exhibit description. Again, with enjambment, punctuation, and capitaliza-
tion, Lewis adjusts the language of the museum to prompt a broader, more
open-ended perspective, one that is skeptical of history's claims to have
represented the past apolitically:

> A standing figure of a Laughing Person
> wearing a short tunic with large broad nose, thick
> lips, and both male and female attributes: his right
>
> arm broken off at the elbow, the left
> arm missing completely. (55)

The changes that Lewis makes to this exhibit description draw attention
to the joy of the model, whose title—*Laughing Person*—she capitalizes, at
once reinforcing a sense of personhood while maintaining the figure's ano-
nymity and, by extension, metonymic function within the symbolic realm
of poem. By isolating the unidentifiable figure and his posture to a single
line, she prompts an acknowledgment of the strength and freedom that his
upright position signals. Further, as with the previous example, line sepa-
ration plays an important role. The space that Lewis creates between the
Laughing Person's facial attributes and broken extremities resonates with
the sense of distance between personhood—which Lewis finds in the face
and celebrates as beautiful—and the violence of nominal erasure (not to
mention the severed limbs).

More significant, however, is the colon that Lewis adds to the third line
of the selection. Functioning as an intervention in the politics of gender
and the body, as well as their relation to the figure of Venus, Lewis's dis-
senting colon and subsequent "his right" endorse the androgynous body
of the other and assert its right to be. No longer does the language of the
description serve merely to direct a viewer's gaze to the irregular or dam-
aged body. Now "his right" is a gesture that ratifies personhood. We might
read this blunt confirmation as a heretical stand against the arithmetical
multiplications and general linguistic rationalism that Hortense Spillers has
argued dehumanized, ungendered, and defaced enslaved persons during

the movement out of Africa and into the world of racial capitalism,[35] as Lewis's poetics repositions the language of history to affirm the legitimacy of the nonnormative subjectivities it had once summarily dismissed: "both male and female attributes."

As with the first example, then, Lewis's critique of the language describing the Laughing Person turns the words of history against the rationalism that they uphold, providing an opportunity for speculation about the limits of Western philosophy more generally. Henry Louis Gates, Jr., has shown that Western art objects' representations of Africa can be read as "the projection of [white] fantasies from their collective unconscious."[36] The found-poetry aesthetic of "The Voyage of the Sable Venus" suggests that the museum language titling and describing such art objects functions no differently. Just by including the note "both male and female attributes," Lewis's alteration indicates, the historians and curators who titled, preserved, and displayed the Laughing Person have revealed anxiety over the limitations of categories like male and female, masculine and feminine, and perhaps even heterosexual and homosexual, or Black and white. Lewis's carefully placed colon exposes both this anxiety and, arguably, the fantasy of exceeding the binary categories to which rationalism has bound itself.

The "Medieval Colonial" catalog of "The Voyage of the Sable Venus" is also an exemplar of Lewis's heretical poetics. Consider, for example, the recuration of the entry "negro man strapped to a ladder being lashed," which Lewis changes to "Negro Man strapped to a ladder, Being. / Lashed" (72). As an accompaniment to this recuration, several lines later but on the same page, Lewis breaks, capitalizes, and punctuates this other descriptive title:

At Left Negro Man at right, Being.

Held by the collar, two dogs wear
collars, one labeled "Cass,"
the other: "Expounder." (72)[37]

At first glance the descriptive source titles seem objectively and accurately to report the visual content of the art objects (or so we can imagine, since "The Voyage of the Sable Venus" withholds the visuals to which the language corresponds). But Lewis's poetics refocuses our attention on the way that the language surrounds each Black body, highlighting the tension

between its performance of objectivity and the broken humanity that it catalogs. She shows how the seemingly evenhanded language representing each scene is actually invested in dehumanizing its subjects. As before, the language of each entry is complicit in a historical discourse that predetermines how the Black body can be seen, in this case by substantiating slavery as an economic practice. Lewis thus emphasizes that the Western art-historical canon's grammar of description, which feigns objectivity, ultimately reinscribes difference in terms of race and, by extension, humanity, by laying out a power hierarchy between humans, animals, and property—"these are just slaves," Lewis prompts the language of the catalog entry to admit in a whisper, "but the dogs have names."

To show how these catalog entries condition a disconnected and dispassionate engagement with difference and pain, Lewis reshapes their language in significant ways. As with previous examples, she capitalizes "Negro Man" in each entry, which underscores how racial capitalism revokes not only the names but also the subjectivity of Black bodies. Additionally, Lewis creates a line break that partitions the violences of the art objects to separate, second lines of text, then both capitalizes and punctuates "Being." In placing "Being" in proximity to "Negro Man" in each example, Lewis makes a claim for the metaphysical significance of otherness while illustrating the senselessness of the assaults that the other incurs. Specifically, this break highlights the passive constructions, "being lashed" and "being held," in particular how the language of the entry quietly excuses the assailants from the act of violence. Whereas the source texts condition a disinterested mode of engagement with the punishment of the enslaved, the language of Lewis's recuration attends to the humanity of the figures at the image's center, again giving presence to Venus as the critical voice of history's rationalist ambitions.

Lewis's poetic alterations show how the language historicizing art objects of the Woman Reduced, the Laughing Person, and the two enslaved men functions as political machinery that systematically dehumanizes Black subjects while predetermining their representational possibilities in the historical record. The titles and descriptions in each case identify the Black body as not appropriately whole, gendered, or human in a way that calls to mind Spillers's descriptions of enslaved African women and their descendants, for whom no such subject positions existed. Out of such fugitive modes of being, to which normative subjectivities adhere no symbolic

integrity, Venus emerges as a figuration of critical Blackness, a figural embodiment of the heresy that questions and polices the language of history and the representation of the past that it asserts.

With this radical figuration in mind, we might read the laughter of the aforementioned statuette as a critique of the language that tries to obfuscate Blackness in the Western art-historical canon. To let Rancière say it, the laugh of Venus emerges because Lewis, as a heretical historian, has cultivated for her audience a mode of engagement with the past in which "the only one who speaks is the one who *would speak*. And not, certainly not, the one who *spoke*."[38] Once inaudible, the laugh of Venus here challenges the historicity that has produced the whitewashed narrative of Western development. "The Voyage of the Sable Venus" questions this narrative by destabilizing the legitimacy of history's words and, in this way, illuminates history's allegiance to the rationalist project that it chronicles. As a critical accompaniment to the grand historical narrative that we think we know, Lewis's poetry asks not only about the propagandistic ambitions of the histories that such language constructs but also about the heretical histories that become perceptible when it is violated.

VISUAL SILENCE: THE POLITICAL EFFICACY OF THE UNFAMILIAR

Lewis's criticisms of the politics of the museum's language are clear in the way that she positions the titles and catalog entries with which she works to prompt questions about the nature of the historical narrative that they help to substantiate. However, the visual emptiness that pervades "The Voyage of the Sable Venus" magnifies the ambiguity surrounding the art objects that such language titles and describes. This visual emptiness has political and aesthetic effects that pick up on the *jamais vu* and sightless encounter that I theorized in chapters 1 and 2. In line with DeCarava and Walker, Lewis uses an abstractionist mode of ekphrasis to produce a sense of conceptual unease, furnishing an encounter in which the images that manifest our sense of the past become unfamiliar.

One of the most interesting choices that Lewis makes in "The Voyage of the Sable Venus" is to include only linguistic signs referring to museum-housed art objects rather than to reproduce any visual representations of the paintings, sculptures, or other works she uncovered.[39] Instead of

providing photographs or scans of the art pieces whose titles, descriptions, and catalog entries make up her poem, Lewis relies only on the language that artists, artisans, historians, and curators have afforded those pieces.[40] Although these parties have filtered the visual works into verbal representations, Lewis's poetics create even more distance between language and the unseen art objects. "The Voyage of the Sable Venus" thus conditions a sort of sightlessness for the reader, who can "see" the visuals in question only through the twice-filtered language belonging to the unseen objects. In truth, the reader could find visual reproductions of some of the works, like Stothard's painting, with a quick internet search, yet because the vast majority of the artworks are far less infamous, and because many of Lewis's allusions rely on obscure catalog descriptions rather than well-known titles, most of her sources remain unseen. They are opportunities for questions, yet they reassert a mode of visual silence when queried.

At first glance, this visual silence may appear frustrating, as it seems only to amplify Venus's apparent absence from the archive. However, Lewis uses this sense of absence and emptiness to further defamiliarize the art objects to which she alludes and thus draws her audience even further into an intimate and revealing encounter with the potentialities of the possible pasts that white supremacist historiography has concealed. In doing so, she shows how illegibility acts as an entryway into the open-ended essence of heretical history. As Lewis has explained, prompting her reader to think of the archive as constructed and propagandistic does not depend on establishing a cohesive historical counternarrative, or filling in the narrative gaps of Venus's irrecoverably lost story, but on spotlighting the potential that exists in history's ambiguities: "I don't need that story to be present on the page—in fact, I think it's better if it's not. That's where I like silence, that's why I like silence so much."[41] If we take this notion of silence to describe how Lewis withholds visual representations to slow or suspend meaning-making processes, a defiant act that calls into question the very possibility of history's telling, then we might recognize how "The Voyage of the Sable Venus" uses ambiguity and uncertainty to preserve the incoherency and illegibility of the past.[42]

For example, consider how Lewis's line breaks and punctuation actuate a visual silence to amplify historical ambiguity in the following passage, which comes from the opening of her sixth catalog, "Modern, Civil, Right." Across the lines, she combines and breaks apart a series of descriptive titles in a

way that blurs the boundaries between them, disorienting the reader by disturbing the psychophysiological visual processes of the reading experience:

> Anonymous speaking at memorial for Four Negro Girls
> killed in church bombing in Birming. Ham.
>
> President Kennedy addressing the crowd: A Red *Boo!*
> A Negro *Boo!* Young Girls being held
>
> in a prison cell at the Leesburg
> Stockade. Wounded, civil.
>
> Rights demonstrators in the hospital
> and on the street-burned-out-bus:
>
> Bronzeville Inn Cabins for Coloreds. Here lies
> Jim Crow drink Coca-Cola white.
>
> *Customers*
> *Only!* (94)

In this series of couplets, Lewis creates a collage of a number of descriptions of images from the Civil Rights era. Among others, these include pictures of a memorial for the victims of the 16th Street Baptist Church bombing of 1963; President Kennedy delivering a speech; the Stolen Girls of Leesburg, Georgia; hospitalized civil rights protestors; and a symbolic funeral for Jim Crow. Toward the end of the passage, Lewis also includes an advertisement for Coca-Cola and a whites-only sign, or perhaps the language of a Coca-Cola advertisement that promises an ice-cold drink but only to white customers. Each of these images, even with the indistinctness surrounding the advertisement and segregation sign, is easy to envision.

The artfulness of Lewis's collage, on the other hand, blends the language describing the individual art objects in ways that complicate the audience's encounter with their withheld visual content. Once Lewis remixes the descriptions, it is no longer easy to separate the memorial service from the symbolic funeral, or Kennedy's address from the hospitalized protestors. Lewis's poetic alterations do not help the audience to visualize each of the

described works as distinct images, as they might appear in a museum's collection, even though the reader may desire to do so. Instead, her poetic play blurs the images, defamiliarizing each scene. By rendering the original art objects difficult for the reader to separate and envision, Lewis highlights the rupture between the image and the language that historians and curators have given to it. We might recognize such illegibility and disruption of the visualization process as an effect of Lewis's ekphrasis of absence.

Ekphrasis, according to W. J. T. Mitchell and, similarly, Grant F. Scott and James A. W. Heffernan, is "the verbal representation of visual representation."[43] More traditionally, among the ancient *Progymnasmata* writers, Hermogenes argued that ekphrastic language should match its subject matter[44] and Aphthonius claimed that it should imitate the thing described completely.[45] In these conventional senses, ekphrasis is a rhetorical tool that refers to a process by which artists verbally recreate visual artworks in the mind of their audience. These definitions are broad in their utility yet somewhat limited for understanding the radical recurations of Lewis's poem. Reading "The Voyage of the Sable Venus" as "the verbal representation of visual representation" offers little for understanding Lewis's role in the rewriting of the language with which she works. Moreover, conventional models of ekphrasis seem at odds with the visual silence that the poem asserts when we attempt to picture the images that its twice-filtered language describes.

Lewis is less interested in prompting her reader to see the museum pieces to which her language alludes than in highlighting the museum's complicity in racist patriarchal epistemologies. For this reason, her ekphrasis of absence gives an illuminative liveness not to the art objects as the language of the archive has cataloged and displayed them but to the Black femininity that it has aspired to erase from the Western art-historical archive. As an aesthetic strategy that acts on the original visual to which it corresponds, rather than mimetically representing it, Lewis's ekphrasis of absence unwrites the language of historians and curators to unhinge the museum-housed art objects from the rationalism that determines how they can be seen. Lewis's recuration process reproduces the illegibility that the museum space rationalizes and, in doing so, conjures a critical sense of the Venus that the narrative of art history has corrupted.

For example, the transgressive alterations Lewis makes when modifying and mixing the titles and descriptions in her "Modern, Civil, Right" catalog

may prompt readers to give faces to the four girls murdered in Birmingham, whom Lewis highlights by capitalizing the phrase "Four Negro Girls" and placing it at the end of the line of text, even though their faces are likely absent from the original funerary image. The visual-linguistic ambiguity of this passage may further spur the reader to picture "young girls being held," to create bodies for those who hold them, and thus to free the Stolen Girls from their imprisonment by imagining them outside of their cells as attendees to Kennedy's speech. More abstractly, Lewis's poetic retooling of the ekphrastic descriptions may prompt readers to envision anonymity incarnate—giving a body to the speaker in the first line—or to ask what shape civility takes when personified, even if it remains locked in a stockade. In each case, Lewis's enjambment confuses where the description of one image ends and the other begins, but it also draws her reader into more intimate and imaginative encounters with the dramatic scenarios that the language describes.

Importantly, the precise mental visions that the reader imagines are not necessarily relevant. More significant is how Lewis's poetics invoke "phantasia," which Aristotle defines as our desire to provide a mental image for remote or absent sense-objects,[46] as a technique for troubling the relationship of history and historical narrative to epistemology. Unlike the ancient critics, who evaluated poets and storytellers on their ability to make audiences feel "as if you were there yourself," Lewis's ekphrasis of absence intentionally leaves the art objects unseen and unknown to prompt readers to produce imaginings that exceed the visual capacity of the art objects that the language of the poem seems to describe. By withholding visuals and abstracting the source text's descriptions and titles, Lewis creates an illegibility that aims to trouble readers, who must remedy the discomfort of their sightlessness by imagining the absent artwork and its space in the museum. In this way, Lewis intercepts the language of artists, artisans, historians, and curators and then manipulates it, effectively disrupting the pattern of ekphrasis so that it is no longer a mimetic act. It is, instead, a way of evoking radical, fugitive mental images, imaginings that are intentionally unfaithful to the historical record. Lewis's ekphrasis of absence, in other words, puts the reader of "The Voyage of the Sable Venus" in Hartman's position— "long[ing] to write a new story, one unfettered by the constraints of the legal documents and exceeding the restatement and transpositions"[47]—because it asks the reader to ruminate over the vacuousness of Venus's history and

the ambiguities that surround her historical figuration; although whether the reader imagines hospitalized civil rights protestors, the Stolen Girls, or "a vision of . . . the bodies of two girls settling on the floor of the Atlantic" remains largely irrelevant.

The critical value of Lewis's ekphrasis of absence lies in the way it engrosses the reader in the effects of an experience resonant with "mistaking memory," which Tavia Nyong'o presents as a rubric for establishing a theory of hybrid agency in misremembering. As he explains, "most accounts of historical memory are preoccupied with truth: the possible deviation from the recorded truth that memory affords, the performative acts of reconciliation that truth-telling ostensibly effects, or else the higher truth that embodied, experiential memory somehow obtains over dry, written documents." As an alternative, if we concern ourselves "not with the virtues of getting it right but with the ethical chance that may lie within getting it wrong,"[48] we can come to see how the rationalism of historical meaning-making necessarily obfuscates our relation to the people, events, and phenomena that make up the past. Indeed, as I have argued, part of Lewis's project is to create a reading experience that shows how the language of the museum has substantiated racial thought by instilling certain manners of thinking about the relation of the art and documentation to the past and its inhabitants, events, and phenomena.

Bringing Nyong'o into conversation with Lewis's heretical poetics is useful because his interest in the deliverances of misremembering the past—or of remembering the past incorrectly—helps us understand more clearly the potential that accompanies the historical illegibility over which "The Voyage of the Sable Venus" prompts the reader to meditate. The insolubility of Lewis's ekphrasis of absence, the way she suspends her reader in visual silence without the cues necessary for sensemaking, dismisses the notion of historical rightness or wrongness in favor of a broader notion of historical thought in which the past is irreducible to the type of historical "truth" that rationalism has conditioned us to desire. Though Aristotle would dismiss the aforementioned heretical perceptions as false, we must remember that Lewis's poetry calls into question the possibility of history, meaning that it has little interest in questions of truthfulness and no desire to provide anything resembling historical data.

Put another way, Lewis's goal in troubling readers' relation to history is not to provide a corrective but to antagonize what she has called the

"Western fantasy of cohesion" as a performance of wholeness that neglects to engage the discordant fibers and fragments that give it form.[49] In place of the familiar notion of historical accuracy, "The Voyage of the Sable Venus" affirms the value of historical opacity. Having situated a broad notion of truth in the radical ambiguity surrounding the archive's inconsistencies, the spaces of uncertainty in which Blackness manifests as a critical attitude that provokes a policing of the grand narrative of Western history, Lewis animates Venus as a figure at work to dispute the legitimacy of a historical narrative shaped by the modern racial episteme.

Reading Lewis's ekphrasis of absence as a strategy for producing a heretical truth modality suggests that the sightlessness of "The Voyage of the Sable Venus" is not a limitation but a complement to her dissenting project, as the fugitive images it provokes indicate that no archival materials can accurately capture the fullness of the events that contribute to our sense of the past. Through the unfaithfulness of imaginative encounters with the materials of the archive, Lewis explores the possibility of a history that indirectly spotlights the unknown and unknowable aspects of the past. Accordingly, the liberties she takes with the museum-housed art objects are not betrayals of the past to which they correspond but, rather, opportunities to acknowledge the politics always at work in the narrativization of history. By conditioning a desire for completeness and resolution, Lewis draws out some of the concealed aspects of the art objects included in her work. In Hartman's words, Lewis asks her audience "to generate a different set of descriptions from this archive" by "imagin[ing] what could have been."[50] Or, as Rancière might say, she prompts the reader to engage with the unseen aspects of the historical record, those that the historian has overlooked in favor of privileging other stories, even if that engagement is abstract and intangible.

We can see Lewis's poetics prompting this sort of imaginative questioning throughout "The Voyage of the Sable Venus." In each instance, she invites readers to engage an art object or scene that the language of the title, description, or catalog entry contradicts. For example, the line "A-Go-Go Woman Holding Up" (95) evokes a picture of strength, a visual that moves beyond the source image itself.[51] Similarly, "Board the Dead-and-Dying" (73) elicits an image of unselfish care, though it is a description of the exact opposite;[52] and "American Gothic Colored Individuals" (74) encourages the reader to give Grant Woods's well-known painting the racial inversion

that Gordon Parks captured in his 1942 photographic parody, effectively making a statement about how old-time racist values of the United States have Blackened individuals, how white supremacist ideas have invented Blackness as a condition of dejection.[53] In each of these examples, Lewis slows readers' engagement with the poem's language and thus draws them and the language into a critical closeness that begs unanswerable questions about the relation of the art objects to their language.

To think of emptiness as an opportunity for political potential, rather than an inconvenience, is to open history's confines to emancipating possibilities. The apparent silences and ambiguities that heretical history highlights are not shortcomings; rather, they are opportunities for the reader to forge a nonrational connection to the people, events, and ideas that have gone unrecorded. The unfamiliarity of such a process is the driving force behind Lewis's heretical poetics—indeed, heresy, as a doctrine maintained in opposition, or held to be contrary to, orthodoxy, should feel radically unfamiliar. For this reason, it is the art objects' unavailability that conditions an active mode of engagement, one that wakes readers to the bodily, emotional responses that accompany an encounter with history's limits. Like the other artists of *The Racial Unfamiliar*, Lewis encourages us to attend to the feelings we come to experience as we struggle with the vagaries of interpretation and unfamiliarity, the anxiety that we feel when our questions refuse to resolve into answers.

VIOLENT REPOSITIONING: HISTORY, IDENTITY, AND WHITE PATHOLOGY

"The Voyage of the Sable Venus" also exposes the museum's conscious decision to erase some historical racial violence and, as a consequence, the individuals and communities that such instances of racialization have affected. Though Lewis's formal rules prevented her from syntactically annotating, editing, or fragmenting any of the titles or descriptions with which she worked, she explains that she did edit the museum's language to reclaim historically appropriate racial markers:

I realized that museums and libraries (in what I imagine must have been either a hard-won gesture of goodwill, or in order not to appear irrelevant) had removed many nineteenth-century historically specific markers—such as *slave*, *colored*, and

Negro—from their titles or archives, and replaced these words instead with the sanitized, but perhaps equally vapid, *African-American*. In order to replace this historical erasure of slavery (however well intended), I re-erased the postmodern *African-American*, then changed those titles back. That is, I re-corrected the corrected horror in order to allow that original horror to stand. (35)

Lewis elaborates that she had decided to recover the language that the historians and museum curators had chosen to erase "to explore and record not only the history of human thought, but also how normative and complicit artists, curators, and art institutions have been in participating in—if not creating—this history" (35). Her alteration, which she describes as a process of recorrection, is a departure from the found-poetry rules she had established for herself but in line with her overall project. Perhaps the most straightforward act of heresy in "The Voyage of the Sable Venus," these recorrections show how certain language conceals or reveals different perspectives on the past, as well as the experiences of all the people who were involved in its usage. Of course, those whom such usage has affected include the countless people whose lives it ruined, but it also includes those people who participated in its perpetuation by writing and saying it, counting even the artists, artisans, historians, curators, and collectors who participated in the naming, collecting, displaying, and preserving of the art objects under the pretense of objectivity because reproduction is an act of participation.

Lewis's recorrections permeate "The Voyage of the Sable Venus," including the more contemporary catalogs, such as "The Present/Our Town":

Still:

Life
(of Flowers)
with Figures—

including
a Negro servant. (110)

These broken lines, which come from a descriptive title that one might sooner associate with the Renaissance period than the present, end with

the phrase "a Negro servant," suggesting that the racial markers of the past persist into our contemporary moment. At the same time, Lewis's subtle colon in the first line indicates that a sort of (life) force endures despite the archive's racist patriarchal violence. We might characterize Lewis's sense of "Life" as critical Blackness made manifest by heresy, which queries the museum's claims to objectivity and history's claims to truth.

Lewis's linguistic recovery reminds the reader, as Spillers has argued, that racial semantics carry layers of attenuated meanings through time, and that a change in coding does not mean that racial markers no longer reproduce and substantiate difference.[54] The language ascribed to the Black body always signifies more than it names. By collapsing the temporal distance between the "African American" of today and the "slave," "colored," and "Negro" of the past, Lewis again offers up the language of the archive for critique. Even in the present day, this offering illustrates, terminology designating racial difference has a significant political effect, as its usage adds up to a continuation of the same semantic violence that linguistic substitution aims to alleviate. As Lewis has explained, the perpetuation of "African American" as a grammar of description fails to account for the vastness of the African diaspora. It threatens to "put [people of African descent] into this box," she clarifies, and its persistence overlooks "the incredible diversity, even from county to county, parish to parish, not to mention state to state."[55] Accordingly, Lewis's linguistic recovery is another way of making the concealing language of the museum reveal its racism, a way to refute the logic of categorical capture and recover Blackness's illegibility beyond the confines of labels and names.

Recorrection also reintroduces an ethical question that this chapter has deferred. If Lewis's heretical poetics furnish an encounter with the racial violences that the Western art-historical archive has tried to obscure, then we need to return to Hartman's characterization of the archive's limits and her desire to salvage the story of Venus. More directly, in Hartman's endeavor to recover and share Venus's narrative lies a question regarding ethical representation and aesthetic experience: "How does one revisit the scene of subjection without replicating the grammar of violence?"[56] This question pertains to Lewis's poetry because much of the language that she includes in "The Voyage of the Sable Venus" refers to art objects that incorporate an element of racist patriarchal violence.[57] Moreover, an effect of Lewis's invocation of phantasia is a provocation for the reader to visualize

the images of violation and torture that are common to the exhibitions and displays of the museum.

Lewis seems acutely aware of how "The Voyage of the Sable Venus" calls on such scenes, as well as more abstract notions of violence, inasmuch as she foregrounds violation and mutilation in a short invocation that precedes the poem. The invocation's opening line announces Africa's erasure from Western historical consciousness: "Untitled / Anonymous" (40). A few lines later, in the same short section of poetry, Lewis adds a subtle space to the phrase "paint on tin" to remind her reader that the centrality of violence to the art objects behind her poetry can overwhelm the beauty she associates with representations of Black femininity, such as Stothard's image of Venus, with which this chapter began: "Pain t / On tin" (40). Like Hartman's discovery when trying to recover and share Venus's story, Lewis's heretical project appears unable to avoid the violence inherent in the archive of slavery. In fact, her invocation seems to suggest that an interrogation of the relation of history to Africa and its diaspora necessitates a confrontation with the brutalities that historians and curators are sometimes hesitant to record and share: "Heads and Busts / Headless— Footless—Armless" (41).

By deciding to represent typographically the violence of the past, Lewis seems to indicate that the political potential of violence's re-presentation may outweigh the resurgence of its threats, those that Hartman has called "the dangers of looking (again)."[58] This is not to suggest that Lewis wishes to romanticize the barbarism inscribed onto the art objects she catalogs, or that she turns the violence of the past into masochist pornography for the reader's consumption. Rather, "The Voyage of the Sable Venus" seems to take up Fred Moten's argument that the trick in looking (again) is not to cushion or diminish the violence of the past—and, in doing so, to inadvertently empower it—but to confront it and work through the ensuing encounter, even if indirectly. As Moten explains in *In the Break*, the act of listening to the screams of Frederick Douglass's Aunt Hester as she is beaten, like the act of looking into the open casket of Emmett Till, is markedly political. He explains that acts of witnessing are encounters with violence's disillusioning affect, meaning they open onto "the revelation of a fundamental truth," even if such a truth is difficult to experience, express, or share.[59] The revelatory power or truth potential of the encounter that Moten describes raises questions about how we should listen and look, as

his argument seems to hinge on the possibility that certain ways of listening and looking are constitutive of political meaning precisely because they are unbearable. Taken further, it is because the act of listening and looking (again) is unbearable that it becomes meaningful and necessary.

To return to Lewis's reading of Stothard's *The Voyage of the Sable Venus from Angola to the West Indies*, encountering the violence of the past (again) can be an act that is revealing (rather than concealing) and, as consequence, beautiful (rather than just horrible). There is critical potential in readers' heretical encounters with the possible histories behind the art objects that Lewis's poetics animate, and such encounters reconceptualize what it means to be subject to the violences of history. If one function of history is to tell the story of a community and its identity, and if, in doing so, history works to reinforce national values and fortify commitments to national loyalty, then what are we to make of the violences that Lewis's work pulls from the outwardly tame history that cultural hegemony popularizes? Among other revelations, by prompting her reader to look (again), Lewis draws attention to history's cultural function as a white pathology. While the poetics of "The Voyage of the Sable Venus" illustrate how the language of the museum privileges certain accounts of the past and its inhabitants while dismissing others, it is by revealing the violence that Western history tries to conceal that Lewis underlines the sinister nature of the historical narrative with which we are familiar.

As a means of trying to describe the revelatory power of looking and listening (again), of bearing witness to history's violences and recognizing its pathological tendencies, consider the horror that Lewis evokes in the following passage, which appears midway through her "Medieval Colonial" catalog:

> Tall Figure Lilith, The Goat Tender of the Colonies,
> (A Christmas Gift to Ole Marster and Missus):
>
> *"Merry Christmas and Christmas Gift, Ole Massa!"*
> A Black Child Wearing
>
> Broken Chains
> And Blowing Him
>
> A Kiss (79)

As with previous examples, this passage's ekphrasis of absence invokes a sense of phantasia that aims to inset in readers' minds a scene that exceeds the visual content of the individual art objects themselves. Not one of the objects broadcasts any element of sexual violence, according to the descriptive language that curators and historians have ascribed to each of them, yet the artfulness of Lewis's collage evokes an image of a young enslaved girl (or possibly boy) fellating a white slaveholder in the penultimate line. Although Lewis does not replicate the grammar of violence herself, the poetics of "The Voyage of the Sable Venus" certainly prompt the reader to do so. The poem can invoke this image only because readers already know the horrible violations that enslavers forced on the enslaved, even as we also know not to know them. "The Voyage of the Sable Venus" does not let us turn away; instead, it cultivates an encounter with the violence that we wish not to look at (again). This transforms the outwardly innocent language that surrounds the rape—no longer is the kiss an act of affection, a loving deed, or a sign of care; Christmas no longer implies divinity, rebirth, or spiritual awakening.

In the contrast between the unrecorded rape and the romantic and religious language that surrounds it, the reader bears witness to a truth that Lewis urges her critical figuration of Venus to announce in every line of the poem. Although the museum's scenes of brutality may appear to make the racial violence of the past documented and knowable, the language through which that violence is discussed tends to conceal its centrality to the character of Western nations instead of giving it presence, even if that is what it appears to do. Whatever the museum displays synchronously conceals everything it cannot. If, as Rancière reminds us, Venus, as a figural embodiment of heresy, "always speaks the truth, for her speech is only the expression of her mode of being," then we must recognize this commentary on history and hegemony to be true.[60]

Venus's heretical truth challenges us to rethink what it means to be subject to history, and thus makes looking (again) at the violence of the past a necessary—if unbearable—act. To do so is especially necessary if we acknowledge that the linear history of sequential events that documents Western development and supremacy while erasing any sign of Africa and its diaspora is pathological, as the poetics of "The Voyage of the Sable Venus" suggests it is. As Lewis explains, "it exposes a failure of white imagination, and the need to fetishize that failure to the point where we're carving black

women into the handle [of] our razor blades. Why would a person need to hold a black woman's body in their hand while they shave their face? That's not a black sadness, to me. That's a white, pathological, tragic sadness that has really nothing to do with me."[61] Such a radical repositioning amounts to nothing short of a departure from the historical subjectivity through which Lewis works, a poetic departure that marks her poem as a form of interventionary politics that interrogates the radically nonintegrative history of the West.

The result of Lewis's intervention is a disruption of history in the mind of her reader, as it prompts an unlearning—or, at the very least, a questioning—of the mythological model of continuous development in the history of ideas. "The Voyage of the Sable Venus" thus enacts critical Blackness to challenge racist patriarchal systems, including the racist patriarchal systematicity of history itself. It does so not by providing a historical counternarrative, given that the basic premise of "accuracy" or "recovery" only serves history's rationalist impulse. Instead, it furnishes an encounter with the limitations of history's words, one that reveals their power in predetermining how Blackness can be perceived, known, and imagined.

AN ARRIVAL: THE END OF BELIEF IN HISTORY AS A SYSTEM OF RATIONALITY

Although Lewis has characterized poetry as a "gorgeous, complex history rendered in verse and song, a blueprint that can lead you back into the world after you've walked into air,"[62] her work does not document a particular version of the past. Further, "The Voyage of the Sable Venus" neither describes the true nature of history nor identifies its invariable essence or structure. Instead, Lewis's poem takes shape as a circumspect intervention into the writing of history. That is, her work affects the reader's understanding of the historical, political, and cultural climate in which art objects featuring Black women have been created, collected, displayed, and preserved in the West, as well as how such institutional acts contribute to the writing of a history that erases certain individuals and communities while privileging accounts of others. "The Voyage of the Sable Venus" thus stands as a fundamental displacement of grand narratives and their perceived authority, as it comments on the limitations of history writing and criticizes the violent rationalism that conventional narratives of the past have committed against

Black women and descendants of the African diaspora more generally. Rather than recover Venus's story in any conventional sense, Lewis's work positions the idea of Venus in such a way as to show the reader how history teaches—and how we might unlearn—racist, patriarchal, heteronormative epistemologies.

Lewis has explained that she intends her work to prompt questions regarding history as a structure of power that continues to position gender, race, and sexual orientation as means of othering: "The work I ultimately decide to publish is work I hope will engage certain public or social conversations," she has emphasized, "or work that I hope will begin those conversations."[63] The transgressive irresolution of "The Voyage of the Sable Venus," or the way that it celebrates history's illegibility without providing an alternative to fill the nonrational void that such a critique produces, is a productive means of disrupting our comfort and familiarity because it challenges our expectations and conceptual complacency. As I have argued in previous chapters, the sense of irresolution that such an enactment of critical Blackness creates is generative precisely because of the way it devolves into unintelligibility, creating an epistemological rupture.

Lewis has characterized her artistic impulse along these lines. "I really feel that a lot of the problems we have as readers—and in our lives—is that we don't want to be uncomfortable," she explains, "but I *want* to trigger you. It's my job. I will not leave you there. But I want to upset you wholly. I also want to love you wholly. I also want to tell you a joke. It depends on the project. But the idea that we should not upset the reader—that we should have you feeling safe and give you a floor—that's not interesting to me, and it certainly isn't art."[64] By refusing to furnish a recognizable narrative, and by rejecting the authority of history in favor of the past's illegibility, "The Voyage of the Sable Venus" aims to trigger and challenge its readers. The reading experience Lewis offers depends on the difficulties of interpretation and the unlimited possibilities of radical ambiguity rather than the comforts of ordered resolution and static familiarity; however, its transgressive challenges and disorientations function as boundless and unending pathways through which new ways of encountering and engaging the past might become possible, even if only in the abstract.

Reading Lewis's figuration of Venus as a strategy for producing a heretical truth modality suggests that the emptiness of the archive is not just a limitation; it is also a chance to cultivate a sense of openness. In that

spirit, the liberties that Lewis takes with the language of museum-housed art objects are not betrayals of the past to which they correspond; rather, they are opportunities to acknowledge and surmount the racist patriarchal politics at work in the narrativization of history.

With this understanding of Lewis's radical abstractionist project in mind, we should return to the series of couplets with which this chapter opened, those that describe an image that is easy to visualize but difficult to see:

> Nude Black Woman
> in an Oyster Shell

> Drawn by Dolphins
> through the Water

> and Accompanied by Cupids,
> Neptune, and Others. (73)

Accompanying our return to Stothard's *Voyage of the Sable Venus from Angola to the West Indies* is a sense of disorientation. As we have seen, Lewis's rearrangement of the source text prompts a host of competing and diverging perceptions but few concrete means of conceptualizing the Venus to which the language alludes beyond an embodiment of the very heresy that upends museal politics. Analyses of this passage may depart from the description I offered at the beginning of this chapter—which noted that Stothard's Venus is one-dimensional, pro-slavery propaganda—but they are likely to arrive at a rupture, because Lewis's description draws us close to something beautiful and horrible, a celebration and a delusion.

AFTERWORD

Circulating Critical Blackness

What will blackness be?

—FRED MOTEN, *IN THE BREAK*

In the introduction to this book, I posed a series of questions about racial discourse and twenty-first-century Black cultural production: Through what strategies might contemporary artists confront endemic cultural assumptions about race? In what ways can the devices that make race feel familiar—such as stereotypes—be used to make race feel unfamiliar? What new perspectives might emerge out of such disorienting encounters?

The Racial Unfamiliar has answered these questions by arguing that some twenty-first-century Black artists have turned to abstractionist aesthetics to complicate and confuse how we perceive, know, and imagine race. These artists expose the incongruities that underlie racist attitudes and, I have argued, refute the idea that any collective depiction of Black life exists to be represented in photography, installation art, the novel, satire, drama, or poetry. By cultivating disorienting encounters in which audiences come to question the effects of racial discourse on processes of looking, interpreting, categorizing, laughing, historicizing, and remembering, the artworks collected in this book insist that Blackness exceeds the historically entrenched paradigms through which the modern racial episteme tries to make race intelligible, meaning that contemporary Black cultural production can be understood as an operation in abstracting and unsettling the cultural determinants that make racial Blackness seem legible.

To draw together the experimental and abstractionist strategies that this book delineates, I have offered the term "critical Blackness." Critical

Blackness does not try to describe or define what it means to be Black in the twenty-first century, nor does it reduce the idea of Blackness to bodies with Black skin. Instead, it refers to a radical artistic sensibility that queries the idea of Blackness by critiquing and upending popular ideas about Black art and its creators, audiences, and expressive practices. In theorizing this concept, my attention has not been on how artworks fit into established traditions of Black cultural production; rather, it has focused on how literature and visual-art projects enact a kind of Blackness that queries the free-floating ideas that give those traditions their shape and meaning. As a deconstructive sensibility that aims to raise questions about the conceptual validity of racial discourse, critical Blackness is a strategic antiessentialism, a radical artistic sensibility that confronts the determinants of categorical capture without re-essentializing the idea of Blackness.

The constellation of artworks examined in *The Racial Unfamiliar* is far from exhaustive because critical Blackness circulates and adapts, appearing in many expressive objects and creative acts in various forms and degrees of urgency. Among many other twenty-first-century artworks that question and confuse the legibility of race, I had thought to write about critical Blackness in Toni Morrison's *Home*; John Edgar Wideman's *Fanon*; Colson Whitehead's *Apex Hides the Hurt* and *Zone One*; Claudia Rankine's *Don't Let Me Be Lonely*, *The End of the Alphabet*, and *Citizen*; Nathaniel Mackey's *Splay Anthem*, but also components in his ongoing epistolary project, *From A Broken Bottle Traces of Perfume Still Emanate*, specifically *Atet A. D.* and *Brass Cathedral*; Evie Shockley's *The New Black*; Nikky Finney's *Head Off & Split*; Kevin Young's *Jelly Roll* and *To Repel Ghosts*; Terrance Hayes's *Lighthead*; Tracy K. Smith's *Life on Mars*; Elizabeth Alexander's *American Sublime*; Suzan-Lori Parks's *Topdog/Underdog* and *Father Comes Home from the Wars, Parts 1, 2 & 3*; DJ Spooky's *Rebirth of a Nation*; Barry Jenkins's *Moonlight*; Donald Glover's *Atlanta*; Jay-Z's *The Black Album*; Danger Mouse's *The Grey Album*; Kanye West's *My Beautiful Dark Twisted Fantasy*; Kendrick Lamar's *To Pimp a Butterfly* and *Damn*; and a number of the artworks featured in Bennett Simpson's interdisciplinary show *Blues for Smoke*. Each of these twenty-first-century art objects comments on the modern racial episteme and raises questions about racial knowledges, often by querying the perceptual and historical determinants through which Blackness is categorically captured. But that list is still far from exhaustive.

For critical Blackness to be a genre-opening mode, we have to be open to finding it in other places, too. I had wanted to explore more directly the appearances and effects of critical Blackness in social movements and protests, which are not always discussed in aesthetic terms. It may be productive to think about the #BlackLivesMatter movement and its defacement of Confederate statuary as enactments of critical Blackness, for example, because they abstract the narrow patterns through which racial discourse aims to delimit Blackness's cultural legibility. Like the artworks listed in the previous paragraph, such social movements and protests introduce us to new ways of perceiving, knowing, and imagining, those that might subvert normative, oppressive epistemological structures. In that spirit, critical Blackness might help to illustrate how cultural workers and artists are engaged in entwined intellectual projects, uncovering the processual nature of social action and artistic production, the ways that historical processes of political struggle stimulate creative expression even as artistic production helps to spur social action.

Finally, we might enhance this book's analyses of identity, representation, and experimentation by asking how critical Blackness complicates our understanding of diaspora—and, inversely, how diasporic artworks refine the book's theorization of critical Blackness. These questions, which the present study did not have space to consider, concern discovering critical Blackness in artworks that have a more tenuous relation to the established cannon of "African American" literature and art, but also what those discoveries might mean to the study of "African American" literature and art. Yogita Goyal has emphasized that "we need new diasporas" to account for contemporary artists who are "moving away from well-worn frames of racial ancestry or heritage," that we must rethink diasporic experience to discover "fresh ways to conceive of race and racial formation in a global frame."[1] We might begin unmaking tired notions of the Black diaspora by thinking through the terms of critical Blackness in the generic confusion and *jeringonza* of Junot Díaz's fiction, or in the experimental essays of Jamaica Kincaid and Victor Fowler Calzada, the poetry of M. NourbeSe Philip and Edwidge Danticat, the novels of Chimamanda Ngozi Adichie and Teju Cole, and the performances and visual-art projects of artists like Ana Mendieta, Karin Jones, Mmekutmfon "Mfon" Essien, Simphiwe Ndzube, and Wangechi Mutu. Querying the determinants of "Black diaspora"—as a broad, generic label—would help to show in greater detail

how race continues to act as a cultural litmus test for national and artistic identity, how established perceptions of literary and artistic traditions make race and racial narratives seem discernible, and how these traditions might be refashioned to break apart received ideas about the nature and aims of Black expression.

The Racial Unfamiliar is not meant to collect, chronicle, and chart every enactment of critical Blackness but to consider the limitations of racial recognition and legibility as paradigms for making sense of twenty-first-century Black literature and art. By turning to illegibility as a strategy for upending popularly held beliefs about race and difference, I had hoped to bring a new perspective to a collection of art that is too often assumed to convey a truth about Black identity and Black experience in the United States. The book's discussions of critical Blackness suggest that aesthetic experimentation and sense confusion continue to circulate, always troubling what we think we know about race, but also that contemporary Black expressive practices are fundamentally antiessentialist, an intervention that stresses the importance of encountering illegibility when studying contemporary Black creative expression.

NOTES

INTRODUCTION

1. *Get Out*, directed by Jordan Peele, Universal Pictures, 2017; and Jason Zinoman, "Jordan Peele on a Truly Terrifying Monster: Racism," *New York Times*, February 16, 2017, https://www.nytimes.com/2017/02/16/movies/jordan-peele-interview-get-out.html.
2. I use Black when discussing the lives, ideas, and creative expressions of Black people but African American when referring to established canons of cultural production like African American literature and traditions like African American humor (see esp. chap. 3).
3. Peele defined "social thriller" as "thriller/horror movies where the ultimate villain is society" in interviews for the *Chicago Tribune* and *Criterion*, and he gave the genre coherency by curating a list of social thrillers for the Brooklyn Academy of Music. See Michael Phillips, "Jordan Peele's Directorial Debut a Keen 'Social Thriller,'" *Chicago Tribune*, February 24, 2017, https://www.chicagotribune.com/entertainment/movies/ct-jordan-peele-get-out-interview-20170224-column.html; Andrew Chan, "Waking Nightmares: A Conversation with Jordan Peele," *Criterion Collection*, February 23, 2017, https://www.criterion.com/current/posts/4439-waking-nightmares-a-conversation-with-jordan-peele; and BAM, "Jordan Peele: The Art of the Social Thriller," accessed November 14, 2021, https://www.bam.org/film/2017/jordan-peele.
4. Many critics felt that such a categorization trivialized the film's social commentary. See Eric Kohn, "Jordan Peele Challenges Golden Globes Classifying 'Get Out' as a Comedy: 'What Are You Laughing At?'" *IndieWire*, November 15, 2017, https://www.indiewire.com/2017/11/jordan-peele-response-get-out-golden-globes-comedy-1201897841/; Graeme Virtue, "Is Get Out a Horror Film, a Comedy … or a Documentary?" *The Guardian*, November 17, 2017, https://www.theguardian.com/film/filmblog/2017/nov/17/get-out-golden-globes-race-horror-comedy-documentary-jordan-peele;

and Emily Mae Czachor, "'Get Out' Is a Comedy According to the Golden Globes & Seriously, WTF?," *Bustle*, December 11, 2017, https://www.bustle.com/p/why-is -get-out-nominated-as-a-comedy-at-the-2018-golden-globes-the-horror-movie -isnt-exactly-a-laugh-riot-6789813.

5. See Harvey Roy Greenberg, "Get Out: Invasion of the Brother Snatchers," *Psychiatric Times* 34, no. 6 (June 14, 2017), https://www.psychiatrictimes.com/depression/get -out-invasion-brother-snatchers; Thomas Trussow, "Get Out (Peele, 2017)," *Lonely Film Critic*, November 14, 2017, https://thelonelyfilmcritic.com/2017/11/14/get-out/; and "VS V1 (Skeleton Key, Get Out)," *Night of the Moving Pictures Podcast*, July 22, 2019, https://www.stitcher.com/podcast/night-of-the-moving-pictures-podcast/the -night-of-the-moving-pictures-podcast/e/62742584#/.

6. For example, see Racquel J. Gates, *Double Negative: The Black Image and Popular Culture* (Durham, NC: Duke University Press, 2018).

7. Kevin Young, *The Grey Album: On the Blackness of Blackness* (Minneapolis: Graywolf, 2015), 128–29.

8. @JordanPeele, "'Get Out' Is a Documentary," *Twitter*, November 14, 2017, 8:56 a.m., https://twitter.com/JordanPeele/status/930796561302540288.

9. Jordan Peele, quoted in Zadie Smith, "Brother from Another Mother," *New Yorker*, February 16, 2015, https://www.newyorker.com/magazine/2015/02/23/brother-from -another-mother.

10. Young, *The Grey Album*, 24.

11. Toni Morrison, "Rootedness: The Ancestor as Foundation," in *What Moves at the Margin* (Jackson: University Press of Mississippi, 2008), 60–61, 64.

12. Although she predominantly associates "black post-blackness" with contemporary artists, Crawford's investigation into Black aesthetics exposes a historical circularity that discovers similar ambitions in earlier art movements of the twentieth century. For example, she explains that the Black Arts Movement practiced "black post-blackness" when participants recognized movement as the ethos of Black style or when they imagined Blackness as a gesture of freedom and self-determination. Moreover, a number of Harlem Renaissance artists anticipated the militancy of the 1960s in their efforts to give form to Blackness, she explains. See Crawford, *Black Post-Blackness: The Black Arts Movement and Twenty-First Century Aesthetics* (Champaign: University of Illinois Press), 3–6, 21–22.

13. Crawford, *Black Post-Blackness*, 2.

14. See Michael Omi and Howard Winant, *Racial Formation in the United States: From the 1960s to the 1990s*, 2nd ed. (New York: Routledge, 1994). For research building on Omi and Winant's theory of racial formation, see also Mustafa Emirbayer and Matthew Desmond, *The Racial Order* (Chicago: University of Chicago Press, 2015); Eduardo Bonilla-Siva, *Racism Without Racists: Color-Blind Racism and the Persistence of Racial Inequality in America* (Lanham, MD: Rowman & Littlefield, 2014); and Audrey Smedley and Brian D. Smedley, *Race in North America: Origin and Evolution of a Worldview*, 4th ed. (Boulder, CO: Westview, 2012).

15. Michael Boyce Gillespie might characterize this reversal as an example of "film blackness," which he uses to describe films that enact and express Black culture, often by opening the discursivity of race to radical critique. See Gillespie, *Film Blackness: American Cinema and the Idea of Black Film* (Durham, NC: Duke University Press, 2016).

16. La Marr Jurelle Bruce, *How to Go Mad Without Losing Your Mind: Madness and Black Radical Creativity* (Durham, NC: Duke University Press, 2021), 4.

17. Stuart Hall, "Ethnicity: Identity and Difference," *Radical America* 23, no. 4 (1989): 16.

18. Hortense Spillers, "Mama's Baby, Papa's Maybe: An American Grammar Book," *Diacritics* 17, no. 2, special issue, "Culture and Countermemory: The 'American' Connection" (Summer 1987): 68, 79.

19. Hortense J. Spillers, "Peter's Pans: Eating in the Diaspora," in *Black, White, and in Color* (Chicago: University of Chicago Press, 2003), 5.

20. Paul Gilroy, *The Black Atlantic: Modernity and Double Consciousness* (New York: Verso, 1993), 101.

21. Spillers, "Peter's Pans," 11, 34.

22. Fred Moten, "Taste Dissonance Flavor Escape: Preface for a Solo by Miles Davis," *Women & Performance: A Journal of Feminist Theory* 17, no. 2 (July 2007): 218.

23. Gilroy, *The Black Atlantic*, 72–110.

24. Fred Moten, *In the Break: The Aesthetics of the Black Radical Tradition* (Minneapolis: University of Minnesota Press, 2003), 6

25. Moten, *In the Break*, 98.

26. As Moten describes it, his project "is invested in the analysis, preservation, and diffusion of the violent 'affectability' of 'the aesthetic sociality of blackness,' to which the violence of the slave owner/settler responds and to whose regulatory and reactionary violence it responds, in anticipation." Moten, *Black and Blur* (Durham, NC: Duke University Press, 2017), xi. In this description, he riffs on the work of Laura Harris, who explores dissident/dissonant social forms (and their relation to a sense of Blackness as production and reproduction) in Harris, *Experiments in Exile: C. L. R. James, Hélio Oiticica, and the Aesthetic Sociality of Blackness* (New York: Fordham University Press, 2018).

27. For a detailed account, see Sidney W. Mintz and Richard Price, *The Birth of African-American Culture: An Anthropological Perspective* (Boston: Beacon, 1992), 48.

28. Paul C. Taylor, *Black Is Beautiful: A Philosophy of Black Aesthetics* (Hoboken, NJ: Wiley-Blackwell, 2016), 6.

29. Zora Neale Hurston, "Characteristics of Negro Expression," in *Negro: An Anthology*, ed. Nancy Cunard (1934; New York: Continuum, 1994), 27–28.

30. Greg Tate, "Cult-Nats Meet Freaky-Deke," in *Flyboy in the Buttermilk: Essays on Contemporary America* (New York: Touchstone, 2015), 207.

31. Trey Ellis, "The New Black Aesthetic," *Callaloo*, no. 38 (1989): 235.

32. Nelson George, *Post-Soul Nation: The Explosive, Contradictory, Triumphant, and Tragic 1980s as Experienced by African Americans (Previously Known as Black and Before That Negroes)* (New York: Penguin, 2005), 8.

33. See Bertram D. Ashe, "Theorizing the Post-Soul Aesthetic: An Introduction," *African American Review* 41, no. 4 (2007); Thelma Golden, "Introduction," *Freestyle* (New York: Studio Museum in Harlem, 2001), 14; and Mark Anthony Neal, "The Birth of New Blackness: The Family Stand's Moon in Scorpio," in *Rip It Up: The Black Experience in Rock N Roll*, ed. Kandia Crazy Horse (New York: Palgrave Macmillan, 2004).

34. Touré, *Who's Afraid of Post-Blackness? What It Means to Be Black Now* (New York: Free Press, 2011), 1.

35. K. Merinda Simmons, "The Dubious Stage of Post-Blackness—Performing Otherness, Conserving Dominance," in *The Trouble with Post-Blackness*, ed. Houston A. Baker and Merinda Simmons (New York: Columbia University Press, 2015), 4.

36. Here I am calling on Moten's question, "what will blackness be?" See Moten, *In the Break*, 22.

37. Cedric J. Robinson, *Black Marxism: The Making of the Black Radical Tradition* (Chapel Hill, NC: University of North Carolina Press, 2000), 73.

38. James Leo Cahill and Rachel Leah Thompson, "The Insurgency of Objects: A Conversation with Fred Moten," *Octopus* 1 (Fall 2005): 61, 63.

39. D. Soyini Madison, "Foreword," in *Black Performance Theory*, ed. Thomas F. DeFrantz and Anita Gonzalez (Durham, NC: Duke University Press, 2014), viii.

40. Phillip Brian Harper, *Abstractionist Aesthetics: Artistic Form and Social Critique in African American Culture* (New York: New York University Press, 2015), 2–3.

41. Kathryn Hume, *Aggressive Fictions: Reading the Contemporary American Novel* (Ithaca, NY: Cornell University Press, 2012), 9.

42. Michel Serres, *The Five Senses: A Philosophy of Mingled Bodies*, trans. Margaret Sankey and Peter Cowley (New York: Continuum, 2008), 170.

43. Paul Gilroy, *Against Race: Imagining Political Culture Beyond the Color Line* (Cambridge, MA: Harvard University Press, 2000), 42.

44. Nicole Fleetwood, *Troubling Vision: Performance, Visuality, and Blackness* (Chicago: University of Chicago Press, 2011), 6.

45. Fleetwood, *Troubling Vision*, 6.

46. Roy DeCarava, *The Sound I Saw: Improvisation on a Jazz Theme* (New York: Phaidon, 2001).

47. See Ivor Miller, " 'If It Hasn't Been One of Color': An Interview with Roy DeCarava," *Callaloo* 13, no. 4 (Autumn 1990).

48. Quoted in Ruth Wallen, "Reading the Shadows—the Photography of Roy DeCarava," *Exposure* 27, no. 4 (1990): 13.

49. See Golden, introduction, 14.

50. Kara Walker, *Katastwóf Karavan*, February 23–25, 2018, part of *Prospect.4: The Lotus in Spite of the Swamp*, November 17, 2017–February 25, 2018, New Orleans.

51. Percival Everett, *Erasure* (Hanover, NH: University Press of New England, 2001).

52. Paul Beatty, *The Sellout* (New York: Picador, 2015).

53. Paul Beatty, ed., *Hokum: An Anthology of African-American Humor* (New York: Bloomsbury, 2006).

54. Barbara J. Fields, "Ideology and Race in American History," in *Region, Race, and Reconstruction: Essays in Honor of C. Vann Woodward*, ed. J. Morgan Kousser and James M. McPherson (Oxford: Oxford University Press, 1982), 150.

55. See Christina Sharpe, *In the Wake: On Blackness and Being* (Durham, NC: Duke University Press, 2016); Saidiya Hartman, "Venus in Two Acts," *Small Axe* no. 26 (vol. 12, no. 2, June 2008); and Hartman, "The Anarchy of Colored Girls Assembled in a Riotous Manner," *South Atlantic Quarterly* 117, no. 3 (July 2018).

56. Suzan-Lori Parks, *100 Plays for the First Hundred Days* (New York: Theatre Communications Group, 2018).

57. Robin Coste Lewis, *The Voyage of the Sable Venus* (New York: Knopf, 2015).

58. Zadie Smith, "Getting In and Out: Who Owns Black Pain?," *Harper's Magazine*, June 24, 2017, https://harpers.org/archive/2017/07/getting-in-and-out/.

1. PICTURING BLACKNESS IN
THE PHOTOGRAPHY OF ROY DECARAVA

1. Ivor Miller, "'If It Hasn't Been One of Color': An Interview with Roy DeCarava," *Callaloo* 13, no. 4 (Autumn 1990): 856. The critic A. D. Coleman also read a racial distinctiveness into DeCarava's perspective, from which he concluded that "a black man . . . sees the world through black eyes, and it's this blackness that shapes his world. The black man—and, of course, this means the black photographer too—tends to see the world in a more truthful, realistic way; he must, to survive." See Coleman, "Roy DeCarava: Thru Black Eyes," in *Light Readings: A Photography Critic's Writings, 1968–1978* (Oxford: Oxford University Press, 1979), 22.

2. See Norman Bryson, "The Gaze in the Expanded Field," in *Vision and Visuality* (Seattle: Bay Press, 1988), 92.

3. Judith Butler, "Endangered/Endangering: Schematic Racism and White Paranoia," in *Reading Rodney King/Reading Urban Uprising*, ed. Robert Gooding-Williams (New York: Routledge, 1993), 17.

4. Robyn Wiegman, *American Anatomies: Theorizing Race and Gender* (Durham, NC: Duke University Press, 1996), 26.

5. Roy DeCarava, *The Sound I Saw: Improvisation on a Jazz Theme* (New York: Phaidon, 2001).

6. Phillip Brian Harper, *Abstractionist Aesthetics: Artistic Form and Social Critique in African American Culture* (New York: New York University Press, 2015), 2–3.

7. Coleman, "Roy DeCarava," 26.

8. Although DeCarava took the photographs in the 1950s and 1960s, he compiled the volume and wrote the accompanying poetry many years later. I take this atypical publication history, which makes *The Sound I Saw* politically visible to a national audience beginning in 2001, as a sign of the work's contemporaneity.

9. Curated by Edward Steichen, the director of the Museum of Modern Art's Department of Photography at the time of DeCarava's exhibition, this ambitious and historic display traveled to thirty-seven countries on six continents, attracting an audience of more than nine million viewers during its eight-year tour.

10. DeCarava ran this gallery, which was located at 48 West 85th Street, New York, from 1955 to 1957. Notable artists featured in the gallery include Berenice Abbott and Minor White.

11. Receiving its name from the Bantu language of the Kikuyu, the largest ethnic group in Kenya, Kamoinge translates roughly as "group effort." DeCarava saw the workshop, which operated from 1963 to 1966, as a way of exploring racial themes with other Black photographers in New York.

12. Coleman, "Roy DeCarava," 22. A decade prior, in his Guggenheim proposal, DeCarava similarly stated that he wanted "to show the strength, the wisdom, the dignity of the Negro people" not as "a documentary or sociological statement" but as "a creative expression" to create "the kind of penetrating insight and understanding of Negroes which [he] believe[d] only a Negro photographer can interpret." See Peter Galassi, "Introduction," in *Roy DeCarava: A Retrospective* (New York: Museum of Modern Art, 1996), 18.

13. DeCarava, "If It Hasn't Been One of Color," 847.

14. DeCarava, "If It Hasn't Been One of Color," 855.

15. DeCarava, "If It Hasn't Been One of Color," 850.

16. DeCarava, "If It Hasn't Been One of Color," 855.

17. *Roy DeCarava: Photographs*, ed. James Alinder (Carmel, CA: Friends of Photography, 1981), 13.

18. I recognize that the term "post-black" opens the possibility of a critique of discourse on Black creative expression, but I do not make use of it in this book because my understanding of the Black radical aesthetic is not invested in separating racial projects from their racial origins. See Thelma Golden, "Introduction," in *Freestyle* (New York: Studio Museum in Harlem, 2001), 14.

19. Harper, *Abstractionist Aesthetics*, 2–3.

20. Cedric J. Robinson, *Black Marxism: The Making of the Black Radical Tradition* (Chapel Hill, NC: University of North Carolina Press, 2000), 6; Fred Moten, "Taste Dissonance Flavor Escape: Preface for a Solo by Miles Davis," *Women & Performance: A Journal of Feminist Theory* 17, no. 2 (July 2007): 228.

21. James Leo Cahill with Rachel Leah Thompson, "The Insurgency of Objects: A Conversation with Fred Moten," *Octopus* 1 (Fall 2005): 63.

22. This is the same language that Deborah Willis uses to describe her first encounter with DeCarava's photography in 1955, when she read *The Sweet Flypaper of Life*: "Their ordinary stories were alive and important and to be cherished. There were photographs of black women in tight sweaters dancing sensually—just like the movies of Marilyn Monroe!—sassy women and women who sacrificed for the family; and then there was Rodney, photographed handsomely by DeCarava in lighting only he could capture. For me a veil was lifted." See Willis, *Picturing Us: African American Identity in Photography* (New York: New Press, 1996), 4.

23. DeCarava's hazy shadows and muted tones produce a deep illegibility effect, deeper even than the civic photography of James Van Der Zee and Gordon Parks, who preceded him, and in the street photography of Carrie Mae Weems, Jamel Shabazz, and LaToya Ruby Frazier, who came later.

24. As opposed to auditory-visual synesthesia, a psychological condition in which auditory stimuli elicit involuntary visual experiences, visually induced auditory synesthesia is a condition in which the spectacle of sight automatically causes the perception of sound.

25. Jacques Attali, *Noise: The Political Economy of Music*, trans. Brian Massumi (Manchester, UK: Manchester University Press, 1985), 26–27.

26. Attali, *Noise*, 26.

27. See J. Kevin O'Regan and Alva Noë, "A Sensorimotor Account of Vision and Visual Consciousness," *Behavioral and Brain Sciences* 24, no. 5 (2011): 939–73.

28. See Henri-Louis Bergson, *Creative Evolution*, trans. Arthur Mitchell (New York: Henry Holt, 1911), 262; Bergson, *Matter and Memory*, trans. N. M. Paul and W. S. Palmer (New York: Zone, 1990), 12; and Maurice Merleau-Ponty, *Phenomenology of Perception*, trans. Colin Smith (New York: Routledge, 2002), 273.

29. Keren Omry, *Cross-Rhythms* (New York: Continuum, 2008), 8.

30. Galassi, "Introduction," 18.

31. Sara Blair, *Harlem Crossroads: Black Writers and the Photograph in the Twentieth Century* (Princeton, NJ: Princeton University Press, 2007), 50.

32. Quoted in Sherry Turner DeCarava, "Celebration," in *Roy DeCarava: Photographs*, ed. James Alinder, 12.

33. I discovered the details behind each of these images after examining many of Guerrier's pictures and bringing aspects of photographs not made available in Golden's exhibit to the interpretive process. Both the unpictured office chair and Guerrier's figuration as the subject of his own picture would not have been apparent to observers who were not already exceedingly familiar with Guerrier's ongoing photographic series constructed around the performativity of the *flâneur*.

34. In French, literally "the urban wanderer." Drawing on Victor Fournel in his reading of Charles Baudelaire's poetry, Benjamin expands this notion of the *flâneur* as an urban spectator, a personification of alienation that comes together as a sort of detective or investigator of the changing city. As opposed to the figure of the *badaud*, who melts into the crowd in the face of the spectacle of the outside world, the *flâneur* preserves his or her individuality in the act of distanced and questioning spectatorship. See Walter Benjamin, *Charles Baudelaire: A Lyric Poet in the Era of High Capitalism*, trans. Harry Zohn (New York: Verso, 1997).

35. Hunter Braithwaite, "Miami: Adler Guerrier, David Castillo," *Art in America* 100, no. 11 (2012): 191.

36. Quoted in Sherry Turner DeCarava, "Celebration," 14.

37. Sherry Turner DeCarava, "Celebration," 18.

38. Sherry Turner DeCarava, "Celebration," 18.

39. Quoted in Sherry Turner DeCarava, "Celebration," 18.

40. Roy DeCarava, *The Sound I Saw*, n. p.

41. Frantz Fanon, *Black Skin, White Masks*, trans. Richard Philcox (New York: Grove, 2008), 89.

42. Fanon, *Black Skin, White Masks*, 92.

43. Harvey Young, *Embodying Black Experience: Stillness, Critical Memory, and the Black Body* (Ann Arbor: University of Michigan Press, 2010), 7.

44. Young, *Embodying Black Experience*, 4.

45. Laylah Ali and Isaac Allan, "Here Comes the Kiss: A Conversation Between Laylah Ali and Allan Isaac," *Massachusetts Review* 49, nos. 1–2 (2008): 155, 156.

46. Olukemi Ilesanmi, "Laylah Ali," in *Freestyle* (New York: Studio Museum in Harlem, 2001), 20.

47. Michel Serres, *The Five Senses: A Philosophy of Mingled Bodies*, trans. Margaret Sankey and Peter Cowley (New York: Continuum, 2008), 239.

48. Serres, *The Five Senses*, 239.

49. Alan S. Brown, *The Déjà Vu Experience: Essays in Cognitive Psychology* (New York: Psychology Press, 2004), 103.

50. Jareh Das, "Science or Fiction: Imaginary Narratives in the Works of Laylah Ali, Hamad Butt, Basim Magdy and Larissa Sansour," *Contemporary Practices: Visual Arts from the Middle East* 13 (January 2013): 46.

51. Darby English, "Almost Comic: The Art of Laylah Ali," *Afterall: A Journal of Art, Context and Enquiry* 6 (2003): 18.

52. English, "Almost Comic," 18.

53. Richard Ings, "'And You Slip Into the Breaks and Look Around': Jazz and Everyday Life in the Photographs of Roy DeCarava," in *The Hearing Eye: Jazz and Blues Influences in African American Visual Art*, ed. Graham Lock and David Murray (Oxford: Oxford University Press, 2009), 317.

54. Nicole Fleetwood, *Troubling Vision: Performance, Visuality, and Blackness* (Chicago: University of Chicago Press, 2011), 6.

55. Sherry Turner DeCarava, "Celebration," 18.

56. Martha J. Farah, *Visual Agnosia*, 2nd ed. (Cambridge, MA: MIT Press, 2004), 69.

57. Nicole J. Caruth, "Just Beyond Reality's Edge: Kira Lynn Harris," *NKA: Journal of Contemporary African Art* 27 (2010): 94.

58. Susette Min, "Kira Lynn Harris," in *Freestyle* (New York: Studio Museum in Harlem, 2001), 42.

59. Susan Sontag, *On Photography* (New York: Picador, 2001), 51.

60. See Jean-Luc Nancy, *Corpus*, trans. Richard A. Rand (New York: Fordham University Press, 2008), 11, 23, 71.

61. Geoffrey Jacques, "Roy DeCarava: Looking," *Journal of Contemporary African American Art* no. 5 (Fall/Winter 1996): 22.

62. Harper, *Abstractionist Aesthetics*, 63.

63. Quoted in Ings, " 'And You Slip Into the Breaks and Look Around,' " 309.

64. Roland Barthes, *Image-Music-Text*, trans. Stephen Heath (New York: Hill and Wang, 1978), 40.

65. Walter Benjamin, "On Some Motifs in Baudelaire," in *Illuminations: Essays and Reflections*, trans. Harry Zohn, ed. Hannah Arendt (New York: Schocken, 1969), 157.

66. Ariella Azoulay, *The Civic Imagination: A Political Ontology of Photography* (New York: Verso, 2012), 13, 27.

67. Sarah Boxer, "Catching the Image of Jazz as It Will Never Be Again," *New York Times*, March 27, 1996, late edition, C1, 13, https://www.nytimes.com/1996/03/27/arts/catching-the-image-of-jazz-as-it-will-never-be-again.html.

68. Coleman, "Roy DeCarava," 28.

69. Quoted in Ruth Wallen, "Reading the Shadows—the Photography of Roy DeCarava," *Exposure* 27, no. 4 (1990): 13.

70. Sherry Turner DeCarava, Roy DeCarava, and Ron Carter, "Inventory: A Conversation Between Roy DeCarava and Ron Carter," *MoMA* 21 (Winter–Spring 1996): 6.

71. See Wallen, "Reading the Shadows," 23.

2. A MUSE FOR BLACKNESS: KARA WALKER'S "OUTLAW REBEL" VISION

1. *The End of Uncle Tom* was first exhibited during the Whitney Museum of American Art Biennial in New York from March 20 to June 1, 1997, then again at the San Francisco Museum of Modern Art that same year.

2. Shaw further explains: "Like many of the other spectators around me that day, I, too, was confounded by the uncanny drama in which these life-size, cut-paper figures required me to participate. I was both bewildered and elated by the exciting, yet largely incomprehensible narrative of graphic violence and sexual depravity that spread before me in a great gothic panorama. . . . I started to see that there was something phenomenal going on in her images, something that was being overlooked by the various reactions of the so-called African American community and the mainstream art world." Gwendolyn Dubois Shaw, *Seeing the Unspeakable: The Art of Kara Walker* (Durham, NC: Duke University Press, 2004), 4.

3. Rebecca Peabody, *Consuming Stories: Kara Walker and the Imagining of American Race* (Berkeley: University of California Press, 2016), 25.

4. For example, in 1997, the *International Review of African American Art* dedicated a special issue to the politics of representation. Titled "Stereotypes or Subverted? Or for Sale?" it pivots around Walker's uses of anti-Black iconography. In the introduction, editor Juliette Bowles describes Walker as a "disputatious outlaw artist" who is too young to recognize the damage she inflicts and whose shock-art is rapidly becoming redundant. See Juliette Bowles, *"Extreme Times Call for Extreme Heroes,"* *International Review of African American Art* 14, no. 3 (1997): 15.

5. Kara Walker, *Katastwóf Karavan*, February 23–25, 2018, *Prospect.4: The Lotus in Spite of the Swamp*, New Orleans.

6. *The Katastwóf Karavan* was scheduled to be unveiled during the opening festivities for *Prospect.4* and to be available for the exhibition's duration. However, installation of the work was postponed until the show's closing weekend due to the complexity of its staging and the cost of shipping it from New York to New Orleans. It was on view from February 23 through 25, 2018. The calliope played from a programmed playlist during most performances, with Moran's calliope improvisations scheduled for 4:30 p.m. on Friday and 2:30 p.m. on Saturday.

7. Walker installed her sugar sphinx in the relics of Brooklyn's Domino Sugar Factory, where it was on display from May 10 to July 6, 2014. See Kara Walker, *A Subtlety, or the Marvelous Sugar Baby, an Homage to the unpaid and overworked Artisans who have refined our Sweet tastes from the cane fields to the Kitchens of the New World on the Occasion of the demolition of the Domino Sugar Refining Plant*, Creative Time, Brooklyn, May 10–July 6, 2014.

8. bell hooks, *Black Looks: Race and Representation* (Boston: South End, 1992), 4.

9. See Darby English, *How to See a Work of Art in Total Darkness* (Cambridge, MA: MIT Press, 2007), 75, 77.

10. Amber Jamilla Musser, *Sensational Flesh: Race, Power, and Masochism* (New York: New York University Press, 2014), 154.

11. Glenda R. Carpio, *Laughing Fit to Kill: Black Humor in the Fictions of Slavery* (Oxford: Oxford University Press, 2008), 178, 172.

12. David Wall, "Transgression, Excess, and the Violence of Looking in the Art of Kara Walker," *Oxford Art Journal* 33, no. 3 (2010): 281.

13. This panoramic tableau was shown at the California College of Arts and Crafts (now California College of the Arts) from April 2 to May 15, 1999, and then at the UCLA/Armand Hammer Museum of Art and Culture Center in Los Angeles from September 22, 1999, to January 2, 2000.

14. Kara Walker, "Kara Walker Depicts Violence and Sadness That Can't Be Seen" (video), *San Francisco Museum of Modern Art*, https://www.sfmoma.org/watch/kara-walker-depicts-violence-and-sadness-that-cant-be-seen/.

15. Kara Walker, "Sikkema Jenkins and Co. Is *Compelled* to Present," Sikkema Jenkins & Co., New York, September 7–October 14, 2017, https://www.sikkemajenkinsco.com/kara-walker-2017.

16. Putting audiences on display as a sort of artwork is a recurrent theme for Walker. In 2014, for instance, she filmed attendees of *A Subtlety* and released the twenty-eight-minute recording as a follow-up project titled *An Audience*. The video shows attendees posing for pictures, taking sometimes tasteless selfies, and miming sexual

gestures in front of the statue. See Kara Walker, *An Audience*, November 21, 2014–January 17, 2015, Sikkema Jenkins & Co., New York.

17. Walker, "Sikkema Jenkins and Co. Is *Compelled* to Present."

18. Karmen Mackendrick offers a clear discussion of the problem of "transgression" as a concept; see "Embodying Transgression," in *Of the Presence of the Body: Essays on Dance and Performance Theory*, ed. André Lepecki (Middletown, CT: Wesleyan University Press, 2004), 140. For theories of transgression that focus on artworks designed to disgust or annoy, see Anthony Julius, *Transgressions: The Offences of Art* (Chicago: University of Chicago Press, 2003); and Cashell Kieran, *Aftershock: The Ethics of Contemporary Transgressive Art* (London: I. B. Tauris, 2009).

19. Michel Foucault, "A Preface to Transgression," in *Language, Counter-Memory, Practice: Selected Essays and Interviews*, ed. and trans. Donald F. Bouchard (Ithaca, NY: Cornell University Press, 1977), 52.

20. Maurice Blanchot, *The Stop Not Beyond*, trans. Lycette Nelson (Albany: State University of New York Press, 1992), 101.

21. Kara Walker, untitled painting, 1998, in *Kara Walker: Narratives of a Negress*, ed. Ian Berry, Darby English, Vivian Patterson, and Mark Reinhardt (Cambridge, MA: MIT Press, 2003), 49.

22. Walker, untitled painting, 49.

23. While delivering a paper at the Second Johannesburg Biennale Conference, Pindell denounced Walker for "catering to the bestial fantasies about Black culture created by white supremacy and racism." She went on to publish an essay collection in which other artists and critics condemned Walker's work. Alongside Bettye Saar, who infamously mounted a letter-writing campaign against the exhibition of Walker's installations, Pindell has been one of the artist's most outspoken critics. See Howardena Pindell, "Diaspora/Realities/Strategies," a paper presented at "Trade Routes, History, Geography, Culture: Towards a Definition of Culture in the late 20th Century," 2nd Johannesburg Biennale, Johannesburg, South Africa, October 1997; and Pindell, *Kara Walker/No, Kara Walker/Yes, Kara Walker/?* (New York: Midmarch Arts, 2009). For critical background about Saar's campaign, see Shaw, *Seeing the Unspeakable*, 103–24; English, *How to See a Work of Art*, 77–78; and Carpio, *Laughing Fit to Kill*, 185–86.

24. Walker has expressed a similar sentiment, explaining, "I can't say, 'Well, you shouldn't be offended.' Why not? It's a valid response, it's a valid way to feel." See Julia Szabo, "Kara Walker's Shock Art," *New York Times*, March 23, 1997, sect. 6, 49, https://www.nytimes.com/1997/03/23/magazine/kara-walker-s-shock-art.html.

25. "New Orleans Tourism Visitation and Visitor Spending Break Records in 2018," Visit New Orleans, Official New Orleans Tourism Website, May 15, 2019, http://www.neworleans.com/articles/post/new-orleans-tourism-visitation-and-visitor-spending-break-records-in-2018/.

26. Michel de Certeau, *The Practice of Everyday Life*, trans. Steven F. Rendall (Berkeley: University of California Press, 1984), 106; also see Dean MacCannell, "Staged Authenticity: Arrangements of Social Space in Tourist Settings," *American Journal of Sociology* 79, no. 3 (1973).

27. Discussing the historical formations of New Orleans and London specifically, Roach argues that cities of the circum-Atlantic world "have invented themselves by performing their pasts in the presence of others." Clarifying, he says that "they could not perform themselves, however, unless they also performed what and who

they thought they were not. By defining themselves in opposition to others, they produced mutual representations from encomiums to caricatures, sometimes in each other's presence, at times behind each other's back." See Joseph Roach, *Cities of the Dead: Circum-Atlantic Performance* (New York: Columbia University Press, 1996), 5.

28. For a more detailed history of New Orleans and the role of the slave trade in its development through the eighteenth century, see Cécile Vidal, *Caribbean New Orleans: Empire, Race, and the Making of a Slave Society* (Chapel Hill, NC: Omohundro Institute of Early American History and Culture and the University of North Carolina Press, 2019).

29. See Rashuana Johnson, *Slavery's Metropolis: Unfree Labor in New Orleans During the Age of Revolutions* (Cambridge: Cambridge University Press, 2016), 3.

30. To date, *The Katastwóf Karavan* has not traveled widely to other historical sites that have rootedness in the institution of slavery, but it did reappear as part of Moran's first solo exhibition at the Whitney Museum of Art in New York City on October 12, 2019. It was activated for a one-day-only performance, and Moran himself played the calliope live at 6:00 p.m.

31. Algiers Historical Society, "Enslaved Africans," Historical Marker, Algiers, Louisiana.

32. Quoted in "A Steam-Powered Statement: Kara Walker's *The Katastwóf Karavan*," *Public Art Review*, no. 58 (2019): 26.

33. Kevin Fox Gotham, *Authentic New Orleans: Tourism, Culture, and Race in the Big Easy* (New York: New York University Press, 2007), 82–83.

34. My intention is not to suggest that New Orleans's creole culture, jazz history, and carnival traditions have shed their relationship to Black American folkways—many historians continue to celebrate the city for precisely these features. For instance, Gwendolyn Mido Hall describes New Orleans as, "in spirit, the most African city in the United States." See Hall, "The Formation of Afro-Creole Culture," in *Creole New Orleans: Race and Americanization*, ed. Arnold R. Hirsch and Joseph Logsdon (Baton Rouge: Louisiana State University Press, 1992), 59; and Anthony J. Stanonis, *Creating the Big Easy: New Orleans and the Emergence of Modern Tourism, 1918–1945* (Athens: University of Georgia Press, 2006), 2.

35. In her reading of tourist websites, Thomas shows how the New Orleans architecture, food, and even musical traditions have continued to be "equated with a white European identity, stemming from the city's French and Spanish colonial projects in the seventeenth and eighteenth centuries." See Lynnell L. Thomas, *Desire and Disaster in New Orleans: Tourism, Race, and Historical Memory* (Durham, NC: Duke University Press, 2014), 34–37.

36. Spinning Code Noir for palatable consumption is especially telling, as it convinces tourists that capitalism offered an escape from enslavement even though capitalism begat chattel slavery to begin with. See Thomas, *Desire and Disaster*, 37.

37. "History," Steamboat NATCHEZ: New Orleans' Only Steamboat, accessed this and other NATCHEZ sources December 8, 2021, http://www.steamboatnatchez.com/history.

38. A historical marker near Belzoni, Mississippi, in Humphreys County memorializes this occasion: "On March 13, 1863, near this site, the NATCHEZ burned and sank into the Yazoo. Converted into a confederate gunboat and armored with cotton bales, the vessel had been taken into the Yazoo to avoid capture." See Mississippi Department of Archives and History, "Steamboat Natchez," 1993.

39. See "Steamboat Specs" https://www.steamboatnatchez.com/uploads/files/TheSteam-boatNatchez.pdf, and "Steamboat Guide," Steamboat NATCHEZ: New Orleans' Only Steamboat, https://www.steamboatnatchez.com/uploads/files/SteamboatNat-chezGuide.pdf.

40. "True to tradition in every detail, boarding the NATCHEZ makes you feel as if you have entered another era," the website states. "The captain barks his order through an old-time hand-held megaphone. The calliope trills a melody into the air while the great wheel, 25 tons of white oak, churns the heavy water of the Mississippi. You soon find yourself slipping into a sense of the old, vast and timeless river." See "History," Steamboat NATCHEZ, https://www.steamboatnatchez.com/about/history.

41. Steamboat NATCHEZ, https://www.steamboatnatchez.com/cruises/evening-jazz-cruise-with-dinner-option.

42. Thomas Walsh and Mark Cave, "Doc Hawley & The Calliope: 'It's More Of a Machine Than an Instrument,' " (interview), New Orleans Public Radio, October 6, 2016, http://www.wwno.org/post/doc-hawley-calliope-its-more-machine-instrument.

43. Kara Walker and Jason Moran, "Sending Out a Signal," Art21, October 31, 2018, http://art21.org/watch/extended-play/kara-walker-jason-moran-sending-out-a-signal-short/.

44. Christian McWhirter, *Battle Hymns: The Power and Popularity of Music in the Civil War* (Chapel Hill: University of North Carolina Press, 2012), 69.

45. Daniel Decatur Emmett, "Dixie," 1861; quoted in McWhirter, *Battle Hymns*, 69.

46. Walker and Moran, "Sending Out a Signal."

47. Danielle Goldman, *I Want to Be Ready: Improvised Dance as a Practice of Freedom* (Ann Arbor: University of Michigan Press, 2010), 146.

48. See Philip Alperson, "On Musical Improvisation," *Journal of Aesthetics and Art Criticism* 43, no. 1 (1984); Lee B. Brown, "Musical Works, Improvisation, and the Principle of Continuity," *Journal of Aesthetics and Art Criticism* 54, no. 4 (1996); and Andy Hamilton, "The Art of Improvisation and the Aesthetics of Imperfection," *British Journal of Aesthetics* 40, no. 1 (2000).

49. Wayne Bowman, "A Somatic, 'Here and Now' Semantic: Music, Body, and Self," *Bulletin of the Council for Research in Music Education* no. 144 (2000): 50.

50. The critical relationship between improvisatory performer and active listener undergirds Daniel Fischlin's, Ajay Heble's, and George Lipsitz's argument that musical improvisations enact a politics of hope: "In its most fully realized forms, improvisation is the creation and development of new, unexpected, and productive cocreative relations among people. It teaches us to make 'a way' out of 'no way' by cultivating the capacity to discern hidden elements of possibility, hope, and promise in even the most discouraging circumstances." See Daniel Fischlin, Ajay Heble, and George Lipsitz, "Prelude: 'The Fierce Urgency of Now': Improvisation, Rights, and the Ethics of Cocreation," in *The Fierce Urgency of Now: Improvisation, Rights, and the Ethics of Cocreation* (Durham, NC: Duke University Press, 2013), xii.

51. See Robert Walser, "The Body in the Music: Epistemology and Musical Semiotics," *College Music Symposium* no. 31 (1991): 122; Gene Ann Behrens and Samuel B. Green, "The Ability to Identify Emotional Content of Solo Improvisations Performed Vocally and on Three Different Instruments," *Psychology of Music* 21, no. 1 (1993); Alf Gabrielsson and Patrik N. Juslin, "Emotional Expression in Music Performance: Between the Performer's Intention and the Listener's Experience," *Psychology*

of Music, 24, no 1 (1996); and Julia C. Hailstone et al., "It's Not What You Play, It's How You Play It: Timbre Affects Perception of Emotion in Music," *Quarterly Journal of Experimental Psychology* 62, no. 11 (2009).

52. Zachary Wallmark, "Theorizing the Saxophonic Scream in Free Jazz Improvisation," in *Negotiated Moments: Improvisation, Sound, and Subjectivity*, ed. Gillian Siddall and Ellen Waterman (Durham, NC: Duke University Press, 2016), 237.

53. I intentionally transcribe the hesitation in Walker's delivery to capture her inability to express the feeling she recounts. See Walker and Moran, "Sending Out a Signal."

54. Asma Naeem, *Black Out: Silhouettes Then and Now* (Princeton, NJ: Princeton University Press, 2018), 41.

55. Quoted in John D'Addario, "Art & History: Kara Walker's 'The Katastwóf Karavan' Spotlights New Orleans' Slave Legacy," *New Orleans Advocate*, February 20, 2018, http://www.nola.com/entertainment_life/arts/article_7701be6e-f395-5bc1-8371 -e98cbcc2c6ef.html.

56. Mikel Dufrenne, *The Phenomenology of Aesthetic Experience*, trans. Edward S. Casey (Chicago: Northwestern University Press, 1973), 117, 123.

57. Quoted in "A Steam-Powered Statement," 25.

58. Walker and Moran, "Sending Out a Signal."

59. Walker and Moran, "Sending Out a Signal."

60. Dufrenne, *The Phenomenology of Aesthetic Experience*, 120

61. Fred Moten, *In the Break: The Aesthetics of the Black Radical Tradition* (Minneapolis: University of Minnesota Press, 2003), 255.

62. Walker and Moran, "Sending Out a Signal."

3. ANTIESSENTIALIST FORM: THE BEBOP EFFECT
OF PERCIVAL EVERETT'S *ERASURE*

1. In the same way that Everett has written in a number of genres, his working history is diverse. Beyond writing and painting, his career includes stints as a jazz musician, ranch worker, high school teacher, and luthier and appointments in English Departments and creative writing programs at the University of Kentucky, Lexington (1985–89); University of Notre Dame (1989–92); University of California, Riverside (1992–98); and University of Southern California (1998–present).

2. Percival Everett, *Erasure* (Lebanon, NH: University Press of New England, 2001). Subsequent references, unless otherwise noted, are to this edition, and page numbers are cited parenthetically in the text.

3. In terms of John Reichert's straightforward notion of "any group of works selected on the basis of some shared features," see Reichert, "More Than Kin and Less Than Kind: The Limits of Genre Theory," in *Theories of Literary Genre*, ed. Joseph P. Strelka (University Park: Pennsylvania State University Press, 1978), 57.

4. Seth Morton, "Locating the Experimental Novel in *Erasure* and *The Water Cure*," *Canadian Review of American Studies* 43, no. 2 (2013): 194–95.

5. Ralph Cohen, "History and Genre," *New Literary History* 17, no. 2 (Winter 1986): 204.

6. Jacques Derrida, "The Law of Genre," *Critical Inquiry* 7, no. 1 (Autumn 1980): 64–65.

7. Derrida, "The Law of Genre," 66.

8. Jon Panish, *The Color of Jazz: Race and Representation in Postwar American Culture* (Jackson: University Press of Mississippi, 1997), 11.

9. Scott DeVeaux, *The Birth of Bebop: A Social and Musical History* (Berkeley: University of California Press, 1997), 3–4.

10. Amiri Baraka, *Blues People: Negro Music in White America* (New York: William Morrow, 1999), 188.

11. DeVeaux, *Birth of Bebop*, 62–63.

12. Keren Omry, *Cross-Rhythms: Jazz Aesthetics in African-American Literature* (New York: Continuum, 2008), 8.

13. Or, as Baraka writes, the younger musicians of this period took jazz and "drag[ged] it outside the mainstream of American culture again." Baraka, *Blues People*, 188.

14. DeVeaux, *Birth of Bebop*, 6.

15. Ross Russell, "Bebop," in *The Art of Jazz*, ed. by Martin Williams (New York: Grove, 1959), 202. In an interpretation that brings together the work of Lorenzo Thomas, Houston A. Baker, Jr., and Eric Lott, Mark Osteen reflects on the effects of these recompositions. He notes that bebop compositions evolved by recomposing popular songs and are thus contradictorily part of and apart from that tradition. See Osteen, "Rhythm Changes: Contrafacts, Copyright, and Jazz Modernism," in *Modernism and Copyright*, ed. Paul K. Saint-Amour (Oxford: Oxford University Press, 2010), 94–96

16. Russell, "Bebop," 202.

17. Ralph Ellison, "The Golden Age, Time Past," in *The Collected Essays of Ralph Ellison*, ed. John Callahan (New York: Modern Library, 2003), 239.

18. Lorenzo Thomas, "The Bop Aesthetic and Black Intellectual Tradition," in *The Bebop Revolution in Words and Music*, ed. David Oliphant (Austin: University of Texas at Austin, 1995), 117.

19. Omry, for instance, argues that, "through its own transience and atextuality, and its complex and shifting approach to form, jazz reflects the material, intellectual and communal implications of racialized African-American experience." She extends this claim to bebop as an especially powerful mode of harnessing the creative energies of Black experience in particular. Thomas likewise claims that bebop's "style is a creative and explicit expression of racial pride that is logically and inextricably linked to the musicians' desire for artistic recognition and economic self-determination." See Omry, *Cross-Rhythms*, 23; and Thomas, "The Bebop Aesthetic," 117.

20. Paul Gilroy, *The Black Atlantic: Modernity and Double Consciousness* (New York: Verso, 1993), 102, 100.

21. Paul Gilroy, "It Ain't Where You're from, It's Where You're at . . .: The Dialectics of Diasporic Identification," *Third Text* 15, no. 13 (1991): 113.

22. Paul F. Berliner, *Thinking in Jazz: The Infinite Art of Improvisation* (Chicago: University of Chicago Press, 1994), 158.

23. Everett, *Erasure*, 52. I format this block quote with word spacing that simulates its appearance in the novel.

24. For example, Charlie Parker played an important role in the development of what are now commonly known as "Bird changes," variations on the twelve-bar blues that features two chords in nearly every bar, as well as a mixture of major and minor key ii-V progressions. He featured this innovative progression in songs like "Confirmation" and, more notably, "Blues for Alice." Below is a musical chord progression diagram.

Basic blues progression:		C		C		C		C	
		F		F		C		C	
		G		F		C		C	
With Bird changes:		CMaj7	Bm7b5 / E7	Am7 / D7	Gm7 / C7				
		F7	F7 / Bb7	Em7 / A7	Ebm7 / Ab7				
		Dm7	G7	CMaj7 / A7	Dm7 / G7				

25. DeVeaux, *Birth of Bebop*, 267–68.
26. In truth, Van is no less carefully constructed than Monk. Despite Everett's claim to have written *Fuck* in a single sitting, both Van and Monk are characters of his invention. For this reason, I suggest that the encounter of the voices alongside one another allows for a sensibility of improvisation. The narrative distance of the reader from each voice allows one to appear improvisational next to the other, a technique that is difficult to accomplish in literature, which inevitably eliminates the liveness one usually associates with improvisation.
27. This is not to suggest that Van's improvisatory language signifies escape from categorical capture; rather, it is to draw attention to how the contrast between the divergent voices of *Erasure* frustrates the singularity on which the categorical notion of racial identity depends. By calling into question the imagined notion of a paradigmatic racial voice (such as the one that fictional critics and readers believe Jenkins realized) Everett's bebop effect undermines his reader's expectations of race in addition to the genre of the novel.
28. DeVeaux, *Birth of Bebop*, 348.
29. See Frantz Fanon, *Black Skin, White Masks*, trans. Richard Philcox (New York: Grove, 2008), 89–92.
30. Unlike *Fuck*, which Everett includes within *Erasure*, readers must piece together the details of Jenkins's novel. *We's Lives in Da Ghetto* tells the story of Sharonda, a fifteen-year-old Black woman who is pregnant with her third child by a third father. She becomes a prostitute after her basketball-playing brother, Juneboy, dies in a rival gang's drive-by shooting. Sharonda then becomes a famous tap dancer after taking classes at the community center and, in the end, earns enough money to readopt her children from a child welfare agency. Although it is fictional, for Everett, Jenkins and her work critique American author Sapphire's debut novel, *Push*, which won two Academy Awards as a film adaptation titled *Precious* in 2009. As with Jenkins's work in *Erasure*, Sapphire's novel won approval for being a "realistic" glimpse of Black life despite the fact that many people—including Everett, his critique suggests—found the portrayals of race to be demeaning and steeped in damaging stereotypes.
31. Kenya Dunston, the talk show host, is a reference to Oprah Winfrey and the power that Oprah's Book Club had in determining what the nation read and considered legitimately literary. Because of the popularity of *The Oprah Winfrey Show*, many of the titles included in the book club became instant bestsellers, a phenomenon widely known as the "Oprah effect," which Everett has criticized in interviews. "I'm artistically offended by that kind of thing. That anybody can claim to vet art and then feed it to the public seems to me pretentious, portentous, and probably pernicious and vile. And I won't participate in it." More bluntly, he stated in a separate interview, "Oprah should stay the fuck out of literature and stop pretending she

knows anything about it." See Anthony Stewart, "Unrecognizable Is Still a Category: An Interview with Percival Everett," *Canadian Review of American Studies* 3, no. 37 (2007): 302; and Rone Shavers, "Percival Everett" (interview), *BOMB* 88 (Summer 2004): 49.

32. Guthrie P. Ramsey, *Race Music: Black Cultures from Bebop to Hip-Hop* (Berkeley: University of California Press, 2003), 106.

33. Ingrid Monson, "The Problem with White Hipness: Race, Gender, and Cultural Conceptions in Jazz Historical Discourse," *Journal of the American Musicological Society* 48, no. 3 (Autumn 1995): 421.

34. Gillespie later changed his mind about Armstrong, admitting that the latter's grinning and appeasement was actually a productive strategy to preserve his spirit in the face of oppression. See Dizzy Gillespie and Al Fraser, *To Be, or Not . . . to Bop* (Minneapolis: University of Minnesota Press, 2009), 296–97.

35. Krin Gabbard, "Signifyin(g) the Phallus: *Mo' Better Blues* and Representations of the Jazz Trumpet," in *Representing Jazz*, ed. Krin Gabbard (Durham, NC: Duke University Press, 1995), 126, n14.

36. Brian Priestley, *Mingus, a Critical Biography* (New York: Da Capo, 1983), 19.

37. Gillespie, *To Be, or Not*, 296.

38. Robert Fikes, Jr., reading the *New York Times* annual roster of Notable Books for the year 2000, similarly noted that "predictably, *The Times*, the flagship news and culture arbiter of the nation's media, did what the rest of the mainstream press does consistently: namely, selectively publicizing those books that reinforce the majority group perception that blacks are experts on themselves and little else," after he realized that thirteen of the fifteen titles authored by Black writers took Black experience as their primary subjects. After further analysis, he concludes that "this may not be so much a matter of editorial discretion or censorship as deeply ingrained stereotypical thinking on both sides of the racial divide." See Fikes, "How Major Book Review Editors Stereotype Black Authors," *Journal of Blacks in Higher Education* 33 (Autumn 2001): 110–11.

39. Monk extends this claim also to cases in which the knowledge in question seems outwardly positive. An apparently positive example of racial thought is the suggestion that Black Americans are inherently athletic, which Everett challenges at several points throughout *Erasure*—including the first page—by reiterating that Monk is "no good at basketball" (1). Surrender to such an instance of racial stereotyping could inadvertently lessen the defamiliarizing effect that Everett works to achieve.

40. One of Monk's fictional novels is a reworking of Aeschylus's *The Persians* (2).

41. Her prophecy that king Agamemnon was to be murdered having gone unheeded, Cassandra laments, "It is all one to me, if you do not believe any of this; / what difference? / It is to be and will come. / Soon you will stand here and say of me, in pity, / she was too true a prophet." See Aeschylus, *Agamemnon*, trans. David Greene and Wendy Doniger O'Flaherty, in *The Bedford Introduction to Drama*, 4th ed., ed. Lee A. Jacobus (New York: Bedford/St. Martin's, 2001), 1338–42.

42. Melanie Klein, *Envy and Gratitude and Other Works 1946–1963* (New York: Free Press, 1975), 293.

43. Laurie Layton Schapira, *Cassandra Complex: Living with Disbelief: A Modern Perspective on Hysteria* (Charleston, SC: BookSurge, 1988), 10.

44. Schapira, *Cassandra Complex*, 65.

45. Jean Shinoda Bolen, *Gods in Everyman: A New Psychology of Men's Lives and Loves* (New York: Harper, 1993), 135.

46. Schapira, *Cassandra Complex*, 65.

47. In his journal, Monk goes so far as to name Wright's novel as one of the texts that he rejects as foundational to the limiting category of African American literature: "I remembered passages of *Native Son* and *The Color Purple* and *Amos and Andy* and my hands began to shake, the world opening up around me, tree roots trembling on the ground outside, people in the street shouting *dint, ax, fo, screet* and *fahvre!* and I was screaming inside, complaining that I didn't sound like that, that my mother didn't sound like that, that my father didn't sound like that" (62). Like Wright's novel, Monk's novella chronicles the defeat of an aggressive Black male. Specifically, *Fuck* shares with *Native Son* the basic plot of a poor young man going to work for the wealthy Dalton family (which Monk changes from white to Black), driving his employer's daughter through the community where he lives to observe the spectacle of inner-city life and committing a crime against the Dalton girl (a murder in the case of Bigger Thomas and a rape in the case of Van Go Jenkins) that provokes an extended police chase and arrest.

48. Berliner, *Thinking in Jazz*, 262–63.

49. In addition to Monk's in-text explanations that he writes *Fuck* in response to *We's Lives in Da Ghetto*, the protagonist of his novella shares last names with the novel's author—Van Go Jenkins functions as an understated reference to Juanita Mae Jenkins.

50. Panish, *The Color of Jazz*, 131.

51. In Monk's opening journal entry, he writes, "I am Thelonious Ellison. Call me Monk" (2). The structure of this introduction makes connection also with the character Ishmael in Herman Melville's *Moby Dick*.

52. As W. Lawrence Hogue notes in his analysis of *Erasure*, Monk's pseudonym alludes to the folk figure of Stagolee, an archetype for a strong Black man who defies white authority through his sly, streetwise, and violent demeanor. See Hogue, *Postmodernism, Traditional Cultural Forms, and African American Narratives* (Albany: State University of New York Press, 2013), 124.

53. In addition to this specific clothing, Monk's hotel number is the same as the number of lightbulbs with which the invisible man lights the basement in the prologue of Ellison's novel. The descent imagery in this scene appears throughout *Invisible Man*—for example, when falling into the open manhole cover, Ellison writes that the invisible man felt himself "plunge down, down." See Ellison, *Invisible Man* (New York: Vintage, 1995), 565. Finally, Everett's subtle inclusion of the word "bop" echoes the jazz subgenre that Thelonious Monk helped to pioneer.

54. After passing as Rinehart, the invisible man removes his disguise and remarks, "If dark glasses and a white hat could blot out my identity so quickly, who actually was who?" See Ellison, *Invisible Man*, 493. Mary Lou Williams comments that Thelonious Monk started wearing heavy-framed sunglasses and a hat after he began playing at Minton's Playhouse, an intimate and informal space in Harlem, in the early 1940s. "He had [the glasses] made in the Bronx, and several days later came to the house with his new glasses and, of course, a beret. He had been wearing a beret, with a small piano clip on it, for some years previous to this. Now he started wearing the glasses and beret and the others copied him." See Williams, "The Mad Monk," *Melody Maker*, May 22, 1954, 11, 14.

55. Baraka, *Blues People*, 201.

56. Review of "Epistrophy" and "In Walked Bud," composed and performed by Thelonious Monk. *Down Beat* (October 20, 1948): 13.

57. André Hodeir, *Toward Jazz* (New York: Grove, 1962), 156–77.

58. Ran Blake, "The Monk Piano Style," *Keyboard* (July 1982): 24.

59. Robin D. G. Kelley, *Thelonious Monk: The Life and Times of an American Original* (New York: Free Press, 2009).

60. Thomas Fitterling, *Thelonious Monk: His Life and Music*, trans. Robert Dobbin (Albany, CA: Berkeley Hills Books, 1997), 99–100.

61. Thelonious Monk's "Trinkle, Tinkle" and "Four in One" are fine examples of the whole-tone scale in action.

62. The whole-tone scale allowed Monk to experiment with unconventional tone production that often resulted in a harshly percussive sound. This impulse to improvise and incorporate jarring harmonies into his music is particularly clear in Monk's recompositions of pre–World War II musical standards—like "Smoke Gets in Your Eyes," which he recorded in 1954 and later released on *Piano Solo*—though it is also audible in much of his original material. Eric Lott cites "Thelonious," from *Genius of Modern Music*, vol. I, for example, as a typically subversive bebop number that "riffs self-consciously on tradition—Monk suddenly erupting into stride piano—and depends for its effect on a cool surface continually broken up by jarring piano, the shock of the new." See Lott, "Double V, Double-Time: Bebop's Politics of Style," *Callaloo* 36 (Summer 1988): 601.

63. Pitches sound harmonious together when there is a simple ratio between the frequency of two notes. The ratio of two notes that are an octave apart is 2:1, and the ratio of a perfect fifth is 3:2. Tritonic relations have a ratio of 45:32, which sounds extremely discordant to the human ear. The dissonance produced in this restless interval has been symbolically associated with the devil since the early Middle Ages, sometimes being referred to as *diabolus in musica*, or "the devil in music." Tritones are often used in alarm bells or emergency sirens because of their harshness.

64. Theodor Adorno, *Aesthetic Theory*, ed. Gretel Adorno and Rolf Tiedemann, trans. Robert Hullot-Kentor (New York: Bloomsbury, 2013), 151.

65. See Leslie Gourse, *Straight, No Chaser: The Life and Genius of Thelonious Monk* (New York: Schirmer, 1997), 113–21; Kelley, *Thelonious Monk*, xvii, 214–15; and Laurent de Wilde, *Monk*, trans. Jonathan Dickinson (New York: Da Capo, 1997), 204.

66. Raymond Horricks, *These Jazzmen of Our Time* (London: Victor Golancz, 1959), 20–23.

67. Horricks, *These Jazzman of Our Time*, 23.

68. For a thoughtful disarticulation of "madness" as a socially constructed ethical paradigm that white hegemony uses to pathologize Black people while validating normative (read, "white") behaviors, see La Marr Jurelle Bruce, *How to Go Mad Without Losing Your Mind: Madness and Radical Black Creativity* (Durham, NC: Duke University Press, 2021), 6–8.

69. Here I refer to the work of Fred Moten, who has theorized this jazz term at length. See Moten, *In the Break: The Aesthetics of the Black Radical Tradition* (Minneapolis: University of Minnesota Press, 2003).

70. Derrida, "The Law of Genre," 66.

71. W. E. B. Du Bois, *The Souls of Black Folk* (San Bernardino, CA: Eucalyptus, 2014), 4.

72. Percival Everett, "F/V: Placing the Experimental Novel," *Callaloo* 22, no. 1 (Winter 1999): 21.

73. *Publisher's Weekly* review excerpt on back cover of *Erasure* by Percival Everett.

4. BEYOND SATIRE: THE HUMOR OF INCONGRUITY IN PAUL BEATTY'S *THE SELLOUT*

1. Paul Beatty, ed., *Hokum: An Anthology of African-American Humor* (New York: Bloomsbury, 2006), 300.

2. Here I reference Michael T. Taussig, *Defacement: Public Secrecy and the Labor of the Negative* (Stanford, CA: Stanford University Press, 1999), 5.

3. Beatty, *Hokum*, 300. Throughout this chapter, I refer to Beatty's works, where context is clear, by page number parenthetically in the text.

4. Paul Beatty, *The Sellout* (New York: Picador, 2015).

5. Glenda Carpio, *Laughing Fit to Kill: Black Humor in the Fictions of Slavery* (Oxford: Oxford University Press, 2008), 5.

6. See Ibram X. Kendi, *Stamped from the Beginning: The Definitive History of Racist Ideas in America* (New York: Nation, 2016), 15–21; and Richard Dyer, *White: Essays on Race and Culture* (New York: Routledge, 1997), 102.

7. See Alexandra Alter, "Paul Beatty Wins Man Booker Prize with 'The Sellout,'" *New York Times*, October 25, 2016, https://www.nytimes.com/2016/10/26/business /media/paul-beatty-wins-man-booker-prize-with-the-sellout.html; and Kevin Young, "Paul Beatty's 'The Sellout,'" *New York Times*, April 9, 2015, https://www.nytimes .com/2015/04/12/books/review/paul-beatty-sellout.html.

8. Reni Eddo-Lodge, "The Sellout by Paul Beatty Review—a Whirlwind Satire About Racial Identity," *The Guardian*, May 11, 2016, https://www.theguardian.com/books /2016/may/11/the-sellout-by-paul-beatty-review. See also Charlotte Higgins, "Turned Down 18 Times. Then Paul Beatty Won the Booker . . .," *The Guardian*, October 26, 2016, https://www.theguardian.com/books/2016/oct/26/man-booker-prize-winner -paul-beatty-the-sellout-interview.

9. See Jeffrey Brown, "Novelist Paul Beatty Pokes Fun at How We Talk About Race in America," *PBS News Hour*, May 8, 2015, https://www.pbs.org/newshour/show /novelist-paul-beatty-pokes-fun-at-how-we-talk-about-race-in-america; Joshua Barajas, "Paul Beatty Wins Man Booker Prize with 'The Sellout,' a Sendup of Race in America," *PBS News Hour*, October 25, 2016, https://www.pbs.org/newshour/arts /paul-beatty-wins-man-booker-prize-sellout-sendup-race-america; Michael Schaub, "'The Sellout' Is a Scorchingly Funny Satire on 'Post-Racial' America," NPR, March 2, 2015, https://www.npr.org/2015/03/02/388955068/the-sellout-is-a-scorchingly-funny -satire-on-post-racial-america; and Lynn Neary, "Novelist Paul Beatty Is First American to Win Britain's Man Booker Prize," NPR, October 25, 2016, https://www .npr.org/sections/thetwo-way/2016/10/25/499368241/novelist-paul-beatty-is-first -american-to-win-britains-man-booker-prize.

10. Sameer Rahim, "Man Booker Prize 2016 Winner Paul Beatty's The Sellout Is an Outrageous Racial Satire—Review," *The Telegraph*, October 26, 2016, https:// www.telegraph.co.uk/books/what-to-read/man-booker-prize-shortlist-2016-paul -beattys-the-sellout-is-an-o/.

11. Darryl Dickson-Carr, *African American Satire: The Sacredly Profane Novel* (Columbia: University of Missouri Press, 2001), 202.

12. See Cameron Leader-Picone, "Pilgrims in an Unholy Land: Satire and the Challenge of African American Leadership in *The Boondocks* and *The White Boy Shuffle*," in *Post-Soul Satire: Black Identity After Civil Rights*, ed. Derek C. Maus and James J. Donahue (Jackson: University of Mississippi Press, 2014), 137–49; and Christian Schmidt, "Dissimulating Blackness: The Degenerative Satires of Paul Beatty and Percival Everett," in *Post-Soul Satire: Black Identity After Civil Rights*, ed. Derek C. Maus and James J. Donahue (Jackson: University of Mississippi Press, 2014), 150–61.

13. Yogita Goyal, *Runaway Genres: The Global Afterlives of Slavery* (New York: New York University Press, 2019), 114.

14. Amrita Tripathi, "'Satire Is an Easy Word to Just Hide Behind': Paul Beatty on His Man Booker-Winning Novel," *Scroll.in*, January 23, 2017, https://scroll.in /article/827378/satire-is-an-easy-word-to-just-hide-behind-paul-beatty-on-his -man-booker-winning-novel.

15. Specifically, Beatty explained: "I'm surprised that everybody keeps calling this a comic novel. . . . it's an easy way not to talk about anything else. . . . There's comedy in the book, but there's a bunch of other stuff in there, too. It's easy just to hide behind the humor and then you don't have to talk about anything else. But I definitely don't think of myself as a satirist." See Chris Jackson, "Our Thing: An Interview with Paul Beatty," *Paris Review*, May 7, 2015, https://www.theparisreview.org/blog/2015/05/07 /our-thing-an-interview-with-paul-beatty/.

16. Northrop Frye, "The Nature of Satire," *University of Toronto Quarterly* 14, no. 1 (1944): 79. Frye's theory reiterates key ideas from David Worcester's *The Art of Satire* and Ian Jack's *Augustan Satire*, and his ideas were repeated for the next fifty years in Gilbert Highet's *Anatomy of Satire* (Princeton, NJ: Princeton University Press, 1962), 26, 65; Frederick Kiley and Jack M. Shuttleworth's *Satire from Aesop to Buchwald* (Indianapolis: Bobbs-Merrill, 1971), 479; Leon Guilhamet's *Satire and the Transformation of Genre* (Philadelphia: University of Pennsylvania Press, 1987); and John Clark's *The Modern Satiric Grotesque and Its Traditions* (Lexington: University Press of Kentucky, 1991), 51. See also Worcester, *The Art of Satire* (Cambridge, MA: Harvard University Press, 1940); and Jack, *Augustan Satire: Intention and Idiom in English Poetry 1660–1750* (Oxford: Oxford University Press, 1942).

17. See John Gray, *Liberalism*, 2nd ed. (Minneapolis: University of Minnesota Press, 2003), xi–xii.

18. Contemporary criticism of African American satire builds on Michael Weisenburger's "degenerative" model of satire, which describes satire as "a form of interrogating and subverting codified knowledge and revealing it as a dissimulation of violence." See Weisenburger, *Fables of Subversion: Satire and the American Novel* (Athens: University of Georgia Press, 1995), 11–12. In addition to studies by Dickson-Carr, Carpio, and Goyal, see Lisa A. Guerrero, *Crazy Funny: Popular Black Satire and the Method of Madness* (New York: Routledge, 2019); and Danielle Fuentes Morgan, *Laughing to Keep from Dying: African American Satire in the Twenty-First Century* (Champaign: University of Illinois Press, 2020).

19. Frye, "The Nature of Satire," 79–80.

20. Charles W. Mills, *The Racial Contract* (Ithaca, NY: Cornell University Press, 1999), 1–7, 122.

21. Domenico Losurdo, *Liberalism: A Counter History* (New York: Verso, 2011), 37.

22. See W. E. B. Du Bois, *Black Reconstruction in America 1860–1880* (Cambridge: Athenaeum, 1975), 700.

23. Michelle Alexander, *The New Jim Crow: Mass Incarceration in the Age of Colorblindness* (New York: New Press, 2010).

24. Richard Rothstein, *The Color of Law: A Forgotten History of How Our Government Segregated America* (New York: Liveright, 2017).

25. Mehrsa Baradaran, *The Color of Money: Black Banks and the Racial Wealth Gap* (Cambridge, MA: Belknap, 2017); and Carol Anderson, *One Person, No Vote: How Voter Suppression Is Destroying Our Democracy* (New York: Bloomsbury, 2018).

26. Harriet A. Washington, *A Terrible Thing to Waste: Environmental Racism and Its Assault on the American Mind* (New York: Little, Brown Spark, 2020).

27. For a theory of "civic estrangement," see Salamishah Tillet, *Sites of Slavery: Citizenship and Racial Democracy in the Post–Civil Rights Imagination* (Durham, NC: Duke University Press, 2012), 3.

28. Here I reference Elijah Anderson, "The White Space," *Sociology of Race and Ethnicity* 1, no. 1 (2015): 10–21.

29. This evokes the theoretical framework that has come to be called "Afro-pessimism," a mode of Black radical thought that approaches race as a condition of social exclusion and negation. On the topic of U.S. civil society's constituent anti-Blackness, Cornel West writes, "black subordination constitutes the necessary condition for the flourishing of American democracy, the tragic prerequisite for America itself." Frank B. Wilderson III adds that "the death of the black body is . . . foundational to the life of American civil society." See West, "Black Strivings in a Twilight Civilization," in *The Future of the Race*, ed. Henry Louis Gates, Jr., and Cornel West (New York: Vintage, 1997), 55–114; and Wilderson, "Gramsci's Black Marx: Whither the Slave in Civil Society," *Social Identities* 9, no. 2 (2003): 225–40.

30. Carpio, *Laughing Fit to Kill*, 4.

31. For example, Thomas Hobbes and René Descartes thought of laughter as an expression of one's superiority over others, a way of thinking about humor that was popular during the seventeenth and eighteenth centuries. In the nineteenth century, Herbert Spencer and Sigmund Freud associated laughter with the release of nervous energy. See Hobbes, *Leviathan*, ed. A. R. Waller (Cambridge: Cambridge University Press, 1904); and Descartes, *The Passions of the Soul*, in *Philosophical Works of Descartes*, vol. 1, trans. Elizabeth Haldane and G. R. T. Ross (Cambridge: Cambridge University Press, 1911). See also Herbert Spencer, "On the Physiology of Laughter," in *Essays on Education, Etc.* (London: Dent, 1911); and Sigmund Freud, *Jokes and Their Relation to the Unconscious, trans. James Strachey (New York: Penguin, 1974).

32. See Arthur Schopenhauer, *The World as Will and Idea*, vol. 1, 7th ed., trans. R. B Haldane and J. Kemp (London: Kegan Paul, Trench, Trübner, 1909); and Immanuel Kant, *Critique of Judgment*, trans. James Creed Meredith (Oxford: Clarendon, 1911).

33. Carpio, *Laughing Fit to Kill*, 6.

34. Carpio, *Laughing Fit to Kill*, 6.

35. These are the specific designations that the United States Congress has given to Parks. See United States, 106th Congress, Public Law 106-26, Section 1, Finding 2, Approved May 4, 1999, https://www.congress.gov/106/plaws/publ26/PLAW-106publ26.pdf.

36. The earliest known human classification scheme was actually published by François Bernier in 1684, but his system categorized people into four geographic divisions, leaving notions of racial difference a vague implication of regional difference. See Nell Irvin Painter, *The History of White People* (New York: W. W. Norton, 2010), 43–44, 79–86; and Kendi, *Stamped from the Beginning*, 55–56.

37. A sense of color difference preceded Blumenbach's work, having roots even in the ancient world; however, *On the Variety of Mankind* delineated this difference according to a clear articulation of race, a concept that had remained ambiguous since its first dictionary appearance in 1606. As Kendi records, color-based hierarchies preceding Blumenbach's work attributed epidermal difference to climate difference or referred to Christian scripture by suggesting that Blackness was the product of a curse (which later evolved into theories of polygenesis). See Kendi, *Stamped from the Beginning*, 36, 17–21, 50.

38. See Painter, *History of White People*, 88.

39. Dyer, *White*, 72.

40. Ian Haney López has shown that notions of behavior and crime have functioned as proxy language for race since the end of the Civil Rights era and featured prominently in the politics of Richard Nixon and, later, Ronald Reagan. See López, *Dog Whistle Politics: How Coded Racial Appeals Have Reinvented Racism & Wrecked the Middle Class* (Oxford: Oxford University Press, 2014), 35–76. See also Kendi, *Stamped from the Beginning*, 411, 432, 502; and Painter, *History of White People*, 379–380.

41. Dyer, *White*, 19–20.

42. Kendi, *Stamped from the Beginning*, 124.

43. Dyer, *White*, 9.

44. Dyer, *White*, 63.

45. The narrator's specific gesture toward state proficiency exam scores further emphasizes that students have reacted to hierarchization by adopting performances of a cultural construction of whiteness, as such testing has historically been designed to "prove" the existence of innate racial difference and, for this reason, has historically privileged white test takers. As Painter and Kendi explain, standardized (and IQ) testing has been the "objective" method of demonstrating the intellectual inferiority of Black test takers since the administration of Army intelligence testing during World War I. See Painter, *History of White People*, 278–90; and Kendi, *Stamped from the Beginning*, 311–12.

46. Kendi, *Stamped from the Beginning*, 96–97.

47. Among others, Kendi explores the ironies of the "extraordinary Negro" in analyses of Phillis Wheatley and Francis Williams. See Kendi, *Stamped from the Beginning*, 92–96.

48. Cornel West, "Niggerization," *The Atlantic*, November 2007, https://www.theatlantic.com/magazine/archive/2007/11/niggerization/306285/.

49. Kendi traces the history of reverse racism to President Andrew Johnson's vetoing of the Civil Rights Act of 1866. He writes, "only from the perspective of someone who refused to acknowledge discrimination in racial disparities, who wanted to maintain White privileges and power to discriminate, could this bill be seen as 'in favor of the colored and against the white race,' to use Johnson's words. . . . If there was any semblance of equal opportunity, these racists argued, then Blacks would become dominators and Whites would suffer. This was—and still is—the racist folklore of reverse discrimination." See Kendi, *Stamped from the Beginning*, 239.

50. Carpio, *Laughing Fit to Kill*, 6.

51. See Herman Melville, "Bartleby," in *The Piazza Tales* (New York: Dix & Edwards, 1856).

52. In interviews, Beatty has remarked on his interest in Cross's theory, which attracted his attention when earning a master's degree in psychology at Boston University. "Although I didn't necessarily agree with his hierarchical notions of black identity development, it was refreshing to see someone talking about black identity as a shifting construct, to see it represented schematically. But, more importantly, it was an excellent illustration of the cultural bias so rampant in the social sciences. I like to think Cross's work changed how psychology as a whole talks about identity development, irrespective of demographic context." See Paromita Chakrabarti, "I'm No Astronaut of Blackness: Paul Beatty," *Indian Express*, October 26, 2016, https://indianexpress.com/article/lifestyle/books/im-no-astronaut-of-blackness-paul-beatty/.

53. *Black World* is the name under which the *Negro Digest* was released from 1970 to 1976, at which point it abruptly ceased publication.

54. See Joseph White, "Toward a Black Psychology," *Ebony* 25, no. 11 (September 1970): 44–53.

55. William E. Cross, Jr., "The Negro-to-Black Conversion Experience," *Black World* 20, no. 9 (July 1971): 13–14.

56. Cross, "The Negro-to-Black Conversion Experience," 15.

57. Cross, "The Negro-to-Black Conversion Experience," 16.

58. Cross, "The Negro-to-Black Conversion Experience," 17.

59. Cross, "The Negro-to-Black Conversion Experience," 18.

60. Cross called the third and fourth phases of his conversion experience "Internalization" and "Internalization-Commitment." In the internalization stage, a person synthesizes and incorporates the experiences gained in the immersion-emersion phase. According to Cross, it produces one of three psychological profiles: (1) the individual develops feelings of disappointment and rejection, which reinforce a sense of racial inferiority; (2) the individual becomes fixated on the devices of racialization, which produces a hatred for all things white; or (3) the individual enjoys a sense of inner security, which makes him or her receptive to plans that might result in meaningful change. Cross believed that the individual could not reach a sense of racial enlightenment until the final stage of development, and that the final stage could be reached only by those who arrived at a sense of inner security in the internalization phase. A person functioning in the internalization-commitment phase has overcome "anxiety over Blackness," according to Cross, and can thus commit to acting on plans of liberation. See Cross, "The Negro-to-Black Conversion Experience," 22–23.

61. In order of appearance, Beatty lists Donald Goines, Chester Himes, Abbey Lincoln, Marcus Garvey, Alfre Woodard, Clarence Cooper, Charlie Parker, Richard Pryor, Maya Deren, Sun Ra, Kenzi Mizoguchi, Frida Kahlo, Jean-Luc Godard, Céline, Gong Li, David Hammons, Björk, and the Wu-Tang Clan. We might add to this list the name Hominy Jenkins.

62. Fred Moten, "Taste Dissonance Flavor Escape: Preface for a Solo by Miles Davis," *Women & Performance: A Journal of Feminist Theory* 17, no. 2 (2007): 223.

63. Moten, "Taste Dissonance Flavor Escape," 223.

5. THE POLITICS OF INERTIA: TEMPORAL DISTORTION IN SUZAN-LORI PARKS'S *100 PLAYS FOR THE FIRST HUNDRED DAYS*

1. To date, the cycle has not been produced. Suzan-Lori Parks, *100 Plays for the First Hundred Days* (New York: Theatre Communications Group, 2018).

2. For definitions and origins of the temporal turn, see Penelope J. Corfield, "History and the Temporal Turn: Returning to Causes, Effects and Diachronic Trends," in *Les âges de Britannia: Repenser l'histoire des mondes britanniques (Moyen Âge-XXIe siècle)*, ed. Jean-François Dunyach and Aude Mairey (Rennes, France: Presses Universitaires de Rennes, 2015); Robert Hassan, "Globalization and the 'Temporal Turn': Recent Trends and Issues in Time Studies, *Korean Journal of Policy Studies* 25, no. 2 (2010); and Andrew R. Hom, "Silent Order: The Temporal Turn in Critical International Relations," *Millennium: Journal of International Studies* 46, no. 3 (2018).

3. See Daylanne K. English, "Race, Writing, and Time," in *Literature and Time*, ed. Thomas M. Allen (Cambridge: Cambridge University Press, 2018).

4. Hortense Spillers, "Mama's Baby, Papa's Maybe: An American Grammar Book," *Diacritics* 17, no. 2, special issue, "Culture and Countermemory: The 'American' Connection" (Summer 1987): 65.

5. Karla F. C. Holloway, "The Death of Culture," *Massachusetts Review* 40, no. 1 (1999): 35.

6. Here I reference Bruno Latour, "Morality and Technology," trans. Couze Venn, *Theory, Culture & Society* 19, nos. 5–6 (2002). For "pornotroping" see Spillers, "Mama's Baby, Papa's Maybe," 67; for "rememory," see Toni Morrison, *Beloved* (New York: Knopf, 1987).

7. Mark M. Smith, *Mastered by the Clock: Time, Slavery, and Freedom in the American South* (Chapel Hill: University of North Carolina Press, 1997). For discussions of time consciousness and capitalism, see Barbara Adam, *Timewatch: The Social Analysis of Time* (Cambridge: Polity, 1995), 86–91; Gerhard Dohrn-van Rossum, *History of the Hour: Clocks and Modern Temporal Orders*, trans. Thomas Dunlap (Chicago: University of Chicago Press, 1996), 8–15; and David Landes, *Revolution in Time: Clocks and the Making of the Modern World* (Cambridge, MA: Harvard University Press, 1983).

8. Smith, *Mastered by the Clock*, 5, 11, 15–16.

9. See Georg Wilhelm Friedrich Hegel, *The Philosophy of History*, trans. John Sibree (New York: P. F. Collier, 1902), 157; David Hume, "Of National Character," in *Essays and Treatises on Several Subjects, in Two Volumes. Vol. 1: Essays, Moral, Political, and Literary* (London: T. Cadell, 1784), 551; and Immanuel Kant, "Of the Different Races of Human Beings," in *Anthropology, History, and Education*, trans. Robert B. Louden and Günter Zöller (Cambridge: Cambridge University Press, 2007), 93.

10. Michael Hanchard, "Afro-Modernity: Temporality, Politics, and the African Diaspora," *Public Culture* 11, no. 1 (1999): 252, 263–64.

11. Suzan-Lori Parks, *Betting on the Dust Commander*, in *The America Play and Other Works* (New York: Theatre Communications Group, 1995), 76.

12. Parks, *Betting on the Dust Commander*, 83.

13. Parks, *Betting on the Dust Commander*, 77, 83.

14. Suzan-Lori Parks, *The Death of the Last Black Man in the Whole Entire World*, in *The America Play and Other Works* (New York: Theatre Communications Group, 1995), 111.

15. La Marr Jurelle Bruce, *How to Go Mad Without Losing Your Mind: Madness and Radical Black Creativity* (Durham, NC: Duke University Press, 2021), 219.

16. Parks, *The Death of the Last Black Man*, 126.

17. Suzan-Lori Parks, "Possession," in *The America Play and Other Works* (New York: Theatre Communications Group, 1995), 4.

18. Shelby Jiggetts, "Interview with Suzan-Lori Parks," *Callaloo* 19, no. 2 (Spring 1996): 317.

19. Shawn-Marie Garrett, "An Interview with Suzan-Lori Parks," in *Suzan-Lori Parks: Essays on the Plays and Other Works*, ed. Philip C. Kolin (Jefferson, NC: McFarland, 2010), 136; and Parks, "Elements of Style," in *The America Play and Other Works* (New York: Theatre Communications Group, 1995), 15.

20. Suzan-Lori Parks, *The American Play*, in *The America Play and Other Works* (New York: Theatre Communications Group, 1995), 180.

21. Parks, *The America Play*, 196.

22. Also in 2006, the cycle enjoyed a year-long, nationwide premiere under the name *365 Festival*, which gathered more than eight hundred theater groups into sixteen regional networks, each comprising fifty-two production companies. Individual theater groups produced seven plays (one week's worth), matching the dates on which Parks wrote them, so that each network yielded an entire production of the cycle between November 13, 2006, and November 12, 2007.

23. John H. Muse, "Eons in an Instant: The Paradoxes of Suzan-Lori Parks's *365 Days/365 Plays*," *Journal of American Drama and Theatre* 22, no. 1 (Winter 2010): 7–8.

24. Parks, "Possession," 5.

25. See Julien Lagarde, Oliver Hantkie, Abderrazak Hajjioui, and Alain P. Yelnik, "Neuropsychological Disorders Induced by Cerebellar Damage," *Annals of Physical and Rehabilitation Medicine* 52, no. 4 (2009).

26. For more on disciplinary methods and aims of historians, see Andrew Shryock and Daniel Lord Smail, eds., *Deep History: The Architecture of the Past and Present* (Berkeley: University of California Press, 2011); and Andrew Shryock, Thomas R. Trautmann, and Clive Gamble, "Imagining the Human in Deep Time," in *Deep History: The Architecture of the Past and Present*, ed. Andrew Shryock and Daniel Lord Smail (Berkeley: University of California Press, 2011).

27. Bradley Dowden, *The Metaphysics of Time: A Dialogue* (Lanham, MD: Rowman & Littlefield, 2009), 31–32.

28. Newton asserted that "absolute, true, and mathematical time, in and of itself and of its own nature, without reference to anything external, flows uniformly." See Michelle M. Wright, *Physics of Blackness: Beyond the Middle Passage Epistemology* (Minneapolis: University of Minnesota Press, 2015), 14–16, 39.

29. As Michel-Rolph Trouillot observes, "the classification of all non-Westerners as fundamentally non-historical is tied also to the assumption that history requires a linear and cumulative sense of time that allows the observer to isolate the past as a distinct entity." See Trouillot, *Silencing the Past: Power and the Production of History* (Boston: Beacon, 1995), 7.

30. Wright, *Physics of Blackness*, 40.

31. A. Aaboe, "Scientific Astronomy in Antiquity," *Philosophical Transactions of the Royal Society of London. Series A, Mathematical and Physical Sciences* 276, no. 1257, special issue, "The Place of Astronomy in the Ancient World" (1974): 21.

32. Astronomers turned to ephemeris data to standardize time. They aimed to devise a uniform but dynamic scale in which time could be absolutely defined based on the observed position of astronomical objects relative to the Earth. Previously, scientists measured the length of a second as a fraction of the average solar day, yielding imprecise results because the Earth's rotation speed is variable. In 1948, American astronomer Gerald Maurice Clemence proposed "ephemeris time" as a corrective. Clemence's method calculated the duration of a second by subdividing the revolution of the Earth around the Sun, eliminating the Earth's variable rotation speed. Ephemeris time—and the "ephemeris second"—became the benchmark for calculating and measuring time when the International Astronomical Union approved Clemence's recommendation in 1952. Relativistic models of time, such as "terrestrial dynamic time" and "international atomic time," began superseding ephemeris time in 1976 and officially replaced it in 1984, but these theoretical scales still defer to the ephemeris second in their calculations.

33. This is where our word "ephemerality" comes from; when first used in English, it was a scientific term that was applied to short-term illnesses and, following that, organisms with short life spans.

34. Diep Tran, "Wide Awake in America," *American Theatre*, October 24, 2017, https://www.americantheatre.org/2017/10/24/wide-awake-in-america.

35. Suzan-Lori Parks, "The Playwright: Suzan-Lori Parks," PBS, *American Masters* (podcast), August 14, 2017, http://www.pbs.org/wnet/americanmasters/podcast/playwright-suzan-lori-parks/.

36. Jonathan Alter writes that the United States adopted the hundred-day standard following FDR's extraordinary productivity during his first one hundred days but that the phrase refers to the period between Napoleon's escape from Elba and his defeat at Waterloo in 1815 ("*cent jours*"). See Alter, *FDR's Hundred Days and the Triumph of Hope* (New York: Simon & Schuster, 2006), 274.

37. Parks's players comment on the hundred-day standard in several plays toward the cycle's conclusion, including *Ridiculous* (Day 92: April 21), *Forget the Wall* (Day 96: April 25), and *A House Divided Will Not Stand* (Day 100: April 29). In general, these comments come from Trump and his supporters, who try to anticipate and neutralize critiques that the administration has not lived up to its promises, a sign of a stalled presidency.

38. The National Parks Service does not publish crowd estimates about events at the National Mall, so crowd sizes are estimated through overhead imagery and statistics from the Washington Metropolitan Transit Authority. The *Washington Post* estimated Barak Obama's inauguration attendance to be 1.8 million people, and the crowd science professor Keith Still estimated the total attendance of Trump's to be 600,000. See Michael E. Ruane and Aaron C. Davis, "D.C.'s Inauguration Head Count: 1.8 Million," *Washington Post*, January 22, 2009, http://www.washingtonpost.com/wp-dyn/content/article/2009/01/21/AR2009012103884.html; and Sarah Frostenson, "A Crowd Scientist Says Trump's Inauguration Attendance Was Pretty Average," *Vox*, January 24, 2017, https://www.vox.com/policy-and-politics/2017/1/24/14354036/crowds-presidential-inaugurations-trump-average.

39. See John H. Muse, *Microdramas: Crucibles for Theatre and Time* (Ann Arbor: University of Michigan Press, 2017).

40. Edmund Husserl, *On the Phenomenology of the Consciousness of Internal Time (1893–1917)*, trans. John Barnett Brough (Boston: Kluwer Academic, 1991), 286.

41. See Henri Bergson, *An Introduction to Metaphysics*, trans. T. E. Hume (Cambridge, MA: Hackett, 1912); and Bergson, *Creative Evolution*, trans. Arthur Mitchell (New York: Henry Holt, 1911).

42. Matthew Wagner, *Shakespeare, Theatre and Time* (New York: Routledge, 2011), 12.

43. David Ian Rabey, *Theatre, Time and Temporality: Melting Clocks and Snapped Elastics* (Chicago: Intellect, 2016), 17.

44. A lot can happen in a *(Rest)* and a spell, but the dramatic text of *100 Plays for the First Hundred Days* does not supply that action the way a performance might.

45. The title of this essay plays on the canonical writing guide by William Strunk, Jr., and E. B. White. See Parks, "Elements of Style," 9.

46. For Aristotle, a play must have a self-contained and ordered structure with a sense of closure: "a *whole* is something that has a beginning, a middle and an end." See Aristotle, *Poetics*, trans. Anthony Kenny (Oxford: Oxford University Press, 2013), book I, sec. 7, 26.

47. Parks, "Elements of Style," 9.

48. Aristotle, *Physics*, trans. Robin Waterfield (Oxford: Oxford University Press, 1996), book IV, sec. 12, 111.

49. Lutz Koepnick, *On Slowness: Toward an Aesthetic of the Contemporary* (New York: Columbia University Press, 2014), 6.

50. The Austrian philosopher and social phenomenologist Alfred Schutz and the Austrian-American sociologist Thomas Luckmann characterize waiting as a "time structure that is imposed upon us." Similarly, Gaston Bachelard, a French philosopher, has explained that waiting is significant because "we only find that time has *length* when we find it *too long*." See Schutz and Luckman, *The Structures of the Life-World*, trans. Richard M. Zaner and H. Tristam Engelhardt, Jr. (Chicago: Northwestern University Press, 1973); and Bachelard, *The Dialectic of Duration*, trans. Mary McAllester Jones (New York: Clinamen, 2000), 44.

51. Parks, "Elements of Style," 10.

52. See Lagarde et al., "Neuropsychological Disorders Induced by Cerebellar Damage."

53. Frantz Fanon, *Black Skin, White Masks*, trans. Richard Philcox (New York: Grove, 2008), 91.

54. Fanon, *Black Skin*, 95.

55. Saidiya Hartman, *Lose Your Mother: A Journey Along the Atlantic Slave Route* (New York: Farrar, Straus and Giroux, 2007), 6.

56. Christina Sharpe, *In the Wake: On Blackness and Being* (Durham, NC: Duke University Press, 2016), 15.

57. Sharpe, *In the Wake*, 14.

58. Fanon, *Black Skin*, 117.

59. As Parks's asterisk indicates, this quote is an approximation; Trump said, "Frederick Douglass is an example of somebody who's done an amazing job and is being recognized more and more." See "Remarks by President Trump in African American History Month Listening Session," WhiteHouse.gov, February 1, 2017, https://trumpwhitehouse.archives.gov/briefings-statements/remarks-president -trump-african-american-history-month-listening-session/.

60. As discussed in chapter 1, Fanon is hailed by his race when a child tells his mother, "Look! A Negro!" For some audiences, this term may conjure images of the Jim Crow era, as "Negro" was in common use through the 1960s; however, its historical usage is rooted in the nineteenth century, when it functioned as a legal term for enslaved Africans. John Belton O'Neall's *The Negro Law of South Carolina* summarizes the legal definition of the term in the nineteenth century: "the term negro is confined to slave Africans, (the ancient Berbers) and their descendants. It does not embrace the free inhabitants of Africa, such as the Egyptians, Moors, or the negro Asiatics, such as the Lascars." See Fanon, *Black Skin*, 89; and O'Neall, *The Negro Law of South Carolina* (State Agricultural Center of South Carolina, 1848), 5, https://archive.org/details/negrolawsouthca00goog/page/n5/mode/2up.

61. Sharpe, *In the Wake*, 13.

62. Isaac Newton, *The Mathematical Principles of Natural Philosophy*, vol. 1, trans. Andrew Motte (London: Benjamin Motte, 1729), 2.

63. Sharpe, *In the Wake*, 15–16.

64. Debra Walker King, *Deep Talk: Reading African-American Literary Names* (Charlottesville: University Press of Virginia, 1998), 48.

65. Hortense Spillers, " 'The Permanent Obliquity of an In(pha)llibly Straight': In the Time of the Daughters and the Fathers," in *Black, White, and in Color: Essays on American Literature and Culture* (Chicago: University of Chicago Press, 2003), 233; and King, *Deep Talk*, 48.

66. Fred Moten, "The Case of Blackness," *Criticism* 50, no. 2 (Spring 2008): 179, 185, 188.

67. Suzan-Lori Parks, "New Black Math." *Theatre Journal* 57, no. 4 (December 2005): 576.

68. Parks, "New Black Math," 577–578, 582.

69. Parks, "New Black Math," 582.

70. Fanon, *Black Skin*, 113.

71. Fanon, *Black Skin*, 115.

6. HERETICAL POETICS IN ROBIN COSTE LEWIS'S
THE VOYAGE OF THE SABLE VENUS

1. Robin Coste Lewis, *The Voyage of the Sable Venus* (New York: Knopf, 2015), 73.

2. Following Lewis's example, I have elected not to reproduce visually *Voyage of the Sable Venus from Angola to the West Indies* or any of the other art objects to which the language of "The Voyage of the Sable Venus" alludes.

3. Matthew Sharpe, "Robin Coste Lewis" (interview), *BOMB*, January 13, 2016, https://bombmagazine.org/articles/robin-coste-lewis/.

4. Angela Chen, "I Am an Artist Through to My Marrow" (interview), *The Guardian*, December 21, 2015, https://www.theguardian.com/books/2015/dec/21/robin-coste-lewis-poetry-voyage-of-the-sable-venus.

5. Wendy W. Walters, *Archives of the Black Atlantic: Reading Between Literature and History* (New York: Routledge, 2013).

6. Carl Plasa, "Ekphrastic Poetry and the Middle Passage: Recent Encounters in the Black Atlantic," *Connotations* 24, no. 2 (2014/2015): 315.

7. Dabydeen's work responds to J. M. W. Turner's 1840 painting, *Slavers Throwing Overboard the Dead and Dying—Typhoon Coming On*, and the short untitled poem

Turner wrote to accompany it, whereas Philip's comments on the historical events that inspired Turner's painting, signifying on and rewriting the 1783 legal decision *Gregson v. Gilbert*, which determined that the deliberate killing of the enslaved was legal and that insurers were required to pay for their deaths. In this spirit, Rankine reproduces Turner's painting alongside a close-up section focused on the chained feet of the enslaved. Also see M. NourbeSe Philip, *Zong!* (Middletown, CT: Wesleyan University Press, 2008); and Claudia Rankine, *Citizen* (Minneapolis, MN: Graywolf Press, 2014).

8. The transatlantic slave trade also features in other poets' work, such as that of Derek Walcott, especially his *Omeros*, and in Clarence Major's "The Slave Trade: View from the Middle Passage." It is also the subject of a number of novels, including Charles R. Johnson's *Middle Passage* and Toni Morrison's *Beloved* and features in visual-art projects, such as Tom Feelings's *The Middle Passage: White Ships / Black Cargo* (New York: Dial, 1995). Finally, it is also a key concept in critical work, such as Paul Gilroy's *The Black Atlantic: Modernity and Double Consciousness* (New York: Verso, 1993).

9. I engage explicitly with Hartman's critique of the historical archive in the "Writing Heresy" section of this chapter. See Saidiya Hartman, "Venus in Two Acts," *Small Axe* no. 26 (vol. 12, no. 2, June 2008).

10. Leah Mirakhor, "A Door to Robin Coste Lewis's Los Angeles" (interview), *Los Angeles Review of Books*, April 24, 2016, https://lareviewofbooks.org/article/a-door-to -robin-coste-lewiss-los-angeles/.

11. Mirakhor, "A Door to Robin Coste Lewis's Los Angeles."

12. Rancière titled this book *Les Mots de l'histoire* (the words of history) in its first edition, changing the name to *Les Noms de l'histoire* (the names of history) for the second edition.

13. Benjamin writes, "Whoever has emerged victorious participates to this day in the triumphal procession in which the present rulers step over those who are lying prostrate. . . . There is no document of civilization which is not at the same time a document of barbarism. And just as such a document is not free of barbarism, barbarism taints also the manner in which it was transmitted from one owner to another." See Walter Benjamin, "Theses on the Philosophy of History," in *Illuminations*, trans. Harry Zohn, ed. Hannah Arendt (New York: Schocken, 2007), 256.

14. In his critique of historians' methods and procedures, Rancière aligns himself with modern thinkers who have questioned the discipline of historical study, most notably Michel Foucault, to whom his approach to the study of history is indebted. Rancière spoke of that indebtedness in a number of interviews. For example, see Jacques Rancière, Solange Guénoun, James H. Kavanagh, and Roxanne Lapidus, "Jacques Rancière: Literature, Politics, Aesthetics: Approaches to Democratic Disagreement," *SubStance* 29, no. 2 (2000): 13; and Rancière, "The Janus-Face of Politicized Art: Jacques Rancière in Interview with Gabriel Rockhill," in *The Politics of Aesthetics: The Distribution of the Sensible*, ed. and trans. Gabriel Rockhill (New York: Continuum, 2004), 50. For a more elucidating discussion of Rancière's relationship to his immediate predecessors, including Foucault, see Gabriel Rockhill, *Radical History & The Politics of Art* (New York: Columbia University Press, 2014), 145–62.

15. Jacques Rancière, *The Names of History: On The Poetics of Knowledge*, trans. Hassan Melehy (Minneapolis: University of Minnesota Press, 1994), 67.

16. Rancière explains: "It is . . . very much a question of the truth, in so far as the truth signifies more than the exactitude of the facts and figures, the reliability of the sources, and the rigor of the inductions, insofar as the truth concerns the ontological modality to which a discourse is devoted." See Rancière, *The Names of History*, 49–50.

17. Hayden White, "Rancière's Revisionism," in *The Names of History*, trans. Hassan Melehy (Minneapolis: University of Minnesota Press, 1994), ix.

18. Claire Schwartz, "Black Joy Is My Primary Aesthetic" (interview with Robin Coste Lewis), November 14, 2016, https://lithub.com/robin-coste-lewis-black-joy -is-my-primary-aesthetic/.

19. Rancière, *The Names of History*, 102.

20. Darby English, *How to See a Work of Art in Total Darkness* (Cambridge, MA: MIT Press, 2007), 148.

21. Hartman, "Venus in Two Acts," 2.

22. Hartman finds a historical record of Venus in only a few documents regarding the court case that followed her murder. The first mention is in a short exchange during the trial; see *The Whole Proceedings and Trial of Captain John Kimber, for the Murder of a Negro Girl* (1792), 14–15. Venus's second mention is longer but reads only, "there was another girl on board the Recovery . . . whom they named Venus, and she too had the pox;" see *The Trial of Captain John Kimber for the Murder of Two Female Negro Slaves, on Board the Recovery, African Slave Ship* (1792), 19, https://www.loc .gov/item/42028621/.

23. Hartman, "Venus in Two Acts," 9.

24. For a critical discussion of other artists who use postmodern aesthetic strategies to criticize narratives of linear progress and Western art histories, see Huey Copeland, *Bound to Appear: Art, Slavery, and the Site of Blackness in Multicultural America* (Chicago: University of Chicago Press, 2013).

25. Mirakhor, "A Door to Robin Coste Lewis's Los Angeles."

26. Philip's *Zong!* practices a similar found-poetry aesthetic. In her work, Philip signifies on and rewrites the legal decision *Gregson v. Gilbert*. Her repurposing of this decision's language challenges the legitimacy of legal discourse by creating a counternarrative that results in a nondiscursive construction—an absence of language that encourages the reading subject to resist historical and legal narratives and their power regarding racial knowledge. Though her approach resembles what Lewis exercises in "The Voyage of the Sable Venus," her historical critique focuses more on the control of legal decisions over the classification of bodies as property than on defamiliarizing history as a field of rationality. See Philips, *Zong!*, 191.

27. Saidiya Hartman, *Lose Your Mother: A Journey Along the Atlantic Slave Route* (New York: Farrar, Straus and Giroux, 2007), 137; Michel Foucault, "Lives of Infamous Men," in *The Essential Foucault*, ed. Paul Rabinow and Nikolas Rose (New York: New Press, 2003), 284.

28. Hartman produces such a speculative history of a specific woman, Esther Brown, with her method of critical fabulation in Saidiya Hartman, "The Anarchy of Colored Girls Assembled in a Riotous Manner," *South Atlantic Quarterly* 117, no. 3 (July 2018).

29. Hartman, "Venus in Two Acts," 12.

30. The *Venus of Tan-Tan* and the *Venus of Berekhat Ram* are believed to be the oldest Venus figurines, dating from the Middle Acheulean period, between 300,000

and 500,000 years ago. However, some critics have contended that these human-like objects were not deliberately carved but are the result of natural weathering and erosion.

31. Morgan Parker wrote a poem titled "Thirteen Ways of Looking at a Black Girl" in September 2015 for her residency night at Ace Hotel in New York. This poem similarly references Stevens's "Thirteen Ways of Looking at a Blackbird," but because Morgan's and Lewis's works were published the same year, there is not significant evidence that they are alluding to each other.

32. Rancière, *The Names of History*, 101.

33. Hartman, "Venus in Two Acts," 8.

34. Rancière, *The Names of History*, 45.

35. Hortense Spillers, "Mama's Baby, Papa's Maybe: An American Grammar Book," *Diacritics* 17, no. 2, special issue, "Culture and Countermemory: The 'American' Connection" (Summer 1987): 72.

36. Henry Louis Gates, Jr., *Wonders of the African World* (New York: Knopf, 1999), 16–17.

37. It is difficult to determine where the original title begins and ends, but the source version may have read: "slave woman carrying baby and negro boy, running, at left; negro man at right, being held by the collar; two dogs wear collars, one labeled 'Cass,' the other, 'Expounder' " (72).

38. Rancière, *The Names of History*, 45.

39. Though Lewis initially believed that "The Voyage of the Sable Venus" would include only media that the Western art-historical canon now recognizes as traditional—such as paintings, sculpture, installations, photography, lithographs, engravings, and any work on paper—her research uncovered a vast collection of other, everyday objects featuring Black female figures. These included carvings in clocks, buckles, and furniture components such as table legs and bedposts and the handles of combs, cutlery, and pans. After discovering this unexpected but extensive archive of objects that do not seem to be artworks in the conventional sense, she expanded her formal rules to include any material or visual object archived in a museum collection.

40. Only one conventionally visual-art object appears in *The Voyage of the Sable Venus*: Eudora Welty's photograph, "Window Shopping," adorns the volume's cover. The photograph features a slim woman in a floral-print sundress; she gazes into the display window of a shop from a Mississippi sidewalk in the 1930s and seems at once both private and imaginative.

41. Sharpe, "Robin Coste Lewis."

42. Kevin Quashie's differentiation of quiet and silence speaks to the performance that Lewis's "visual silence" enacts: "Quiet is often used interchangeably with silence or stillness, but the notion of quiet . . . is neither motionless nor without sound. Quiet, instead, is a metaphor for the full range of one's inner life—one's desires, ambitions, hungers, vulnerabilities, fears," whereas "the expressiveness of silence is often aware of an audience, a watcher or listener whose presence is the reason for the withholding—it is an expressiveness which is intent and even defiant." See Quashie, *The Sovereignty of Quiet: Beyond Resistance in Black Culture* (New Brunswick, NJ: Rutgers University Press, 2012), 6, 22.

43. W. J. T. Mitchell, *Picture Theory* (Chicago: University of Chicago Press, 1994), 52. See also Grant F. Scott, "The Rhetoric of Dilation: Ekphrasis and Ideology," *Word & Image* 7, no. 4 (1991): 301n2; James A. W. Heffernan, *Museum of Words: The Poetics*

of Ekphrasis from Homer to Ashbery (Chicago: University of Chicago Press, 1993), 3; and Heffernan, "Ekphrasis and Representation," *New Literary History* 22 no. 2 (1991): 299.

44. See Hermogenes, "On Ecphrasis," in *Progymnasmama: Greek Textbooks of Prose Composition and Rhetoric*, trans. George Alexander Kennedy (Boston: Brill, 2003), 86.

45. See Aphthonius, "On Ecphrasis," in *Progymnasmama: Greek Textbooks of Prose Composition and Rhetoric*, trans. George Alexander Kennedy (Boston: Brill, 2003), 117–19.

46. Aristotle, *De Anima*, trans. Hugh Lawson-Tancred (New York: Penguin, 1986), 196–201.

47. Hartman, "Venus in Two Acts," 9.

48. Tavia Nyong'o, *The Amalgamation Waltz: Race, Performance, and the Ruses of Memory* (Minneapolis: University of Minnesota Press, 2009), 136.

49. Schwartz, "Black Joy Is My Primary Aesthetic."

50. Hartman, "Venus in Two Acts," 7.

51. The original descriptive title seems to have read, "a go-go woman holding up spoon at boy with mask who is scaring young girl."

52. The original longer descriptive title is likely "slavers throwing overboard the dead and dying."

53. The original descriptive title combines "American Gothic" with what was probably "colored individuals along the roadside."

54. Spillers, "Mama's Baby, Papa's Maybe," 65.

55. Mirakhor, "A Door to Robin Coste Lewis's Los Angeles."

56. Hartman, "Venus in Two Acts," 4.

57. As an exception, toward the end of the poem, Lewis includes titles of art *by* Black female curators and artists, as well as by queer Black artists regardless of gender, some featuring the Black female figure and some not. She explains that she did so "because this body of work has made consistently some of the richest, most elegant, least pretentious contributions to Western art interrogations of gender and race" (35).

58. Hartman, "Venus in Two Acts," 4.

59. Fred Moten, *In the Break: The Aesthetics of the Black Radical Tradition* (Minneapolis: University of Minnesota Press, 2003), 14–22, 198–200.

60. Rancière, *The Names of History*, 89.

61. Lewis, "Robin Coste Lewis."

62. Robin Coste Lewis, "Life Lines," *O, The Oprah Magazine* (April 2016): 84–85.

63. Schwartz, "Black Joy Is My Primary Aesthetic."

64. Schwartz, "Black Joy Is My Primary Aesthetic."

AFTERWORD

1. Yogita Goyal, "We Need New Diasporas," *American Literary History* 29, no. 4 (Winter 2017): 643.

BIBLIOGRAPHY

@JordanPeele. "'Get Out' Is a Documentary." *Twitter*. November 15, 2017, 8:56 a.m., https://twitter.com/JordanPeele/status/930796561302540288.

Aaboe, A. "Scientific Astronomy in Antiquity." *Philosophical Transactions of the Royal Society of London. Series A, Mathematical and Physical Sciences* 276, no. 1257, special issue, "The Place of Astronomy in the Ancient World" (1974): 21–42.

Adam, Barbara. *Timewatch: The Social Analysis of Time.* Cambridge: Polity, 1995.

Adorno, Theodor. *Aesthetic Theory*. Ed. Gretel Adorno and Rolf Tiedemann, trans. Robert Hullot-Kentor. New York: Bloomsbury, 2013.

Aeschylus. *Agamemnon*. Trans. David Greene and Wendy Doniger O'Flaherty. In *The Bedford Introduction to Drama*, 4th ed. Ed. Lee A. Jacobs, 42–61. New York: Bedford/ St. Martin's, 2001.

Alexander, Michelle. *The New Jim Crow: Mass Incarceration in the Age of Colorblindness.* New York: New Press, 2010.

Algiers Historical Society. "Enslaved Africans." Historical Marker. Algiers, Louisiana, n.d.

Ali, Laylah, and Isaac Allan. "Here Comes the Kiss: A Conversation Between Laylah Ali and Allan Isaac." *Massachusetts Review* 49, nos. 1–2 (2008): 153–60.

Alperson, Philip. "On Musical Improvisation." *Journal of Aesthetics and Art Criticism* 43, no. 1 (1984): 17–29.

Alter, Alexandra. "Paul Beatty Wins Man Booker Prize with 'The Sellout.'" *New York Times,* October 25, 2016. www.nytimes.com/2016/10/26/business/media/paul-beatty-wins -man-booker-prize-with-the-sellout.html.

Alter, Jonathan. *FDR's Hundred Days and the Triumph of Hope.* New York: Simon & Schuster, 2006.

Anderson, Carol. *One Person, No Vote: How Voter Suppression Is Destroying Our Democracy* New York: Bloomsbury, 2018.

Anderson, Elijah. "The White Space." *Sociology of Race and Ethnicity* 1, no. 1 (2015): 10–21.

Aphthonius. "On Ecphrasis." In *Progymnasmama: Greek Textbooks of Prose Composition and Rhetoric*. Trans. George Alexander Kennedy, 117–19. Boston: Brill, 2003.

Aristotle. *De Anima*. Trans. Hugh Lawson-Tancred. New York: Penguin, 1986.

——. *Physics*. Trans. Robin Waterfield. Oxford: Oxford University Press, 1996.

——. *Poetics*. Trans. Anthony Kenny. Oxford: Oxford University Press, 2013.

Ashe, Bertram D. "Theorizing the Post-Soul Aesthetic: An Introduction." *African American Review* 41, no. 4 (2007).

Attali, Jacques. *Noise: The Political Economy of Music*. Trans. Brian Massumi. Manchester, UK: Manchester University Press, 1985.

Azoulay, Ariella. *The Civic Imagination: A Political Ontology of Photography*. New York: Verso, 2012.

Bachelard, Gaston. *The Dialectic of Duration*. Trans. Mary McAllester Jones. New York: Clinamen, 2000.

BAM. "Jordan Peele: The Art of the Social Thriller." April 14, 2020. https://www.bam .org/film/2017/jordan-peele.

Baradaran, Mehrsa. *The Color of Money: Black Bodies and the Racial Wealth Gap*. Cambridge, MA: Belknap, 2017.

Barajas, Joshua. "Paul Beatty Wins Man Booker Prize with 'The Sellout,' a Sendup of Race in America." *PBS News Hour*, October 25, 2016. https://www.pbs.org/newshour /arts/paul-beatty-wins-man-booker-prize-sellout-sendup-race-america.

Baraka, Amiri. *Blues People: Negro Music in White America*. New York: William Morrow, 1999.

Barthes, Roland. *Image-Music-Text*. Trans. Stephen Heath. New York: Hill and Wang, 1978.

Beatty, Paul. *The Sellout*. New York: Picador, 2015.

——, ed. *Hokum: An Anthology of African-American Humor*. New York: Bloomsbury, 2006.

Behrens, Gene Ann, and Samuel B. Green. "The Ability to Identify Emotional Content of Solo Improvisations Performed Vocally and on Three Different Instruments." *Psychology of Music* 21, no. 1 (1993): 20–33.

Benjamin, Walter. *Charles Baudelaire: A Lyric Poet in the Era of High Capitalism*. Trans. Harry Zohn. New York: Verso, 1997.

——. "On Some Motifs in Baudelaire." In *Illuminations: Essays and Reflections*. Trans. Harry Zohn, ed. Hannah Arendt, 155–200. New York: Schocken, 2007.

——. "Theses on the Philosophy of History." In *Illuminations: Essays and Reflections*. Trans. Harry Zohn, ed. Hannah Arendt, 253–64. New York: Schocken, 2007.

Bergson, Henri. *Creative Evolution*. Trans. Arthur Mitchell. New York: Henry Holt, 1911.

——. *An Introduction to Metaphysics*. Trans. T. E. Hume. Cambridge: Hackett, 1912.

——. *Matter and Memory*. Trans. N. M. Paul and W. S. Palmer. New York: Zone, 1990.

Berliner, Paul F. *Thinking in Jazz: The Infinite Art of Improvisation*. Chicago: University of Chicago Press, 1994.

Blake, Ran. "The Monk Piano Style." *Keyboard* 8 (July 1982): 24–30.

Blanchot, Maurice. *The Stop Not Beyond*. Trans. Lycette Nelson. Albany: State University of New York Press, 1992.

Blair, Sara. *Harlem Crossroads: Black Writers and the Photograph in the Twentieth Century*. Princeton, NJ: Princeton University Press, 2007.

Bolen, Jean Shinoda. *Gods in Everyman: A New Psychology of Men's Lives and Loves.* New York: Harper, 1993.

Bonilla-Siva, Eduardo. *Racism Without Racists: Color-Blind Racism and the Persistence of Racial Inequality in America.* Lanham, MD: Rowman & Littlefield, 2014.

Bowles, Juliette. "Extreme Times Call for Extreme Heroes." *International Review of African American Art* 14, no. 3 (1997): 3–15.

Bowman, Wayne. "A Somatic, 'Here and Now' Semantic: Music, Body, and Self." *Bulletin of the Council for Research in Music Education* no. 144 (2000): 45–60.

Boxer, Sarah. "Catching the Image of Jazz as It Will Never Be Again." *New York Times,* March 27, 1996, late edition, C1, 13. https://www.nytimes.com/1996/03/27/arts /catching-the-image-of-jazz-as-it-will-never-be-again.html.

Braithwaite, Hunter. "Miami: Adler Guerrier, David Castillo." *Art in America* 100, no. 11 (2012): 190–91.

Brown, Alan S. *The Déjà Vu Experience: Essays in Cognitive Psychology.* New York: Psychology Press, 2004.

Brown, Jeffrey. "Novelist Paul Beatty Pokes Fun at How We Talk About Race in America." *PBS News Hour,* May 8, 2015. https://www.pbs.org/newshour/show/novelist-paul -beatty-pokes-fun-at-how-we-talk-about-race-in-america.

Brown, Lee B. "Musical Works, Improvisation, and the Principle of Continuity." *Journal of Aesthetics and Art Criticism* 54, no. 4 (1996): 353–69.

Bruce, La Marr Jurelle. *How to Go Mad Without Losing Your Mind: Madness and Black Radical Creativity.* Durham, NC: Duke University Press, 2021.

Bryson, Norman. "The Gaze in the Expanded Field." In *Vision and Visuality,* 87–114. Seattle: Bay Press, 1988.

Butler, Judith. "Endangered/Endangering: Schematic Racism and White Paranoia." In *Reading Rodney King/Reading Urban Uprising.* Ed. Robert Gooding-Williams, 15–22. New York: Routledge, 1993.

Cahill, James Leo, with Rachel Leah Thompson. "The Insurgency of Objects: A Conversation with Fred Moten." *Octopus* 1 (Fall 2005): 45–66.

Carpio, Glenda. *Laughing Fit to Kill: Black Humor in the Fictions of Slavery.* Oxford: Oxford University Press, 2008.

Carrier, David. *Principles of Art Writing.* University Park: Pennsylvania State University Press, 1997.

Caruth, Nicole J. "Just Beyond Reality's Edge: Kira Lynn Harris." *NKA: Journal of Contemporary African Art* 27 (2010): 90–99.

Chakrabarti, Paromita. "I'm No Astronaut of Blackness: Paul Beatty." *Indian Express,* October 26, 2016. http://indianexpress.com/article/lifestyle/books/im-no-astronaut-of -blackness-paul-beatty/.

Chan, Andrew. "Waking Nightmares: A Conversation with Jordan Peele." *Criterion Collection,* February 23, 2017. https://www.criterion.com/current/posts/4439-waking -nightmares-a-conversation-with-jordan-peele.

Chen, Angela. "I Am an Artist Through to My Marrow." *The Guardian,* December 21, 2015. https://www.theguardian.com/books/2015/dec/21/robin-coste-lewis-poetry -voyage-of-the-sable-venus.

Clark, John R. *The Modern Satiric Grotesque and Its Traditions.* Lexington: University Press of Kentucky, 1991.

Cohen, Ralph. "History and Genre." *New Literary History* 17, no. 2 (Winter 1986): 203–18.

Coleman, A. D. "Roy DeCarava: Thru Black Eyes." In *Light Readings: A Photography Critic's Writings, 1968–1978*, 18–28. Oxford: Oxford University Press, 1979.

Collins, Hattie. "Paul Beatty Talks About His Award-Winning, Post-Race Novel, *The Sellout*." *Vice*, January 20, 2017. https://i-d.vice.com/en_uk/article/43wmvq/paul-beatty-talks-about-his-award-winning-post-race-novel-the-sellout.

Cooks, Bridget R. "Snapshots: Brief Takes on Rising Talents." *International Review of African American Art* 19, no. 2 (Spring 2003): 40–49.

Copeland, Huey. *Bound to Appear: Art, Slavery, and the Site of Blackness in Multicultural America*. Chicago: University of Chicago Press, 2013.

Corfield, Penelope J. "History and the Temporal Turn: Returning to Causes, Effects and Diachronic Trends." In *Les âges de Britannia: Repenser l'histoire des mondes britanniques (Moyen Âge-XXIe siècle)*. Ed. Jean-François Dunyach and Aude Mairey, 259–74. Rennes, France: Presses Universitaires de Rennes, 2015.

Crawford, Margo Natalie. *Black Post-Blackness: The Black Arts Movement and Twenty-First-Century Aesthetics*. Champaign: University of Illinois Press, 2017.

Cross, William E., Jr. "The Negro-to-Black Conversion Experience." *Black World* 20, no. 9 (July 1971): 13–27.

Czachor, Emily Mae. "'Get Out' Is a Comedy According to the Golden Globes & Seriously, WTF?" *Bustle*, December 11, 2017. https://www.bustle.com/p/why-is-get-out-nominated-as-a-comedy-at-the-2018-golden-globes-the-horror-movie-isnt-exactly-a-laugh-riot-6789813.

D'Addario, John. "Art & History: Kara Walker's 'The Katastwóf Karavan' Spotlights New Orleans' Slave Legacy." *New Orleans Advocate*, February 20, 2018. http://www.nola.com/entertainment_life/arts/article_7701be6e-f395-5bc1-8371-e98cbcc2c6ef.html.

Das, Jareh. "Science or Fiction: Imaginary Narratives in the Works of Laylah Ali, Hamad Butt, Basim Magdy and Larissa Sansour." *Contemporary Practices: Visual Arts from the Middle East* 13 (January 2013): 44–49.

DeCarava, Roy. *The Sound I Saw: Improvisation on a Jazz Theme*. New York: Phaidon, 2001.

DeCarava, Sherry Turner. "Celebration." In *Roy DeCarava: Photographs*. Ed. James Alinder, 7–20. Carmel, CA: Friends of Photography, 1981.

DeCarava, Sherry Turner, Roy DeCarava, and Ron Carter. "Inventory: A Conversation Between Roy DeCarava and Ron Carter." *MoMA* 21 (Winter–Spring 1996): 2–7.

de Certeau, Michel. *The Practice of Everyday Life*. Trans. Steven F. Rendall. Berkeley: University of California Press, 1984.

de Wilde, Laurent. *Monk*. Trans. Jonathan Dickinson. New York: Da Capo, 1997.

Derrida, Jacques. "The Law of Genre." *Critical Inquiry* 7, no. 1 (Autumn 1980): 55–81.

Descartes, René. *The Passions of the Soul*. In *Philosophical Works of Descartes*, vol. 1. Trans. Elizabeth Haldane and G. R. T. Ross. Cambridge: Cambridge University Press, 1911.

DeVeaux, Scott. *The Birth of Bebop*. Berkeley: University of California Press, 1997.

Dickson-Carr, Darryl. *African American Satire: The Sacredly Profane Novel*. Columbia: University of Missouri Press, 2001.

Dohrn-van Rossum, Gerhard. *History of the Hour: Clocks and Modern Temporal Orders*. Trans. Thomas Dunlap. Chicago: University of Chicago Press, 1996.

Dowden, Bradley. *The Metaphysics of Time: A Dialogue*. Lanham, MD: Rowman & Littlefield, 2009.

Du Bois, W. E. B. *Black Reconstruction in America 1960–1880*. Cambridge: Athenaeum, 1975.

——. *The Souls of Black Folk*. San Bernardino, CA: Eucalyptus, 2014.

Dufrenne, Mikel. *The Phenomenology of Aesthetic Experience*. Trans. Edward S. Casey. Chicago: Northwestern University Press, 1973.

Dyer, Richard. *White: Essays on Race and Culture*. New York: Routledge, 1997.

Eddo-Lodge, Reni. "The Sellout by Paul Beatty Review—a Whirlwind Satire About Racial Identity." *The Guardian*, May 11, 2016. https://www.theguardian.com/books /2016/may/11/the-sellout-by-paul-beatty-review.

Ellis, Trey. "The New Black Aesthetic." *Callaloo* no. 38 (1989): 233–43.

Ellison, Ralph. *Invisible Man*. New York: Vintage, 1995.

——. "The Golden Age, Time Past." In *The Collected Essays of Ralph Ellison*. Ed. John Callahan, 237–49. New York: Modern Library, 2003.

Emirbayer, Mustafa, and Matthew Desmond. *The Racial Order*. Chicago: University of Chicago Press, 2015.

English, Darby. "Almost Comic: The Art of Laylah Ali." *Afterall: A Journal of Art, Context and Enquiry* 6 (2003): 14–23.

——. *How to See a Work of Art in Total Darkness*. Cambridge, MA: MIT Press, 2007.

English, Daylanne K. "Race, Writing, and Time." In *Literature and Time*. Ed. Thomas M. Allen, 225–42. Cambridge: Cambridge University Press, 2018.

"Evening Jazz Cruise." Steamboat NATCHEZ. Accessed December 8, 2021. https://www .steamboatnatchez.com/cruises/evening-jazz-cruise-with-dinner-option.

Everett, Percival. *Erasure*. Lebanon, NH: University Press of New England, 2001.

——. "F/V: Placing the Experimental Novel." *Callaloo* 22, no. 1 (Winter 1999): 18–23.

——. *Percival Everett by Virgil Russell*. Minneapolis: Graywolf, 2013.

Fanon, Frantz. *Black Skin, White Masks*. Trans. Richard Philcox. New York: Grove, 2008.

Farah, Martha J. *Visual Agnosia*, 2nd ed. Cambridge, MA: MIT Press, 2004.

Feelings, Tom. *The Middle Passage: White Ships / Black Cargo*. New York: Dial, 1995.

Fields, Barbara J. "Ideology and Race in American History." In *Region, Race, and Reconstruction: Essays in Honor of C. Vann Woodward*. Ed. J. Morgan Kousser and James M. McPherson, 143–77. Oxford: Oxford University Press, 1982.

Fikes, Robert, Jr. "How Major Book Review Editors Stereotype Black Authors." *Journal of Blacks in Higher Education* 33 (Autumn 2001): 110–13.

Fischlin, Daniel, Ajay Heble, and George Lipsitz, eds. "Prelude: 'The Fierce Urgency of Now': Improvisation, Rights, and the Ethics of Cocreation." In *The Fierce Urgency of Now: Improvisation, Rights, and the Ethics of Cocreation*, xi–xxxi. Durham, NC: Duke University Press, 2013.

Fitterling, Thomas. *Thelonious Monk: His Life and Music*. Trans. Robert Dobbin. Albany, CA: Berkeley Hills Books, 1997.

Fleetwood, Nicole. *Troubling Vision: Performance, Visuality, and Blackness*. Chicago: University of Chicago Press, 2011.

Foucault, Michel. "Lives of Infamous Men." In *The Essential Foucault*. Ed. Paul Rabinow and Nikolas Rose, 279–93. New York: New Press, 2003.

——. "A Preface to Transgression." In *Language, Counter-Memory, Practice: Selected Essays and Interviews*. Ed. and trans. Donald F. Bouchard, 29–52. Ithaca, NY: Cornell University Press, 1977.

Freud, Sigmund. *Jokes and Their Relation to the Unconscious.* Trans. James Strachey. New York: Penguin, 1974.

Frostenson, Sarah. "A Crowd Scientist Says Trump's Inauguration Attendance Was Pretty Average." *Vox,* January 24, 2017. https://www.vox.com/policy-and-politics /2017/1/24/14354036/crowds-presidential-inaugurations-trump-average.

Frye, Northrop. "The Nature of Satire." *University of Toronto Quarterly* 14, no. 1 (1944): 75–89.

Gabbard, Krin. "Signifyin(g) the Phallus: *Mo' Better Blues* and Representations of the Jazz Trumpet." In *Representing Jazz.* Ed. Krin Gabbard, 104–30. Durham, NC: Duke University Press, 1995.

Gabrielsson, Alf, and Patrik N. Juslin. "Emotional Expression in Music Performance: Between the Performer's Intention and the Listener's Experience." *Psychology of Music* 24, no. 1 (1996): 68–91.

Galassi, Peter. "Introduction." In *Roy DeCarava: A Retrospective,* 11–39. New York: Museum of Modern Art, 1996.

Garrett, Shawn-Marie. "An Interview with Suzan-Lori Parks." In *Suzan-Lori Parks: Essays on the Plays and Other Works.* Ed. Philip C. Kolin, 181–90. Jefferson, NC: McFarland, 2010.

Gates, Henry Louis, Jr. *Wonders of the African World.* New York: Knopf, 1999.

Gates, Racquel J. *Double Negative: The Black Image and Popular Culture.* Durham, NC: Duke University Press, 2018.

Gennari, John. "Jazz Criticisms: Its Development and Ideologies." *Black American Literature Forum* 25, no. 3 (1991): 449–523.

George, Nelson. *Post-Soul Nation: The Explosive, Contradictory, Triumphant, and Tragic 1980s as Experienced by African Americans (Previously Known as Black and Before That Negroes).* New York: Penguin, 2005.

Gillespie, Dizzy, and Al Fraser. *To Be, or Not . . . to Bop.* Minneapolis: University of Minnesota Press, 2009.

Gillespie, Michael Boyce. *Film Blackness: American Cinema and the Idea of Black Film.* Durham, NC: Duke University Press, 2016.

Gilroy, Paul. *Against Race: Imagining Political Culture Beyond the Color Line.* Cambridge, MA: Harvard University Press, 2000.

——. *The Black Atlantic: Modernity and Double Consciousness.* New York: Verso, 1993.

——. "It Ain't Where You're from, It's Where You're at . . .: The Dialectics of Diasporic Identification." *Third Text* 5, no. 13 (1991): 3–16.

Golden, Thelma. "Introduction." *Freestyle* (exhibition), 14–15. New York: Studio Museum in Harlem, 2001.

Goldman, Danielle. *I Want to Be Ready: Improvised Dance as a Practice of Freedom.* Ann Arbor: University of Michigan Press, 2010.

Gopnik, Blake. "Kara Walker, 'Tired of Standing Up,' Promises Art, Not Answers." *New York Times,* August 16, 2017. https://www.nytimes.com/2017/08/16/arts/design /kara-walker-race-art-charlottesville.html.

Gotham, Kevin Fox. *Authentic New Orleans: Tourism, Culture, and Race in the Big Easy.* New York: New York University Press, 2007.

Gourse, Leslie. *Straight, No Chaser: The Life and Genius of Thelonious Monk.* New York: Schirmer, 1997.

Goyal, Yogita. *Runaway Genres: The Global Afterlives of Slavery.* New York: New York University Press, 2019.

——. "We Need New Diasporas." *American Literary History* 29, no. 4 (Winter 2017): 640–63.

Greenberg, Harvey Roy. "Get Out: Invasion of the Brother Snatchers." *Psychiatric Times* 34, no. 6 (June 14, 2017). https://www.psychiatrictimes.com/depression /get-out-invasion-brother-snatchers.

Gray, John. *Liberalism.* 2nd ed. Minneapolis: University of Minnesota Press, 2003.

Guerrero, Lisa A. *Crazy Funny: Popular Black Satire and the Method of Madness.* New York: Routledge, 2019.

Guilhamet, Leon. *Satire and the Transformation of Genre.* Philadelphia: University of Pennsylvania Press, 1987.

Hailstone, Julia C., et al. "It's Not What You Play, It's How You Play It: Timbre Affects Perception of Emotion in Music." *Quarterly Journal of Experimental Psychology* 62, no. 11 (2009): 2141–55.

Hall, Gwendolyn Mido. "The Formation of Afro-Creole Culture." In *Creole New Orleans: Race and Americanization.* Ed. Arnold R. Hirsch and Joseph Logsdon, 58–87. Baton Rouge: Louisiana State University Press, 1992.

Hall, Stuart. "Ethnicity: Identity and Difference." *Radical America* 23, no. 4 (1989): 9–20.

Hamilton, Andy. "The Art of Improvisation and the Aesthetics of Imperfection." *British Journal of Aesthetics* 40, no. 1 (2000): 168–85.

Hanchard, Michael. "Afro-Modernity: Temporality, Politics, and the African Diaspora." *Public Culture* 11, no. 1 (1999): 245–68.

"Harbor Jazz Cruise." Steamboat NATCHEZ. Accessed December 8, 2021. http://www .steamboatnatchez.com/harborcruise.

Harper, Phillip Brian. *Abstractionist Aesthetics: Artistic Form and Social Critique in African American Culture.* New York: New York University Press, 2015.

Harris, Laura. *Experiments in Exile: C. L. R. James, Hélio Oiticica, and the Aesthetic Sociality of Blackness.* New York: Fordham University Press, 2018.

Hartman, Saidiya. "The Anarchy of Colored Girls Assembled in a Riotous Manner." *South Atlantic Quarterly* 117, no. 3 (July 2018).

——. *Lose Your Mother: A Journey Along the Atlantic Slave Route.* New York: Farrar, Straus and Giroux, 2007.

——. "Venus in Two Acts." *Small Axe* 26 (vol. 12, no. 2, June 2008): 1–14.

Hassan, Robert. "Globalization and the 'Temporal Turn': Recent Trends and Issues in Time Studies." *Korean Journal of Policy Studies* 25, no. 2 (2010): 83–102.

Heffernan, James A. W. "Ekphrasis and Representation." *New Literary History* 22, no. 2 (1991): 297–316.

——. *Museum of Words: The Poetics of Ekphrasis from Homer to Ashbery.* Chicago: University of Chicago Press, 1993.

Hegel, Georg Wilhelm Friedrich. *The Philosophy of History.* Trans. John Sibree. New York: P. F. Collier, 1902.

Hermogenes. "On Ecphrasis." In *Progymnasmama: Greek Textbooks of Prose Composition and Rhetoric.* Trans. George Alexander Kennedy, 86. Boston: Brill, 2003.

Higgins, Charlotte. "Turned Down 18 Times. Then Paul Beatty Won the Booker. . . ." *The Guardian,* October 26, 2016. https://www.theguardian.com/books/2016/oct/26 /man-booker-prize-winner-paul-beatty-the-sellout-interview.

Highet, Gilbert. *Anatomy of Satire*. Princeton, NJ: Princeton University Press, 1962.

"History." Steamboat NATCHEZ. Accessed December 8, 2021. http://www.steamboatnatchez
.com/history.

Hobbes, Thomas. *Leviathan*. Ed. A. R. Waller. Cambridge: Cambridge University Press,
1904.

Hodeir, André. *Toward Jazz*. New York: Grove, 1962.

Hogue, W. Lawrence. *Postmodernism, Traditional Cultural Forms, and African American
Narratives*. Albany: State University of New York Press, 2013.

Holloway, Karla F. C. "The Death of Culture." *Massachusetts Review* 40, no. 1 (1999):
31–43.

Hom, Andrew R. "Silent Order: The Temporal Turn in Critical International Relations."
Millennium: Journal of International Studies 46, no. 3 (2018): 303–30.

hooks, bell. *Black Looks: Race ad Representation*. Boston: South End, 1992.

Horricks, Raymond. *These Jazzmen of Our Time*. London: Victor Golancz, 1959.

Hume, David. "Of National Character." In *Essays and Treatises on Several Subjects, in
Two Volumes. Vol. 1: Essays, Moral, Political, and Literary*. London: T. Cadell, 1784.

Hume, Kathryn. *Aggressive Fictions: Reading the Contemporary American Novel*. Ithaca,
NY: Cornell University Press, 2012.

Hurston, Zora Neale. "Characteristics of Negro Expression." In *Negro: An Anthology*.
Ed. Nancy Cunard, 24–31. New York: Continuum, 1994.

Husserl, Edmund. *On the Phenomenology of the Consciousness of Internal Time (1893–1917)*.
Trans. John Barnett Brough. Boston: Kluwer Academic, 1991.

Ilesanmi, Olukemi. "Laylah Ali." *Freestyle* (exhibition), 20–21. New York: Studio
Museum in Harlem, 2001.

Ings, Richard. " 'And You Slip Into the Breaks and Look Around': Jazz and Everyday Life
in the Photographs of Roy DeCarava." In *The Hearing Eye: Jazz & Blues Influences in
African American Visual Art*. Ed. Graham Lock and David Murray, 303–31. Oxford:
Oxford University Press, 2009.

Jack, Ian. *Augustan Satire: Intention and Idiom in English Poetry 1660–1750*. Oxford:
Oxford University Press, 1942.

Jackson, Chris. "Our Thing: An Interview with Paul Beatty." *Paris Review*, May 7, 2015.
https://www.theparisreview.org/blog/2015/05/07/our-thing-an-interview-with-paul
-beatty/.

Jacques, Geoffrey. "Roy DeCarava: Looking." *Journal of Contemporary African American
Art* no. 5 (Fall/Winter 1996): 20–23.

James, Stephanie. "Extraordinary Shades of Gray: The Photographs of Roy DeCarava."
Bulletin of the Detroit Institute of Arts 80, nos. 1–2, Graphic Arts (2006): 58–67.

Jiggetts, Shelby. "Interview with Suzan-Lori Parks." *Callaloo* 19, no. 2 (Spring 1996): 309–17.

Johnson, Gaye Theresa. *Spaces of Conflict, Sounds of Solidarity: Music, Race, and Spatial
Entitlement in Los Angeles*. Berkeley: University of California Press, 2013.

Johnson, Rashuana. *Slavery's Metropolis: Unfree Labor in New Orleans During the Age of
Revolutions*. Cambridge: Cambridge University Press, 2016.

Julius, Anthony. *Transgressions: The Offences of Art*. Chicago: University of Chicago Press,
2003.

Kant, Immanuel. *Critique of Judgment*. Trans. James Creed Meredith. Oxford: Claren-
don, 1911.

——. "Of the Different Races of Human Beings." In *Anthropology, History, and Education*. Trans. Robert B. Louden and Günter Zöller. Cambridge: Cambridge University Press, 2007.

Kelley, Robin D. G. *Thelonious Monk: The Life and Times of an American Original*. New York: Free Press, 2009.

Kendi, Ibram X. *Stamped from the Beginning: The Definitive History of Racist Ideas in America*. New York: Nation, 2016.

Kieran, Cashell. *Aftershock: The Ethics of Contemporary Transgressive Art*. London: I. B. Tauris, 2009.

Kiley, Frederick, and J. M. Shuttleworth. *Satire from Aesop to Buchwald*. Indianapolis: Bobbs-Merrill, 1971.

King, Debra Walker. *Deep Talk: Reading African-American Literary Names*. Charlottesville: University Press of Virginia, 1998.

Kite, Lorien. "Man Booker Winner Paul Beatty on Race in a 'Post-Racial World.'" *Financial Times*, October 27, 2016. https://www.ft.com/content/fd256bf0-9c47-11e6 -8324-be63473ce146.

Klein, Melanie. *Envy and Gratitude and Other Works 1946–1963*. New York: Free Press, 1975.

Koepnick, Lutz. *On Slowness: Toward an Aesthetic of the Contemporary*. New York: Columbia University Press, 2014.

Kohn, Eric. "Jordan Peele Challenges Golden Globes Classifying 'Get Out' as a Comedy: 'What Are You Laughing At?'" *IndieWire*, November 15, 2017. https://www.indiewire .com/2017/11/jordan-peele-response-get-out-golden-globes-comedy-1201897841/.

Lagarde, Julien, Oliver Hantkie, Abderrazak Hajjioui, and Alain P. Yelnik. "Neuropsychological Disorders Induced by Cerebellar Damage." *Annals of Physical and Rehabilitation Medicine* 52, no. 4 (2009): 360–70.

Landes, David. *Revolution in Time: Clocks and the Making of the Modern World*. Cambridge, MA: Harvard University Press, 1983.

Latour, Bruno. "Morality and Technology." Trans. Couze Venn. *Theory, Culture & Society* 19, nos. 5–6 (2002): 247–60.

Leader-Picone, Cameron. "Pilgrims in an Unholy Land: Satire and the Challenge of African American Leadership in *The Boondocks* and *The White Boy Shuffle*." In *Post-Soul Satire: Black Identity After Civil Rights*. Ed. Derek C. Maus and James J. Donahue, 137–49. Jackson: University Press of Mississippi, 2014.

Lewis, Robin Coste. "Life Lines." *O, The Oprah Magazine* (April 2016): 84–85.

——. *The Voyage of the Sable Venus*. New York: Knopf, 2015.

López, Haney. *Dog Whistle Politics: How Coded Racial Appeals Have Reinvented Racism & Wrecked the Middle Class*. Oxford: Oxford University Press, 2014.

Losurdo, Domenico. *Liberalism: A Counter History*. New York: Verso, 2011.

Lott, Eric. "Double V, Double-Time: Bebop's Politics of Style." *Callaloo* 26 (Summer 1988): 597–605.

MacCannell, Dean. "Staged Authenticity: Arrangements of Social Space in Tourist Settings." *American Journal of Sociology* 79, no. 3 (1973): 589–603.

Mackendrick, Karmen. "Embodying Transgression." In *Of the Presence of the Body: Essays on Dance and Performance Theory*. Ed. André Lepecki, 140–56. Middletown, CT: Wesleyan University Press, 2004.

Madison, D. Soyini. "Foreword." In *Black Performance Theory*. Ed. Thomas F. DeFrantz and Anita Gonzalez, vii–x. Durham, NC: Duke University Press, 2014.

McWhirter, Christian. *Battle Hymns: The Power and Popularity of Music in the Civil War*. Chapel Hill: University of North Carolina Press, 2012.

Melville, Herman. "Bartleby." In *The Piazza Tales*, 31–108. New York: Dix & Edwards, 1856.

Merleau-Ponty, Maurice. *Phenomenology of Perception*. Trans. Colin Smith. New York: Routledge, 2002.

Miller, Ivor. "'If It Hasn't Been One of Color': An Interview with Roy DeCarava." *Callaloo* 13, no. 4 (Autumn 1990): 847–57.

Mills, Charles W. *The Racial Contract*. Ithaca, NY: Cornell University Press, 1999.

Min, Susette. "Kira Lynn Harris." *Freestyle* (exhibition), 42–43. New York: Studio Museum in Harlem, 2001.

Mintz, Sidney W., and Richard Price. *The Birth of African-American Culture: An Anthropological Perspective*. Boston: Beacon, 1992.

Mirakhor, Leah. "A Door to Robin Coste Lewis's Los Angeles." *Los Angeles Review of Books*, April 24, 2016. https://lareviewofbooks.org/article/a-door-to-robin-coste -lewiss-los-angeles/.

Mitchell, W. J. T. *Picture Theory*. Chicago: University of Chicago Press, 1994.

Monson, Ingrid. "The Problem with White Hipness: Race, Gender, and Cultural Conceptions in Jazz Historical Discourse." *Journal of American Musicological Society* 48, no. 3 (Autumn 1995): 396–422.

Morgan, Danielle Fuentes. *Laughing to Keep from Dying: African American Satire in the Twenty-First Century*. Champaign: University of Illinois Press, 2020.

Morrison, Toni. *Beloved*. New York: Knopf, 1987.

——. *Playing in the Dark: Whiteness and the Literary Imagination*. Cambridge, MA: Harvard University Press, 1992.

——. "Rootedness: The Ancestor as Foundation." In *What Moves at the Margin*, 56–64. Jackson: University Press of Mississippi, 2008.

Morton, Seth. "Locating the Experimental Novel in *Erasure* and *The Water Cure*." *Canadian Review of American Studies* 43, no. 2 (2013): 189–201.

Moten, Fred. *Black and Blur: Consent Not to Be a Single Being*. Durham, NC: Duke University Press, 2017.

——. "The Case of Blackness." *Criticism* 50, no. 2 (Spring 2008): 177–218.

——. *In the Break: The Aesthetics of the Black Radical Tradition*. Minneapolis: University of Minnesota Press, 2003.

——. "Taste Dissonance Flavor Escape: Preface for a Solo by Miles Davis." *Women & Performance: A Journal of Feminist Theory* 17, no. 2 (July 2007): 217–46.

——. *The Universal Machine*. Durham, NC: Duke University Press, 2018.

Miller, Paul D., aka DJ Spooky that Subliminal Kid. *Rhythm Science*. Cambridge, MA: MIT Press, 2004.

Muse, John H. "Eons in an Instant: The Paradoxes of Suzan-Lori Parks's *365 Days/365 Plays*." *Journal of American Drama and Theatre* 22, no. 1 (Winter 2010): 7–31.

——. *Microdramas: Crucibles for Theatre and Time*. Ann Arbor: University of Michigan Press, 2017.

Musser, Amber Jamilla. *Sensational Flesh: Race, Power, and Masochism*. New York: New York University Press, 2014.

Naeem, Asma. *Black Out: Silhouettes Then and Now*. Princeton, NJ: Princeton University Press, 2018, 2–43.

Nancy, Jean-Luc. *Corpus*. Trans. Richard A. Rand. New York: Fordham University Press, 2008.

Neal, Mark Anthony. "The Birth of New Blackness: The Family Stand's Moon in Scorpio." In *Rip It Up: The Black Experience in Rock N Roll*. Ed. Kandia Crazy Horse. New York: Palgrave Macmillan, 2004.

Neary, Lynn. "Novelist Paul Beatty Is First American to Win Britain's Man Booker Prize." NPR, October 25, 2016. https://www.npr.org/sections/thetwo -way/2016/10/25/499368241/novelist-paul-beatty-is-first-american-to-win-britains -man-booker-prize.

"New Orleans Tourism Visitation and Visitor Spending Break Records in 2018." Visit New Orleans, Official New Orleans Tourism Website, May 15, 2019. http:// www.neworleans.com/articles/post/new-orleans-tourism-visitation-and-visitor -spending-break-records-in-2018/.

Newton, Isaac. *The Mathematical Principles of Natural Philosophy*, vol. 1. Trans. Andrew Motte. London: Benjamin Motte, 1729.

"Novelist Paul Beatty Pokes Fun at How We Talk About Race in America." *PBS News Hour*, May 8, 2015. http://www.youtube.com/watch?v=j4PYhbZvz_g.

Nyong'o, Tavia. *The Amalgamation Waltz: Race, Performance, and the Ruses of Memory*. Minneapolis: University of Minnesota Press, 2009.

Omi, Michael, and Howard Winant. *Racial Formation in the United States: From the 1960s to the 1990s*. 2nd ed. New York: Routledge, 1994.

Omry, Keren. *Cross-Rhythms: Jazz Aesthetics in African-American Literature*. New York: Continuum, 2008.

O'Neall, John Belton. *The Negro Law of South Carolina*. State Agricultural Center of South Carolina, 1848. https://archive.org/details/negrolawsouthca00goog/page/n5 /mode/2up.

O'Regan, J. Kevin, and Alva Noë. "A Sensorimotor Account of Vision and Visual Consciousness." *Behavioral and Brain Sciences* 24, no. 5 (2011): 939–73.

Osteen, Mark. "Rhythm Changes: Contrafacts, Copyright, and Jazz Modernism." In *Modernism and Copyright*. Ed. Paul K. Saint-Amour, 89–113. Oxford: Oxford University Press, 2010.

Painter, Nell Irvin. *The History of White People*. New York: W. W. Norton, 2010.

Panish, Jon. *The Color of Jazz: Race and Representation in Postwar American Culture*. Jackson: University Press of Mississippi, 1997.

Parks, Suzan-Lori. *The America Play*. In *The America Play and Other Works*, 157–99. New York: Theatre Communications Group, 1995.

——. *Betting on the Dust Commander*. In *The America Play and Other Works*, 70–90. New York: Theatre Communications Group, 1995.

——. *The Death of the Last Black Man in the Whole Entire World*. In *The America Play and Other Works*, 99–131. New York: Theatre Communications Group, 1995.

——. "Elements of Style." In *The America Play and Other Works*, 6–18. New York: Theatre Communications Group, 1995.

——. "New Black Math." *Theatre Journal* 57, no. 4 (December 2005): 576–83.

——. *100 Plays for the First Hundred Days*. New York: Theatre Communications Group, 2018.

——. "The Playwright: Suzan-Lori Parks." PBS, *American Masters* (podcast), August 14, 2017. http://www.pbs.org/wnet/americanmasters/podcast/playwright-suzan-lori-parks/.

——. "Possession." In *The America Play and Other Works*, 3–5. New York: Theatre Communications Group, 1995.

Peabody, Rebecca. *Consuming Stories: Kara Walker and the Imagining of American Race.* Berkeley: University of California Press, 2016.

Peele, Jordan, dir. *Get Out.* Universal Pictures, 2017. Blu-Ray.

Phillips, Michael. "Jordan Peele's Directorial Debut a Keen 'Social Thriller.'" *Chicago Tribune*, February 24, 2017. https://www.chicagotribune.com/entertainment/movies/ct-jordan-peele-get-out-interview-20170224-column.html.

Philip, M. NourbeSe. *Zong!* Middletown, CT: Wesleyan University Press, 2008.

Piper, Adrian. "Art Talk: Xenophobia and the Indexical Present." Talk at Seminole Community College, 1993. http://www.adrianpiper.com/vs/video_at.shtml.

Plasa, Carl. "Ekphrastic Poetry and the Middle Passage: Recent Encounters in the Black Atlantic." *Connotations* 24, no. 2 (2014/2015): 290–324.

Pindell, Howardena. "Diaspora/Realities/Strategies." Presented at "Trade Routes, History, Geography, Culture: Towards a Definition of Culture in the late 20th Century." 2nd Johannesburg Biennale, Johannesburg, South Africa, October 1997.

——. *Kara Walker/No, Kara Walker/Yes, Kara Walker/?* New York: Midmarch Arts, 2009.

Priestley, Brian. *Mingus, a Critical Biography.* New York: Da Capo, 1983.

Prince, Lyric. "Dear Kara Walker: If You're Tired of Standing Up, Please Sit Down." *Hyperallergic*, August 29, 2017. https://hyperallergic.com/398123/dear-kara-walker-statement-response/.

Quashie, Kevin. *The Sovereignty of Quiet: Beyond Resistance in Black Culture.* New Brunswick, NJ: Rutgers University Press, 2012.

Rabey, David Ian. *Theatre, Time and Temporality: Melting Clocks and Snapped Elastics.* Chicago: University of Chicago Press, 2016.

Rahim, Sameer. "Man Booker Prize 2016 Winner Paul Beatty's The Sellout Is an Outrageous Racial Satire—Review." *The Telegraph*, October 26, 2016. https://www.telegraph.co.uk/books/what-to-read/man-booker-prize-shortlist-2016-paul-beattys-the-sellout-is-an-o/.

Ramsey, Guthrie P. *Race Music: Black Cultures from Bebop to Hip-Hop.* Berkeley: University of California Press, 2003.

Rancière, Jacques. "The Janus-Face of Politicized Art: Jacques Rancière in Interview with Gabriel Rockhill." In *The Politics of Aesthetics: The Distribution of the Sensible.* Ed. and trans. Gabriel Rockhill, 49–66. New York: Continuum, 2004.

——. *The Names of History: On The Poetics of Knowledge.* Trans. Hassan Melehy. Minneapolis: University of Minnesota Press, 1994.

——. *The Politics of Aesthetics: The Distribution of the Sensible.* Trans. Gabriel Rockhill. New York: Continuum, 2011.

Rancière, Jacques, Solange Guénoun, James H. Kavanagh, and Roxanne Lapidus, "Jacques Rancière: Literature, Politics, Aesthetics: Approaches to Democratic Disagreement," *SubStance* 29, no. 2 (2000): 3–24.

Reichert, John. "More Than Kin and Less Than Kind: The Limits of Genre Theory." In *Theories of Literary Genre.* Ed. Joseph P. Strelka, 57–79. University Park: Pennsylvania State University Press, 1978.

"Remarks by President Trump in African American History Month Listening Session." WhiteHouse.gov. February 1, 2017.

Review of "Epistrophy" and "In Walked Bud." Composed and performed by Thelonious Monk. In *Down Beat* (October 20, 1948): 13.

Rich, Nathaniel. "Paul Beatty's Uncomfortable Race Novel." *Daily Beast*, Updated July 12, 2017. https://www.thedailybeast.com/paul-beattys-uncomfortable-race-novel.

Roach, Joseph. *Cities of the Dead: Circum-Atlantic Performance*. New York: Columbia University Press, 1996.

Robinson, Cedric J. *Black Marxism: The Making of the Black Radical Tradition*. Chapel Hill: University of North Carolina Press, 2000.

Rockhill, Gabriel. *Radical History & The Politics of Art*. New York: Columbia University Press, 2014.

Rothstein, Richard. *The Color of Law: A Forgotten History of How Our Government Segregated America*. New York: Liveright, 2017.

Ruane, Michael E., and Aaron C. Davis. "D.C.'s Inauguration Head Count: 1.8 Million." *Washington Post*, January 22, 2009. http://www.washingtonpost.com /wp-dyn/content/article/2009/01/21/AR2009012103884.html.

Russell, Ross. "Bebop." In *The Art of Jazz*. Ed. Martin Williams, 187–214. New York: Grove, 1959.

Russett, Margaret. "Race Under Erasure." *Callaloo* 28, no. 2 (Spring 2005): 358–68.

Saxton, Alexander. *The Rise and Fall of the White Republic: Class Politics and Mass Culture in Nineteenth Century America*. New York: Verso, 1991.

Schapira, Laurie Layton. *Cassandra Complex: Living with Disbelief: A Modern Perspective on Hysteria*. Charleston, SC: BookSurge, 1988.

Schaub, Michael. " 'The Sellout' Is a Scorchingly Funny Satire on 'Post-Racial' America." NPR, March 2, 2015. https://www.npr.org/2015/03/02/388955068/the-sellout-is-a -scorchingly-funny-satire-on-post-racial-america.

Schmidt, Christian. "Dissimulating Blackness: The Degenerative Satires of Paul Beatty and Percival Everett." In *Post-Soul Satire: Black Identity After Civil Rights*. Ed. Derek C. Maus and James J. Donahue, 150–61. Jackson: University Press of Mississippi, 2014.

Schopenhauer, Arthur. *The World as Will and Idea*, vol. 1. 7th ed. Trans. R. B Haldane and J. Kemp. London: Kegan Paul, Trench, Trübner, 1909.

Schutz, Alfred, and Thomas Luckman. *The Structures of the Life-World*. Trans. Richard M. Zaner and H. Tristam Engelhardt, Jr. Chicago: Northwestern University Press, 1973.

Schwartz, Claire. "Black Joy Is My Primary Aesthetic" (interview with Robin Coste Lewis). *Literary Hub*, November 14, 2016. https://lithub.com/robin-coste-lewis-black -joy-is-my-primary-aesthetic/.

Scott, Grant F. "The Rhetoric of Dilation: Ekphrasis and Ideology." *Word & Image* 7, no. 4 (1991): 301–10.

Serres, Michel. *The Five Senses: A Philosophy of Mingled Bodies*. Trans. Margaret Sankey and Peter Cowley. New York: Continuum, 2008.

Sharpe, Christina. *In the Wake: On Blackness and Being*. Durham, NC: Duke University Press, 2016.

Sharpe, Matthew. "Robin Coste Lewis." *BOMB*, January 13, 2016. https://bombmagazine .org/articles/robin-coste-lewis/.

Shavers, Rone. "Percival Everett." *BOMB* 88 (Summer 2004): 46–51.

Shaw, Gwendolyn Dubois. *Seeing the Unspeakable: The Art of Kara Walker*. Durham, NC: Duke University Press, 2004.

Shryock, Andrew, and Daniel Lord Smail, eds. "Introduction." In *Deep History: The Architecture of the Past and Present*, 3–20. Berkeley: University of California Press, 2011.

Shryock, Andrew, Thomas R. Trautmann, and Clive Gamble. "Imagining the Human in Deep Time." In *Deep History: The Architecture of the Past and Present*. Ed. Andrew Shryock and Daniel Lord Smail, 21–52. Berkeley: University of California Press, 2011.

Siddall, Gillian, and Ellen Waterman. "Improvising at the Nexus of Discursive and Material Bodies." In *Negotiated Moments: Improvisation, Sound, and Subjectivity*. Ed. Gillian Siddall and Ellen Waterman, 1–19. Durham, NC: Duke University Press, 2016.

Simmons, K. Merinda. "The Dubious Stage of Post-Blackness—Performing Otherness, Conserving Dominance." In *The Trouble with Post-Blackness*. Ed. Houston A. Baker and K. Merinda Simmons, 1–20. New York: Columbia University Press, 2015.

Smedley, Audrey, and Brian D. Smedley. *Race in North America: Origin and Evolution of a Worldview*. 4th ed. Boulder, CO: Westview, 2012.

Smith, Mark M. *Mastered by the Clock: Time, Slavery, and Freedom in the American South*. Chapel Hill: University of North Carolina Press, 1997.

Smith, Zadie. "Brother from Another Mother." *New Yorker*, February 16, 2015. https://www.newyorker.com/magazine/2015/02/23/brother-from-another-mother.

——. "Getting In and Out: Who Owns Black Pain?" *Harper's Magazine*, June, 24, 2017. https://harpers.org/archive/2017/07/getting-in-and-out/.

Sontag, Susan. *On Photography*. New York: Picador, 2001.

Spencer, Herbert. "On the Physiology of Laughter." In *Essays on Education, Etc*, 298–309. London: Dent, 1911.

Spillers, Hortense J. "Mama's Baby, Papa's Maybe: An American Grammar Book." *Diacritics* 17, no. 2, special issue, "Culture and Countermemory: The 'American' Connection, (Summer 1987): 64–81.

——. "'The Permanent Obliquity of an In(pha)llibly Straight': In the Time of the Daughters and the Fathers." In *Black, White, and in Color: Essays on American Literature and Culture*, 230–50. Chicago: University of Chicago Press, 2003.

——. "Peter's Pans: Eating in the Diaspora." In *Black, White, and in Color*, 1–64. Chicago: University of Chicago Press, 2003.

Stanonis, Anthony J. *Creating the Big Easy: New Orleans and the Emergence of Modern Tourism, 1918–1945*. Athens: University of Georgia Press, 2006.

"Steamboat Guide." Steamboat NATCHEZ. Accessed December 8, 2021. https://www.steamboatnatchez.com/uploads/files/SteamboatNatchezGuide.pdf.

"Steamboat Specs." Steamboat NATCHEZ. Accessed December 8, 2021. https://www.steamboatnatchez.com/uploads/files/TheSteamboatNatchez.pdf.

"A Steam-Powered Statement: Kara Walker's *The Katastwóf Karavan*." *Public Art Review*, no. 58 (2019): 20–27.

Stewart, Anthony. "Unrecognizable Is Still a Category: An Interview with Percival Everett." *Canadian Review of American Studies* 3, no. 37 (2007): 293–324.

"Sunday Jazz Cruise with Optional Brunch." Steamboat NATCHEZ. Accessed December 8, 2021. https://www.steamboatnatchez.com/cruises/sunday-jazz-brunch-cruise.

Szabo, Julia. "Kara Walker's Shock Art." *New York Times*, March 23, 1997, sect. 6, 49–50, https://www.nytimes.com/1997/03/23/magazine/kara-walker-s-shock-art.html.

Tang, Amy. "Postmodern Repetitions: Parody, Trauma, and the Case of Kara Walker." *differences: A Journal of Feminist Cultural Studies* 21, no. 2 (2010): 142–72.

Tate, Greg. "Cult-Nats Meet Freaky-Deke." In *Flyboy in the Buttermilk: Essays on Contemporary America*. New York: Touchstone, 2015.

Taussig, Michael T. *Defacement: Public Secrecy and the Labor of the Negative*. Stanford, CA: Stanford University Press, 1999.

Taylor, Paul C. *Black Is Beautiful: A Philosophy of Black Aesthetics*. Hoboken, NJ: Wiley Blackwell, 2016.

The Trial of Captain John Kimber for the Murder of Two Female Negro Slaves, on Board the Recovery, African Slave Ship. 1792. https://www.loc.gov/item/42028621/.

The Whole Proceedings and Trial of Captain John Kimber, for the Murder of a Negro Girl. 1792.

Thomas, Lorenzo. "The Bop Aesthetic and Black Intellectual Tradition." In *The Bebop Revolution in Words and Music*. Ed. David Oliphant, 105–17. Austin: University of Texas at Austin, 1995.

Thomas, Lynnell L. *Desire and Disaster in New Orleans: Tourism, Race, and Historical Memory*. Durham, NC: Duke University Press, 2014.

Tillet, Salamishah. *Sites of Slavery: Citizenship and Racial Democracy in the Post–Civil Rights Imagination*. Durham, NC: Duke University Press, 2012.

Touré. *Who's Afraid of Post-Blackness?: What It Means to Be Black Now*. New York: Free Press, 2011.

Tran, Diep. "Wide Awake in America." *American Theatre* (October 24, 2017). https://www.americantheatre.org/2017/10/24/wide-awake-in-america/.

Tripathi, Amrita. "'Satire Is an Easy Word to Just Hide Behind:' Paul Beatty on His Man Booker-Winning Novel." *Scroll.in*, January, 23 2017. https://scroll.in/article/827378/satire-is-an-easy-word-to-just-hide-behind-paul-beatty-on-his-man-booker-winning-novel.

Trouillot, Michel-Rolph. *Silencing the Past: Power and the Production of History*. Boston: Beacon, 1995.

Trussow, Thomas. "Get Out (Peele, 2017)." *Lonely Film Critic*, November 14, 2017. https://thelonelyfilmcritic.com/2017/11/14/get-out/.

United States. 106th Congress. 106th Congress, Public Law 106-26, Section 1, Finding 2, Approved May 4, 1999. https://www.congress.gov/106/plaws/publ26/PLAW-106publ26.pdf.

Vidal, Cécile. *Caribbean New Orleans: Empire, Race, and the Making of a Slave Society*. Chapel Hill: Omohundro Institute of Early American History and Culture and University of North Carolina Press, 2019.

Virtue, Graeme. "Is Get Out a Horror Film, a Comedy . . . or a Documentary?" *The Guardian*, November 17, 2017. https://www.theguardian.com/film/filmblog/2017/nov/17/get-out-golden-globes-race-horror-comedy-documentary-jordan-peele.

"VS V1 (Skeleton Key, Get Out)." Stitcher, *Night of the Moving Pictures Podcast*, July 22, 2019. https://www.stitcher.com/podcast/night-of-the-moving-pictures-podcast/the-night-of-the-moving-pictures-podcast/e/62742584#/.

Wabuke, Hope. "Why a Comical Book About Slavery? Ask Paul Beatty." *The Root*, April 1, 2015. http://www.theroot.com/why-a-comical-book-about-slavery-ask-paul-beatty-1790859332.

Wagner, Matthew. *Shakespeare, Theatre and Time*. New York: Routledge, 2011.

Walker, Kara. *A Subtlety, or the Marvelous Sugar Baby, an Homage to the unpaid and overworked Artisans who have refined our Sweet tastes from the cane fields to the*

Kitchens of the New World on the Occasion of the demolition of the Domino Sugar Refining Plant. Creative Time, Brooklyn, May 10–July 6, 2014.

——. *An Audience.* Sikkema Jenkins & Co., New York, November 21, 2014–January 17, 2015.

——. "Artist Forces Racism out of the Shadows." NPR, April 4, 2007. www.npr.org /templates/transcript/transcript.php?storyId=7898752.

——. "Kara Walker Depicts Violence and Sadness That Can't Be Seen." *San Francisco Museum of Modern Art*, October 29, 2019. https://www.sfmoma.org/watch /kara-walker-depicts-violence-and-sadness-that-cant-be-seen/.

——. *No mere words can adequately reflect the Remorse this Negress feels at having been Cast into such a lowly state by her former Masters and so it is with a Humble heart that she brings about their physical Ruin and earthly Demise.* California College of Arts and Crafts, Oakland, April 2–May 15, 1999.

——. "Sikkema Jenkins and Co. is *Compelled* to present The most Astounding and Important Painting Show of the fall Art Show viewing season! Collectors of Fine Art will Flock to see the latest Kara Walker offerings, and what is she offering but the Finest Selection of *artworks* by an African-American Living Woman Artist this side of the Mississippi. Modest collectors will find her prices reasonable, those of a heartier disposition will recognize Bargains! Scholars will study and debate the *Historical Value* and *Intellectual Merits* of Miss Walker's Diversionary Tactics. Art historians will wonder whether the work represents a *Departure* or a *Continuum*. Students of Color will eye her work suspiciously and exercise their free right to Culturally Annihilate her on social media. Parents will cover the eyes of innocent children. School Teachers will reexamine their art history curricula. Prestigious Academic Societies will withdraw their support, former husbands and former lovers will recoil in abject terror. Critics will shake their heads in bemused silence. Gallery Directors will wring their hands at the sight of throngs of the gallery- curious flooding the pavement outside. The Final President of the United States will visibly wince. Empires will fall, although which ones, only time will tell." Sikkema Jenkins & Co., New York, September 7–October 14, 2017.

——. *The End of Uncle Tom and the Grand Allegorical Narrative of Eva in Heaven.* Whitney Museum of American Art, *The Whitney Biennial 1997*, New York, March 20–June 1, 1997.

——. *The Katastwóf Karavan. Prospect.4: The Lotus in Spite of the Swamp*, New Orleans, February 23–25, 2018.

——. *Untitled painting*, 1998. In *Kara Walker: Narratives of a Negress*. Ed. Ian Berry, Darby English, Vivian Patterson, and Mark Reinhardt, 49. Cambridge, MA: MIT Press, 2003.

Walker, Kara, and Jason Moran, "Sending Out a Signal." *Art21* (October 31, 2018). https://art21.org/watch/extended-play/kara-walker-jason-moran-sending-out -a-signal-short/.

Wall, David. "Transgression, Excess, and the Violence of Looking in the Art of Kara Walker." *Oxford Art Journal* 33, no. 3 (2010): 277–99.

Wallen, Ruth. "Reading the Shadows—the Photography of Roy DeCarava." *Exposure* 27, no. 4 (1990): 13–26.

Wallmark, Zachary. "Theorizing the Saxophonic Scream in Free Jazz Improvisation." In *Negotiated Moments: Improvisation, Sound, and Subjectivity*. Ed. Gillian Siddall and Ellen Waterman, 233–44. Durham, NC: Duke University Press, 2016.

Walser, Robert. "The Body in the Music: Epistemology and Musical Semiotics." *College Music Symposium* no. 31 (1991): 117–26.

Walsh, Thomas, and Mark Cave. "Doc Hawley & The Calliope: 'It's More of a Machine Than an Instrument.' " New Orleans Public Radio, October 6, 2016. http://www .wwno.org/post/doc-hawley-calliope-its-more-machine-instrument.

Walters, Wendy W. *Archives of the Black Atlantic: Reading Between Literature and History.* New York: Routledge, 2013.

Washington, Harriet A. *A Terrible Thing to Waste: Environmental Racism and Its Assault on the American Mind.* New York: Little, Brown Spark, 2019.

Weisenburger, Steven. *Fables of Subversion: Satire and the American Novel.* Athens: University of Georgia Press, 1995.

West, Cornel. "Black Strivings in a Twilight Civilization." In *The Future of the Race.* Ed. Henry Louis Gates, Jr., and Cornel West, 53–114. New York: Vintage, 1997.

——. "Niggerization." *The Atlantic* (November 2007). https://www.theatlantic.com /magazine/archive/2007/11/niggerization/306285/

White, Hayden. "Rancière's Revisionism." In *The Names of History.* Trans. Hassan Melehy, vii–xx. Minneapolis: University of Minnesota Press, 1994.

White, Joseph. "Toward a Black Psychology." *Ebony* 25, no. 11 (September 1970): 44–53.

Wiegman, Robyn. *American Anatomies: Theorizing Race and Gender.* Durham, NC: Duke University Press, 1996.

Wilderson, Frank B. III. "Gramsci's Black Marx: Whither the Slave in Civil Society." *Social Identities* 9, no. 2 (2003): 225–40.

Williams, John. "Paul Beatty, Author of 'The Sellout,' on Finding Humor in Issues of Race." *New York Times,* March 2, 2015. https://www.nytimes.com/2015/03/03/books /paul-beatty-author-of-the-sellout-on-finding-humor-in-issues-of-race.html.

Williams, Mary Lou. "The Mad Monk." *Melody Maker* (May 22, 1954).

Williams, Monte. "AT LUNCH WITH: Suzan-Lori Parks; From a Planet Closer to the Sun." *New York Times,* April 17, 1996, C1, 14. https://www.nytimes.com/1996/04/17 /garden/at-lunch-with-suzan-lori-parks-from-a-planet-closer-to-the-sun.html.

Willis, Deborah. *Picturing Us: African American Identity in Photography.* New York: New Press, 1996.

Worcester, David. *The Art of Satire.* Cambridge, MA: Harvard University Press, 1940.

Wright, Michelle M. *Physics of Blackness: Beyond the Middle Passage Epistemology.* Minneapolis: University of Minnesota Press, 2015.

Young, Harvey. *Embodying Black Experience: Stillness, Critical Memory, and the Black Body.* Ann Arbor: University of Michigan Press, 2010.

Young, Kevin. *The Grey Album: On the Blackness of Blackness.* Minneapolis: Graywolf, 2012.

——. "Paul Beatty's 'The Sellout.' " *New York Times,* April 9, 2015. https://www.nytimes .com/2015/04/12/books/review/paul-beatty-sellout.html.

Zinoman, Jason. "Jordan Peele on a Truly Terrifying Monster: Racism." *New York Times,* February 16, 2017. https://www.nytimes.com/2017/02/16/movies/jordan-peele -interview-get-out.html.

INDEX

Aaboe, Asger Hartvig, 166
abstractionism, 223; alienation effect of,
 55; of Blackness, 3–4, 188; definition
 of, 14; disorientation in, 84; in *Get
 Out*, 14–15; Harper on, 27–28, 31–32;
 in *The Sound I Saw*, 27–28; visual
 experience in, 56. *See also* visual
 abstractionism
Abstractionist Aesthetics (Harper), 14
Adorno, Theodor, 115
Aeschylus, 108, 110, 242n41
aesthetic object: as affective, 85, 87; of
 The Katastwóf Karavan, 86
aesthetic strategy, 15–16
African American, 227n2; as identity, 57;
 literature, 5–6, 107, 111–12, 120, 242n38
African American Studies, 103
Afro-pessimism, 247n29
Agamemnon (Aeschylus), 108, 110, 242n41
Aggressive Fictions (Hume), 15
Alexander, Michelle, 128
Ali, Laylah, 17, 27; ambiguity by, 43–44;
 déjà vu by, 42, 44; Greenheads by,
 42–44; *jamais vu* by, 45–46; *Untitled*
 (Basketball) by, 42, 42; *Untitled*
 (Running) by, 43, 43
Alter, Jonathan, 252n36

Americans, The (Frank), 25
America Play, The (Parks, S.), 162–63
anchorage of meaning, 55–56
Anderson, Carol, 128
Apollo, 109
archetype, 109
Archives of the Black Atlantic (Walters),
 191
Aristotle: on phantasia, 211; on plays,
 253n46; on time, 173
Armstrong, Louis, 106–7, 242n34
Ask Your Mama (Hughes), 6
Attali, Jacques, 33
Audience, An, 235n16
Azoulay, Ariella, 56

Baradaran, Mehrsa, 128
Baraka, Amiri: on bebop style, 113; "It's
 Nation Time" by, 6; on jazz music, 95
barbarism, 255n13
Barthes, Roland, 55–56, 93, 120
Beatty, Paul: on activism, 122; Black
 humor of, 151–52; on black identity,
 249n52; on equality and hierarchy
 under social inversion, 130–38; on
 fallacy of white victimhood, 138–44;
 on generative transgressions of black

CPSIA information can be obtained
at www.ICGtesting.com
Printed in the USA
JSHW041236070722
27617JS00001B/3